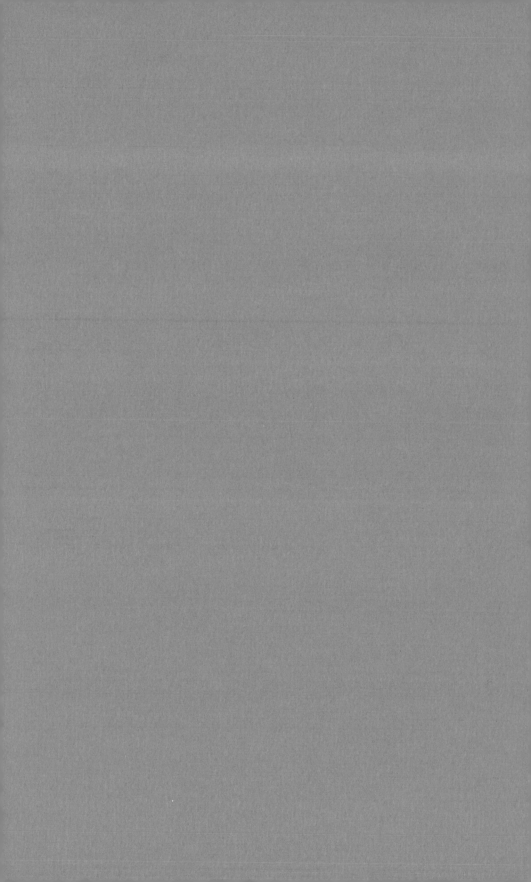

Fire Light

Angel De Cora painting in Howard Pyle's Franklin Street studio, Wilmington, Delaware, circa 1898, from Frank Schoonover's scrapbook. (Courtesy of Delaware Art Museum)

Fire Light

The Life of Angel De Cora, Winnebago Artist

Linda M. Waggoner

University of Oklahoma Press : Norman

Library of Congress Cataloging-in-Publication Data

Waggoner, Linda M.
 Fire light : the life of Angel De Cora, Winnebago artist / Linda M.
Waggoner.
 p. cm.
 Includes bibliographical references and index.
 ISBN 978-0-8061-3954-8 (hardcover : alk. paper) 1. Henook-Makhewe-
Kelenaka. 2. Winnebago women—Biography. 3. Winnebago
artists—Biography. 4. Winnebago Reservation (Neb.)—History.
5. Winnebago Reservation (Neb.)—Social life and customs. I. Title.
 E99.W7W34 2008
 978.2'5—dc22

 2008007769

The paper in this book meets the guidelines for permanence and durability
of the Committee on Production Guidelines for Book Longevity of the
Council on Library Resources. ∞

1 2 3 4 5 6 7 8 9 10

To William Scott Waggoner (1956–1997)

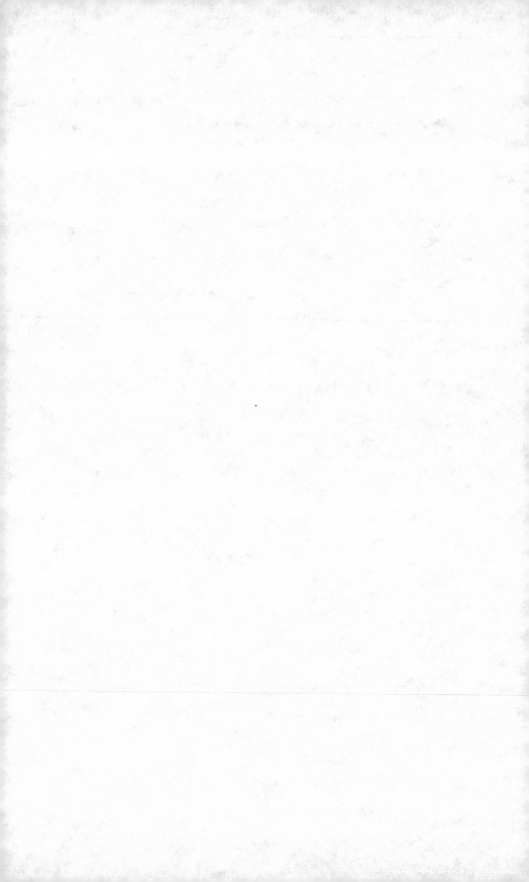

"And this also I send with you that you may use it in life. When you offer anything it shall be your mediator. It shall take care of you through life. It shall stand in the center of your dwellings and it shall be your grandfather." Thus Earthmaker spoke to them. What he meant was fire.

Winnebago man
of the Thunderbird clan, circa 1910

Contents

Illustrations

Preface

Angel De Cora painted *Fire Light* to illuminate warm memories of her childhood on the Nebraska plains after she settled far from home in the east. This book, *Fire Light,* is my attempt to light her way back to us. I discovered Angel while researching a community of nineteenth-century Winnebago (or Ho-Chunk) Métis. My interest in this group developed when I discovered names from my own paternal line included in a study on the fur trade and the genesis of Métis (mixed) culture in the Great Lakes region by ethnohistorian Jacqueline Peterson. The members of my family left the Winnebago tribe long, long ago, but I'm descended from the sister of Angel's paternal great-grandfather, White War Eagle Decorah, a Winnebago civil chief who died in 1836 just before the U.S. government removed the Winnebagos from their homeland in Wisconsin and Illinois. According to Winnebago oral tradition, the firstborn child, Chougeka, of the first recorded marriage between a Winnebago woman (certainly not a princess but an alleged "chieftess") and a non-Native man fathered White War Eagle and his siblings. Angel's father descended from this line of patriarchs of the Thunderbird clan.[1]

Angel's unique heritage, her family history, and the migration and diaspora of the Winnebagos render themselves visible and audible through the many spellings of her family name. Although today she is commonly referred to as "DeCora" and "DeCora Dietz" (or "Deitz"), from the beginning of her formal education to the end of her life she usually wrote her name "De Cora" (choosing "de Cora" as her professional name, but quite often signing her paintings "A. de C."). Others wrote her family name in various ways as well, and the reader will encounter these forms. (The reader will also notice that Angel is not the only person in her story whose name is not hampered by English standardized spelling.) Occasionally Angel shortened her name to "De-Cora," especially when paired with her married name. Rarely, she used "Decora," the spelling that many of her relatives settled on because it eventually settled on them through tribal records referring to Angel's grandfather. In his prime, however, her grandfather was often called "Little Decorri," while his father, White War Eagle Decorah, was noted

in his day as "Decaré" or "Day-kau-ray." Both men had several other monikers, including their Indian names, for which there was no standard spelling, because the Winnebago inhabited an oral culture. A French ancestor with a name something like "de Carrie" (recorded with its own variety of phonetic spellings) introduced his name to the Winnebago people through marriage nearly three hundred years ago. As the name traveled through space, time, and a variety of cultural influences, a multitude of pronunciations and spelling practices shaped it into at least thirty recorded versions. The name's dynamic journey proves Angel's people cared little about standardized spelling, even when they were literate, and separated public names from private to safeguard their spiritual health. It also symbolizes her family's remarkable ability to accommodate change, for better and worse.

Angel's mother was a product of the fur trade. More French-Canadian in habits than Winnebago, she nevertheless adapted to reservation life. Angel first came into my view, consequently, as a descendent of the Decorah family, rather than as a significant Native American artist. When I discovered the work of the few who studied her art career, I noticed their observations omitted the ways her unique heritage shaped her life and influenced her career as an artist, educator, and advocate for the preservation of Native American art.

David Lee Smith, the tribal historian for the Nebraska Winnebagos and also a Wisconsin Decorah descendant, welcomed me to this path several years ago when he graciously granted me permission to write Angel's biography. His permission, which does not necessarily include his endorsement of my viewpoint, included a file box filled with research materials. Anna Romero, a Winnebago woman and scholar, collected much of the box's contents several years ago for a documentary film on Angel's art career. Unfortunately she lost her funding for the project and the film was never made. I visited the archives Romero diligently searched to discover more materials relevant to my project. I also visited several archives not included in her quest. Adding these records, tribal records, and my own research on the Winnebagos and their Métis kin into the mix, I believe I've gathered enough material to create an *interpretation* of Angel's life, which is all a biography can really ever be.

Angel left little record of her personal life. The largest collection of her correspondence comes from the student files of Hampton Normal and Agricultural Institute, held by the Hampton Museum Archives in Virginia. Her file is a wonderful scrapbook of her many accomplishments from childhood to her death. It includes several letters she wrote to Hampton staff member and teacher Cora M. Folsom, her mentor and

her (first) second mother (prior to Gertrude Clapp). It also includes a few precious letters she wrote to Carrie Andrus, Folsom's successor. Angel's letters to Folsom are personal and extend over thirty years, but she did not disclose her deepest feelings, particularly about her troubled marriage. Angel expressed herself more freely in letters to Andrus, who was much younger than Folsom. I also collected letters Angel wrote to employers and colleagues, such as Franz Boas. These letters contain little personal information, and only one of these correspondents, Francis La Flesche, was a Native American. I depended on letters written by her sister, Julia De Cora, and other Winnebago students who attended Hampton or Carlisle. They are also written to school staff, but offer important insight into Angel's life.

§

Native American art appreciators revere southwestern artists such as Maria and Julian Martinez of the San Idelfonso Pueblo, but few remember that a modest Winnebago woman passionately promoted talents such as theirs many years before the 1920s. She also created her own rugs, jewelry, beaded objects, and so on, employing traditional techniques, as well as adding new innovations. She taught students at Carlisle to create such objects as well, but their work and hers is lost to anonymity.

The lack of recognition for Angel's contributions became strikingly clear to me when I visited the "International Arts and Crafts" exhibit at the de Young Museum in San Francisco on June 17, 2006, the day before it closed. The exhibit originated in London's Victoria and Albert Museum, traveled to the Indianapolis Museum of Art, and finished in San Francisco. Mark Jones, director of the Victoria and Albert, said he was "delighted" to send the exhibit to America, "and to celebrate the international dimensions of the Arts and Crafts Movement in a country where it was perhaps at its boldest and most successful."[2]

Visitors entered the de Young exhibit through Great Britain's extensive collection. The wide array of beautifully handmade crafts included not only furniture pieces and household items, but also clothing and print- and book-making creations. Exhibit commentary gave special attention to William Morris and explained his great influence on the international movement.

The exhibit rooms were geographically divided within Europe and Russia, then the United States, and last Japan. Many items were spectacular, and though each country or area, such as Austria-Hungary, had its own national or "race character," unique pieces broke these molds. I held my breath as I read each printed description, savoring my anticipation of the

American section. After spending such a long time learning and writing about Angel's vital connection to America's arts and crafts movement, I couldn't wait to see how Native America would be portrayed.

As I entered the U.S. part of the exhibit, I found myself in the American Indian section. At first I felt awestruck, but my excitement quickly turned to disappointment. I nearly walked right into two of Edward Curtis's vanishing Indian sepia-toned photographs, one "Chief of the Desert–Navaho," and the other, "Canon de Chelly, Arizona"—chosen, apparently, to show the chief's habitation. A Navajo chief's blanket hung on the wall to complete the diorama. A beautifully beaded Yakima dress, a willow puberty basket, and another Indian basket gave the display its female component. These last pieces, along with the chief's blanket, were the only objects made by American Indians. The anonymous basket, however, demonstrated its generic influence on the non-Native artist of a Marblehead pottery vase sitting next to it. A Tiffany 'Pueblo' vase, derived from Pueblo pottery, rested nearby, though no Native American pottery claimed its place. A highly glazed, brown Rockwood Pottery vase completed the Native American section. Its non-Native artist decorated it in 1896 with a weirdly romanticized portrait of the head of an Indian chief or warrior.

As I tried to grasp the simplistic vision of Native America's contribution to the era, my husband called me to look at the large Gustav Stickley living room that bordered "Navajo country." I approached the velvet cord that kept us at bay and followed the direction of his finger to an octagonal dining table graced with a Tiffany lamp. Editions of the *Craftsman*, *Harper's Weekly*, and *Country Life in America* from 1904 ornamented the tabletop along with one large book. I gasped when I saw the book's cover. "I have that book, I have that *exact* book!" I exclaimed loudly to the poor woman next to me. I didn't realize until a moment passed that not only did I *have* that book, but it also validated my great anticipation. The first edition copy of *The Indians' Book* by Natalie Curtis, published in 1907, fulfilled my expectations for at least one small gesture to Angel De Cora. The book not only launched Angel's national reputation as an American Indian designer, but thrust her into a teaching career where she influenced countless American Indian students.

I thought about the significance of the gesture that placed that particular book on the table for the "Re-creation of a 'Craftsman' room based on original drawings from Gustav Stickley's Craftsman Workshops," as the description card read. I suddenly had a feeling of déjà vu. I remembered a similar gesture described by the Commissioner of Indian Affairs in his 1901 report. The commissioner had appointed

Angel to design the centerpiece and settee for an arts and crafts style room in the Indian School Exhibit at the Pan-American Exposition held in Buffalo, New York, in 1901—the same year Stickley launched his famous magazine.

Angel designed the fireplace mantle and andirons with thunderbird and fire motifs. "This poetic conception is carried out with clearness, simplicity and skill, and makes Miss de Cora's mantel [*sic*] a work of art," boasted the commissioner.

Angel also created *Fire Light*, a tonalist-style oil painting, to hang over the mantle, and her more realistic painting for the frontispiece of *The Middle Five*, a book about Indian boys at school published in 1900, appeared on another wall. The director of that exhibit gestured to the room's Indian designer as well when he or she displayed *The Middle Five* on top of a bookshelf in the room. The year before, Angel designed the book's unique cover, merging American Indian design elements with arts and crafts style.

Given the dates of the magazines prominently displayed on Stickley's table in San Francisco, Angel's rooms in Buffalo predated it by three years. I wondered how the curator decided on *The Indians' Book* to complement not only Stickley's room, but also his famous magazine, the *Craftsman*, which sat beside it. The curator probably didn't realize that in 1910 Stickley's lawyers requested that the Carlisle Indian School stop using the title the *Indian Craftsman* for *its* monthly publication. The quality of Carlisle's magazine was so good Stickley's readers were getting the two confused. I assumed the curator was also unaware that Stickley's competitor, Elbert Hubbard of Roycrofters, visited the school during this interchange to see for himself what the fuss was about. He discovered the impressive work done by Angel's students and encouraged them to continue. As its art directors, Angel and her husband decorated the school magazine's first page with an arts and crafts style letter block. A bold red "C" for Carlisle arose from a black and white geometric square, beautifully cut with a Navajo blanket design. A Roycrofters-like credo appeared beneath the school's logo with a subtle message lost on readers today: "A magazine not only *about* Indians, but mainly *by* Indians."

I imagined the *Craftsman* gesture wildly to *The Indians' Book* sitting on Stickley's octagonal table, but *The Indians' Book* was silent—though not stoic. The "object list" of "A Craftsman Room" for the exhibit read: "*The Indian's Book* [note incorrect apostrophe]. Recorded and edited by Natalie Curtis, New York and London, 1907." But who could read between the lines? If only Natalie Curtis lived, she would claim, perhaps with some prejudice, "Though [Angel] started her career by illustrating

books of Indian tales, she later looked down on these early efforts, for her greatest work lay in decorative design." Natalie would also recall that when Angel created the first unique Indian lettering for the Winnebago chapter heading, her publisher's in-house designer claimed he couldn't possibly reproduce the style. "Whoever did that lettering is a genius! Don't ask *me* to make letters like that." Consequently, Angel created all the chapter headings and the title page. Curtis's anecdote reveals that Angel influenced America's arts and crafts movement not as an *inspiration* but as an artist.

The International Arts and Crafts exhibit tried to exhibit Native America's influence on the arts and crafts movement, but it provided no place and no space for the agency of American Indian artists themselves. What could have been, at least partially, "*by* Indians," appeared as usual only "*about* Indians." Like *The Indians' Book*, with its beautiful arts and crafts sand painting–inspired cover, lying seemingly stoic on Stickley's table, a deeply layered, rich historical text remained closed. I hope this book, at least in some small measure, will begin to open it.

Acknowledgments

I often depend on the kindness of strangers to steer me in the right direction through the lonely process of independent scholarship. Sometimes the strangers become friends who do more than their share of handholding. There are five such people at the top of my list to thank, who have supported me in various and immeasurable ways. First, my best buddy and near brother, David Lee Smith, who for many years has offered me full access to the archives of the Ho-Chunk Historical Society. More importantly for this project, he gave me his blessing, backed up by the "OK" from his amazing mom, Emily Smith. As tribal historian for the Nebraska Winnebago, David has also provided, without saying a word, the little voice in my ear that constantly reminds me Angel was more than a "pan-Indian," she was a Winnebago who deserves to be honored.

Second, I am indebted to Matthew Bokovoy, my acquisitions editor at the University of Oklahoma Press. The job title does not at all reflect the amount of work he dedicated to this project. His faith in my work never seemed to waver. I don't know where in the universe he came from or why he chose to stick by me, but I do know that he gave it his all and has continued to inspire me to do my best for the last three years.

Next I owe my gratitude to two fantastic women who have nurtured and encouraged me, Barbara Landis and Karol Schmiegel. Barbara, from Pennsylvania's Cumberland County Historical Society, single-handedly and lovingly maintains the archives for the Carlisle Indian and Industrial School. She also adds new material, transcribes the school's old newspapers and sends them out via e-mail attachment to a long list of people. She encourages our scholarship, takes care of us when we come to visit, offers us tours of the old campus, and puts us in touch with each other if necessary. She is the ultimate networker, but she has also become my trusted friend.

I met Karol when she directed the Biggs Museum in Dover, Delaware. The museum's exhibit, "Almost Forgotten: Delaware Women Artists and Art Patrons 1900–1950," featured a painting Angel did as a student of Howard Pyle. When the show moved to a historical art colony at

Rehoboth Beach, Karol gave the painting an honored place over the fire-place. She also gave me a grand tour of places significant to Angel's time with Howard Pyle. She took me under her wing the moment we met and has not dropped me once. Her encouragement for this project as it relates to American art has sustained me.

The fifth wheel is certainly no fifth wheel. L. George Moses is a won-derful writer and professor of History of the American West and Native North America, a reader extraordinaire, with a surname that says it all. George sifted carefully through my manuscript and offered helpful detailed suggestions and truly constructive criticism that were my ten, or I should say forty something, commandments. Without these, I would have been lost in the final phase and maze of revisions. George's wise comments (and wise cracks) helped me make the book more his-torically relevant and accurate.

I also want to thank Anna Romero and Paulette Fairbanks Molin, whose research on Angel De Cora came to me in a box from David Lee Smith. I have not met Anna, but I can't thank her enough for the wealth of materials she diligently gathered, especially concerning Angel's art and teaching career. I have met Paulette, who, in addition, provided me with her scholarship on Hampton Institute. I also owe my gratitude to Mary Lou Hultgren, former director of Hampton Museum Archives. Mary Lou shared her scholarship, hosted me when I visited Hampton, and cheerfully answered my questions until she retired. Thanks to archivist Donzella Maupin for making copies and procuring scans from the Hampton archives, and to Vanessa Thaxton-Ward for providing the scan of Angel's painting held by the museum.

I extend my undying gratitude to James L. Hansen of the Wisconsin Historical Society in Madison and Diane Dietz, descendant of the brother of Angel's husband, Lone Star Dietz. Both have helped me with the mysteries surrounding Angel's husband. I've so enjoyed Diane's buoyant, wonderfully open personality. She generously shared her research on her relative with me. As always, Jim Hansen is my steady guide through Wisconsin fur trade era history. No one knows more in this area.

I thank the many archivists, librarians, photo curators, and others, across the land, named and unnamed, at the following institutions that I have visited (in alphabetical order): Beinecke Rare Book and Manu-script Library, Yale University, New Haven; Blue Earth Historical Soci-ety Mankato; "Deb," Coffrin Library, Green Bay Area Research Center; Linda Witmer and Richard Tritt, Cumberland County Historical Soci-ety, Carlisle; Kraig A. Binkowski, Sarena Fletcher, and Lois A. Stoehr, the

Delaware Art Museum, Wilmington (a special thanks to the Delaware Art Museum for its generosity in sharing its archives and images); Green Library, Stanford University, Palo Alto; Kate Graham, Iowa County Area Research Center, Platteville, Wisconsin; Dallas R. Lingren, Minnesota State Historical Society, St. Paul; Aubrey Baer, School of the Museum of Fine Arts, Boston; Jeannie Sklar and Daisy Njoku, National Anthropological Archives, Suitland; Kimberley Reid, National Archives—Central Plains Region, Kansas City; Jill M. Abraham and Mitchell Yockelson, National Archives, Washington, D.C.; Matt Piersol and Linda Hein, Nebraska State Historical Society, Lincoln; New York State Archives, Albany; Joel Minor, Oglala Lakota College Archives, Kyle, South Dakota; Karen Kappenman, Portage Public Library, Portage, Wisconsin; Mark G. Thiel, Raynor Library, Special Collection and Archives, Marquette University, Milwaukee; Sioux City Public Library, Sioux City, Iowa; Nanci Young and Susan Sanborn Barker, Smith College Archives, Northampton; Ken R. Stewart, South Dakota Historical Society, Pierre; the lovely women from the Studio Group, Wilmington; Kevin Thorie, University of Wisconsin-Stout, Library Learning Center; and Jacqueline DeGroff and Stephen T. Janick, the W. W. Hagerty Library, Drexel University, Philadelphia.

Thanks also go to those staff members from institutions I have not visited, but who helped me by phone, letter, or e-mail: American Philosophical Society Archives, Philadelphia; Max Bunson, Friends University Archives, Wichita; Kim Walters, Institute for the Study of the American West, Southwest Museum, Los Angeles; Ben Stone, Kansas State Historical Society, Topeka; National Archives—Pacific Region, Seattle; Oklahoma Historical Society, Oklahoma City; Leslie Green and Richard Sorensen, Smithsonian American Art Museum; Tracy Elizabeth Robinson, Smithsonian Institution Archives; St. Louis Public Library, St. Louis, Missouri; and Wichita State University Library, Special Collections.

Special individuals who have aided, encouraged, and/or inspired me (sometimes from afar) to take on or complete this project include: Al Bredenberg, Susan Rose Dominguez, Suzan Shown Harjo, Elizabeth Hutchinson, Tsianina Lomawaima, Sarah McAnulty Quilter, Jacqueline Peterson, Ginny Risk, Ted Sargent, Katie J. Shindall, Gerald Vizenor, Michael Willard, and Ray Wilson. Thanks also to my niece, Cassandra Waggoner, who scanned newspaper microfilm for hours at the University of Washington, Seattle, where she is an undergraduate. I also thank Maggie Miller of Sonoma State University (SSU) and Bud Metzer of the Santa Rose Junior College for getting me up to snuff on the Progressive era, and Paddy Moore for sharing her expertise in Native American art.

In addition, I appreciate the generosity of Trip Lynch and his late father, Harry W. Lynch, Jr., for allowing me to reproduce *Lafayette's Headquarters* for this book. Much thanks also to John R. Schoonover, grandson of Frank E. Schoonover, who photographed it.

A big thanks to Andrew J. Darling, great grandson of Angel's friend from Hampton, Mary "Mollie" Gorton Darling, for allowing me to reproduce the frontispiece for *The Middle Five*.

Special mention goes to SSU's Office of Research and Sponsored Programs, for providing me a $500 grant to begin my research on the Winnebago Métis many years ago. Thanks also to SSU's library staff for putting up with my many requests for interlibrary loans and for the multitude of faculty and students who contributed their influence (over the years) in numerous ways.

I'm also deeply grateful to Alice K. Stanton, my delightful, caring, and organized project editor from the University of Oklahoma Press. If it weren't for Alice I would still be panicking over the state of my manuscript rather than feeling such happy anticipation for the publication of my book. Thanks to Alice's match-making skills, I worked with Rosemary Carstens, the copy editor of my dreams. Rosemary's clear direction, thoughtful suggestions, our inspirational discussions, and her eagle eye helped make this a story I feel proud to have written.

Finally, I thank my loving family profusely for their never-ending support. The faith of my siblings, Larry and Chris Waggoner and Cathy Johnston, and my mom, Elaine Edwards, means the world to me. My husband, Roger Bell, always makes me feel like he's my biggest fan, even when I know he wishes we had something else to talk about at the end of the day. I also depend on the encouragement (and tolerance) from our incredible children, Biba and Gelsey Bell, Mr. and Mrs. Brooke Vermillion-Tong, Neal Carson, and, especially, Hilary Carson, who has listened patiently and offered her empathy in my times of need.

Introduction

"Angel De Cora, a Winnebago with noble French blood and descended from a line of famous chiefs," wrote Elaine Goodale Eastman, "was an idealist and an artist to her fingertips." To characterize Angel as an American Indian artist today, however, involves a paradox that Angel's friend, Elaine, could not have foreseen. Like a shooting star, we see Angel's trace, but we can no longer see her originality. To many, her artwork is too western in execution to be considered authentic Native American art. To others her paintings, such as *Fire Light*, are apparitions marked with the stigmata of imperialist nostalgia. But it is not only her artwork that poses a challenge for our perceptions. In order to contextualize her work today, we are left with the rhetoric of authenticity that she herself disseminated.

Angel is not honored as a significant Native American artist, at least according to the National Museum of the American Indian's commemorative book, *Creation's Journey: Native American Identity and Belief.*[1] Her artwork is not represented inside the book's covers, nor is the prolific work of her art students from the Carlisle Indian and Industrial School in Pennsylvania. Yet the text is steeped in her influence: Concepts of abstraction, discussions of Indian trade economies and Native women, ideals about the American Indian's connection to the land, debunking myths about symbols, such as feathers, and, in general, educating Americans on the appropriate use and representation of American Indian design elements.

It might seem Angel had little in common with the Pomo basketmakers or the Pueblo potters, but she identified with these women. She even claimed an affinity with the ledger book artists, who are also featured in the museum's book. Unlike her, Richard Henry Pratt's Fort Marion prisoners created two-dimensional subjects that acted mostly on the battlefield. Some, like Kiowa Paul Zotom (1853–1913), also decorated fans and souvenirs to sell to curio collectors. Zotom later gained distinction for painting teepees for the Trans-Mississippi and International Exposition held in Omaha in 1898, where Angel exhibited her artwork in the Bureau of Indian Affairs (BIA) exhibit.[2] Although they

traveled in the same World's Fair circuit, Angel's pictures proved what a little Indian education could do, while Zotom offered fair goers a spectral vision of vanishing Indians.

Ethnologist John C. Ewers highlighted Angel's artistic career in his catalogue *Images of a Vanished Life: Plains Indian Drawings from the Collection of the Pennsylvania Academy of the Fine Arts,* but he proclaimed "there was little in Angel De Cora's mature artistic style to suggest her Indian background."[3] There was also little to reflect the influence of Ewers's subjects, the Fort Marion ledger book artists, who lent themselves to Hampton Institute's first experimental Indian classes in Virginia. Angel arrived at the school in 1883, only four years after their pictographs came free with a subscription to the school's publication, the *Southern Workman.*

In *Independent Spirits: Women Painters of the American West, 1890–1945,* Patricia Trenton names Angel De Cora, Suzette La Flesche, and Narcissa Chisholm Owen as three Native American women "who distinguished themselves through their paintings and cultural activities."[4] It's not difficult to see how Omaha Métis La Flesche (1854–1903), known as "Bright Eyes," made her mark through her cultural activities, since her lectures with Ponca Chief Standing Bear influenced Helen Hunt Jackson to write the primary text of the Indian reform movement, *A Century of Dishonor.* La Flesche also was known as "the first published Native American writer" in 1881, forging a trail nearly twenty years before Angel published her short stories. La Flesche received little art training, however, and her paintings hung mostly in her own home.[5]

The artwork of Narcissa Chisholm Owen (1831–1911), mother of Senator Robert L. Owen, offers a clearer comparison, as well as providing a stark cultural contrast to the ledger book artists. Owen was well reared, well educated, and well married. Her mother was an Old Settler Cherokee woman, daughter of a chief. Her father was a wealthy Scotch-Irish farmer and slave holder, who received a peace medal from Thomas Jefferson. Owen received some art training and is recognized for her portraits of Thomas Jefferson's family. She also painted a striking self-portrait in 1896, the year Angel graduated from the Department of Art at Smith College. "The studied elegance and genteel confidence of her self-portrait," writes Trenton, "reveals a great deal about the woman: by her own admission she was using her art to counteract misconceptions about Native Americans."[6] Trenton compares Owen's self-portrait to the work of Cecilia Beaux, who actually became Angel's friend. When Angel's artwork appeared, again, in the Indian school exhibit at the 1904 Louisiana Purchase Exposition, Owen's work was shown in the Okla-

homa Territory exhibit. Both women could paint well, but Angel engaged directly with American Indian subjects and, later, with American Indian design. It is doubtful she would have painted a self-portrait, let alone exhibit one.

Regardless of how she fits into the canon, in her day, the public crowned Angel "the first real Indian artist." She advanced the idea that American Indians, as a race, were innately gifted artists and designers and viewed her own talents as a reflection of theirs. Born about 1869 on the Winnebago reservation in Nebraska, Angel grew up during an era when Indians could *inspire* art, but were regarded as craft makers, not artists themselves. Although she refused titles in all their variations, such as "the Greatest of Redskin Painters," she gained national recognition. At first this distinction reflected America's devotion to western art forms. She studied with James M. Whistler's colleague, Dwight Tryon, the American impressionists Joseph DeCamp, Edward Tarbell, and Frank Benson, and the famed American illustrator Howard Pyle. When the arts and crafts movement spread to the United States, the public's recognition of Angel as an important Indian artist and expert on Native Indian art, as she called it, grew. Likewise, Angel realized at this time, thank goodness, that her Euro-American training had not obliterated her "latent aboriginal talents."

First trained as an artist of the aesthetic movement, Angel preferred tonalism and painted scenes with firelight, an element that expressed her nostalgia for traditional life on the Nebraska plains. True to her training, she yearned to live the life of an "artist for art's sake," but financial constraints kept her from realizing this dream. After designing the cover for *The Middle Five* (written by Suzette La Flesche's brother, Francis) in 1900, she began educating herself in American Indian design.

Angel received her education when Indian reformers promoted either the complete Americanization of Native children or returned them as cultural missionaries to their reservations to uplift their people. In this historical context Angel's professional accomplishments seemed to prove the value of Indian education. In turn, she shaped the next generation of Indian school students after the commissioner of Indian Affairs appointed her in 1906 to establish the innovative department of Native Indian art at Carlisle Indian and Industrial School in Pennsylvania. Here she solidified her role as a key figure in America's arts and crafts movement as one of the few to infuse it with insider knowledge about the esoteric elements of Native design. As a national spokesperson, she promoted the ideal of the Indian craftsman to both Native and non-Native Americans and taught the public to value its *own* indigenous artists.

During her lifetime, Angel witnessed educated Indians evolve from acted upon to actors of their own destiny. For those interested in the complexities of American Indian identity, her life has much to teach us. With a mother who was three-quarters French-Canadian and one-quarter Winnebago and a father whose paternal line extended back to three civil chiefs of the Thunderbird clan, who championed peace with their Euro-American neighbors, Angel found acculturation easier than many of her more traditionally raised peers.

Her unorthodox marriage in 1907 to a Carlisle art student, William "Lone Star" Dietz (1884–1964), reflected her distance from traditional culture, as well as her naiveté. Clearly he fashioned his Indian identity, but he was a larger-than-life, multi-talented dynamic individual who added pizazz to her life. He assisted her in the art department and played football on Carlisle's popular team, headed by Glenn "Pop" Warner. Instead of meeting his wife's desire to leave the Indian service and make an art career together, as they had planned, he left Carlisle in 1915 to embark on a career coaching college football. They divorced two months before she died in 1919.

Angel's remains lie in an unmarked grave in the Clapp family plot in Bridgeport Cemetery in Northampton, Massachusetts. She died a victim of the Spanish flu pandemic. Only Gertrude Clapp, her second mother (a New England reformer who took her in when she went to Smith College) was by her side. After her death, accolades for the influential and unselfish work she had accomplished for "her people" came forth. Today, however, some taciturnly reject her offerings, believing she was far too assimilated. Some accuse her of turning away from her Winnebago people. This latter charge is not far from the truth. Angel avoided the reservation and turned instead to the pan-Indian progressive movement to become a founding member of the Society of American Indians in 1911.

Angel was like most progressives of her day. She was optimistic.[7] She believed in human progress, particularly for American Indians. She championed the progressive cause to uplift the disadvantaged, though without the usual Protestant emphasis. She felt, in contrast to those of the previous laissez-faire generation, intervention could improve her people's lot in life. She rallied against industrialism, but didn't seek to reinvent the wheel. She felt at ease substituting Persian rug-weaving techniques for the primitive Navajo loom. She also, for example, urged Native women to make beaded opera purses for the market place, instead of traditional tobacco pouches. She faced head-on the progressive challenge of how to balance the ideals of social justice with the practice of

social regulation. While at Carlisle, she could not achieve the former without the support of the BIA (commonly referred to as the "Indian Service"), which, like any government bureaucracy, stressed the latter.

Finally, as a female professional in a male-dominated "culture of professionalism," she popularized knowledge about American Indian art and design, such as the significance of the thunderbird, her clan emblem. As Robyn Muncy claims, in popularizing technical, specialized, scientific, and esoteric knowledge, progressive women fulfilled "their obligation to pull groups together, to heal the divisions between the educated and uneducated, between professionals and potential clients, between elite and mass."[8] Native American art historian Nancy Parezo sets forth a credo that Angel, as an American Indian artist intuitively followed: "Knowledge carries responsibilities, particularly for those who would create representation."[9] Angel carried this weight on her shoulders from the beginning of her career until she died.

When Angel became an educator and spokesperson about the value of Native American art and artists, her words helped shaped the discourse of "authentic" American Indian art, despite the fact that she learned much about design elements from ethnological reports she borrowed from prominent anthropologists, including Franz Boas. She determined authenticity to redress the cultural destruction wrought by Indian removals (just one generation behind her) and assimilation policies, hoping to revive the pride of American Indians.

Not surprisingly, Parezo's study of indigenous art found a lack of understanding. She believes "a great deal of research remains to be done on both traditional and contemporary art."[10] But this quest is often fraught with the pitfalls of identity politics and the suppression of important histories that seem shameful in retrospect. These histories, nonetheless, must be faced in order to salvage the inspiring deeds, like Angel's, that can sustain us today.

Parezo also notes that American Indian artists did not concern themselves with modernist issues until the late twentieth century.[11] As she concludes, more research needs to be done. Angel experimented with impressionism, tonalism, realism, and abstraction at the turn of the twentieth century. In fact, she consciously experimented with these styles as a means to express her American Indian identity. One should ask why. Before colleges offered Native American art study, Angel trained her eye to detect differences between western and indigenous art forms and passed on this knowledge, esoteric in her day, to the masses.

Parezo's conclusion about the study of indigenous art serves to illuminate Angel's paradox: "We need better to understand, on the one

hand, the criteria of legitimation and the politics of artistic critique and, on the other, the points of view of Native artists and cultures."[12] Even if we understand how Angel legitimated Native American art forms, can we understand why she was legitimized as a "real Indian artist" in her day? Does she still deserve that title? If not, then this book, *Fire Light*, proudly tells the story of a truly gifted American female artist. One who just happened to be born a Winnebago girl in Nebraska, and who grew to become an important spokesperson and advocate for American Indians and their art.

Fire Light

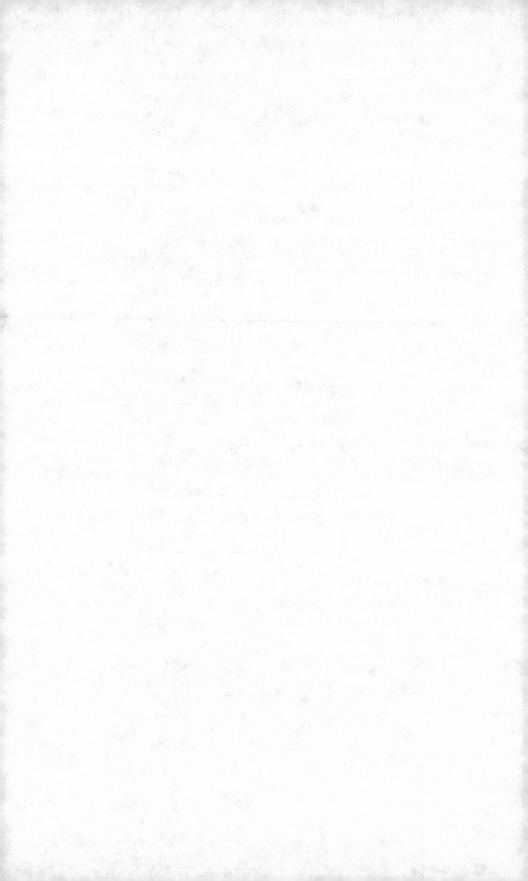

Thunderbird Woman

In the late spring of 1868 or 1869, Angel De Cora was born in a traditional wigwam nestled on a wooded hillside just above the banks of the Missouri river on the Winnebago Indian reservation in northeastern Nebraska. Her parents were David Decora (Hagarsarechkaw), the fourth son of Winnebago chief Little Decora and his fourth wife, Ruth (Henunkinkaw), and Elizabeth Lamere.[1] Shortly after Angel's mother gave birth, she bundled her tiny newborn and carried her to a trusted kinswoman, beseeching her relative to choose a Christian name for her daughter. As Elizabeth waited breathlessly, the young woman carefully opened her Bible to a random page where "angel" suddenly appeared. Thus, the new baby was both named and blessed.[2]

This family story indicates to some that Angel's Winnebago mother was an unversed, illiterate neophyte. More likely, Elizabeth, called "Me-say-bate" or "Zeebet" by the Winnebagos, simply could not read English. Raised as a Catholic, her religious training provided little bible reading, and her native language was French. The mother tongue she still favored, actually a French patois, offered testament to the unique heritage Angel inherited when she came into the world.

Elizabeth was the first child born to Joseph Le Mire, a French-Canadian fur trader employed at Lake Koshkonong, Wisconsin, and Catherine Amelle, a Winnebago Métis (French for "mixed").[3] Le Mire married Catherine in a civil ceremony in Winnebago County, Illinois, on December 28, 1843, and Elizabeth was born the next year. Family lore suggests Catherine's father offered her treaty allotment as a dowry to anyone who would marry her.[4] Regardless of what attracted Le Mire to his new bride, their children, who changed their surname to "Lamere," grew to be well-regarded Winnebago people. Moses, Joseph, Francis (Frank), and Mary followed Elizabeth in birth order. Very little is recorded about their father, except that he lived with the family until at least 1857 and died in 1884.

Angel's grandmother, Catherine, was born about 1826 in northern Illinois, the eldest child of Oliver Amelle (originally "Hamel") and Elizabeth,

commonly known as Henukaw or first-born daughter.[5] The American Fur Company in Prairie du Chien, Wisconsin, employed Amelle from 1821 to 1827.[6] Amelle was illiterate, at least in English, and seems to have been the son of a Montreal farmer, christened as "Olivier Hamel" on January 13, 1798.[7] If so, he was the youngest child of at least eighteen full and half siblings with few economic prospects at home. By his twenty-second birthday, he left Canada, cast his fortune with the Great Lakes fur trade, and arrived in Illinois in 1820. Within three years he married Henukaw in the "custom of the country" and started a family. He probably never returned home.[8]

Amelle acted as a pilot and spy for the United States during the Black Hawk War. In his own words, he "very frequently painted himself as an Indian," trying "to ascertain their position." Colonel Henry Dodge, later Wisconsin's governor, testified he sent Amelle "on important and dangerous duties, which he always discharged with dispatch and fidelity." Amelle claimed he advised the Winnebagos "to stand by the United States," and "he would stand by them." All who passed by his dwelling were made welcome, he stated, and "they slept at his fire and [ate] at his board." Dodge further commended him, declaring, "He has Bean [*sic*] the character of a good Man."[9]

Eventually Amelle moved his growing family to the Four Lakes, a once remote area encompassing present-day Madison, Wisconsin, where he kept a small Indian trading post or grog shop. In 1836 his and a few other Métis families celebrated Madison's first Independence Day with a feast and a fiddler.[10] Two years later, after Henukaw delivered to him Oliver, Jr., Louis, Theresa (who died in infancy), and Joseph, Amelle married her in a civil ceremony to validate both the paternity and maternity of his children, who were eligible for treaty money. In the next four years, Mary and Nancy were born when the family moved to Pecatonica, Illinois, on land allotted to Catherine and Olivier, Jr., by an 1829 Winnebago treaty.[11] Their last child, Prosper, was born in Iowa in 1846.

The Nebraska Winnebagos knew Angel's grandmother well, since she lived to be seventy years old.[12] Catherine's children (whose surname became "Armel") served as cultural brokers, that is, mediators, interpreters, and so on, for their Native kin. All her children, including Elizabeth, married Winnebago spouses and lived out their days on the Nebraska reservation.

Angel noted in a short autobiography that her mother, Elizabeth, "had a little training in a convent" as a girl. She claimed that, after her mother married her father, she "gave up all her foreign training and made a good, industrious Indian wife."[13] Julia De Cora, Angel's younger and

only full sister, revealed that their mother was not quite a traditional Winnebago wife however. "After the Winnebagoes came down here to Nebraska," she wrote, "my grandfather signified to my mother's relatives that he would be pleased to have his favorite son to have my mother for [a] wife." Since the Winnebago subscribed to an avuncular system of kinship, Little Decora consulted with the Lamere brothers. When "arrangements were made," Julia explained, "my mother entered the lodge of my father's people."[14] Although it was customary for a woman's brothers to contract her marriage, a Winnebago man usually entered the lodge of his wife's family and supported them for the first year of marriage. Elizabeth and David's uncommon arrangement illustrates that the Winnebagos had long adapted to the Great Lakes fur trade, making room and allowances for its large population of Métis children.

Julia freely admitted her mother was "only a quarter Indian," while Angel, later a prominent so-called Red Progressive, left the details of her mother's ancestry to the imagination of her public. Julia mistakenly believed Elizabeth was born in Montreal in a French convent, though only Joseph, her brother, was born in Montreal (whether or not in a convent). Julia said her mother was "unusually bright," but spoke with a ridiculous Winnebago accent and was unaware of Winnebago "customs as little as any white girl." Eager to perform as a proper Winnebago wife, she earned the respect of her in-laws, so much so that Little Decora became like a father to her.

Julia's charming family anecdote illustrates her point. While still in the honeymoon phase of her marriage, Julia explained, Elizabeth noticed "all the young women of the household taking queer looking harnesses and going to the woods." Hoping to fit in, she grabbed one of the strange contraptions and followed the women into the woods. She carefully observed them chop wood, pack it in bundles, load the harness, and strap it unto their backs. After they turned for home, Elizabeth loaded her own bundle and followed behind. When the women reached Little Decora's village, they quickly dropped their loads to enter their lodges. As Elizabeth lowered to the ground struggling futilely to remove the cumbersome harness, Little Decora appeared beside her. Speaking softly in her "beloved French," as Julia noted, he politely entreated her: "Allow me, Madame, to relieve you of your burden." Winnebago etiquette forbade a father-in-law to address his daughter-in-law so personally, and vice versa, but Little Decora's kindness "proved too much for the homesick girl, and she caught hold of his hand and cried."[15]

Though Little Decora acted inappropriately by Winnebago custom, his behavior reflects his family heritage. His father, who Angel never met

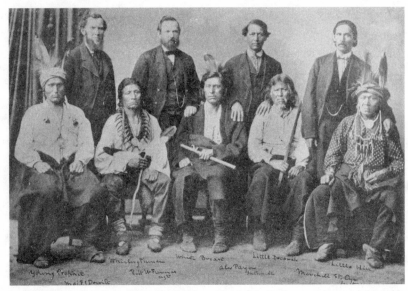

Winnebago chiefs in New York City, 1866. Little Decora is seated in the front row, second from right.
(NEBRASKA STATE HISTORICAL SOCIETY PHOTOGRAPH COLLECTIONS)

but revered, was White War Eagle (Heetschawausharpskawkau, aka John Schachipkaka), whom Americans simply called "Old Gray-headed Decorah."[16] A beloved civil chief, Decorah headed a village of one hundred lodges near present-day Portage, Wisconsin.[17] He had six brothers and five sisters.[18] Three of his sisters married American Indian men, and the other two married or partnered with French-Canadian or Métis men, all engaged in the fur trade. Decorah himself had a French-Canadian grandfather. He sometimes expressed pride in his French ancestry, asserting that, unlike the British and, to a greater extent, the Americans, the French had been good allies to the Winnebagos.

Decorah signed two treaties with the United States. The first treaty followed Red Bird's so-called war, and the second followed the Black Hawk War of 1832.[19] Near the end of the latter conflict, Decorah held council with U.S. officials. When they urged him to reveal the names of his men who had joined Black Hawk's warriors, Decorah assured them he had dissuaded his young men from joining in the hostilities. Downplaying his influence and strategically exaggerating his outsider status to officials, he stated: "Among the Winnebagos I am nothing at all. I am half-white and half red." Despite his ethnic makeup, Decorah kept close watch over his warriors, urging them to "return every night." "There are

four fires under my eye," he told officials, and his sole purpose in life was to keep them burning. Decorah maintained the peace, but he admired Black Hawk's Sac and Fox warriors, who "shunned the ways and the haunts of the white men."[20]

Events preceding the war show why it was difficult for Decorah to keep his warriors in check. Squatters trespassed on Winnebago cornfields and lead miners invaded in droves, pillaging the Winnebagos' ancestral mines in southwestern Wisconsin and northern Illinois.[21] Decorah expressed anguish to U.S. authorities in 1828. "When some lead is found, and it was known down the Mississippi, white men came flocking to Fever River like the wolves in the plains to the dead buffalo," he said. "They spread out in every direction and began to dig and find and carry off lead on the Winnebago lands." He worried the land could not hold them all. "More and more are coming every day," he warned, "the game and furs are leaving the country, and the Indians cannot live in it any longer."[22] Decorah reminded U.S. officials they had promised to mark a good line.

In 1830 John Kinzie, a Winnebago subagent, arrived at the newly constructed Fort Winnebago, near the two-mile portage that linked the Fox and Wisconsin rivers and provided water transportation from Green Bay to the Mississippi River.[23] His agency was situated in a small Métis fur-trading settlement, where at least two of Decorah's sisters lived with their husbands.[24] His wife, Juliette, became well acquainted with "old Day-kau-ray," as Kinzie called him in her memoirs. Angel, who decades later read the memoirs, was undoubtedly delighted to learn that Kinzie found her great-grandfather "striking" in appearance, with a "fine Roman countenance," and "a courteous demeanor." He dressed "perfectly neat" and "appropriate," donning "one solitary tuft of long silvery hair neatly tied and falling back on his shoulders." Most significantly, Angel read, he was "the most noble, dignified, and venerable of his own, or indeed any tribe."[25]

She also discovered that John Kinzie suggested Decorah send his sons away to be educated. Decorah's response eerily foreshadows Angel's experience in maintaining an American Indian identity after being sent away to school. When Decorah heard "all the advantages of civilization and education, including that returning students could instruct the Winnebago in 'the arts, and manufactures, and habits of civilized life,'" he was not persuaded. He believed "the Great Spirit" created both Indian and the white man, but "did not make them alike."

> He gave the white man a heart to love peace, and the arts of a quiet life.
> He taught him to live in towns, to build houses, to make books, to learn
> all things that would make him happy and prosperous in the way of life

appointed him. To the red man the Great Spirit gave a different charac-
ter. He gave him a love of the woods, of a free life, of hunting and fishing,
of making war with his enemies and taking scalps. The white man does
not live like the Indian—it is not his nature. Neither does the Indian love
to live like the white man—the Great Spirit did not make him so.[26]

Either Decorah was being facetious about the "white man's love of
peace" or his words were heavily edited—or both. His Great Father
caved in when the lead miners refused to budge. When the Black Hawk
War erupted in 1832, Decorah's good line was permanently expunged.
Still Decorah held the peace. According to his son, Spoon: "Our sympa-
thies were strongly with the whites. Our trading interests were with
them, and we were bound to them by treaties."[27] But a few Winnebago
warriors stood by Black Hawk, giving the United States justification for
another treaty, the last Decorah would sign.[28] As a result, not only were
the tribe's vital cornfields and valuable lead mines lost to them forever,
but the U.S. army determined to remove them from their homeland.

As Angel read Kinzie's account, she found her people suffered des-
perately by the end of 1833. The treaty conditions left them without a
harvest and bereft of food to make it through the winter. War parties had
driven off game, and the Great Father failed to deliver annuities. Many
died of starvation. Métis families also suffered. Kinzie stated hers and
the "half-breed" families doled out their meager supplies, "as long as
their stock lasted."[29] When the Winnebagos were left to eat slippery elm
bark soup and stewed acorns, Decorah's eldest daughter came begging
for food at the agency. She was offered a little for herself, taking it back
to her village to share. "We were soon obliged to keep both doors and
windows fast, to shut out the sight of the misery we could not relieve,"
Kinzie admitted.[30] Soon after, Decorah came to "apprise us of the state
of his village." "More than forty of his people had now been for many
days without food, save bark and roots." When the Kinzies could only
scrounge enough food for his family, Angel's great-grandfather
responded adamantly, "if his people could not be relieved, he and his
family would starve with them!"[31]

The treaty following the Black Hawk War abolished the Fort Win-
nebago agency. On July 1, 1833, the Kinzies departed. After the Win-
nebagos "completed their tender farewells," wrote Kinzie, "they turned
to accompany their Father [John Kinzie] across the Portage, on his route
to Chicago; and long after, we could see them winding along the road,
and hear their loud lamentations at a parting which they foresaw would
be forever."[32] This touching scene highlights the sadness of parting
friends, but the Winnebagos' feelings of abandonment clearly had

Du-cor-re-a. Chief of the Tribe, and His Family on the Wisconsin River, by George Catlin, ca. 1830.
(Smithsonian American Art Museum, Gift of Mrs. Joseph Harrison, Jr. [1985.66.199–206])

deeper roots. Decorah feared that when the agent left, his people would no longer be represented in decisions regarding their future. He was absolutely right.

A smallpox outbreak killed at least one-quarter of the population the next year despite earlier vaccinations.[33] Another smaller outbreak followed in 1836.[34] Finally Decorah succumbed to illness, though probably not smallpox. He called for his Métis brother-in-law to informally baptize him, since no Catholic priest was available. He died three days later, on May 2, 1836.[35] Events of his last days illustrate the cultural dissonance Angel's great-grandfather experienced. According to a visiting Catholic priest, when Decorah's wife and some of his sons had been baptized three years earlier, his eldest son had threatened "to kill his own father" if he followed suit. "The good old man, intimidated by these threats, did not dare to join the Christians openly, although he often came to the services," claimed the priest.[36] Whether or not Christian piety drove Decorah to convert to Catholicism is another matter. He was a dying,

elderly, despondent man, whose last thoughts, according to Spoon, returned to happier childhood days, which included the rare visits of the "white medicine-men in black gowns" and the "Frenchmen" of his youth.[37]

§

Angel recalled her early years, "born of Indian parents," fondly. Her father provided for his parents, Little Decora and Ruth. They spent summers on the reservation, with her "mother cultivating her garden," and her "father playing the chief's son." Winters, as in the old days, were times to "follow the chase . . . along rivers and forests." Although her family was "always moving camp," she found life "ideal." She also received her Indian name, Hi-nook-mahiwi-kilinaka. After she became well known, the name was erroneously translated as "Angel," "Woman Coming on the Clouds in Glory," "Cloud Queen," or "Thunderbird Woman." According to her sister, Julia, her name's literal meaning was "Fleecy Clouds Floating in Space."[38] More importantly, it was a traditional name of the Thunderbirds, the clan of her father's line.

Angel felt secure surrounded by her father's family. "I never received a cross word," she said proudly. Still his family trained her "incessantly" to conduct herself as a good Winnebago daughter. For as far back as she remembered, she "was lulled to sleep night after night," and awoke the next morning, to her "father's or grandparents' recital of laws and customs that had regulated the daily life of [their] grandsires for generations and generations."[39] Taught to have a modest demeanor and to take care of the domestic chores for the family, she likely received the following instructions: "My daughter, as you travel along the path of life . . . Do not let your mother work. Attend to the wants of your father. All the work in the house belongs to you. Do not shirk it. Chop wood, pack it; look after the gardens; gather the vegetables and cook them. When you come back to the village in the spring, plant your fields immediately. Never get lazy, for Earthmaker created you to do these things."[40]

Though she would later joke about doing domestic chores, Angel felt a modest deportment was essential to being an American Indian female. In her estimation, her early training distinguished her from the immodest Euro-American women she encountered. She also shared or gave away her possessions in quiet defiance of capitalistic, U.S. values. She was more than proud of her traditional Winnebago upbringing, saying it was how she "acquired the general bearing of a well-counselled [sic] Indian child, rather reserved, respectful, and mild in manner."[41]

Destined to become an artist, Angel was extremely sensitive to her environment. Deer and other game inhabited the woodlands where she

grew to girlhood, while corn grew tall in the rich soil of the river flood plain. The wide Missouri River near her home bordered the eastern edge of the reservation, separating it from Iowa. Low woodland hills met the river, but the terrain spread out in expansive, rolling prairies to the west. The stark beauty of this land, especially when the setting sun set the prairie aglow with magnificent, fiery hues, remained etched in Angel's psyche long after she left it. Throughout her life, she harbored a deep emotional bond to the land where she was nurtured. This poignant memory of place sustained her in times of loneliness and alienation as she learned to survive in a modern, industrialized, "white" world far from home. It also linked her, inappropriately so, to the Progressive era generation, who pined nostalgically for vanishing Indians as the frontier closed.

§

When Angel was an infant, a Bureau of Indian Affairs (BIA) census counted 1,343 Nebraska Winnebagos. One hundred and seventy-nine of these lived with her in Little Decora's village, one of fourteen bands on the reservation.[42] Shortly after, in 1870, a regular federal census taker counted eight households of BIA agency employees who worked on the reservation. The Indian agent, his clerk, an Indian trader, a physician, two carpenters, a mechanical engineer, a blacksmith, and a miller provided services designated by treaties. In addition, the census taker identified Oliver Amelle as one of the agency's two farmers.

Amelle lived peacefully among his wife's kin, who may have adopted him as one of their own. When the BIA sent an official the next year to divide and allot reservation land to Winnebago heads of families, including his wife, Henukaw, Amelle managed to receive an allotment, intended only for Indians. Did he once again don "Indian garb" to fool the allotting agent? No one could explain. Those who knew him simply remembered him as the "Frenchman who wore a black hat, high boots, a goatee and handlebars mustache" with "a nice horse and buckboard."[43]

Angel did not record her impression of her great-grandmother, Henukaw (who died between 1871 and 1887), or Amelle, even though she was ten years old before he died. Unfortunately, the men she acknowledged for shaping her idyllic childhood left the reservation before she reached her sixth birthday. As early as Angel's second birthday, Little Decora expressed a desire to return to Wisconsin to "be near the graves of his fathers." After the death of his wife, Ruth, in March of 1875, he got his wish.

The Nebraska Winnebagos were known as the "treaty abiding faction," to reflect a division in the tribe that began with a fraudulent treaty

in 1837 to remove the Winnebagos from Wisconsin and Illinois to north-ern Iowa. Four more removals followed over the next twenty-five years: from Iowa to Long Prairie, Minnesota, in 1848; to Blue Earth County, Minnesota, in 1855; to Crow Creek, South Dakota, in 1863; and to Nebraska by 1865. Removals severely decimated the population. But some Winnebago people resisted, hiding out in areas of Wisconsin that few white settlers desired. Over the years many returned to their home-land, living quietly where Euro-American neighbors more or less toler-ated their presence.

In 1873 the government determined to remove these eight hundred or so Wisconsin "stragglers" to Nebraska. In preparation officials made a deal with the Omaha Indians to expand the Winnebago reservation. It didn't solve the problem. Some protested the sudden influx of so many people, even if their own. Newcomers became anxious when many suf-fered illnesses soon after their arrival. By the summer of 1875, a large number made their way back to Wisconsin. Government officials finally accepted that these people, now known as the Wisconsin Ho-Chunk, intended to stay. Legislation passed in 1881 allowing individuals to claim 40-acre homesteads in Wisconsin.

The mass exodus from the reservation in 1875 must have convinced Little Decora it was now or never. Sometime between that year and the next his son separated from his wife, left his two daughters, and took his father home.[44] Good Winnebago sons took care of their elderly fathers, but not at the expense of their wife and children.[45] Did David leave Eliz-abeth, Angel, and Julia willingly, or did Elizabeth refuse to abandon her mother? Why he accompanied his father without Angel's mother is unknown.

The lifestyle of her Métis mother and siblings changed the course of Angel's future before she turned seven, though her public statements obscured this fact. Angel and Julia lived mostly with their maternal uncles and grandmother. "Of course, being mostly French," explained Julia, they "didn't live like the rest of our Indian people so our child-hood was much like that of any white children."[46] On the other hand, the old fur trade culture was deeply entrenched in tribal life. Some still spoke the archaic French of their forebears; some still served as cultural brokers; some still distinguished themselves as Métis through religious or cultural practices. All found themselves traversing a widening gap separating whites from Indians during the last half of the nineteenth century.

Angel's father gained a new family, but no sons, in Wisconsin.[47] By 1876 Elizabeth remarried Peter Sampson (Chaesthrungkaw or "Wave").

At least five years younger than his wife, Sampson could not read or write, and he drank. Neither Angel nor Julia took to their stepfather or condoned what seemed to them to be their mother's blind devotion to him. Identified on tribal records as a mixed-blood of the Deer clan, Sampson's father or mother was a Menominee, though he claimed his father was Madiahekaw (Burning Earth), a Winnebago.[48] Sampson fathered a daughter, Mary, before he married Elizabeth, and Elizabeth delivered five daughters to him between 1877 and 1886. Louisa, Emma (who died as a toddler), Josephine, Mary, and Grace Sampson became Angel and Julia's new sisters.

Angel kept the memory of the father who abandoned her mostly to herself. Except a story she wrote, called "The Sick Child," she left no account of three siblings who died before she was born. An unnamed sister, and two brothers, Alex and Frank, lived and died between 1863 and 1869. Julia explained the family's circumstances (that may have contributed to her parents' separation): "my father and mother had five children, the first three died in infancy and the whole tribe mourned with my parents as two of the children were boys, then Angel and I were born much to their disappointment for they wanted us to be boys."[49]

Soon after Little Decora and David left Nebraska, the tiny village of Winnebago gained a trading post and other new buildings. Many tribal members began moving out of the Missouri river bottom. The fertile land attracted farmers to the area. In 1880 the population of the agency had barely grown and had lost one of its most colorful characters. Oliver Amelle died on September 25, 1879.[50] Had he lived until the 1880 federal census, instead of farmer, he likely would have been listed as "squaw man," the occupation the census taker assigned to the agency's other 1870 farmer. Times were changing. Society overtly despised "half-breeds," and likewise branded their Euro-American fathers as shiftless opportunists who exploited Indian women for land and annuities.[51] To repel the barbs of those who deemed mixed-race people degenerate, Winnebago Métis became unmixed, white or Indian, but not both. Yet there had been a time when fusion seemed the best option. Angel's ancestors, who shaped her accommodation to non-Native society, once welcomed newcomers into their world.

<p style="text-align:center">§</p>

The Winnebagos, or Hochungras, as the people called themselves, lived near present-day Green Bay at the Red Banks on Lake Michigan's southwestern shore. While many Wisconsin Ho-Chunk believe Red Banks is their place of origin, Nebraska's tribal historian, David Lee Smith, thinks his people migrated from Middle America through the

Gulf of Mexico to northern Tennessee and Kentucky. Along with their relatives, the Iowas, Otos, and Missouris, the Winnebagos continued to migrate north through present-day Indiana, Illinois, and Michigan until they reached the Red Banks about AD 700. The Iowas, Otos, and Missouris moved west, leaving the Winnebagos to adapt to a woodland environment.[52]

The Hochungras speak a Siouan language, a progenitor of the Chiwere languages spoken by the Iowas, Missouris, and Otos. In fact, one translation of Hochungra is "People of the parent speech."[53] "Winnebago" came from their Algonquian woodland neighbors to signify stagnant water, such as Lake Michigan appears at Green Bay. Thus, the French, who first met the Winnebagos at Lake Huron in 1614 and at Red Banks in 1634, gave them, affectionately or not, a third moniker, Puants or stinkards.

Many generations before Angel was born, the Winnebagos divided themselves into twelve clans governed by beings from the sky and beings from the earth. The Sky clans are the Thunderbird, Hawk, Eagle, and Pigeon. The Bear, Wolf, Water Spirit, Deer, Elk, Buffalo, Fish, and Snake make up the Earth clans. Each clan took on responsibilities crucial for the stability and health of the tribe. For example, while the Hawk clan authorized "life-and-death decisions when captives were taken in war," the Bear clan was in charge of safekeeping the land, giving them authority in treaty making. Some thought the Thunderbird clan was the most important of all, although it was a relatively new clan that, perhaps, originated at Red Banks.[54]

According to oral tradition, Earthmaker gave a tobacco plant to four Thunder-spirit brothers when he sent them to the earth to live. "And this I shall send with you," he proclaimed. "I myself shall not have any power to take this from you, as I have given it to you; but when of your own free will you make me an offering of some of it, I shall gladly accept it and give you what you ask." Earthmaker also gave fire to the brothers. He told them to use it as a spiritual mediator with tobacco as well as for everyday living. "It shall take care of you through life," Earthmaker promised. "It shall stand in the center of your dwellings and it shall be your grandfather."[55]

From the Thunder-spirit brothers came the Thunderbird clan, and from the Thunderbird clan came the tribe's civil chiefs, namely Angel's paternal line.[56] In this role, tradition called for "a man of well-balanced temper, not easily provoked, and of good habits," one who loved everyone as a brother or sister and strived for peace. This man shared his food and always gave things away to the needy, though his relatives watched

over his possessions and kept him supplied with food and necessities.[57] His pipe, used in councils, was his only sacred possession.

When Jean Nicollet's party appeared on Lake Michigan in 1634, the Winnebagos edged cautiously to the Red Banks. They brought white deerskins and tobacco, their most sacred offerings. When the French saluted the Winnebagos with gunfire, the Winnebagos stood awestruck. "They are thunderbirds," they whispered.[58] The Winnebagos found themselves bewildered by the strangers, but Nicollet's party was likewise confounded. When he put out his hand, the strange people, whom he soon discovered were not the Chinese he had been seeking, filled it with tobacco. The people also poured tobacco on the heads of his crew, seeking victory in war.

As Angel heard this story as a child, the Winnebagos mistook the Frenchmen for spirits, while their nervous visitors poured water on an old man who was smoking. When the Frenchmen discovered the Winnebagos had no tools, they showed them how to chop down a tree with an axe. The Winnebagos "held aloof for a long time through fear," thinking the axe and the guns were holy. Eventually the Winnebagos realized the Frenchmen were human.

Once they mastered the Frenchmen's guns, they decided to trade with the men, though they still believed such objects were holy. The Winnebagos soon gave "furs and things of that nature for the guns, knives, and axes." This period of exchange marked the Winnebagos' engagement in the Great Lakes fur trade.

Following Nicollet's visit, a party of French-Canadian fur traders from Montreal came to the Winnebagos. This time they ventured further inland to the shore of Lake Winnebago.[59] They brought new things to trade, such as sewing needles, wooden implements, and knives. After a time, their leader, Sabrevoir de Carrie, noticed Wahopoekaw (Coming of the Dawn), the daughter of a Thunderbird clan chief. De Carrie appealed to her brothers, and they consented to Wahopoekaw's marriage, the first such union the Winnebagos had ever known.[60] The brothers hoped an alliance with the French would regenerate the tribe's population, decimated by war and disease, lift its economy, enhance its survival, and create political clout with New France. At first their desires were amply rewarded.

De Carrie lived at Wahopoekaw's village on an island in Lake Winnebago for many years. He worked for the Winnebagos and taught them to use many tools. Meanwhile, Wahopoekaw bore the French-Canadian two sons and a daughter. The eldest, born about 1729, was Chougeka (Wooden Ladle or Spoon), named after the Frenchmen's useful wooden

implement. Tcap'o'sgaga (White Breast) came next, and their daughter, Oak Leaf, third.[61]

One day de Carrie took Chougeka home with him to Montreal. When Angel's great-great-grandfather arrived, "everyone took a great liking to him." They brought him toys and many presents. Despite the warm welcome, Chougeka missed the Winnebagos terribly. Afraid Chougeka would die of sadness, de Carrie's family convinced him to take his son home. When they returned to Wahopoekaw, de Carrie decided: "My sons are men and they can remain here and grow up among you. You are to bring them up in your own way and they are to live just as you do."

Soon Chougeka reached adolescence and left the village to fast. Blessed by Earthmaker, he returned a month later with a wooden drum, not for war but to "obtain life." Earthmaker directed the boy "to put his life in the service of the Winnebago." The Winnebagos nicknamed him "the Frenchman," and invited him to participate in all things important. Thus, they "received many benefits" from this first Métis child, and some later remarked, "a man with French blood has always been the chief. Only they could accomplish anything among the whites."[62]

Nonetheless, the accomplishments of the Winnebago chief with French blood and his successors were more legendary than enduring. As Great Lakes Métis ethnohistorian Jacqueline Peterson discovered:

> The people who are born and grow up at the interstices of two civilizations or nations are ... like weather vanes, perpetually testing the winds. ... [I]f such nations are peaceable, intermarriage will occur and a relatively stable composite group will develop along their shared border. Over time, this group may begin to serve as a conduit for goods, services, information[,] and to see its function as that of a broker. It will usually recognize, in the process of acquiring a group history and identity, that it is, to a large degree a dependency of the nations or civilizations it links or separates, to be snuffed out when there is no longer a need for its services.[63]

De Carrie died in Montreal in 1760 after he was wounded in war. His widow lived on for many years and is famed as the Winnebagos' only chieftess.[64] Chougeka lived to father many children, thus, becoming the progenitor of the Winnebago Métis. During his lifetime, the British replaced the French, and the Americans usurped the British with the victory of the War of 1812. One of many chiefs to do so, "Choukeka, or Dekare, the Spoon" touched his "x" mark on the first treaty made between the Winnebagos and the United States in 1816, the same year he died. Unfortunately, he did not realize that this simple touch to parchment would not signify the beginning of "peace and friendship," as the

treaty promised, but would mark the decline of the Great Father's protection. In 1829 and 1832 Chougeka's eldest son, White War Eagle, also placed an x mark next to his name. Forty years later Angel's grandfather, Little Decora, expressed his deep regret that the treaties his father and grandfather signed "were ever made."[65]

§

Angel realized that the Kinzies' departure in 1833 cinched the Winnebagos' fate. As Chougeka's death allegedly marked the beginning of peace and friendship, the death of his eldest son, Decorah, marked the end. The next year when the United States coerced nonauthorized Winnebago delegates, not of the Bear clan, to sign the treaty of 1837 that ceded all their land, the Winnebagos were cast out from Wisconsin and Illinois.[66] X marks wet with cold black ink extinguished Decorah's four fires forever.

Decorah's eldest son succeeded him as civil chief, but he died six months later.[67] This duty was left to Angel's grandfather then known as "White French." As the years passed, and the Great Lakes Métis dispersed with a succession of removals, White French, whose Thunderbird clan name was Makhekushanashekaw (He who stands with his head reaching the clouds), emerged as "Little Decorri" or Decora.[68] Angel did not take after her grandfather in appearance. His facial features were angular and hers more round. She also had deep-set, dark eyes, a distinguishing trait of the Lameres. But she shared personality traits. Like her, Little Decora was sensible and adaptable. Although he was "slow of action and speech," he had a "mild and kind disposition" and expressed passive resistance through a ready wit, like his granddaughter.[69] The two also shared a cleverness with words and a remarkable sensitivity to the ironic.

About 1840, just before or after the birth of Angel's father, troops arrived to remove the Winnebagos to Iowa. The onset of dysentery killed many. Little Decora reported to the new agent in Iowa that the chiefs and bands suffered greatly. "Father, you know our family was a large one. Since we left the Portage my mother and two brothers have died, and now I am left alone with a little brother and sister, both of whom are sick." Hoping to find common ground with this American, he added, "Father, though I call myself a Winnebago, I live under the love of the Great Father above," suggesting he was baptized in 1833.[70]

The new Winnebago agency was located in northeastern Iowa at Fort Atkinson in the so-called Neutral Territory, a buffer zone between warring tribes, the Sacs and Foxes to the south and the Dakotas to the north. The Winnebagos' presence only inflamed violence from the Sacs and

Foxes, who were angry that their allies had mostly abandoned them in 1832. After several deaths, the Winnebagos were removed to near the Long Prairie River in 1848, between the Mississippi and Watab rivers, in central Minnesota. They found themselves in a new buffer zone. The man in charge of removal warned officials that the new reserve was near "the point where most of the war parties from either the Sioux or Chippewa nations cross the Mississippi to invade each others countrys [sic]—consequently the Winnebagos are in constant fear of being struck upon by those warlike tribes." He also noted the area was "the great crossing place for the hundreds of whites that pass & repass between the states and the Hudson Bay Company's Territory. Whiskey is frequently taken north by this route."[71]

Little Decora moved what was left of his family to the Long Prairie reservation. By 1850 Oliver Amelle's family also resided at the new agency. Catherine joined her father's family, but her children were, apparently, with their father in Montreal.[72] By November 13, 1852, Le Mire joined them, however, signing with other "Half-Breeds of the tribe," a petition for a Catholic priest to replace the Protestant minister heading the agency's mission school.[73] The petitioners got their wish, but Long Prairie was not a happy home for the Winnebagos. Many headed right back to Wisconsin. The agent explained why to his superiors: "the poverty of the Soil," "the density of the woods and scarcity of game," and "the danger and dread in which they stand of the Sioux which prevents them penetrating far enough into the country for fear of being cut off by them."[74] Yet they feared more the neighboring Ojibwes, their traditional enemies.

Trouble at the agency escalated when an Ojibwe man murdered a Winnebago man in the spring of 1853. This provoked a revenge killing and led to an exodus from the reservation for fear of war.[75] A delegation went to Washington D.C. in February of 1855, where the commissioner of Indian affairs chastised the Winnebagos. If only they had stuck to farming, instead of wandering off to hunt, there would be no trouble, he insisted. One chief responded in words that echoed the sentiments expressed by Angel's great-grandfather twenty years earlier. "Father, we do work. All the chiefs here raise their own provisions. We work ourselves. In the spring of the year, we work for our women in planting corn. We go out to work with our clouts on, but the way you want us to work, we are not able, and don't understand. If the Great Spirit wanted us to be like you, he would have made us so, but he has made us red men, and you white, and we cannot, for that reason, adopt your habits and customs. Father, even your clothes, however suitable to you we cannot wear."[76]

The commissioner acquiesced. A new treaty was signed. The United States set apart a reservation "eighteen miles square" in southern Minnesota, known as Blue Earth. The removal began in May of 1855, but children starved for lack of government-issued food. The Winnebago gathered from the land whatever they could. A familiar plea was sent to Minnesota's governor: We are starving. Help us.[77] A common strategy for coercing American Indians to remove was to withhold annuities. The Amelles followed their kin to Blue Earth, while Catherine returned to Wisconsin and gave birth to Mary Lamere.

In spite of an ominous beginning, the Winnebagos adjusted well to their new reservation and began farming. Located on the Le Sueur River, the agency was established about ten miles south of Mankato in fertile Blue Earth County. In 1857 Little Decora received annuities for himself, two women, and one child, probably David. "Madam Amell" (Henukaw) collected annuities for Mary, Nancy, Prosper, and herself. "Madam Lemere" (Catherine) had left Wisconsin, and possibly her husband, to live with her parents. She received annuities for herself and all five of her children, including Angel's mother.[78] Shortly thereafter, Catherine married Good Old Man in the Indian custom and gave birth to a daughter named Lizzie Lamere.[79] Meanwhile Amelle farmed with his eldest sons, Oliver, Jr., Louis, and Joseph, who had married.

The Blue Earth years were not without problems. Agents were replaced three times, but the constantly changing administration reflected the Winnebagos' growing independence. They had learned to stand up for themselves, but continued to depend on Métis relatives and Indian trader husbands, for better or worse, to broker for them. They signed a treaty in 1859, agreeing to sell the west two-thirds of their reservation in exchange for 80 acres of farmland per family head, allotted in severalty. The men of the so-called civilized band, including the Amelle and Lameres, became intent on acquiring these allotments.[80]

That year fourteen Winnebago families raised their own wheat and oats, cultivating 1,600 acres of land. Children, averaging seventy-one a day, went to school. If Angel's mother attended school, she received, like her daughters after her, instruction in the domestic arts. Her brothers learned to farm. Academic subjects included the three "Rs," as well as grammar, orthography, and geography.

By the fall of 1860, two thousand Winnebago lived at Blue Earth.[81] The 1859 treaty made 650 of them entitled to 80 acres of farmland each. Allotments began to be surveyed that summer, but several forces impeded the process. The outbreak of the Civil War disrupted life when many young men left to fight in the Union Army. Further, head chief

Winneshiek vehemently opposed selling off two-thirds of the reserva-
tion. He distrusted the Winnebago agent, whom he suspected sold the
tribe's timber.[82] For his protest, the agent deposed him and made Bap-
tiste Lasallieur, a Winnebago-Potawatomi Métis, his replacement.[83]
Winneshiek still rallied against the diminution of Winnebago land and
tried to block allotment surveys. To make matters worse, local citizens,
coveting Winnebago farmland, pushed for another removal.

War close to home was the final deterrence to the allotment process.
The disenfranchised, neighboring Dakotas were sick and tired of their
unfair treatment. Treaties shrunk their homeland and hunting territory
and relegated them to reserves. Traders exploited them. Indian agents
forced them to give up traditional ways and "encouraged an unequal
distribution of goods" so that those who farmed, mostly the Métis pop-
ulation, received extra.[84] On August 18 of 1862 a small group of men
from the soldiers' lodge attacked the Redwood Agency and killed more
than twenty people, many in the Indian trade or agency employees.
Their aggression was unexpected on both sides. Incited by their success,
the warriors quickly galvanized and attacked several other Minnesota
River settlements. While refugees fled for safety, so did many Dakota
Métis, who were being targeted as hostages.[85] Approximately four hun-
dred Euro-Americans and an unspecified number of Dakotas were dead
after a four-day battle.

The close-range violence pushed many Euro-American husbands and
Métis brothers and sons at the Blue Earth agency to join volunteer
forces. But the more fit men were already far from home with the Union
army. A small number of Winnebago warriors joined the Dakotas,
though Little Decora, like his father before him, tried to dissuade them.
Four days before the Redwood Agency attack, "the chief of the Sioux
came to his camp and proposed an alliance with him against the whites,"
Angel's grandfather later recalled. He promised the Sioux chief he would
call a council. Instead he informed the Winnebago agent of "the designs
of the Sioux." He also called a council of chiefs, urging them not to par-
ticipate in the hostilities. A lawyer for the Wisconsin Ho-Chunk later
wrote to President Ulysses S. Grant: "Only thirteen of the Winnebagoes
were engaged in that massacre while large numbers of them assisted in
defending the place and prevented its being taken." Little Decora "thinks
his action at that time has not been understood or appreciated."[86]

Shortly after the outbreak a trader from the Winnebago agency sent a
letter to the editor of the *St. Paul Dispatch* hoping to convince Min-
nesota citizens the whole tribe should not be punished for the actions
of a few. "Little Decorri, a noble Indian, said that night when watching

the lights in the sky from the burning of New Ulm, that he had no fears for himself, nor for the old men, but that if the Sioux came, he did not know about all the young men," he wrote. "As for himself, he would be found dead at a white man's door, defending it."[87]

Over three hundred Dakota men were found guilty of "murders and outrages" and sentenced to be hung. The Winnebago suspects were let go, except one who died while imprisoned. President Abraham Lincoln commuted the death sentence of all but thirty-eight men. They were hanged the day after Christmas of 1862. The following month the Knights of the Forest, a secret vigilante group, formed in Mankato. Members allegedly had inside information that if the attack at New Ulm had been more successful, most Winnebago warriors would have entered the fray. Locals immediately joined with the Knights to demand not only the removal of the Dakotas from the state, but also the Winnebagos.[88] In April 1863 two days after the Dakotas were removed from Minnesota, Congress ruled the Winnebagos would follow them. Attempts to change the decision failed. The Winnebagos ceded their rich farmland, left all the improvements they had made in the last eight years, fronted the cost of their removal, and, in June, again left their homes.

In a last ditch effort to hold onto their allotments, about sixty members of the civilized band went to a local courthouse to try to become naturalized citizens. Several of Chougeka's descendants were among this group, but whether the Amelle or Lameres joined them is unknown. Nonetheless, their wishes were denied. On May 15, 1863, the local newspaper reported with cruel sarcasm: "over 1,000 Winnebago Indians and half-breeds flocked into town and encamped . . . near the river, all ready to embark for their new fields of Eden." They were called a "swarm" descending on the town, "intent on buying or stealing something." The report stated when the steamships arrived, the "precious freight of Aborigines . . . left here quite cheerfully, singing one of their wild Indian refrains." It congratulated the citizens of Blue Earth County "on their safe deliverance from the presence of these lazy, shiftless Winnebagoes."[89] The same edition advertised the sale of the valuable Winnebago trust lands.

Steamers overflowing with frightened Winnebago people headed down the Mississippi River and up the Missouri to a flat and barren land surrounding Fort Thompson at Crow Creek, South Dakota. The exiled and resentful Dakota were their new neighbors. As Chief Lasallieur lamented, it was a "damn bad country for Indians," completely unfit for habitation. Annuity rations came infrequently. When they arrived, they were often

rotten and dumped into a feeding trough. The Winnebagos were fed on one day, and the Dakotas the next. People sickened and several hundreds died. One Office of Indian Affairs official expressed his outrage:

> Hurried from their comfortable homes in Minnesota, in 1863 ... huddled together on steamboats . . . transported to the Crow Creek Agency in Dakota Territory at an expense to themselves of more than $50,000, they were left, after a very imperfect and hasty preparation of their new agency for their reception, upon a sandy beach on the west bank of the Missouri River, in a country remarkable only for the rigors of its winter climate and the sterility of its soil, to subsist themselves where the most industrious and frugal white man would fail, five years out of six, to raise enough grain upon which to subsist a family.[90]

According to one historian, of the "1,934 Winnebago taken from Blue Earth, only 1,382 survived the harsh winter."[91] Lasallieur begged officials to let them leave Crow Creek, explaining they could do so cheaply by taking canoes to join their old friends, the Omahas, in Nebraska. He complained that they had met the government's expectations many times, making "good farms and houses." "We are not afraid to die but we do not wish to die here," he exclaimed, "never before have we had so many get sick and die without any bad disease. The country is not good for farming; it is too dry; everything will dry up. There are no springs, nor creeks, and the ground is all dry dust."[92] Agency authorities warned the Winnebago they would be shot if they tried to run away. By the first of March 1864 all but about two hundred people managed to escape from Crow Creek.[93]

The next year the government purchased the northern portion of the Omaha reservation to settle the scattered Winnebagos.[94] Most of the civilized band, however, returned to Minnesota, including, for a time, Frank Lamere.[95] In late 1870 fifty heads of family crowded the St. Paul, Minnesota, courthouse to become naturalized citizens. Eventually, they procured their allotments and were paid their last annuities. In exchange they relinquished their tribal allegiance to the Winnebago tribe.[96] Many in Nebraska did not condone their actions. One chief warned they would lose their spirituality.[97] At least twenty-one of the fifty were direct descendants of two sisters of Decorah, Angel's great-grandfather, but the Amelle and Lameres did not join them. Instead they made Nebraska their home. This choice reveals not only their loyalty, but also with whom they felt most at home.

Angel learned the mercurial role of cultural broker from her mother's family. Soon she would hone this skill to carve out a significant niche for

herself as an American artist and an authority on "Native Indian art." Her grandfather, the third in line of chiefs "with French blood," influenced her spirit. Like his fathers before him, Little Decora deftly, and with integrity, traversed the shifting "borders that divided native from outsider," all the while maintaining his traditional Winnebago role as civil chief.[98] His was the higher ground she determined to follow through life, not always successively, but always with her sights on the legacy of her Thunderbird clan.

Indian Education

When the break of dawn rose above the gentle rolling hills along the Missouri River, a wagon packed with six Winnebago children headed north on the agency road. It was the last day of the Deer Digging Moon, when their mothers dried corn to store for winter. No longer under their mother's care, the children bumped along the twenty miles to Sioux City, Iowa, feeling fear or excitement, or both. Angel, who was fourteen at the time, later recalled how she came to be a traveler on that autumn morning in 1883: "[A] few days after my Uncle Frank had taken me to the school, a white man came there and was asking the pupils to go a long distance on the steam cars." "I was asked one morning if I would join the ones that were going and I said 'No,'" she told a close friend. "That evening the dress maker measured me for a dress and she must have worked all night long for the next morning a whole outfit was ready for me and at six we were piled into a lumber wagon."[1] When the children arrived at the railway station in Sioux City, the white man appeared again. He boarded them onto a steam car and traveled with them "the whole distance" for "three days and three nights," recalled Angel, while the smoking train lumbered southeast across the continent. Her "promised ride" came to an end, just as the sun rose again, this time on the terminal at Newport News, Virginia.

Angel claimed she had never before seen the white man who "conducted" the children. She thought that he lived near the Winnebago reservation and that his name was Mr. Hedges.[2] She said he "was good to us on the train and we got rather fond of him." She also confided that after having refused his first offer to ride the steamer, he approached her again with an interpreter that afternoon. "I was in the woodshed at the time washing dolls' clothes," she remembered. "I didn't see who he was or what he looked like for I ducked my head down and shook my head 'No' to what they said." Angel failed to disclose whether it was the promise of adventure or her accommodating nature that compelled her to change her mind. She did say once that she found her few days at the

reservation school so tedious and uninspiring, she could understand why Indian children ran away from school. Running away *to* school, however, was not what she had in mind.

If no one told her, she discovered her party was expected at Hampton Normal and Agricultural Institute. They may have traveled overland the few miles to the school or were ferried from Hampton Roads Harbor, which opened to the Chesapeake Bay. On her way there, Angel probably noticed the locals were mostly Negroes, including the men who labored unloading coal from heavy trains onto ships, the oyster tonguers hawking their wares, and the majority of women with hair tidy beneath kerchiefs. In fact, Hampton Institute sprang up from an old plantation site, opening its doors in 1868 as a freedman's training school. An experimental Indian department came ten years later. In 1880 Angel's cousin, Julia St. Cyr, who accompanied the children on the train, became one of its first female students. She quickly learned her teachers intended to train her "hand, head, and heart," so that she could return home "to be an example to her people."[3]

Angel couldn't help but see the imposing school buildings looming just beyond Hampton Creek, a tidal estuary that emptied into Hampton Roads Harbor. The principal's building stood sentinel near the dock. To its left was the green, a large expanse of lawn, and to its right an equally large ground used for drill. The "reservation" stood on the southeast side of campus. A three-and-a-half-story newly built brick dormitory for girls, Winona Lodge, joined the sturdy, older Indian Cottage, now the Wigwam Lodge, for boys. "Girls make the mothers, mothers make the homes," Hampton's founder believed.[4] Equipped with a sewing room, chapel, washroom, ironing room, and bathroom, Winona Lodge kept only two girls per room. At its windows facing the bay the girls could watch luminous sailboats in the distance and track canoes heading to and from the oyster beds.

Before Hedges left his recruits, staff appeared to guide them into one of the buildings. While they enrolled in school, Hedges disappeared and returned to the reservation to take up the Indian trade.[5] The children understood scant English, if at all, but St. Cyr, who spoke Ho-Chunk (Winnebago), English, and French, probably assisted in filling out the enrollment forms. Angel's age was recorded as thirteen, though she was at least fourteen and a half.[6] Dr. Waldron, a pretty woman in spectacles, or the trained nurse, Cora Folsom, likely examined the children. Heights and weights were determined, and the children stood still for the cold stethoscope pressing their chests and backs. Someone worried about signs of consumption in Carrie Alexander and decided her health was poor. An

examination of Grace Decora, Angel's small cousin, revealed she was lame with a spinal deformity, though her health in general was good. Everyone else, Angel, Fannie Earth, Addie Stevens, and Willie Harrison, Angel's young cousin, and the only boy, received clean bills of health.[7]

Where the enrollment form asked for "blood," Angel's was filled with "one half." Her father's name, David Decora, was entered. Wisconsin was recorded as his residence, while Angel's was the Winnebago agency in Nebraska. There was no place for the name of her mother, but if Elizabeth Lamere wasn't sick with worry wondering where her daughter was by now, she soon would be. The place for Angel's Indian name was written in a different hand, perhaps later, as "Hi-nook-mahiwi-kilinaka." Underneath, in small letters, the same person neatly printed: "Thunder-bird Woman."[8]

"A very promising career must have been laid out for me by my grandparents," Angel wrote in her autobiography, "but a strange white man interrupted it." Angel well knew her fate at birth was to become a Winnebago wife and mother. Was she being tactful, discreet, or ironic about the promise her family held out for her? No doubt all three rang true. Was her abduction to Indian boarding school, where she apparently "assimilated" to mainstream culture, ultimately to blame for her turning away from this traditional role? It certainly contributed, but the role had also changed dramatically from her grandparents' generation. A prominent suffragette later claimed that treaties and the allotment process "did violence" to the American Indian's "sense of justice and cooperation," because officials "failed to recognize the women of the tribe in the distribution," thereby ignoring their "primitive prestige of womanhood." One of Angel's teachers at Hampton, Elaine Goodale Eastman, later agreed: "Some corrective is doubtless needed to the mistaken theory of woman's low position in American Indian culture."[9]

Nearly thirty years after she boarded the train in Sioux City, Angel speculated that the Winnebago agent might have "signed the papers, etc.," to permit Hedges to take her, as she acknowledged was sometimes the case in "the pioneer days of Indian education." Though guardians' signatures were required and kidnapping prohibited by the Office of Indian Affairs, laws weren't always obeyed. She also wondered if her Uncle Frank Lamere "had a voice in the matter." If he did, he never informed Angel's mother. Lamere later assured Angel that he did not give his consent, but "struck the trail for Sioux City only to find the train had started on time some days before."[10]

It seems odd that two children under his care, Angel and his stepson, Willie Harrison, found themselves in Virginia before Lamere realized

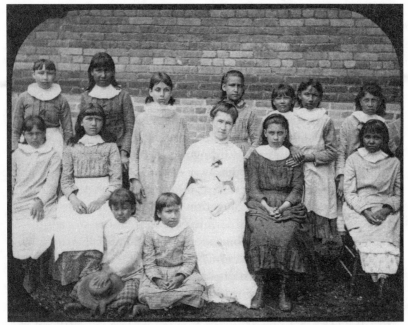

Group of Indian girls at Hampton Institute, 1883–1887. Second row from left: Fannie Earth and Angel De Cora. Girl behind Fannie is probably Addie Stevens. Girl seated in front of Angel is probably Grace Decora. (NATIONAL ANTHROPOLOGICAL ARCHIVES, SMITHSONIAN INSTITUTION [54,793])

they were missing. But if he boarded them at the reservation school, it's possible he didn't know. This leaves the reservation school administration suspect, since Hedges recruited children at the school. Further, the only dressmaker employed by the agency worked for the school.[11] Whether or not anyone in her family gave permission to Hedges, no one asked Angel her opinion on the matter. She never learned the truth about her abduction, but later she would rewrite the script in her story "Gray Wolf's Daughter."

Had she been given the choice, would she have chosen Hampton? It's likely. St. Cyr acted as a recruiter and might have talked Angel's mother into letting her go.[12] But she was not prepared to leave her mother and must have suffered shock when she realized there was no way home. She left no record of her feelings. Did she simply adapt to the new situation, just as her family had adapted to unwanted removals for decades? Perhaps. Did she survive by identifying with her captors, by internalizing their values? To some extent, but they also adjusted to hers.[13] As time went by, she did not fully embrace the goals of Indian education. She

was not much of a Christian, if at all. She also did not become a mother or nurse, though she would eventually work for the Indian service like many "educated Indians" of her day. In fact, she led the life of an independent woman, not only eschewing the "true womanhood" of her generation, but also refashioning an up-to-date "Native Indian" identity for herself.

American Indian children suffered immeasurably when their country determined to obliterate their cultural ties and inculcate them to Euro-American values in Indian boarding schools across the country, but assimilation can't entirely explain away Angel's life choices. Neither can the preferred postcolonial alternative, resistance, though Angel certainly resisted many forms of subjugation throughout her life. Chinua Achebe's conception that borderline people are more susceptible or attracted to the tactics of colonization "when things fall apart" seems appropriate for Angel's situation.[14] But more than this, Hampton's mostly female faculty and staff shaped the course of her promising career, particularly since the worker bees for American hegemony did not enjoy rights equal to men.[15]

Angel's father and grandfather's absence eliminated certain gender role and Winnebago cultural expectations. Her mother's ethnic background made Angel's adoption of Euro-American values less difficult. In addition to the break up of her family and her Métis heritage, one issue clearly contributed to Angel's success in the future, however. Hampton women, like Cora Folsom, eagerly supported her desire for a career in a man's world.[16]

§

When Angel arrived at Hampton on November 1, 1883, she made Winona Lodge her home. The school's aim was "to develop in each newcomer a sense of personal responsibility and individual initiative." Goodale Eastman explained that a Hampton girl didn't wear "impersonal uniforms," but "made, washed, ironed, and often chose the material for her own pretty frocks." She was also allowed to "play and entertain in her own attractive room . . . outside of school hours."[17] Cora Folsom lived on the bottom floor of Winona Lodge to watch over the girls. Folsom learned that homesickness among the Indian students, like Angel, "became a disease; boys and girls actually suffered in the flesh as well as the spirit." When they couldn't eat or sleep, it "prepared the way for more serious trouble."[18]

Angel soon found one thing at Hampton that could buoy her own homesick spirit: art class. A woman artist visited the school the summer before she arrived and set up experimental classes. The experiment a

success, she convinced Hampton's principal "that some permanent arrangements should be made to add the study of drawing to the many advantages already afforded the students."[19] Her new art teacher's direction to "draw independently" melded well with Hampton's educational philosophy and stayed with Angel the rest of her life.

§

Cora Folsom came to the school in 1880 as a nurse for the Indian department and stayed for more than forty years. During that time she served as "teacher, editor of the Indian news for the school's paper, the *Southern Workman*, director of pageants and exhibitions, advisor of *Talks and Thoughts*, the school's student-created publication, and museum curator."[20] Goodale Eastman noted, Folsom "made a dozen hard trips to the Indian country to visit her former pupils, with whom she corresponded faithfully, keeping careful records of their achievements."[21] Her devotion to keeping track of returned students and maintaining their files is Folsom's greatest legacy. Angel's file, more a lovingly assembled scrapbook, overflows with newsy items, publicity, and letters Angel wrote to Folsom from 1886 to 1916. It also includes school records, copies of artwork, personal photographs, and correspondence to Carrie Andrus, Folsom's successor.[22]

Raised as a Congregationalist, Folsom was a sturdy and independent New England girl. She was born Cora Malinda on July 16, 1855, in Clarendon Springs, Vermont, the eldest child of Maine native Henry Wesley Folsom and Eliza A. Barlow of Vermont. Her father and his father-in-law kept a hotel at Clarendon Springs, where Folsom's sister, Ada Sybil, was born in 1857. A brother, John Orville, came in 1861 after the family moved to Farmington, Maine. Sometime between John's birth and 1870, Folsom's mother died, perhaps in childbirth. This loss gave Folsom deep-felt empathy for her homesick students. Characterized by Goodale Eastman as "[k]eenly intuitive and sympathetic, blest with native wit and a warm heart," Folsom was a "slight girl [who] endeared herself to hundreds of girls and boys whom she mothered with skill and success." First among this group was Angel, whom Folsom "helped to advanced training" and a "notable career."[23]

By 1870, Folsom's father and brother lived alone in Roxbury, Massachusetts, while her sister, Ada, resided with their maternal grandparents in Wrentham, Massachusetts (where Angel would one day live). Meanwhile, a fifteen-year-old Folsom boarded at the Mechanicville Academy, a small prep school in Saratoga County, New York, where she experienced boarding school life firsthand. By 1880 she boarded in a household in Lowell, Massachusetts, and received nursing training in New

England's first family health program.[24] Near this time, Samuel Chapman Armstrong, Hampton's founder, asked her to help him with his Indian students' "difficult adjustment to new ways of living."[25]

Folsom was twenty-five when she came to Hampton, but she appeared much younger. One returned student wrote: "I can always picture you a little girl, mothering grown Indians." He also remembered that Folsom made him realize "that a selfish life meant very little in the world."[26] Her own self-sacrificing nature, the ideal of her generation of Indian reformers, drove Folsom to expect Angel to work hard, but to praise her when she did.

In 1904, when Folsom selected Angel as one of three Hampton graduates to best represent Hampton's principles, she offered a rare glimpse of Angel's first years at the school (as well as Angel's ear for French pronunciation).

> Angel de Cora . . . was brought to Hampton with practically no education and a very few words of the English language. She was pretty, bright and affectionate, but painfully shy and scarcely able to endure the sound of her own voice in the classroom. In spite of this she picked up the language quickly even if not always quite correctly.
>
> One evening the quiet study hour was thrown into a panic by her suddenly jumping up on her seat and crying out, "St. Peter! St. Peter!" when one of Virginia's harmless centipedes sped swiftly across the floor.[27]

Angel's gentle charm, combined with a generous spirit, drew many to her. Her sensitivity, intelligence, sparkling wit, and verbal agility also made her very appealing. A year and a half after Angel enrolled in the school an item appeared in the school paper titled "Her Idea of Heaven," likely written by Folsom. The anecdote reveals a sixteen-year-old Angel who was not as young as her enrollment form declared: "Some of the little Indian girls were eagerly propounding questions to a teacher about death and Heaven. Very sweet and serious they were about it, and their questions were not always easy to answer. They were told of the fair City described in Revelations, of the golden streets, the harps and music. Suddenly an impetuous little Winnebago, recalling festive evenings at Winona asked, 'March with boys?'"[28]

In February of 1886 Angel tested her relationship with Folsom when her teacher left the school temporarily for a "good rest." By this time Angel knew more than a little English and could articulate her feelings to the woman who would become her lifelong supporter. "May I write just only few lines to you?" she began. "I have not anything to do and I kept thinking of you most all the time," she confided, "and I made my

mind that I will write to you. I can not write at all Dear so you must excuse me."[29] She suffered an injury and could not attend classes. Seeking sympathy, she explained: "my colar-bone [*sic*] was broken and it is broken again I think, so they bind all up with strings so I am writing only with one hand." She then disclosed a secret, deeper hurt she harbored. "Miss Folsom dear I want to tell that . . . the last time when you kept Maggie and I in the school, no body had never kept me in the school after that time. I did not read loud because I had headache very bad and it was the day before that I was going to have measles." Angel's justification confronts Folsom's observation that she could "scarcely . . . endure the sound of her own voice," but, more importantly, it expressed her feelings that her punishment was unjust. Perhaps she realized that Folsom (like many teachers of American Indian children) viewed her reserve as "typically Indian."

Folsom hurt Angel's feelings and her pride, but Angel did not dwell on it. "Well Dear I must make an end now," she wrote, "every thing is going on very well here. I wish I could see you. I want to see you very much." She asked Folsom to "be well and see us again some of these days," reassuring her, "I will be very happy to see you." She offered her love to "whomever is with you," asking Folsom to tell her company "that I am your Winnebago Indian friend Angel." Showing off her new letter writing skills she closed: "Good-bye Dear. Yours sincerely friend, Angel De Cora."

Angel's letter reveals how Indian schools shamed children out of the customs taught by their parents. Many felt uncomfortable reading aloud in school and were ridiculed. As her future unfolded, Angel proudly described herself as "quiet, reserved and modest," implying these feminine traits were valued in American Indian cultures, even if they were devalued by Euro-American society. But her letter also illustrates a budding emotional bond with her teacher that significantly contributed to her career success.

§

General Armstrong founded Hampton Institute in 1868 and served as principal during Angel's years at the school. He was born to missionary parents in 1839 in Wailuku, Maui, and died in 1893.[30] He witnessed his parents' attempt to Christianize the indigenous people around him. A young man, he left the islands to attend Williams College in Massachusetts, a school acclaimed for its teaching emphasis. At twenty-three, he enlisted as captain of a New York colored regiment during the Civil War.[31] He noticed a similarity between the plight of his men and the Hawaiians from home. His military experience led to a short career

working for the Freedman's Bureau, when, as his daughter stated, he envisioned the Hampton Institute "as it were in a dream."[32]

Ten years after Hampton opened as a school for freedmen, a young army officer, Richard Henry Pratt, changed the course of Indian education. At midnight on April 13, 1878, he arrived at Hampton with seventeen American Indian war hostages, part of a group of forty-nine he had charge of for three years at Fort Marion prison in St. Augustine, Florida.[33] When Pratt first arrived at Fort Marion and looked over the group of prisoners, he determined to "get them out of the curio class." He cut their hair and dressed them in army uniforms. He put them to work doing menial jobs, some for pay. He set up daily drills, began teaching the men English, and welcomed visitors to the prison in order to, as he stated, "correct the unwarranted prejudice promoted among our people against the Indians through race hatred and the false history which tells our side and not theirs."[34] He recruited several "excellent ladies" to teach the men basic academic skills as well as to expose them to Christianity. When the government released the men back to their reservations in late 1877, Pratt worried they could not serve as "a strong civilizing element among their people." He believed the younger men should be educated further. Sarah Mather, one of Pratt's excellent ladies, put him in touch with her friend, Armstrong. Pratt persuaded him to partake in an experiment and allow Indian students to attend Hampton.[35]

Once Armstrong realized the promise of "Indian education," Pratt recruited forty boys and nine girls, mostly teenaged, from western reservations.[36] Congress appropriated traveling expenses and $167 per student annually for the duration of the Indian department. Private contributions, scholarships, and money students earned while under Hampton's care supplemented the meager appropriation. At least sixty tribal groups passed through the halls of the school until the department's demise in 1922. Over the years 158 students graduated, while the student body was composed of 934 males and 518 females.[37] Armstrong and Pratt were especially keen to recruit female students, but Pratt soon discovered "Indian girls are more useful to their parents as laborers than boys are."[38]

Pratt became immediately dissatisfied with how Hampton handled Indian students. By the end of the next year he founded the first full-fledged off-reservation boarding school at the Carlisle Army Barracks in Carlisle, Pennsylvania. No one surpassed Pratt's lifelong dedication to the "Indian problem" or "Indian question," "Can the Indian be civilized?" Pratt's infamous motto, "Kill the Indian in him, and save the man," signified everything wrong with his reformist policy, as well as

one thing right.[39] He dismissed and devalued American Indian culture, despaired over students returning home to the reservation, and wanted to abolish the Office of Indian Affairs, which he believed maintained tribalism, without anything to replace it. "The Indian Bureau is our Indian problem," he exclaimed.[40] On the other hand, he believed "civilization is a habit" not a biological consequence and was unsympathetic to any policy but the complete integration and acceptance of Indians into U.S. society.

Pratt wanted all Indians to become U.S. citizens. Although a devout Methodist, he thought missionary schools failed miserably in this regard, because conversion was their primary aim. "The missionary does not citizenize," he complained.[41] Pratt and Armstrong were both military men, but Armstrong's missionary experience focused his approach on education, while Pratt's military experience prevailed.[42] Pratt's uncompromising toughness had much to do with his childhood. He was born in New York, less than two years after Armstrong, and grew up near the frontier at Logansport, Indiana.[43] His father was murdered while gold mining in California. At thirteen young Pratt left school to support his mother and two brothers, and later left his family to enlist in the Union Army.

Pratt challenged the merit of Hampton's bi-racial student body.[44] He felt both Indians and Negroes should mingle with whites, rather than learn from each other in a segregated environment. "An Indian can do no better thing for himself than to spend years among the best whites, gaining their language, intelligence, industry and skill in the fullest and quickest way."[45] Segregation for Indians, he contended, began on the frontier and ended at the reservation. He believed America's 260,000 Indians, in comparison to its much greater population of Negroes, made possible a viable solution to the Indian problem. Unlike his colleague, Pratt found Indians and Negroes divided by "differences in historical circumstances" that resulted in distinct prejudices. Discrimination against Negroes was a consequence of slavery and the aftermath of the Civil War, which was "destructive to the resources and wealth of the Southern people," while, he felt, prejudice against Indians was a consequence of America's frontier wars.[46]

Pratt expressed optimism that the Indian problem could be solved by a strict and absolute rejection of anything smacking of "Indianism." While Pratt stressed Americanization and rejected the reservation, Angel's principal preferred sending assimilated students back to their reservations as cultural missionaries "to lead and to serve."[47] Ironically, one of Hampton's best students, Angel, was not allowed to do any such

thing, but Armstrong ultimately believed an Indian "should go to where he could make his life count for most."[48]

A great philosophical gap further separated Pratt and Armstrong. Pratt was an old-fashioned universalist, and Armstrong subscribed to scientific evolutionism.[49] Pratt fought a lifelong battle to promote his version of Indian education, embracing the ideal of "universal human capacities," and emphasizing the "Indian is a man like other men." Since the precept "all men are created equal" founded his country, Pratt's orientation was very much an American one. Like Thomas Paine, Pratt was quick to identify his ideas with common sense, "my deductions are from practical and not theoretical knowledge," he claimed.

To his credit, Pratt continually stressed that the Indian "has no innate or inherent qualities that condemn him to separation from other men or to generations of slow development." Armstrong begged to differ and was supported by the evolutionary theories of his day.[50] He did not agree with Pratt's credo "the complete abandonment of the reservation." The test for Armstrong was "not what they received at school," but how students behaved once they returned home.[51] Folsom's careful record keeping of returned students served three purposes: to attain funding for the school, to serve as an archive, and to answer Armstrong's primary concern, "What becomes of the civilized Indian?" Armstrong was pessimistic about the Indian's progress. "The Indians are where they are; a few may be taken away, educated, and live among the whites," he said, "but only a few; this will barely touch, but not settle the Indian question. The work to be done is yet at the reservation."[52]

Pratt equated Native culture with savagery or barbarism and the reservation with indolence, therefore keeping students separated from their families was usually a necessity. He modeled his view of assimilation on the immigrant experience, where citizenship was gained "through public education." Unlike most, Pratt encouraged Indian-white marriages to further assimilation. He repeatedly stressed, "To civilize the Indian, put him in civilization and keep him there."[53] On the surface Armstrong's approach to education was not antithetical to Pratt's, but their approaches to the Indian question were quite distinct. Armstrong drew his views from theories of social evolution that Pratt absolutely rejected. "The Indians are grown up children," Armstrong stated not long after he established the Indian department, "we are a thousand years ahead of them in the line of progress." He also supported Anglo-Saxonism, claiming, "Savages have good memories; they acquire but do not comprehend; they devour but do not digest knowledge. They have no conception of mental discipline."[54]

Later in life Angel criticized Pratt's approach: "The educators seem to expect an Indian to leave behind him all his heritage of tribal training and in the course of five years or more to take up and excel in an entirely new line of thought in mental and industrial training whose methods are wholly foreign to him."[55] Armstrong's "conviction that this process of advancement could only be a slow one, and that total assimilation was not imminent" led him to "nurture the Indian's racial identity and organize the schooling programme of Hampton to accommodate it," which appealed to Angel.[56]

Hampton Institute's less stringent policy of assimilation arose from a charitable tolerance characteristic of the social gospel movement, rather than a pluralist respect for cultural difference. Nevertheless, Angel often expressed great admiration for "the General." Maybe she learned that the social Darwinists of her childhood, under the spell of social scientist William Graham Sumner, were the unsympathetic alternative. Those who embraced laissez-faire politics agreed with Sumner that "reliev[ing] the victims of social pressure from the calamity of their position" only extends "premiums to folly and vice." Nature dictated who had and who had not, and intervening in the eternal, competitive struggle inherent to a society, would only hinder humanity's progress.[58] Angel eventually espoused the reform Darwinism of the Progressive era. This orientation granted the lower classes (and races) a chance to progress if they worked strenuously. It also emphasized the protection of the weak by the strong.[57]

Hampton's approach to biracial education contributed to Angel's unique educational experience. Forbidden to read and denied access to education during the era of slavery, many African Americans viewed books as a "white man's source of power." The taboo of literacy became the inspiration for education.[58] Although the stereotype developed that blacks were "imitative and dependent," these qualities were seen to be beneficial ones for Negro education. In contrast, traditional Indians such as Angel's great grandfather, Decorah, who rejected the call for Winnebago children to be educated like the white man, were judged too independent.

Hampton faculty used the more "talkative" Negro students to teach English to the more reticent Indians, like Angel.[59] Although some feared "Negro dialect was almost an additional language to learn," most believed Indians could not learn "a bad accent or low dialect" since daily phonetic exercises were part of the curriculum.[60] One of the English teachers claimed that Indians sometimes taught the proper use of language to Negroes. She believed Negroes had "a passion for oratory," and

"their musical ear tempts them to prefer a large, sonorous, and unusual word to a short and common one." "Indians are not tempted to misuse by a sense of musical certainty," she explained, "and the love of display would be more restrained by self-consciousness, and a sense of the ludicrous with a consequent fear of ridicule."[61] She also believed the Indian's propensity for "close observation" made them better spellers.

In an effort to create a desire for literacy, Armstrong restricted reading material in the early years of the Indian program, while Angel attended the school. Booker T. Washington, famed Hampton alumnus and later a teacher there, witnessed the results of Armstrong's strategy. He agreed it aroused the Indian students' desires "to attend study hour like the colored students, and have a big pile of school books."[62]

Hampton supported racial stereotypes, but classes, at least initially, were not segregated racially but divided by ability.[63] As African American students tended to be more advanced (at least before 1898, when recruits did not have to take qualifying exams), they did not attend classes with Indian students until about the intermediate level. Knowledge of the English language distinguished the two groups: "From the moment Indians arrived at Hampton, some adjustment to their level of familiarly with white culture had to be made. Generally this meant recognizing the problem of language.... Since Indians had to know English before any formal education could be provided, those versed only in their tribal languages were taught methods of instruction then being developed to assist the deaf, thus, they demanded too much personal time to be placed in regular classes."[64]

Angel spent her first year practicing English. Grace Decora, Addie Stevens, and she attended classes in the Fifth Division (just below junior class level) with ten Sioux and one Mandan girl. Carrie Alexander, Fannie Earth, and Willie Harrison were placed in the seventh and lowest division with ten other Sioux children.[65] Angel's first textbook was probably *Language Lessons: Designed to Introduce Young Learners, Deaf Mutes and Foreigners to a Correct Understanding of the English Language.*[66]

Four years after she enrolled, Indian Commissioner J. D. C. Atkins sent a circular "to all parties who have contracted to educate Indian pupils," reminding them: "Your attention is called to the provisions of the contracts for educating Indian pupils," providing "'the schools shall teach the ordinary branches of an English education. This provision must be faithfully adhered to, and no books in any Indian language must be used or instruction given in that language to Indian pupils in any school where this office has entered into contract for the education of Indians."[67]

In 1889 Atkins's successor, Thomas H. Morgan, further ordered: "tribal relations should be broken up, socialism destroyed, and the family and the autonomy of the individual substituted. The allotment of lands in severalty, the establishment of local courts and police, the development of a personal sense of independence, and the universal adoption of the English language are means to this end."[68]

During most of Angel's years at Hampton, students were allowed to speak some Dakota, the lingua franca of Sioux missionaries. Students could also speak their native languages "before breakfast and after supper, and on holidays and Sundays."[69] Hampton's faculty realized students could not perform as cultural missionaries if they lost their native tongue. In 1890, however, Morgan sent Indian schools the following historic injunction: "Pupils must be compelled to converse with each other in English, and should be properly rebuked or punished for persistent violation of this rule."[70]

The demands of a biracial school shaped Hampton Institute, but it was also shaped by those who shared views with Walt Whitman, who, during Angel's second year at school, wrote for the *Southern Workman*: "the Indian will not respect our civilization the more for being taught to despise his own."[71] Angel's career reflected this attitude that distinguished Hampton from Carlisle from the start. "An Indian's self-respect is undermined when he is told that his native customs and crafts are no longer of any use because they are the habits and pastimes of the crude man," she later argued. "This is one of the secrets and pangs that the educated must suffer."[72]

Gray Wolf's Daughter

During the summer of 1886 Angel traveled by steamship to Boston, destined for her first outing in Berkshire County, Massachusetts. Taking Pratt's cue, Armstrong added outings to the Indian program to advance assimilation. Students lived in households to reinforce lessons learned at school. They practiced English, witnessed appropriate social behaviors, and honed domestic, agricultural, and, sometimes, industrial skills. They usually earned a small monthly wage, but it was forwarded to Hampton for things they might need during the school year. When successful, the outing program also helped to eliminate prejudices, both for students and host families. Typically outings took place during the summer break, but staff arranged longer periods for some.[1]

Advertisements for the school boasted it was located in "a place most healthful and beautiful in situation," but many students, especially from the Great Plains, did not fare well during the humid Virginia summers. Armstrong's many contacts in the Berkshire Hills provided outing students a more pleasant living situation in the summer, at least in theory.[2] The outing program also prevented students from returning home to their reservations, supposedly assuring a smoother transition back to school life in the fall.[3] Armstrong introduced outings for girls the year Angel arrived at the school.

Angel stayed with Mrs. Leicester in Egremont for three months, probably on a farm.[4] Her placement demonstrates school staff trusted in her good character. The previous summer the administration decided to be more careful about the students sent on outings.[5] Armstrong realized that the outing program, which alleviated some of the school's financial burden, could only be sustained if students made good impressions. Outing notes from a Hampton staff member show Angel's likely circumstances: "Girls work in small families where chores [are] not heavy and [the] wife can teach them skills. [They are] paid seventy-five cents to two dollars per week . . . Work varies, [for example,] household waiters and nursery maids. . . . [with] afternoons off to read and sew."[6]

Hosts sometimes exploited students for free labor. Even when they weren't exploited, Berkshire farmers grew to depend on the work of Hampton boys and young men to ensure a successful harvest. The school administration expected host families to submit evaluations of students, and, likewise, students evaluated their host families. Staff also negotiated their wages and kept close track of the entire process, "from the steamer trip to New York or Boston to the specific rules and regulations imposed on students while in white homes."[7]

In the fall Angel returned to Virginia. She rose with the bell at 5:15 A.M. and regulated activities organized the rest of her day until lights out at 9:30 P.M., as the schedule below shows:

Breakfast	6:00 A.M.
Work Bell	6:50
Study Hour	7 to 8:20
Inspection of Men in Ranks	8:30
School Bell	8:40
Devotions	8:50
General Exercises	9 to 9:20
Recitations until	12:00 P.M.
Dinner	12:15
Work Bell	12:50
School Bell	1:20
Recitations until	3:40
Recall from Work	6:00
Supper	6:15
Devotions	6:40
Study Hour	7 to 9:00[8]

She also attended Sunday school and Sunday chapel services. School was not in session on Mondays.

The school aimed to prepare girls and young women to be good wives and mothers and to help support their families if necessary. Its emphasis (and that of Indian schools in general) focused on domestic skills for girls. Angel's week included from one to two days of industrial training, as well as household work and sewing. Sewing classes entailed making clothes by hand or machine, mending, knitting and crocheting. A photograph of Angel's "Fancy Work" class pictures her with her schoolmates looking uncomfortable and distracted, probably due to the camera. Folsom's caption attempts to spice up the tableau: "The girls had their sewing classes and mending days but this was a free-for-all orgy with bright ribbons and worsted and crochet needles."[9] Whether it was as fun as all that, Angel's sewing skills would serve her well. She lived frugally

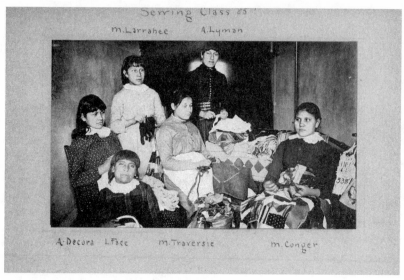

Sewing class at Hampton, 1885.
(Courtesy of Hampton University Archives)

as an artist, rarely earning enough to hire a personal tailor or buy ready-made clothing. She even made a little money sewing for others. When Angel left Hampton, she often joked about her domestic training. Eventually she realized that this prominent feature of Indian schools prepared most girls for a future of servitude.[10]

Hampton's disciplinary policy was strict. It forbid playing cards, permitted inspection of dormitory rooms, subjected males "to drill, guard duty, and training without arms," and regulated letter writing. The worst infractions were punished by solitary confinement. In the winter of 1884, Armstrong began sending misbehaving students to a cell-like room, which students called "the dungeon," located in the basement of the administration building.

After three years Congress intervened. An 1887 investigation found the room had no windows or light and measured only 6½' by 3' 3". A 9½' tall ceiling offered the only expanse of space. Stale air from the basement provided the only ventilation. "On the pavement or floor of the cell was a bed-sacking with apparently a little straw," stated the report. "When a boy was removed from the cell ... the stench was awful."[11] Armstrong insisted there was light enough to read and that "an inmate was taken for exercise three times daily and could effect his own release by confessing who sold him liquor, as the cell's purpose was to 'fight whiskey.'" To prove his point Armstrong slept there himself, but after-

ward improved the room's ventilation.[12] Angel avoided such extreme punishment. She apparently accommodated Hampton's daily routine. Her routine would soon be disrupted.

§

On April 1, 1887 Little Decora died near Tomah, Wisconsin.[13] A few days before his death, the editor of the *Wisconsin Historical Collections* traveled to nearby Adams County to interview a few elderly Winnebagos for posterity, including Decora's brother, Spoon. Moses Paquette accompanied him. Paquette took the census of the Wisconsin Ho-Chunk the year before and listed Little Decora, aged 94, with a new wife, Wankonchawkoowinkah, aged 75.[14] He told the editor that Decora was the "oldest Wisconsin Winnebago now living," but, unfortunately, he was too feeble to be interviewed. "He is now a childish, helpless wreck," Paquette said.[15]

In June Angel finally went home, but not because of her grandfather. Indian Affairs regulations required boarding schools to return students after three or four years.[16] Once students remained home for a period of time, their guardians could reenroll them if they chose. When Angel returned to the reservation, besides learning of her grandfather's death, she faced a grim situation. The Winnebagos were suffering from unrelenting poverty, severe health problems, including tuberculosis, trachoma, and alcoholism among women, and a general state of despair. Later she told Folsom, the Winnebagos "went down to the lowest depth of demoralization" while she had been away, but she may have just seen her surroundings with new eyes.[17] She believed her mother and Willie Harrison's mother "were the only two Indian women on the reservation that didn't drink." Although exaggerated, her claim suggests the reservation was not a pleasant place to live. The "vanishing Indian" myth obfuscated the real tragedy of American Indian life. People lived, but as one chief phrased it, they survived "cornered in little spots of the earth."[18]

The Métis population may have fared better, but women in general inhabited a less mutually supportive society. Before the removals, gender relations were more balanced.[19] Great Lakes Métis women often held respected positions as cultural brokers, religious leaders, and business women. Few still served as such in the last quarter of the nineteenth century.[20] In the past, Winnebago women "had considerable autonomy in their personal lives and economic activities," particularly as they aged.[21] They prepared the soil in the spring for flint corn, pumpkins, and, as one relative noted, "any other vegetable seed" that "found its way into their camps from the fur traders."[22] They ground or dried corn in the fall and harvested maple sap for sugar in the spring. They worked

together weaving grass mats for their wigwams and rugs, keeping them in good repair. They made baskets and brooms. They preserved meat, tanned skin for clothing, moccasins (which they beaded), and storage bags. They cared for their children.

They also had charge of lead mining. Not only were their mines long gone, but the government placed a high premium on transforming their husbands and sons into farmers. As a result, Native women lost a good deal of authority and autonomy after the removal years.[23] As men began farming, or leasing land to white farmers, women lost their valued position as cultivators of the earth. They still raised children, but, without some economic control, they struggled to maintain equilibrium with their mates. Taking advantage of "Indian divorce" much more so than in early years resulted in multiple partners and multiple pregnancies, leading to venereal disease and death.[24] As societal controls unhinged, women found themselves disrespected and unprotected in a more patriarchal United States.

No wonder Angel began rejecting the "promising career" planned for her. At eighteen she was now old enough for marriage. Her teachers, like Folsom, showed by example that she could have a career if she remained single. Either way, they were watching her. Evaluating her behavior as a returned student, Folsom marked Angel's school record as "Good."[25] Ironically, the mark depended on practicing Christianity, abstaining from drinking and gambling, dressing in citizen's clothing, being monogamous and legally married, and raising Americanized children. Angel dressed appropriately and did not drink, but Folsom hoped she would avoid marriage for now.

Folsom, and later Carrie Andrus, often visited returned students and solicited opinions from informants "as to their progress or the reverse."[26] In all likelihood Folsom's reformist friend, Alice Fletcher, passed on Angel's good behavior to Folsom. A budding ethnographer, Fletcher was a staunch supporter of the General Allotment Act (or Dawes Act) of 1887, which sought to break up tribal ties by allotting reservation land to individuals in severalty. Fletcher viewed the Dawes Act as the means to the Indian's ascent to civilization.

Indian Affairs Commissioner Morgan appointed Fletcher to act as allotting agent for the Winnebagos, after she had allotted the Omahas. Fletcher's duties coincided with Angel's return home. She worked from August of 1887 until March of 1888, and again in August of 1888 until December. Morgan thought Fletcher's "work was not only greatly aided by the returned students but would probably have been wholly unsuccessful" without them.[27] Since Angel could speak English, and Fletcher

needed to figure out who could inherit each allotment, Angel may have assisted her.[28]

Determining heirs proved to be a daunting task. Initially Fletcher assumed a "lack of paternal responsibility contributed to weak family ties."[29] She also noted Winnebago women "have some queer privileges here I don't yet get at." She found the Winnebagos "take their identity from one side of the family, inherit from that same side, and consider only the members of that clan as their relatives."[30] This custom clashed with the country's legal standard. Fletcher soon discovered the Winnebagos practiced an avuncular kinship system, evidenced by Frank Lamere's relationship to Angel. The father's line determined clan membership, but the mother's brother served as a paternal figure. Consequently, a man called his sister's children "daughter" or "son." When fathers (like Sabrevoir de Carrie or Angel's father) left their children, mother's brother offered guidance and protection.

Fletcher decided to create a family registry to sort out the confusion. A "kaleidoscopic shifting" of spouses obscured her efforts to understand lines of descent.[31] Traditional rules and mores were lax, but also the Winnebagos accepted polygamy for a man, particularly with his wife's sister or cousin. Another obstacle was the taboo on speaking names directly. The Winnebagos used "elaborate circumlocutions." They also wondered why Fletcher wanted the names of grandparents, aunts, and uncles on *both* sides of the family.[32] Despite challenges, Fletcher completed her job in 1888. Based on the registry, Angel received her own allotment and inherited from four different estates over the years.[33] But the Dawes Act led to a great diminution of reservation land across the country. Like many Winnebagos, American Indians rejected individualism and sold their land, often for a pittance, to farmers, investors, and land sharks.

Angel left little account of her return home, but Fletcher kept a diary that provides insight into daily life on the reservation as well as Angel's childhood influences. She found to her delight that the Winnebagos were more "pagan" than the Omahas. She assumed this was because the tribe had "little contact with missionaries," though this was untrue.[34] She observed with fascination the traditional Medicine Lodge ceremony, headed by Good Old Man, Angel's step-grandfather.[35] She characterized the Winnebagos as "easy-going—and so resigned to government interference—that although uninterested in allotment, they cooperated with her."[36] They were "simple folk," she noted, "who believe what is said, and are not full of all sorts of notions." She also called them "a deft fingered people" who did "quite creditable" work in

silver. Angel believed her artistic skills were, likewise, innate. But her sister, Julia, said Angel's talent was exceptional: "we used to go on visits to our mother and there was the loveliest clay bank where we made all our own toys. Whatever Angel made was done a bit better than we did."[37]

Fletcher's description of the environment shed light on the paintings Angel later created. "It is full of delights to ride over the prairie these peerless days," she wrote, "not a cloud, the sky clear to the edge of the horizon, the sun golden, the grass and vegetation turning a rich russet, and here and there a bird rising to sing its goodbye, as it turns southward."[38] Fletcher also noticed the women's "love of silver ornaments." The way they dressed fascinated her, especially their exuberance for accessorizing with "earrings, bracelets, and rings, sometimes covering every finger."[39] Angel later depicted this quality in her renderings of American Indian women.

Angel knew Fletcher, but whether she spent much time with her is unknown. From the summer of 1887 through the fall of 1888, Angel "lived with relatives over a year," Folsom noted. When Angel returned home to her mother, two daughters already replaced Emma Sampson, the half-sister who died just before she left for school. Now the Sampson girls included Louisa, 10; Josephine, 5; Mary, 3; and Grace, 1. Regardless of how happy her mother was to see her again, Angel didn't stay. The Lamere brothers also had many children, so she lived mostly with her grandmother.

In Folsom's estimation, Angel was "far too young to cope with reservation conditions as they then existed." She later described the way she (or Fletcher) viewed Angel's living situation. "A few months later a representative from Hampton found her living with her grandmother and very unhappily situated. Old and new customs were at that time strongly conflicting currents and a young girl had hardly more weight than a leaf between them. It was not easy to get her out from the stronger of these two currents, but it was accomplished and she was brought back to Hampton where she completed her academic course in 1891."[40]

Angel's broken home contributed as much to her unhappy situation as did reservation conditions. But conflicting old and new customs certainly entered the picture, and, apparently, Folsom believed Angel's grandmother's had the strongest influence. Missionaries on the reservation and their Christian followers crusaded to suppress the Medicine Lodge religion that her husband practiced. Moreover, their daughter, Lizzie Lamere, married Late Rave while Angel had been at Hampton. His brother, John Rave, introduced peyote to the Winnebagos about 1894, shortly after his own religious conversion in Oklahoma.[41] The reli-

Illustration from "Gray Wolf's Daughter," *Harper's New Monthly*, November 1899.

gious beliefs of Angel's family ranged from her mother's Catholicism to the traditional Medicine Lodge religion to the upcoming peyote religion (now Native American Church).

Angel addressed the theme of old and new customs in "Gray Wolf's Daughter," a "semiautobiographical" story published in 1899 by *Harper's New Monthly*.[42] Her portrayal of the unnamed Gray Wolf's daughter contrasts sharply with Folsom's depiction of Angel as a fragile returned student. The story opens as the heroine prepares to leave home to attend school to "learn the white man's way." Deep in thought, she questions the different paths taken by her friends, one who had been at school, the other, "a thorough Indian," who stayed home.

While Gray Wolf takes a ritual vapor bath with three medicine men, the women prepare for a dance ceremony. The girl's mother hopes her daughter will dance with the other girls, but admits she fears it will be "for the last time." "Schoolgirls can't dance," the protagonist's grandmother retorts, "because they have to wear white men's shoes. If they ask you to wear shoes at school, don't you do it—don't you do it!" The grandmother also worried that "the girl was too old for school life, and ought now to be given away in marriage."

Were these the concerns of Catherine Amelle Lamere? Was this the "strong current" Folsom tried to interrupt? If not, Angel's story shows the possibility entered her mind. It also romanticized and "Indianized," as Pratt might say, her experience. When the girls danced, Gray Wolf's wife heard the lament of the other women, concerning her "pretty daughter's" fate. "Such a graceful dancer: Why does her mother let her

Dancing Girls from "Gray Wolf's Daughter," *Harper's New Monthly*, November 1899.

go?" The mother asked herself the same question, but she and her husband had already consented.

The morning after the ceremony, Gray Wolf's daughter gave her pony to her brother and "took all her beautiful things from the basket and told her mother to give them to her sister-in-law." She wanted her mother to have her best blanket after she used it for the journey. As if in mourning, or religious initiation, she wore "her plainest dress" and only "one little silver ring on her finger."

Significantly, objects of Native culture seem more important to Angel's character than the people she left behind. The growing consumerism for American Indian art may have influenced the story's editor, but the tenuous nature of Angel's family life and her love of art objects also cast her character. Gray Wolf accompanied his daughter to the reservation school. He vowed to bring the girl's mother and grandmother to visit often, a touching promise Angel's real father never made to her. The narrative ends with the inner thoughts of the father: "She had been the joy and life of their home, and he longed to have her go back with him, but she had always had her own way."

The life of Gray Wolf's daughter was far from Angel's, and Gray Wolf was clearly a fantasy father figure. In July 1888, one year after Angel's return home, David Decora died in Wisconsin.[43] His death followed his father's

by a year. He left two daughters in Nebraska and two in Wisconsin to mourn his passing.[44] It's unlikely that Angel and Julia attended his wake. Although he was a good son, he had been long absent as their father.

In Angel's story, Gray Wolf's daughter felt free to make choices denied to her creator. Her life centered on family and tradition, and her family nurtured her to "have her own way." Her decision to go to school, and to one close by, was a choice denied Angel. Although she later joked to a friend that she had been "caught wild on the reservation," it was no joke to her mother or to Cora Folsom.[45] Folsom believed for nearly three decades that Julia St. Cyr had made arrangements with Angel's mother to take her to Hampton.

Folsom felt awful for Angel, but also worried about Hampton's reputation. Angel not only accepted her abduction, but justified it: "I am sure my mother and uncle are glad that I got my training elsewhere than the reservation. I wonder that in nearly every case of the same, the kidnapped individual was thankful for the abduction."[46] This disturbing generalization reflects her situation more than truth. It also substantiated what the Commissioner of Indian Affairs believed: "The half-breeds are usually very willing to go to school. The parents seldom object. This is doubtless the result of the training of the white parents."[47]

"Mother told me that it was the one bright spot in her life," Angel wrote Folsom in 1912, "that two of her daughters were so placed that they didn't have to live on the reservation."[48] She also declared her abduction "was the turning point in my own case. I am what I am (nothing much or useful to be sure) but I might have been worse had I never left the reservation."

Her brief autobiography published in 1911 in a Carlisle Indian school publication gave her past a different tone. "My parents found it out, but too late. Three years later when I returned to my mother, she told me that for months she wept and mourned for me. My father and the old chief and his wife had died, and with them the old Indian life was gone." The passage obscures the long separation from her father's family; not only to cover the fact of her broken home, but to leave undisclosed a childhood "much like white children's." Marking her return home as the end of her traditional childhood was not untruthful, however. Suffering the loss of close family members upon her return, whether through death or their neglect, forced Angel to face the fact that her idyllic childhood was over. With little to anchor her now, she soon "had her own way," like Gray Wolf's daughter.

Folsom arrived in the fall. This time Elizabeth Lamere gave Angel her blessing to go. Angel and a few other Winnebago recruits boarded the

train, again, in Sioux City, and returned to Hampton Institute in November of 1888. Angel immediately became a more active presence at the school. At nineteen years old, she was no longer a child. It was time to make her plans. Her time away cemented a sense of purpose and an understanding that the "very promising career" laid out for her by her father's family was no longer an option.

§

The Indian department consisted of forty-five female and ninety-five male students the year Angel returned. She advanced to the junior class, along with twenty-seven others. Nine Winnebago students enrolled in the lower classes, but none in hers. Those from home included her good friends, Addie Stevens and Hattie James, as well as her cousins, Walter Decora and Willie Harrison, only two from the original group of 1883. Angel's courses as a first and second term junior consisted of reading, penmanship, spelling, "practical arithmetic to percentage," "mental arithmetic," natural history, geography, grammar, U.S. History, "Story of the Bible," and the important "Habits and Manners."[49] In addition, she took gymnastics, learned "bread making and plain cooking," practiced vocals, and endured Sunday Bible lessons.

During the next academic year, Angel moved up to the middle class, between the junior and senior classes in the Normal school curriculum. An anecdote printed in the school paper shows that despite her shyness, she liked to entertain. "Miss Snow stood among a group of girls, discussing the weather and speaking of our very mild winter last year. One of them volunteered the statement that we had no snow at all last winter, whereupon Angel, in apparent surprise, looked up, and said, 'Why, yes, we did, don't you know? We had almost six feet of it at one time!' glancing mischievously at Miss Snow."[50]

A more outgoing Angel joined the philanthropic Lend a Hand Club and recorded its activities in *Talks and Thoughts*, the student-run newspaper. She served as one of five editors for the paper. In December she reported that a returned student "got us some good work to do by asking us to help an old Indian woman out west, in raising enough money to get a new floor for her log cabin. We gladly put in and did what we could to raise the required sum of money, and have already sent it."[51] She also reported that "a returned student in Dakota has asked our help in getting geographies and bible pictures, to help in teaching Indians more about the bible in the world. Our idea is to help others, and we are only glad to have some one that we could help." Characteristically, she did not dwell on the benefits of the bible, but focused on the Christian ideal to help others. That year Angel also joined a secret girls' club known only

by its initials "E. S. G." A photograph of the club members, mostly from the Great Plains, shows young women in sophisticated dress. Angel stood off to the side of the group looking shy and holding a cat.[52]

During the next summer in 1890, Hampton sent Angel on a three-month outing to Newton Center, Massachusetts. Her hostess was philanthropist and writer, Frances Campbell Sparhawk. An avid reformer, Sparhawk became interested in the Indian question while she was a girl.[53] *Talks and Thoughts* reported that Angel was "very happy in her pleasant home."[54] Sparhawk welcomed one of Angel's school chums for a visit, and, more importantly, treated Angel to private drawing lessons. "Angel is a good dear little girl, and we are all fond of her," Sparhawk wrote Folsom. "She does everything that she does very nicely, and she has already made some delicious bread with instruction." Angel went to church with her, and Sparhawk put her in Sunday school. Sparhawk hoped Angel would "get a little acquainted here; though the child is very shy."[55]

Sparhawk provided an ideal outing situation for Angel, but Angel seems to have provided her hostess with raw material for her fiction. Off-reservation boarding school students featured prominently in her short story, "Istia," published in 1894.[56] Sparhawk cast her romantic protagonists, Stephen Hits-the-Mark and Istia, as Hampton students with Carlisle inclinations. After the couple married, they return to the reservation, and discover they cannot "help their people." Failing as a cultural missionary, Istia concludes, "There are too many chiefs" on the reservation, and "the white teachers . . . can manage them best."

Sparhawk's story speaks some to Angel's experience. She did not complain about "too many chiefs," but she noticed "demoralization" on the Winnebago reservation, and gave up on helping. "I am glad I was not with them, I couldn't have done any good," she told Folsom.[57] Few Winnebago students attended Hampton after 1890, because even Armstrong declared the Winnebago reservation was "morally corrupt," and "there was so little good for the children to go back to."[58] Angel's autobiography reflects Armstrong's viewpoint: "after graduation, some of my teachers prevailed upon me not to return home as I was still too young and immature to do much good among my people."

"Istia" provides an interesting contrast to Angel's home life as well as to her story, "Gray Wolf's Daughter," which neatly avoids the conflicts of the returned student. While the grandmother of Gray Wolf's daughter worries about white men's shoes, and her community worries about the waste of such a graceful dancer, "Istia" delves into life *after* Indian education. At first Istia admonishes Hits-the-Mark, who has returned home from Hampton: "If this is no place for you, it's better you should

go . . . If you don't love your own people, go among the whites; it's the best thing for you." But once she receives a Hampton education, she, too, feels alienated from her people and leaves the job of their uplifting to someone else.

§

Angel expressed little pathos as a returned student, but many did, including Howard G. Logan, a Winnebago who attended Carlisle. Logan and Angel were contemporaries, related through marriage and similarly well thought of by their teachers. Logan's letter to Pratt, written the same year Angel graduated from Hampton, illustrates the difference between his and Angel's home life. After returning to the Nebraska reservation upon his graduation, Logan wrote to his "dear friend" Pratt, describing his personal ordeal in putting into practice Carlisle's principles, as he decided whether to take a job in Arizona. His letter stands as a testament to the challenges formally educated American Indians faced when they returned home, especially from Carlisle.

> You may be surprised at this since you advocate the complete abandonment of the reservation and think that there is nothing in it that should worry us. That is common sense and I take it as the only way out of Indianism. But when that part of our human nature which is continuously drawing us home gets the best of us, it is indeed hard to overcome it. It may be true that the home of many of us are not as good as the "average" but they are our home, it is there where our loved ones live, and where father and mother are ready to receive us cordially as any King ever did to his children. Verily "there is no place like home." I am at my home.[59]

Logan conveyed to Pratt how his family members were "opposed to my going," how his sisters "go so far as to shed tears," and how he was "now called upon to refuse the beckoning hands of parental love." In the end, he decided he should go to Arizona, even though his family would feel his "decision very keenly," and even though they would "suffer for the right if I am right and that is one comforting thought."

Logan's letter painfully demonstrates how difficult it was for a returned student to follow Pratt's doctrine—despite demoralization on the Winnebago reservation. On the other hand, Hampton's cultural missionaries faced equally difficult challenges, an issue Sparhawk emphasized in "Istia," but resolved with Pratt's total rejection of the reservation. Returned students, like any young adult who returns home after several years, not only saw their homes and families with discriminating eyes, but they also faced obstacles to their mission, such as "cultural conflicts, hardships finding employment, competition with whites

for jobs in the Indian service, and land unsuited to agriculture."[60] Folsom played a crucial role in protecting Angel from these problems (although Julia, her sister, was left to struggle with them). On the other hand, this protection was not without a price. Angel's alienation from her family and the Winnebagos grew greater each year.

§

Eight years after she first enrolled in the Indian department at Hampton Institute, Angel entered the 1890–91 academic school year as a senior. Most students stayed in the lower divisions of the Indian department trying to master English, but those "deemed academically proficient" joined African American students in the Normal school curriculum for teacher training, acquiring about an eighth grade education upon graduation.[61] Angel joined seven other Indian students that year, including her close Wyandotte friend, Lizzie Young.

Little record remains of Angel's senior year. Only "An Indian Girls' Ingenuity," from *Talks and Thoughts*, tells how she and a friend cooked their "supper in one of the Cottages." In not quite proper English the friend happily recounted, "We have biscuit, butter, jelly, chocolate, tea and lemon-pie."[62] Obviously, special foods brightened an otherwise dull boarding school menu. Cooking (and eating the result) became one of Angel's guilty pleasures as she aged.

By the spring of 1891 someone laid plans for Angel to attend a prestigious women's preparatory school in Northampton, Massachusetts. Angel needed financial support to take advantage of this opportunity, and her musical talent persuaded Mrs. M. Griffith and Miss A. C. Lowell to provide a scholarship.[63] As Angel prepared for graduation, her sister, Julia, attended the Genoa Indian boarding school in Nebraska. On May 8, 1891, its school newspaper ran an item exemplifying the divide between the artistic De Cora sisters: "Julia Decora has finished her flower piece, which is a very creditable job. We advise Julia to not let this be the last specimen of her workmanship but to improve her talent for painting."[64] Unfortunately, Julia would never be able to compete with her sister.

Only one summer had passed since Hampton's first three students graduated when Angel first arrived at the school in 1883. By 1892 the number grew to thirty-one. Angel was only one of six Hampton graduates who "further distinguished themselves by pursuing higher education in the east."[65] This accomplishment spoke well for her, but also boosted support for Hampton as a worthy institution of Indian education.

On February 28, 1891, a Senate resolution ordered statistics on the progress of returned Hampton students to demonstrate the institution's contribution to society. The Commissioner of Indian Affairs ordered

the administration to compile a report, which was published in 1892 as the *Record of Returned Indian Students from Hampton Institute*. The illustrated report includes hundreds of student biographies, including Angel's, who was judged to be an "excellent" returned student. Comparing Angel to the Winnebago girls who traveled across the country with her in 1883 provides an important backdrop to her performance and her later success.

Hampton's staff rated students from excellent to bad for the 1891 fiscal year. Seventy-two students rated excellent, according to the report, because they "had exceptional advantages and use[d] them faithfully" or because "by great earnestness and pluck" they "won an equally wide and telling influence for good." One hundred forty-nine students received a good rating for "doing their best and exerting a decidedly good influence, even though it may not be very wide." Legal marriage, honesty, industriousness, temperance, and living "a life which we can point to as an example for others to follow and improve upon" were the criteria for this rating. Next, sixty-two students rated fair. They included "the sick and unfortunate," with "few advantages and from whom no better could be expected." In addition, all three categories of 283 students were marked in the "satisfactory" category, and, so, worthy of continued Congressional support.

Only thirty-five students rated "disappointing." Of these, the report marked twenty-three poor, for not doing "as well as they should." They might have married by Indian custom, "while knowing better," "fallen from weakness rather than from vice," or were "recovering themselves from more serious falls." Finally, twelve students appeared "bad." These individuals did "wrong while knowing better, yet [were], with one exception, those from whom no better was expected." This exception was Angel's cousin, Julia St. Cyr.

The Commissioner of Indian Affairs found Hampton's report to be "a most creditable one." Its subjects, however, had no right to privacy and had no resources to charge defamation of character. Educators learned humiliation often curbed unacceptable behavior in American Indian children. The report dammed the "[b]right but headstrong" Julia to notoriety. An Indian superintendent who employed her expressed his concern in 1898: "The book that you publish giving the record of students, is to be had on this reservation," he alerted Folsom, "and as St. Cyr's record has been bad, and is not much improved, the Indians soon all knew her by reputation. I fear that the published record of this woman will be a stumbling block in her way to success."[66]

Julia's report appeared in stark contrast to Angel's, though her family history was quite similar. Julia was the daughter of a citizen Winnebago

Métis. Julia's mother was the daughter of Little Decora's brother. Despite being the best-educated woman of the Winnebago tribe, according to the report, Julia "had gone entirely to the bad." She wore Indian dress, married Indian custom, and had two illegitimate children (though one died). Only one thing saved Julia from the blanket, or in other words, from reverting to traditional "uncivilized" Indian cultural habits: she "lavished an intelligent mother's care and devotion" upon her child.

A twelve-year-old Julia enrolled in Hampton in June of 1880. Five years later she was in the first graduating class. In February of 1882 she wrote home, saying she had been "locked up for some time." Her father wrote the head of the Indian department pleading for indulgence and forgiveness, but asking that Julia be sent home "if she can not get along without being punished any more in that way."[67] Julia's mother felt "greatly distressed," he explained, and "cried a great deal about it & we fear our daughter may hurt or kill herself, in trying to escape." Still he insisted, "We want our daughter to be dutiful" and "stay out her time & finish her education."[68]

Just three days before graduation, Julia's mother died.[69] Julia returned home to a devastated father, also suffering from trachoma, and seven grieving siblings. "I am willing to do anything to help my poor father now," Julia wrote Alice Fletcher, but she soon discovered "what a hard place [the] West was for educated Indians." The next fall she wrote Armstrong: "I strive for positions and fail to obtain them. I am not discouraged though, for I am determined to keep my good name till I die."[70]

Just after Angel returned home in 1887, Julia found a way back to Hampton to attend Normal school classes.[71] When staff failed to meet her expectations, she confided her problems to a local woman. Her confidant immediately wrote President Cleveland, complaining about the treatment of Hampton students. The letter initiated the 1887 congressional investigation of the school.[72]

By 1893 Julia alleviated some of her "bad record," according to another report titled, *Twenty-Two Years' Work of the Hampton Normal and Agricultural Institute at Hampton, Va.* Julia's "unsatisfactory conduct" after her return to school was duly noted, and again, insensitively publicized. The report showed Julia, "though her self in disgrace," had in part redeemed herself through her efforts to convince Angel and Addie Stevens' guardians to let the girls return to Hampton in 1888, insuring their "salvation."[73]

Next, Grace, daughter of Julia St. Cyr and Angel's uncle, Yank Decora, received a "Fair" rating.[74] A spinal deformity prohibited her from "hard work." After Julia failed to persuade Grace's father to let her return to

Hampton with Angel, she reverted to Indian dress to "please her par-
ents."[75] The report quoted Grace's personal letter to a teacher to demon-
strate Hampton's positive influence: "I am outside like Indians, but
inside a Christian still." The report expressed hope that her recent mar-
riage to an "old man" (Whirling Thunder) would allow Grace more
independence "in her manner of living." Later *Twenty-Two Years' Work*
described her as "a bright girl, with a very unusual taste and skill in
music." The school "would gladly have kept her longer, but it was impos-
sible to persuade her heathen parents that it was best." Grace died in
1897, leaving a beloved four year old, Louisa Thunder.[76]

Addie Stevens' record depicts a woman who accomplished much late
in life.[77] Her excerpt stated she "returned home to poor surroundings,"
attended the reservation school, "and remained until the hoped-for
chance of returning to Hampton appeared." Angel's friend (called
"Mary Cullen" on tribal records) completed her work at Hampton in
1892 and continued her education in the east.[78] In 1896 she graduated
from a two-year nursing course at a Philadelphia maternity hospital
established for indigent women, where she may have also given birth.[79]
Irate about Addie's love child with a "white man," Folsom chastised
Addie, saying she brought "shame to Hampton."[80] Tribal records show
Addie with a son, born about 1895, until 1906, when he either died or
was given up for adoption. She married Thomas Boucher, a French-
Canadian mill operator, in 1901. They would never have children.[81] In
the 1920s Addie redeemed herself, when Nebraska's governor appointed
her as the state's "Nurse of Maternal and Infant Welfare work on Indian
reservations." Folsom traveled to her side, accompanying her on her
rounds. In *Forty Years After*, another report on returned students, Fol-
som lauded, "This woman, Addie Stevens Boucher, so valuable to her
people." Addie succumbed to influenza January 29, 1937.[82]

Fannie, daughter of My Soul Earth, was about ten when she arrived at
Hampton. When she returned home with Angel, it was "to the lowest of
Indian associations," according to the slanderous report. "She soon mar-
ried and now lives in a bark wig-wam, dresses in Indian costume, and
though scrupulously neat and clean (and very picturesque) she has gone
back (outwardly at least) to Indian ways."[83] The backhanded compli-
ments didn't remove the sting from the harsh words. Julia revealed to
Folsom what determined Fannie's future. Her parents were grieving
when she returned home in 1887. Her brother drowned in the Missouri
River, after running away from school.[84]

The picturesque Fannie was probably the model for Angel's thorough
Indian who remained on the reservation in "Gray Wolf's Daughter."

Fannie married according to Indian custom at about fifteen or sixteen. She lived "to all appearances as does the rest of the tribe," stated *Twenty-Two Years' Work*, "though her letters show that a very different life is going on beneath, and that she can see advantages she has lost and urges them upon others as she could never have done had she not known them herself." Hampton agents described young Fannie and her "boyish-looking husband" with their "plump baby" as "playing house," but a "few years will doubtless find them much improved." By 1904 Fannie and her husband had six children, but she died about four years later leaving them to her husband's care.[85]

Carrie Alexander arrived at Hampton when she was eleven or so. Her brief home record was "Good" and her character noted as "Good, very Sweet."[86] According to *Twenty-Two Years' Work* Carrie was a "[v]ery bright and interesting child." She came to Hampton with consumption and was returned home in late September of 1884. A "delicate child," she died in February of 1885.

Hampton's returned student reports vividly exposed and harshly judged the Winnebago girls who traveled to and from Hampton with Angel. Treating them as subalterns, the reports provide an oppressive context for Angel's mark of excellence. Her talents and wit certainly set her apart from others, but a returned student's home life significantly influenced her future. Hampton's current lifted Angel from home, because there was no one strong enough to hold her there. As a result Angel "graduated in 1891" and became "a student of Miss Burnham's school in Northampton, Mass.," the report boasted. "She lives in the family of a wise woman, earning her board by helping with the housework, and gives promise of becoming a strong and accomplished woman."[87]

On September 10, 1891, Angel left the secure hearth of Winona Lodge for the intimidating world of Miss Mary Burnham's Preparatory School for Girls in Northampton, Massachusetts. "She has been with us six years and felt so badly about leaving," reported the *Southern Workman*, "that she was delighted to find every stateroom taken, so that she had to return to 'dear old Hampton' for another day." "We understand she is to live on Paradise St.—quite an appropriate place for an angel."[88] That fall, Angel wrote her sister at Genoa Indian School. She joked that she would "like to see more than one Indian at a time," while conveying her dismay at being "the only Indian among so many white girls."[89]

In the spring of 1892, Angel sent a surprise to Hampton, a crayon portrait of Armstrong to be hung in the Indian girl's parlor. The portrait, rendered from a small photograph, commemorated her principal. It was

a reminder that Angel De Cora still belonged to Hampton Institute, "hand, head, and heart"—and was still "under its care," as the 1892 report acknowledged. The school paper reported that when the "good sized box" was opened, "we rejoiced to behold our dear Principal's face, an excellent likeness. . . . The General was much pleased with it too."[90] The students and faculty wished her "great future success in her art work." They would not have to wish for long.

Angel of Paradise at Smith College

The day after Christmas of 1891, Angel wrote her first letter to Folsom from Northampton, Massachusetts. She thanked her for a Christmas gift and "for remembering this forsaken creature." She told her that her host family, the Clapps, gave her some "fine things" as well. They asked her, she relayed, "What individual person was responsible for me?" "I gave them your name as I was not sure of any other," she explained. "Did I do right?"[1] Angel expressed concern about how to pay for her music lessons. She was not sure "who to tell." Her questions suggest Folsom took financial responsibility for Angel, but didn't want it known.

Already Angel felt alienated at Miss Burnham's school, where she made few, if any, friends. Fortunately, Lizzie Young, her old classmate from Hampton, had come to visit. The welcome event added a cheery, playful tone to her letter, as she expressed her wish for a visit from Folsom as well.[2] "Please don't disappoint me in the Spring," she entreated, "for I look forward to thy coming with great anticipation. Will tell you all when you come for Liz is hurrying me to go downtown." She cleverly signed, "Thy Angel of Cora . . . 65 Paradise Road," showing her new sophistication in language skills. She also demonstrated her love of word play, transforming "Angel De Cora" as she had become transformed by her experiences away from the reservation and Hampton's Indian department.

Angel's new host family very slowly began to fill the void left by Angel's broken home. Mrs. Clapp, the "wise woman" referred to in Angel's returned student's report, was born Gertrude Quimby in 1855 in Barnett, Vermont. She married a Massachusetts attorney, William Henry Clapp, in 1887. Soon after, they moved into the brand new shingle-style house on 65 Paradise Road that Clapp built for his bride.[3] When Angel met the couple, they were childless, but Gertrude's unmarried sister, Flora Quimby, rounded out the family. The sisters belonged to the local Unitarian church, known for its universalist approach to the Indian question.[4] Their early years were marked with tragedy, however, and this difficult childhood sometimes made Gertrude a harsh mother hen.[5]

Angel wrote to Folsom again in January. Money for her expenses had not arrived. Though she insisted Folsom "not be bothered," she admitted, "I was almost smitten down with shame whenever I met my music teacher and others." She found Burnham's preparatory school challenging, and its faculty aloof. "I think I prefer Normal School zeros than the kind we have here," she confided, "for they are too cold."[6] She mentioned recent visits from Hampton staff, including Isabel Eustis, and hoped Folsom still intended to visit her in the spring. Ever sensitive to language nuances, Angel's expression reflected her new environment, and probably Miss Burnham's reading list: "'Tis sweet to be remembered," she emphasized, as she signed her name "Angel de Paradise" this time.

One month later Angel wrote Folsom expressing her desire to leave school.[7] She wanted to enroll in the Northfield Seminary for Young Ladies with Addie Stevens. The boarding school's progressive mission was to provide "education to those who had been systematically denied it," including those denied because of race.[8] Gertrude Clapp supported the change, accounting for Angel's more assertive attitude. "I will be only too glad to go wherever it is possible for Addie and I to be together," she informed Folsom, "but I don't think Burnham School was meant for us." She justified her utter discouragement, explaining, "It is so hard to get along in some ways—Besides we get many of the studies at Hampton that they have excepting the languages, and algebra, etc., unless if you mean to have Ad. take a college course, she will need them." Although Angel assured her that Burnham was " a very fine school," she agreed with Gertrude's opinion, "it is very aristocratic." "I knew it the first day," she said.

Her interest in studying music seems to have declined. "As for me, Mrs. Clapp thinks I ought to make art a special study with 'literature to be up to the times' & I would like to go to Northfield if they teach art." The letter that first mentions her desire to study art is also the first signed "Angel de Cora," the form her name would take when she became a professional artist. Although Miss Burnham's offended Angel's humble sensibility, she nevertheless adopted some of the Francophile affectations of her Gay Nineties, aristocratic schoolmates. "This is the way the French scholars write my name & make me blush (fortunately) unseen," Angel added in a postscript.[9]

That summer the Springfield Ladies Indian Association, otherwise known as the "Indian Reservation of Springfield," treated Angel to drawing lessons.[10] Isabel Eustis, who made the arrangements, assured Folsom it was "an unusual opportunity" for Angel and worth the money.[11] Someone thwarted Angel's plan to go to school in the fall with

her Winnebago friend, though she managed to escape from the uppity preparatory school. Addie enrolled in the Westfield Normal School, but Angel entered the School of Art at nearby Smith College for women. The institution promised an education equal to men's, but vowed to "preserve and perfect every characteristic of a complete womanhood."[12]

As a School of Art student, Angel did not have to take regular courses or entrance exams, but would not receive a degree either. To study art exclusively, she, with Gertrude's support, proved to the principal and faculty she could do the work required.[13] Instead of a regular scholarship, Angel received a custodial job for the school's Hillyer Art Gallery (which boasted a $50,000 endowment) in exchange for the $100 annual tuition. Art materials and taking regular college classes constituted additional expense. On-campus boarding was $250 annually, but less if she lived off campus.[14] Folsom, Eustis, and Josephine E. Richards of Hampton estimated Angel would need an additional $450 per year. This was a large amount of money for the time, but Hampton's dedicated Indian reformers focused on their cause with missionary zeal. They worked madly behind the scenes insuring the education of their Indian pets, Angel and Addie, was funded.

Clapp found a nice boarding house for Angel, just up from Paradise Road and down the street from the college campus. "I had hoped Mrs. Clapp would herself keep Angel at least as a boarder during the first part of the term," Eustis wrote Folsom, "and that we might eventually find a place for her in some other Northampton home, partly for sweet charity's sake. But Mrs. Clapp has doubtless written you that she is not well and that she feels she cannot longer take any responsibility whatever for the child, and this seems to be the best thing that offers now."[15] Once Clapp made arrangements, she informed Folsom, "I feel now as though I must have a rest on the Indian question." Her veiled sarcasm may reflect the ill health she suffered. Still, her conversation with Eustis discloses that the twenty-three-year-old "child" suffered, knowingly or not, the condescension of her caretakers, as if she was solely a philanthropic project Gertrude had grown tired of.

Gertrude went away that summer to recover, and returned home by early September. She still felt ill, though, and planned to go away again the following winter. She advised Richards, "Angel is old enough to keep her own accounts & learn to transact business." She thought it best to let Angel handle the money for her board.[16] "I imagine from Mrs. Clapp's letters," said Eustis to Folsom, "that you want to take Angel entirely under your own wing next year. You must let us know if you need again the aid of the Springfield ladies—or if I can do anything to help you in

regard to the child."[17] It appears Folsom contributed at least some of her own money to support Angel.

Maria and her husband, Alfred G. Carley, a local stationer, ran the Queen Ann–style boarding house at 240 Elm Street where Angel would stay. Maria informed Eustis she had rented out rooms to five other Smith girls for the fall, and "wondered how the little Indian girl would get on with my other young ladies."[18] She tactfully suggested it might "be better" to board Angel "in a more private family where her feelings would be less likely to be hurt in any way." "However, that is not for me to decide," she acknowledged, "and if she comes here, I will make it as pleasant for her as *I* can but cannot be responsible for the others." Richards thought the place was perfect for Angel. Gertrude had approved it, it was close to her house and the campus, it offered socialization with Smith "young ladies" (many who were certainly younger than the "little Indian girl"), and Maria seemed "anxious that her girls should find it a home." "Angel is very happy about it," Richards assured Folsom.[19]

Folsom assumed responsibility for managing Angel's expenses during the school year. Eustis, like Gertrude, felt "Angel is quite able and will be glad to take care of herself during the summer months—if she keeps well."[20] On September 15 Angel settled seemingly peacefully into the boarding house, started art courses, as well as her job at the gallery, and arranged accommodations for a visit from Folsom, which she had been looking forward to all summer.[21] A month later she wrote Folsom about her busy college life, but asked that her letters be kept private, which meant, specifically, she did not want them printed in the *Southern Workman*.[22] She said she went to church and Sunday school, accompanied by Gertrude's old guardian, Stephen Barker, a former Congregational minister. She visited the Clapp household daily, shared meals, and did the dishes. She found it difficult to balance her finances, but in spite of her anxieties, she tried to have fun. After a classmate invited her to a social event, she told Folsom, "I am 'awfully' bashful, but it was so nice of her I accepted her invitation." She also mentioned a mysterious scandal at Hampton, and acknowledged that she understood the importance of maintaining Hampton's good reputation. Although she felt sorry for the "unfortunate girls," she felt "worse for Hampton's record." Sex or alcohol may have been involved in the scandal.

For the first time she mentioned Dwight William Tryon, who, she said, just received "another prize for a painting in Berlin." Tryon, an important American painter, directed the School of Art. "Since I began my work in the Art school, I have been getting very mild criticisms from Prof. Tryon till last week," she confided, "it was rather severe but it had

its intended effect on me for I've a double 'termination in my heart' to do better work."[23]

Tryon's criticisms were tempered with a patient manner and a love of humble, working people, like Angel. She responded well to her new teacher, who was a short man "with the keen, far-sighted eyes of the seafarer, lighted with the whimsical twinkle of the great of heart," as one student described him. "There is no one way to paint," Tryon impressed upon Angel, "if there had been it would have been patented long ago. Each must find for himself his own expression."[24] Tryon insisted she reach for her potential. His enthusiasm was contagious, as he guided students through obstacles, while holding them to "standards of sincerity and truth." He also noticed "temperamental differences in his pupils and adapted his instruction to the peculiarities of each."[25] He must have applied this skill expertly to Angel, because she took his criticisms and compliments to heart.

Tryon's art courses emphasized "good draftsmanship" and "clearness and beauty of line."[26] First and foremost he taught Angel to compose and draw accurately before she laid down paint. Tryon awakened her artistic sensibility, and introduced her to the ideals of the aesthetic movement, known for its motto, "art for art's sake."[27] Art's goal was meditative, and its purpose to uplift, she learned. Realism, symbolism, or narrative content could not achieve this effect. Instead, the artist should express an intuitive truth underlying reality in the *form*, rather than in the *substance* of the artwork. Angel discovered that art should be a transcendental experience for the viewer. Thus, the best artists (as creators of Beauty with a capital "B") were prophetic.[28]

Some called Tryon a "quietist," because he preferred to paint "quiet corners of the world."[29] He favored tonalism, a style of the aesthetic movement distinct from impressionism.[30] As one art critic explained, "Tonalism was fundamentally a landscape art, subdued, profound, and spiritual. Impressionism also concentrated on landscape, but incorporated more cosmopolitan and narrative subject matter."[31] Tonalists rarely used people as subjects, but if they did paint figures, they rendered them as objects frozen in time, rapt in thought, with eyes that stared into space, as Angel later depicted Gray Wolf's daughter. While impressionists used "bright chromaticism" to capture precisely each bit of light reflected upon a surface, the tonalists created a blurred or veiled effect, the muted, the misty, and the at-dawn or at-dusk scenes illuminated by moonlight, otherwise known as the "nocturne."

Angel began practicing tonalism under Tryon's watchful eye. She eventually painted nocturnes illuminated by fire and smoke.[32] Like

tonalist painters, she created a dreamlike feeling in the viewer. Like them, too, she imbued her subjects with a sense of nostalgia, isolation, or even loss and exile. Tonalists attempted to represent an intense but transient or fleeting moment in time, "showing life as a drama or dance."[33] Angel created this effect quite figuratively in the dance scene she painted for "Gray Wolf's Daughter." As Angel began to adopt tonalism, she discovered a means to express her nostalgia for home and her American Indian identity.

Just before the Thanksgiving holiday, Angel wrote Folsom with good news. "Mr. Tryon still says encouraging things on my drawing." Tryon's compliments elevated Angel's spirit, but the demands on her time made her fall behind in her course reading. With pointed irony, she impishly asked Folsom: "Do you think it is too much for an Injun to read Darwin?"[34] Studying theories adopted by her contemporaries to support the inferiority of her race called for a highly developed sense of humor.

Angel learned to balance her accounts. Her expenses included books, medicine, clothing, sundry items, a mackintosh, fees for the wash woman, stamps for letters, drawer rent for art school, and photographs of herself (which Folsom disliked). "I am so surprised to think you don't quite like my picture," responded Angel, "for I thought it flattered me 'right smart' I think you must idealize your mental picture of me too much. Most everyone thought it looked just like me." "Can it be that I am growing *old* and ugly," she kidded.[35] In her early twenties now, Angel adopted her era's beauty and youth obsession for women, but how much her caretakers shared this problem is unclear. Like Angel, Gertrude also lied about her age. However, reformer and colonialist alike tended to view their subjects as childlike to justify conquest.[36]

Angel spent Thanksgiving with the Clapps and "had a beautiful time all day."[37] Gertrude invited her to spend a second night, but she "was afraid the Carleys might disown" her. When Angel returned to the boarding house after Thanksgiving, Mrs. Carley welcomed her with "Better late than never" and "Would you like something to eat." Angel didn't seem to take offense. That weekend a college friend invited her to hike up nearby Mt. Tom with some other girls. The weather was cold, but Angel enjoyed the outing, telling Folsom, "we all felt like turkeys in the oven when we reached the top."[38]

Near Christmastime Folsom sent Angel a copy of *The Scarlet Letter*. Angel received "Mrs. Brownings works," *Ramona*, and *Snow-Bound* from other friends. While most Smith girls went home to families during the holidays, Angel shared Christmas with the Clapps. She spent a fun Sunday with Addie Stevens, too, who, as she informed Folsom, was

"getting along fine." Eustis came for a visit and brought Angel twenty dollars from "a lady recently married" who "wanted to share her happiness with some one else." This act of charity was not without a price. "Miss Eustis wants me to go the Indian association meeting in Springfield some time this month, and as I don't know what I am to do I am trembling," confided Angel to Folsom. "I *cannot* do anything before so many people." "Last year I took some of my drawings so entertained them for a few minutes," she said, "but this year my work is so much simpler that I don't think they'll be interested in them."[39]

Health problems aggravated Angel's social anxiety. After she had some wisdom teeth pulled, Gertrude sent her to a progressive, woman doctor, who began treating her for "the catarrh," a bacterial infection of the nasal and throat passages. The doctor prescribed the use of an atomizer indefinitely. Gertrude grew more concerned about Angel's symptoms, than the illness. "I think I ought to have a little talk with you about Angel," she wrote Folsom. "Not but what she is getting along finally in her art; and doing as well as we expected. She is making friends every day and shows a marked improvement in manners and conversation. What concerns me now more than anything else is the catarrh."[40] Clapp worried if Angel did not keep up with her treatment, her social life would be ruined. "Her breath is so foul now that you notice it the moment she enters a room," she brusquely alerted Folsom. "I know you will understand my feeling, and do something," she added. "I have said all I dare to. I'm afraid of hurting her feelings by saying too much."

Angel survived the bout of catarrh, but bronchial trouble remained a chronic condition throughout her life, surely aggravated by eastern humidity and pollution. How she survived social ostracism, and Gertrude's fear of it, is unknown. In the spring of 1893 Angel's thoughts, instead, were with Hampton. She sent another portrait of Armstrong that Folsom proudly hung in her office. This time Angel intended to commemorate more than her special place in the Indian department. Armstrong was terminally ill. He died on May 11, 1893, at fifty-four years of age.

Shortly after his death, Folsom shipped Angel's picture to the World's Columbian Exposition in Chicago. The portrait, hung in the Indian exhibition, demonstrated that civilization offered salvation to the vanishing race. It also represented what a Hampton education could do and received "warm encomiums."[41] The Indian exhibition embraced the "progress of human evolution," complimenting the fair's theme to honor the conquest of America by Columbus. Still the progressive presentation focused more on savagery than civilization, just like the fair.

Buffalo Bill's Wild West show played near the fair's main entrance, ensuring two million fairgoers a skewed vision of American Indians and American history.[42]

Frederick Putnam of Harvard's Peabody Museum had charge of the ethnological exhibit. He appointed the up-and-coming anthropologist Franz Boas to assist him. Alice Fletcher had hopes that Putnam would choose her, but she was instead relegated to the Women's exhibition.[43] She was not the only one unhappy with Putnam's choices or the exhibition's demeaning evolutionist tone. One of Putnam's staff, Emma Sickles, sent a scathing letter to the *New York Times* criticizing organizers for keeping "self-civilized Indians out of the fair." She attacked "ethnological exhibits for portraying Native Americans as savages whose animal nature only government agencies could tame."[44] She further proclaimed: "Indian agents and their backers" well knew equal representation meant "the public would wake up to the capabilities of the Indians for self-government and realize that all they needed was to be left alone."

Meanwhile, Angel, still dependent on the good will of her alma mater (or just Folsom), went to the Berkshires on an outing. She stayed in Curtisville with Mrs. Dresser, who allegedly provided outing students "a relaxing summer vacation."[45] When not reposing, Angel earned a little money for her fall expenses. Sometime by late summer, she visited with Folsom, who hosted Carlisle's beloved student Chauncey Yellow Robe. Yellow Robe duly noted "the new element in the household" from Smith College. "An Angel has come to live with us in Miss Folsom's family," he wrote to Carlisle's school paper.[46] He also participated in the Indian exhibition in Chicago, and his account to his fellow students included his observance of Pratt's silent rejection of it. Pratt obviously shared Sickles's opinion.

§

When Angel returned to Smith in the fall, eleven students joined her in the School of Art. She also resumed her duties as custodian of the Hillyer Gallery. Besides Tryon, who taught drawing, painting, and composition, her teachers were Mary Williams (drawing and painting), Mary Damon (anatomy), and Frederick Honey (perspective). Angel spent her entire first year learning anatomy and to draw from casts, but this year she would attempt life drawing and still-life painting.[47]

Back home her sister, Louisa Sampson, gave birth to her first niece, Madelyn, while in Northampton Gertrude delivered a new "little sister" (whether by birth or by adoption is unknown). A first child at thirty-eight indicates Gertrude suffered miscarriages, but her health problems seem to have subsided with the arrival of her daughter, Louisa Whiting

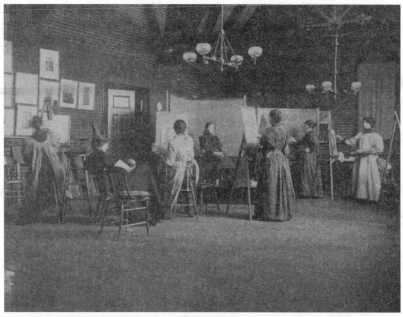

Art class in the Life Room, Hillyer Hall, drawing from a live model, Smith College, 1896. Angel De Cora in white smock left of model.
(SMITH COLLEGE ARCHIVES, SMITH COLLEGE)

Clapp. Angel moved back to 65 Paradise Road and helped Gertrude with the baby.

At school Angel learned from Tryon that drawing was "the probity of art."[48] By the end of the academic year, his rigorous drawing lessons paid off. The School of Art awarded her one of its two annual $25 prizes. The *Boston Journal* sang the praises of "the young lady of Indian parentage" who was finishing her second year at Smith. The *Journal* devoted a lengthy article to her accomplishments. "To have won the undergraduate prize simply from excellence in cast drawing in charcoal is a distinct departure from the custom observed at the college," the reporter wrote, "and, in consequence, Miss DeCora [as her name was sometimes rendered] is receiving many encomiums for her marked ability."[49] The article marks Angel's growing discomfort with publicity, however. Although she dutifully told the reporter about her educational background, starting with Hampton Institute, she "expressed a disinclination to have anything published regarding either her life or her work."

The reporter, whose visit interrupted Angel at the piano, noted she "was as proficient in music as she was in art." But like most reporters who would follow him, he focused undue attention on Angel's "very

dark skin" and "features" that were "unmistakably those of the Indian race." Except for the popular notion that Indians were stoic (and not simply annoyed by rudeness), the reporter wrote a fairly accurate portrayal of Angel's demeanor. "Not the least entertaining of her characteristics is modesty, which was manifested in repeated declarations that her work was undeserving of special mention and that the other prize winners did much better work," he wrote. "She said she has had every advantage enjoyed by other students, and says that as yet she has only begun her studies of art. The brevity of her responses is indicative of the stoical race to which her marked talent does honor."[50]

Hampton's Indian department couldn't have been more pleased with "Smith College's Indian Girl," as the *Southern Workman* titled its feature article. The press was a special coup for the national reputation of Hampton's Indian department, especially when the reporter conveyed Angel's gratitude: "I am glad . . . for the sake of those who have shown faith in me. It is all very encouraging and I shall work still harder another year." The *Southern Workman* complimented Angel on the "success" that was "of her own making," with the qualifying statement that she "quietly and industriously . . . followed the advice of her teachers and friends." Yet her own efforts were also recognized: She worked for her tuition and had "gone out every summer to work on a farm rather than allow her friends to do more than is necessary for her." The writer, probably Folsom, boasted that Angel hoped eventually "to be entirely self-supporting," and, of course, "to use her talents for the good of her race in some way."[51]

The *Southern Workman* also published excerpts from Angel's recent letter to Folsom, even though she asked Folsom to keep her letters private. "I didn't mean to have the papers get ahead of me—I wanted to tell the news all myself, but as usual I am a little behind hand." Angel's letter made light of her success: "Two days after winning the prize, I had to take diligently to the art of dishwashing," she quipped. Angel also clothed her social anxiety with humor: "When the reporter asked for my photograph, I refused that for fear it would mar the good story he might write about me." Hampton's publication noted the *Journal*'s point that Angel took pride in being an alumnus of the "negroe and Indian school." On the other hand, Angel hoped the public's curiosity and the attention she received from her alma mater would soon subside.

That summer Angel worked in "a pleasant home" in Newton, Massachusetts. Eight other Hampton girls joined her on the outing, including, her sister, Julia, who, thanks to Folsom's intervention, enrolled in Hampton's Indian department in the fall of 1891.[52] When Angel returned

to Smith in the fall, she confessed to Folsom that she missed "the Indian girls so much." Angel remarked, "I appreciate their gentle manners more than I ever did before." The girls "were an unusually quiet set," she observed, "and possessed no end of patience. I wish I were going back to Hampton this fall."[53] Angel's affinity for "the Indian girls" signifies the pan-Indian identity off-reservation boarding schools encouraged.[54] It also reveals how alienated she felt at Smith.

Angel gave art lessons and worked again for Hillyer Gallery in the fall of 1894. Landscape sketching and modeling in clay were added to her course of study.[55] With last term's accomplishments publicized, however, came dreaded obligations. Albert K. Smiley invited her to speak at the most influential Indian reform gathering of the day, the Lake Mohonk Conference of Friends of the Indian.[56] Smiley, a Quaker philanthropist, invited prominent Indian reformers to his beautiful resort on Lake Mohonk in New York every fall "for several days of discussion and debate."[57]

Among Angel's prestigious colleagues were Pratt and Pratt's champion, Carlos Montezuma (Yavapai physician), Massachusetts Senator Henry L. Dawes, Hollis B. Frissell (Armstrong's successor), Francis E. Leupp (Indian advocate and future Commissioner of Indian Affairs), prominent reformer Lyman Abbott (a former Congregational minister and associate editor of *Harper's* magazine, now editor of the *Outlook*), as well as Episcopal Bishop Henry Benjamin Whipple of Minnesota, advocate for the Dakotas, beginning with the outbreak of 1862.

Angel's former Hampton teacher, writer Elaine Goodale Eastman, also attended the event with her husband, Charles Eastman, a Dakota physician, YMCA leader, and writer. The Eastmans met at Pine Ridge Agency in 1890 and became engaged a few weeks later. Charles served as the agency doctor and Elaine as the school supervisor during the massacre at Wounded Knee. They attended the wounded and Charles witnessed the carnage of so many women and children strewn across the frozen battleground. Elaine interviewed survivors and alerted Indian Commissioner Morgan about the military debacle.[58] The couple became Angel's lifelong friends.

Angel's fear of public speaking paralyzed her. And to make matters worse, her accomplishments represented the fruits of Indian education to her reformer audience. Introduced as "an art student from Smith College," she opened her presentation expressing gratitude "for the kind resolutions that you have passed here with reference to my people."[59] She recounted her disappointing experience at the reservation school that had no drawing course. Oddly, she told her audience she "spent a

good deal of my time there running away," though she would later claim she had only been there a few days. If she stretched the truth, it was to contrast how "very contented" she'd been at Hampton. She described her course of study at Smith: "drawing from antique casts, still-life studies, oil and portrait painting" and, she added, landscape painting was her favorite. "When I get through, I mean to teach wherever I can get a position, either East or West, among Indian or whites." Clearly her goal was not to be a cultural missionary. Instead, it proved Hampton an extraordinary institution for Indian reform.

§

Angel returned to Northampton in the fall of 1895, having survived her growing celebrity. Composition rounded out her last term of study at Smith. Her classmates in the School of Art included nine New Englanders and one young woman from the Midwest.[60] It's doubtful Angel grew close to any of them. Years later, a Smith spokesperson lamented, Angel had "so little opportunity to mingle with her classmates and her retiring nature added to the difficulty of knowing her; and so her unique personality and sweet nature were lost to most of us."[61]

In June of 1896 Angel completed her course work in the School of Art. Although she received no distinction for being Smith's first American Indian, she received recognition as "one of the most proficient in clay modeling," the skill she honed on banks of the Missouri River. The school also presented her with "special mention" in color studies, "specially meritorious work" for cast drawing, and honorable mention for a "nocturne sketch," which the judges pronounced "a beautiful thing."[62] The latter must have been especially fulfilling, given Tryon's great influence. Likewise, her favorite teacher surely beamed as his humble, hardworking student received the recognition she deserved.

Other than the awards she received, Angel's graduation day remains a mystery. If any family member was there to cheer her, it was only Julia. What a marvelous day it would have been for Elizabeth Sampson. Even if she could have garnered resources to travel to Massachusetts, her own mother was probably dying. Two months after Angel said goodbye to her college days, Catherine Amelle Lamere died.[63] With the last of her traditional family gone, and Cora and Gertrude in line to mother her, Angel of Paradise left the Winnebago reservation and its people mostly behind her.

The Brandywine School

After graduation, Angel packed her things and moved to Philadelphia to begin studying illustration at the Drexel Institute of Art, Science, and Industry. Unfortunately, she found "art for art's sake" could not support her financially. Illustration was a booming career choice, however, as a wide selection of popular magazines, newspapers, and storybooks made their way into almost every U.S. household. Reproducing photographs was still expensive, so skilled illustrators were in demand. The dynamic, charismatic, formidable, and renowned Yankee illustrator, Howard Pyle, was going to be her teacher. This was a fantastic opportunity for her! Pyle had already earned recognition as *the* creative force and technical master of American illustration.[1]

Pyle was born in 1853 to Quaker parents. He grew to boyhood during the Civil War years and lived in the country that bordered Wilmington, Delaware. Early on he was exposed to depictions of Civil War battles, as well as colonial history, both outdoors and in the pictures books that filled his home.[2] His father's ancestors had farmed in nearby Chadds Ford, Pennsylvania, an area famed for its Revolutionary War battlefield. Chadds Ford was located near one of several fords crossing the scenic Brandywine River, which also flowed through Wilmington. The river gave its picturesque name to the artists who learned from Pyle. Pyle's Brandywine School of Art includes among its students such prominent illustrators and painters as Frank Schoonover, Maxfield Parrish, Jessie Wilcox Smith, Stanley Arthurs, Violet Oakley, Elizabeth Shippen Green, Sarah Stillwell Weber, and the famous father-son artists Newell C. and Andrew Wyeth—as well as the lesser known Angel De Cora.

Pyle specialized in illustrations of heroic and historic events. He and his students created scenes of dramatic action executed with dynamic and shifting perspectives. They experimented with color, strong lines, and stark contrasts. Influenced by Britain's arts and crafts movement and the Pre-Raphaelites, Pyle also wrote his own stories to illustrate that focused on history or mythology. He encouraged his students to do the

same. The problem Angel would encounter with Pyle was how she fit into this scheme.

Pyle first accepted a teaching position for the 1894–95 academic year with the Drexel Institute, a cutting-edge school developed to meet the needs of the U.S. burgeoning industrial society.[3] Only advanced students could take his class, "Practical Illustration in Black and White."[4] Pyle's class was instantly popular. "When word came to the Students in the Art Department . . . that Howard Pyle had consented to teach the Composition Class the following Winter most of the students were thrilled at the prospect," according to Angel's classmate. "To many of us this favorite author and illustrator seemed as remote as Whistler, someone to be adored from afar."[5]

By the next year when applicants clamored for Pyle's courses, Drexel transformed them into a school of illustration.[6] A friend recommended to Angel to submit her portfolio. In spite of intense competition, the Institute admitted her in September of 1896.[7] Tryon's drawing courses prepared Angel well for this opportunity. Still, she dreamed of landscape painting. According to Folsom, when "the question of 'art for art sake' or 'art for money's sake'" came up, Angel's "desire to be independent as soon as possible decided her in favor of taking up illustration as a means to this end."[8]

When Angel met her blue-eyed, balding teacher with "bland and pleasant" features, he was an imposing figure. Tall with broad shoulders, according to a lifelong employee, he assumed "a very commanding presence."[9] His personal magnetism drew many to him, and students "grew to love the man," but after a time, Angel found her artistic desires incompatible with his.

At the beginning, they seemed like an ideal match. Indian subjects grew popular at the turn of the century. Yet working artists with personal knowledge about the material details of Native life were rare. Angel found Pyle lacking with regard to matters of Indian costuming (something she struggled to represent accurately). Upon borrowing "a complete woman's costume," she later recalled, Pyle "used the leggings for sleeves," and inappropriately adorned the costume with feathers.[10]

Pyle foresaw a promising future for Angel in the special niche of Indian illustration. As soon as she finished his first year courses at Drexel, he urged her to return to the reservation to sketch and paint "her people." Of course, Folsom vetoed the idea, but offered an alternative. She planned to attend two Indian teachers' conferences out West that summer and she could accompany Angel, but not to Nebraska. In June of 1897, after Pyle packed Angel's "box with everything he thought

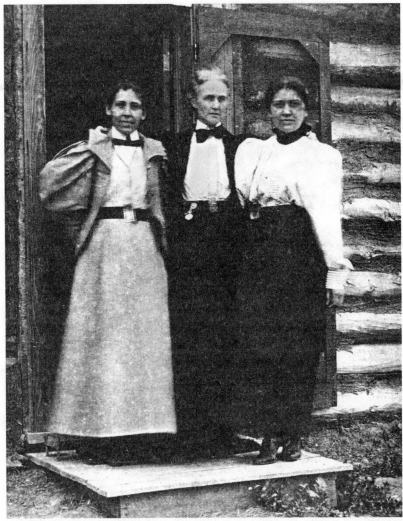

Annie Dawson, Cora Folsom, and Angel De Cora, probably at Fort Berthold, North Dakota, 1897.
(Courtesy of Hampton University Archives)

she could need," the pair set off together, Folsom destined for Omaha, Nebraska, and Salt Lake City, Utah, and Angel to Fort Berthold, North Dakota, where her old school chum, Annie Dawson was field matron.[11]

The Fort Berthold Agency was established in 1870 for the Arikara, Gros Ventre, and Mandan peoples. The agency employed Annie, the daughter of a Euro-American father and Arikara mother.[12] Annie graduated from Hampton with Julia St. Cyr in 1885. After Annie's mother died, Folsom

One of two untitled paintings of heads by Angel de Cora, ca. 1897.
(Courtesy of Hampton University Archives)

doted on her. Unlike Julia St. Cyr, Annie received Hampton's top returned-student rating for assuming the role of cultural missionary.[13]

Angel helped Annie with her work that summer, while "making studies of Indian life for her art work under Howard Pyle."[14] "She went about into the homes of the people and did a great deal of sketching and photographing, as well as several large canvasses," Folsom later explained. "Some of the portraits she made there of the old chiefs are of great value as well as beauty. The Indians watched her skill with interest and pride, and became so fond of her and her bright, witty sayings, that she had no trouble in getting any number of people to pose for her."[15]

Only faded photocopies of the original portraits remain. "Indian head" depicts the profile of a man with an eagle feather headdress and bear claw necklace. A front view of an elderly white-haired man with a

Untitled watercolor of illuminated tepee on prairie by Angel de Cora, date unknown.
(Hampton University Museum, Hampton, Virginia)

kerchief around his neck is named "Painting." However, an oil painting, "Chief Running Deer, Wyoming Territory," signed "A. de C." (a signature Angel often used for her paintings) mysteriously appeared at auction in Philadelphia in 1994.[16] Like the majority of her artwork, Angel probably gave the painting away.

Photocopies of the profile of two Native women titled "Two heads" and a "Lodge at Fort Berthold" also document her days at Fort Berthold. A proof sheet of photographs also shows a tepee, girls in both Native and Euro-American dress, women in scarves, a man on a horse, and a boy in a school uniform, apparently used for a study in one of her paintings, one of the few that survives today.[17] Hampton Museum still holds an untitled watercolor that appears to have been painted at this time. In tonalist style, it depicts a prairie landscape at dusk, adorned by a teepee. A fire inside illuminates its occupants. Scaffolding near the teepee's entrance and an empty wagon complete the composition. An oil painting she created later, called *Fire Light*, is modeled on this scene.

That summer Angel honed her hunting skills—as well as her sense of humor. "She became an expert as a hunter of gophers," even collecting "a handsome array of gopher tails" to give to a friend when she returned from the West, reported the *Southern Workman*. Angel's presence at Fort Berthold caused a stir among more than the gophers, however. North Dakota's *Washburn Leader* happily discovered "Catlin's Successor in Indian Portrait Painting" in its midst.[18] The newspaper reporter (who

was not consistent in the spelling of his subject's name) "visited the studio of Miss Angel De Cora at the home of her friend and schoolmate." He complimented her, claiming, "the wild Indians have always had an aptitude for hieroglyphic or primitive drawing, comparatively few of the educated ones have excelled in the fine arts. Miss DeCora is one of these exceptions and today stands at the head of her race as a portrait painter."

He also mentioned that Angel was "illustrating Indian character in some of Longfellow's poems for an eastern publishing house," though this publication, if it ever existed, has not been discovered. Among other artwork, the reporter stated, Angel painted "a life-size face portrait of venerable old Bull Head, a full length portrait of Standing Bear, Aricarree chief, and some excellent landscape work." The journalist found it "poetically fitting that the successor of Catlin, the great portrayer on canvas of the wild Indian, should have as his successor one of the descendents of those he had immortalized." Catlin had indeed painted White War Eagle Decorah's family on the Wisconsin River in the early 1830s. The painting hung at the Catlin Gallery in the National Museum in Washington, D.C. *Du-cor-re-a, Chief of the Tribe, and His Family* includes Angel's grandfather, Little Decora.[19]

Angel returned to Hampton from the West in mid-November and decided to stay for a few weeks. She took the opportunity to sketch some of the Indian students, as well as to finish up artwork from her trip. The publicity of her Fort Berthold venture did not go unnoticed. On the first of December she met with Otis T. Mason, the curator of Smithsonian's National Museum, who wanted her do a project for the Catlin Gallery. Following their meeting, he wrote to Pyle seeking a recommendation. He told Pyle he had interviewed Angel "with reference to the subject of painting portraits of Indians who have become associated in some way with the Government, or have been noted in the public print." Mason hoped Angel would provide "portraits, lay figures, and objects" documenting "the life and history of those tribes east of the Rocky Mountains." He felt it "eminently proper that a young Indian woman should be the means of perpetuating the faces of some of the noblest of her race."[20] Pyle's response has been lost, but the *Philadelphia Inquirer* reported that Angel declined Mason's offer on "the advice of Mr. Pyle, who hopes still further to develop her natural ability as an artist."[21]

The *Inquirer* described the now twenty-nine-year-old Angel as "a young Indian girl." The portrayal of attractive American Indian women as Indian maidens burgeoned at the turn of the century, and Angel did little to correct the stereotype. She feared growing older and lied about

her age, like many of her Euro-American sisters. Not unlike the deroga-
tory term "squaw," however, the Indian maiden icon granted sexual
favors to white men. Although she was prettily wrapped in romantic
Indian costume and wore long, black braids, she was steeped in the erot-
ica of imperialist nostalgia and a desire for the primitive.[22]

Angel's Indian identity brought attention to her talent and her work,
which, from her summer at Fort Berthold, "met with the most unani-
mous commendation." The *Inquirer* reported that she took "Mr. Pyle's
costume and illustration classes," where "she progressed very rapidly,
making drawings and compositions of a peculiar strength and direct-
ness." "She is at present at work upon some illustrations for a story of
her own," noted the *Inquirer*, "shortly to be published in one of the lead-
ing American periodicals."[23]

Pyle introduced publishers to his "more proficient students." This
gave illustrators-in training a great opportunity to enter the profes-
sion.[24] As one of Angel's classmates noted, he "launched a goodly num-
ber of talented illustrators, who otherwise might have been years trying
to get a start."[25] Folsom confirmed that Pyle kept Angel to her "original
plan" and "introduced her to his own publishers, the Harpers."[26] But
Pyle did not just promote Angel as an illustrator; he also encouraged her
to write "stories of her own."

During the last week of May in 1898, Pyle's School of Illustration at the
Drexel Institute gave its second, end-of-the-year exhibition. Eighty-
eight students, including Stillwell, Arthurs, Oakley, and Schoonover,
entered their artwork, which was divided into five categories. Four of the
categories were based on Pyle's courses (composition, facial construc-
tion and imaginative drawing of the figure, study of the costumed
model, and illustration), while the fifth category consisted of works
"made and accepted for actual publication." The fifth division show-
cased Angel's work, including *Sick Child*. Art critic George S. Goodwin
attended a private showing of the exhibit, declaring he "saw everywhere
signs of maturity, improved technique, tone, grasp of detail, an enlarged
horizon," and "artistic finish." He closed his newspaper review of the
event with "high praise" for "the embryo talent of the Indian girl, Miss
Angel De Cora." *Sick Child* "was much admired last night by . . . art con-
noisseurs," he exclaimed, adding, he was "glad to note" that *Harper's*
magazine had accepted the painting "to be used as a full-page drawing"
for a "short written sketch."[27]

As Pyle's classes grew in demand, he grew impatient with less talented
and unmotivated students, particularly ladies who knitted while he lec-
tured.[28] With Drexel's support, he began a summer school for the more

talented. The school's board of trustees established ten scholarships for the summer of 1898, "open to competition." Winners received tuition and room and board for the ten-week session.[29] Pyle felt very excited to nurture the "creative sparks in a handful of the truly gifted."[30]

The session began on June 23 and ended the first week of September. Pyle acted as school director, gave free instruction, provided a studio, and supplied models. For his family and himself, he rented a large old house, located at Chadds Ford. Next door, two historic farmhouses served as student dorms. The house General George Washington occupied during the Battle of Brandywine provided the men a home, while women lived in Lafayette's headquarters. An old stone mill served as their art studio.[31]

Angel received good news. She won a coveted scholarship to Pyle's summer course. "Ellen Thompson, Sarah S. Stilwell, Anna W. Betts, and Angel deCora (an American Indian) were the girls of that summer," according to a Drexel classmate who gave up her spot to visit Europe for the summer. All three of Angel's roommates became well-known illustrators.[32] That summer the less celebrated Winnebago woman produced the following works: *Across the Hills,* "Sketch of Lafayette Headquarters," and two illustrations, the head-band and tail piece for *Sick Child,* which were exhibited at Drexel to showcase Pyle's summer school in October 1898.[33] Unfortunately, these pieces have been lost (except in published form), but an oil painting titled *Lafayette's Headquarters,* signed by "Angel de Cora," surfaced from a private collection in recent years. Angel probably gave the landscape painting of the women's quarters to Frank Schoonover, who kept it for four decades until he gifted it to the Wilmington Society of Fine Arts in 1941.[34]

Lafayette's Headquarters is significant because it is the only example of Angel's artwork (except for a couple of Christmas cards) that does not portray Indian subjects. It shows a fine art influence; the play of light on the house and garden are impressionistic. Pyle studied the impressionists, so this is not surprising. But Pyle only accepted a modified impressionism. He disliked when the depiction of light "obliterated solid form."[35] *Lafayette's Headquarters* exemplifies an important element of Angel's summer school experience. The house has historical significance, and it shows she undertook the task of meeting Pyle's expectation to achieve a balance between European impressionism and rendering strong form in outdoor light.

Historically, the studio skylight provided the only light for artists. In contrast, as *Lafayette's Headquarters* demonstrates, Chadds Ford offered "opportunities to paint under the sky" so students could hone their

Lafayette's Headquarters by Angel de Cora, oil, summer 1898, photograph by John R. Schoonover.
(COURTESY LYNCH FAMILY COLLECTION)

skills in plein air painting.[36] Most of Pyle's students remembered the summer of 1898 as an exhilarating time. "Look on this, study it, absorb it," Pyle challenged. "Never again will it be the same. If you see it tomorrow, the light will be different and you will be different."[37]

Life at Chadds Ford was not limited to art study. Play balanced work.[38] Angel could picnic, swim, bicycle, play baseball or charades, and go to church on Sundays. Since she played piano, she could also join in the musical gatherings at Pyle's house, which included a "farmer's supper" served at a big table with Pyle's wife and his lively children.[39]

Although Angel left little record of her days at Chadds Ford, one student remembered her well.

One pupil at Chadds Ford Art School was an Indian girl, named Angel de Cora—a graduate of Smith College, and a protégé of a wealthy Boston Woman. Her appearance was of the typical Indian type—olive skin, straight black hair, high cheek bones and short, stocky figure. She was a genial young woman, ambitious to succeed, but seemingly unable to get away from her native Reservation western life. For example, Mr. Pyle

would give the class a subject idea—say, "Springtime in the Country." The Indian girl's composition would show a hillside cottage embowered in roses and vines; but far in the distance would always be the wide spaces and open prairies of her native haunts.[40]

Nothing remains to corroborate this odd account of Angel's tendency to paint her native haunts in the background of more conventional compositions. But evidence suggests it might have been Angel's response to Pyle's authority, both artistic and personal. Later a colleague claimed Angel disliked how Pyle's students "copied their master."[41] She also said Angel told Pyle, "I am Indian and don't want to draw just like a white man."[42] Most of Pyle's students were drawn to colonial subjects or would "stray away on their own bent," toward "mystical or imaginary ideas."[43] Were these attractions what separated Angel from her peers? How could she prefer colonial subjects, which put American Indians in relief or often cast them as savages? Moreover the "mystical or imaginary ideas" of the Pre-Raphaelite movement, such as Arthurian legends that romanticized an ancient, medieval, and mythical *European* past, existed in a cultural imaginary she didn't share.

Tryon had instructed Angel to sound the depths of her experience to develop her own style.[44] Similarly, Pyle espoused a theory of "mental projection," and urged students to "paint as you felt" and to "throw yourself into the picture" without thought of "ideas of technique, classical rendition or art school technique."[45] Angel noticed, however, that Pyle's students often projected *his* repertoire of mental images into *their* paintings. Her "mental projections," on the other hand, proved she was an outsider. Pyle's famous summer classes lasted for five more seasons, but Angel decided to move on after the first year.

Angel trained as a modern painter and, for the most part, painted "like a white man." She did not make pictographs; she painted in a Euro-American tradition. The trick was to infuse the medium with her unique vision, as an American Indian woman. Tryon's stress on good drawing helped Angel meet Pyle's expectations, but his lessons stressing "art for art's sake" meant Pyle failed to meet hers. Just as Pyle rejected the blurring of boundaries in impressionism, he surely rejected those inherent to tonalism. Likewise, Angel didn't favor Pyle's realism, regardless of the subject.

The same colleague, who remembered Angel's response to Pyle, relayed Pyle's alleged judgment of Angel: "unfortunately she was a woman and still more unfortunately an American Indian. She was so retiring that she always kept in the background of my classes. When I tried to rouse her ambition by telling her how famous she might

become, she answered: 'We Indian women are taught that modesty is a woman's chief virtue.'"[46] Pyle's comments, though hearsay, strike at the heart of Angel's personality, but not at her talent or style. He effusively complimented her, telling Folsom, "I now feel that Miss de Cora has not only talent but genius. Out of a thousand pupils ten have genius; she's one of the ten. Of the six compositions she has sent in, every one, if properly painted, with good color and the feeling she shows would make her at once famous. If they were sent to Paris she would at once become notable."[47] Angel, however, was not one to seek fame.

Frank Schoonover, known for his illustrations of Canadian Indian life, photographed Angel at the Wilmington studios of Pyle and his sister, Katherine Pyle. His pictures depict a woman who appears content, not a mood Angel usually projected on film. One photograph shows her sitting in a chair painting at an easel with the caption, "Howard Pyle's studio—1897 or 98?" and another shows her reading in an ornate high-backed chair with the caption, "Katherine Pyle's studio, 97 or 98." The last photograph, however, is the most interesting of the group, because it suggests that Angel's relationship with Pyle was not always a contentious one. Angel (with hat and coat) wears a smile that lights up her face as Howard Pyle pretends to run away from her as they make their way up the walk to Pyle's studio on Franklin Street, Wilminton.[48] The Indian girl and her white master seem to be having fun.

An assertive, sexist and racist or racialist man of his time, Pyle met head on with an introverted, sometimes passive aggressive, Midwestern American Indian woman.[49] Pyle was not the first, or the last, to offend Angel by disrespecting her cultural values. Her shyness, her quiet bearing, her modesty, and her emphasis on generosity over ambition more than once distinguished her as "unfortunately, an Indian woman" throughout her life.

However, Angel was strongly committed to a particular style of art expression; she was not a victim of Pyle's sexism or racism. The story of Pyle's reaction to the "Indian woman" he tried to make famous disguises a more substantial conflict. Their essential difference was an *artistic* one, animated by their conflicting styles and philosophies about art. Pyle urged his students to create realistic portrayals (albeit of sometimes fanciful subject matter) with sharp lines and historical details. Angel preferred "art for art's sake" with its denouncement of realism and emphasis on the artist's feelings and vision. Moreover, Angel's rejection of Pyle's instruction represents a classic case of the gifted art apprentice individuating from her master.

In February 1899, *Harper's Monthly* magazine published Angel's "The Sick Child," an autobiographical story with illustrations. The publisher

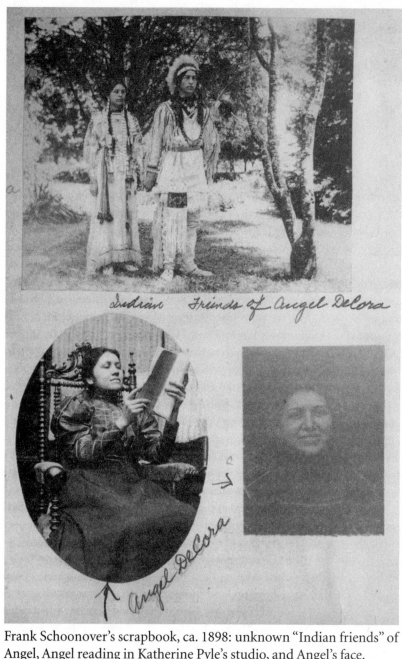

Frank Schoonover's scrapbook, ca. 1898: unknown "Indian friends" of Angel, Angel reading in Katherine Pyle's studio, and Angel's face.
(Courtesy of Delaware Art Museum)

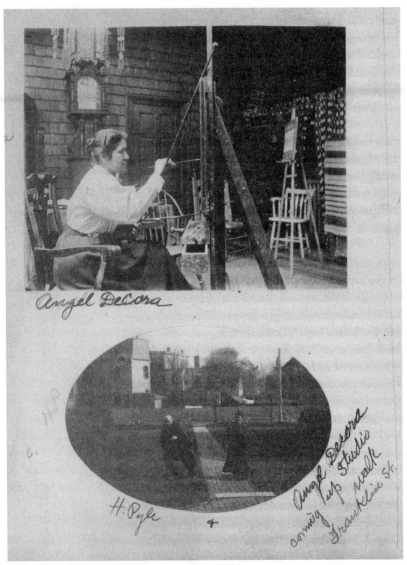

Frank Schoonover's Scrapbook, ca. 1898: Angel painting in Howard Pyle's studio, and Howard Pyle and Angel walking along the path to Franklin Street studios, Wilmington, Delaware.
(COURTESY OF DELAWARE ART MUSEUM)

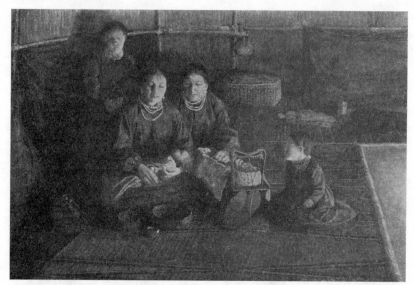

Sick Child from "The Sick Child," *Harper's New Monthly*, February 1899.

added Angel's Indian name to her new pen name, "Angel de Cora," to lend the story authenticity. Folsom called it "a personal reminiscence" and "a prose poem," and declared, justifiably so, that it "opened the way for more of its kind."[50] In November of the same year, due to Pyle's influence, *Harper's* featured "Gray Wolf's Daughter."[51] *Harper's* marketed the story-pair as "naïve tales of the North American Indian" that "assume inherent value and importance from the fact that the author is herself a native Indian girl."[52] Angel claimed she did "not regard her literary work seriously," but it is of value for not only "open[ing] the way for more of its kind," but for joining the chorus of marginalized voices that today enrich America's literary canon.[53]

Angel left Pyle's fold to open a studio with an unknown friend in Philadelphia on 1710 Chestnut Street. She stayed about a year between 1898 and 1899.[54] The well-known U.S. portrait artists, Cecelia Beaux and Alice Barber Stephens, became her friends.[55] Since the 1880s Beaux occupied at least three studios on Chestnut Street, including 1710.[56] Angel continued a friendship with Stephens for some years, but whether she and Beaux extended their friendship is unknown.[57] Many of Angel's Brandywine peers went on to become famous illustrators, but life had other opportunities in store for the "genial Indian young woman" who was, whether Pyle realized it or not, "ambitious to succeed."

A Very Promising Career

Angel's career began to blossom. She exhibited her work at Omaha's Trans-Mississippi and International Exhibition during the summer of 1898. Initially the fair's organizers hoped to highlight the resources of the West. Omaha, a city still suffering the effects of the depression of 1893, was ideally situated and sorely need the economic boost. But the backdrop of the Spanish American War changed the country's mood. "From the moment it opened in June, the fair provided ideological scaffolding for mass support for the government's imperial policies," states one historian. "Through a massive gathering of Indians into an ethnologically validated Indian Congress, promoters explained past and future national and international expansion as the natural outcome of America's westward expansion and Anglo-Saxon racial development."[1] Members of the Indian Congress, from several tribes, lived in traditional encampments near the midway and entertained visitors with music, dance, races, and, the crowd pleaser, sham battles with cowboys. While Julia St. Cyr in traditional Winnebago dress joined the fair's picturesque Indian Congress, Angel represented the less exciting benefits of Indian education with her representations of traditional Indians.[2] As at the Chicago World's Fair, when Cecelia Beaux and Alice Barber Stephens showed their paintings in the Fine Arts and Women's buildings, Angel's were displayed with photographs of "Indians and Indian school-life" in the Government Building.[3]

Alice Fletcher supervised the BIA exhibit that featured the products made in various Indian schools. New Indian Commissioner William A. Jones said Fletcher's display effectively demonstrated that the "good design and skillful workmanship" inherent to Native artisans provided "the fruitful soil in which seeds of education are sown."[4] The display contrasted Indian school products, including items from Sybil Carter's lace schools for women, with "aboriginal work, plaques, pottery, blankets, sashes, baskets, stone pipes, and rush matting."[5] In addition, Angel contributed three oil paintings from Fort Berthold: *The Medicine Lodge,*

and two untitled paintings of heads, (probably the portraits of the man in headdress and the elderly man with the kerchief). In turn, Jones acknowledged Angel's "promise of unusual ability."[6] Her inclusion in the exhibition suggests Fletcher encouraged Angel to believe in the innate artistic ability of American Indians.

At the turn of the century, as indigenous to the land, Indians represented America's *essential* national identity offering "a distinctly non-European symbol for politicians and artists wanting to assert that Americans could chart a different history from the Old World."[7] If their artistic ability was innate, as Angel believed, then Indian-made objects offered a "primitive," esoteric experience in a too industrialized world. Paradoxically, as primitive, the same objects supported the superiority of Anglo-Saxon technology and race. Until anthropology truly embraced cultural relativism, ethnologists engaged uncritically with primitivism's dualism, yet focused on preserving "aboriginal works" for posterity, including languages, oral traditions, and folklore. Pratt tried to suppress the U.S. desire for the primitive (which is why ethnologists irked him as much as the BIA), but Hampton began to tap the wealth of ethnological material just under its roof.

That summer as Angel prepared her short story, "The Sick Child," for *Harper's*, her sister, Julia, completed Hampton's advanced Indian class. She remained at the school "until her plans for work at the west are matured," stated the *Southern Workman*. Her plans, typical for an Indian school graduate, entailed a career with the U.S. Indian Service.[8] While Julia waited for opportunity to knock, *Talks and Thoughts* published her essay, "Indian Superstitions."[9]

Julia prefaced her essay stating that her great-aunt (probably Mary Amelle Parish) was an authority on Winnebago folklore.[10] She told the children many "fairy tales" full of "giants and spirits," but "believed in all of her tales just as firmly as we did," Julia insisted. One of these tales featured a malignant wood spirit. From infancy, parents instructed their children to "pacify" the wood spirit, explained Julia, because it was prone to "unreasonable outbursts of rage." Worse, it might direct its anger toward a "harmless" family member. If so, everyone in the family, from the youngest to the oldest, attempted to appease the angry spirit with an offering of tobacco and dyed feathers.

Julia's essay strongly suggests she and her sister were collaborating at this time. The "Spirit Grandfather" of "The Sick Child" expected the same deference as the wood spirit. And like it, the Spirit Grandfather targeted a harmless child, just as it demanded even the youngest to appease it. Angel may have based the story on the memory of little Emma Samp-

son's death, when she was told, presumably, to "plead for the life" of her little sister.[11]

The eldest daughter narrates Angel's story. A medicine woman instructs her to leave an offering to appease the Spirit Grandfather. She must sprinkle tobacco and red feathers upon a bare spot of earth while facing the sunset, to prevent the death of her sister. When the girl leaves her wigwam to perform her duty, however, she steps into a snow-covered, monotonous landscape. After a painstaking search in the snow for any spot of earth, she tries to sprinkle her offering at the base of a reed. "Spirit grandfather, I offer this to thee," she chants.[12] "I pray thee restore my little sister to health." But the girl frets that the tiny frozen patch of brown earth that holds the reed cannot possibly absorb her offering. "No sooner was the sacrifice accomplished," recounts the narrator, "than a feeling of doubt and fear thrilled me." The next morning she discovers her sister is dead. "Bitter remorse was mine," she exclaims, "for I thought I had been unfaithful, and therefore my little sister was called to the spirit-land." "We must not talk about her," warns her family. "They made us look upon her face," states the narrator. "We felt of her and kissed her, yet no response." The narrator suddenly realizes "what death meant." The story abruptly ends with her terse confession: "Remorse again seized me, but I was silent."

The girl's stoicism is a common trope of the times to identify her Indian essence. It appears, however, that the *Harper's* editors imposed this unreflective silence on Angel's narrator. There are two other versions of the story, one in Angel's handwriting and one typewritten with handwritten corrections (possibly Folsom's), titled "An Indian Child's Experience with Death." Comparing these versions (saved in Angel's student file at Hampton) exposes racial ideologies that circumscribed Angel as a turn-of-the-century, American Indian woman.

Angel's handwritten version is descriptive, contemplative, and personal. It's also poignantly self-reflective and not condescending about her heritage. "As I look back upon it now," she wrote, "I half respect my childish meditation and reasoning." Unlike the *Harper's* version, her story's ending *explains* the reasons for her silence: "When I got back to the house they took me and warmed me but never questioned[,] so in my turn I had nothing to say. Every one was sober for the little one had grown worse. The next day the medicine woman said the case was beyond hope and gave it up. Then bitter remorse, lest I had not done my part faithfully and that therefore my little sister was to be called to the spirit land—I was a reserved child, and never uttered my feelings to any one but my remorse was intense."

Angel's less dramatic version reveals a typical child's magical thinking about her power to affect her world. It is not "Indian superstition," but childish superstition. She was not questioned, so she did not volunteer the details of her offering. Her family did not necessarily believe she could change her sister's fate anyway. They were "sober" because they knew her sister might die. She held in her feelings, because she was "reserved" not stoic.

The typewritten version of the story is writerly and affected. "S. W." is written in the upper corner, indicating it was edited for the *Southern Workman*.[13] Its resolution is quite different from the other two.

> The next morning . . . we were told that our little sister was gone to the spirit land and we must not talk about her. They made us look upon her face; we felt her and kissed her, yet no response. Then I realized what death meant. Remorse lest I had not done my whole duty in making my offering once more seized me. I was silent but I suffered all the more because I could not share my fear with another. Not until education had taught me otherwise could I feel sure that I had not been the cause, innocent perhaps but still the real cause, of my little sister's death.

The *Harper's* story appealed to the sensibilities of middle-class white Americans who believed members of the "vanishing race," even little girls, were innately stoic. The typewritten version, however, sent a clear warning to the readers of the *Southern Workman* that the ills of "Indian superstition" could only be remedied by education and assimilation.

§

In January, Julia De Cora wrote to Folsom from her new post as substitute field matron for Annie Dawson at Fort Berthold. Her stepfather was arrested the month before either for bootlegging or selling liquor to Indians (or both), but she did not mention it.[14] She worried about Angel, though, who "spoke of being not well" in one letter to her and "was as blue as indigo" in the next.[15] Something was wrong in Philadelphia, but Angel never revealed what it was.

In February "The Sick Child" appeared in *Harper's Monthly*. Angel's "little prose poem" with its beautifully rendered illustrations caught the attention of many people across the nation. The story with author's illustrations was unique, but Angel's was a small Native voice competing in a large chorus of imperialist discourse. The same edition of *Harper's* featured the first installment of "The Spanish-American War" by Henry Cabot Lodge, "Anglo-Saxon Affinities," by Julian Ralph, "Ghosts in Jerusalem," by A. C. Wheeler, and A. C. Humbert's "A Trekking Trip in South Africa." Hampton reported Angel's accomplish-

ment was "another item to the credit of the Indian race."[16] *Harper's* published "Gray Wolf's Daughter" in November.

Angel had a new project on the horizon for Omaha author Francis La Flesche. She was chosen to design the frontispiece for his book, *The Middle Five: Indian Boys at School*. La Flesche shared a close friendship with Alice Fletcher, who probably introduced the two. La Flesche assisted Fletcher with the Omaha allotment and with her ethnographic fieldwork. In 1898 they decided to separate professionally, so that Fletcher would no longer have "to share her scientific reputation" with him, and he, in turn, could become a "man of letters" instead of Fletcher's "lowly" Indian informant.[17]

The Middle Five gives an autobiographical account of La Flesche's boyhood at a Presbyterian mission school on the Omaha reservation. He and his four friends made up "the middle five" between, in age and privileges, the oldest and youngest students in the school. Adding to the growing genre that included Angel's short stories, *The Middle Five* represented the author's self-proclaimed desire to "reveal the true nature and character of the Indian boy." Like the heroine of "Gray Wolf's Daughter," who decided against the lifestyle of her stay-at-home reservation friends, La Flesche chose to write about his real-life Omaha "school-fellows" as opposed to the friends of his who, he said, had committed to "aboriginal life."

La Flesche explained his subject choice in the preface of the book. He meant to discourage the stereotype that "paint, feathers, robes, and other articles . . . are marks of savagery." He insisted that the anonymous "school uniform did not change those who wore it," but hoped it would provide readers a positive first impression. He wanted "these little Indians to be judged, as are other boys, by what they say and do."

The first draft of *The Middle Five* stimulated "great interest" from Double Day and McClure in New York. Yet without the telltale markings of the aboriginal, the publishers found La Flesche's boys unrecognizable as Indians and declined to publish the book.[18] Fletcher convinced her more progressive publisher, Small and Maynard, Inc., to take on the project, which probably led to Angel's involvement. For the time being, Angel had other concerns, however. She was desperate to leave Philadelphia.

§

On September 2, 1899, Angel, Gertrude, five-year-old Louisa Clapp, and Gertrude's sister, Flora Quimby, traveled to Boston.[19] Later that month Angel wrote Gertrude from Wrentham, a quaint township just southwest of Boston. She stayed at Red Farm in the household of a well-known reformer and journalist, Joseph Edgar Chamberlain.[20] She

expressed a firm resolve to quit her studio in Philadelphia with no clear explanation. "I am sorry I didn't write when I first rec'd yours, but my letter to Miss F[olsom] went only yesterday & I don't think a meeting is necessary as I have made up my mind even as far back as last year that I would not return to Phila even tho' the other & only choice left me was killing myself." Angel had "other plans," which she did not specify. "Mrs. Chamberlain is about to go thro' a painful operation & wants us off the grounds," she explained. "We are not very happy over it but she will have less suffering when it is done." If all went well with Ida Chamberlain's operation, Angel would arrive in Northampton "next Monday, late in the day likely. Not to stay long but to visit with you." She mentioned her Yankton friend, Gertrude Simmons, who she called by her Indian name Zitkala-Ša (Lakota for "Red Bird," pronounced zit-KAH-lah-shah). "I am going to tarry about Boston this winter. We [she and Zitkala-Ša] are going into the woods while the operation is being performed."

Joseph Chamberlain founded the popular "Listener" column for the *Boston Transcript* and, in 1890, edited the widely read *Youth's Companion*. By the time he met Angel, he also served as the Cuban correspondent for New York's *Evening Post*. Angel left no description of the Chamberlain family or the picturesque Red Farm where they lived, but one famous guest did. Helen Keller retreated to Red Farm off and on over the years. She adored the Chamberlain children and praised their father, who, she said, "initiated me into the mysteries of tree and wildflower, until with the little ear of love I heard the flow of sap in the oak, and saw the sun glint from leaf to leaf."[21] Keller stayed at Red Farm the summer just before Angel arrived, but whether they crossed paths is unknown. She shared a little cottage on the compound with her devoted teacher Annie Sullivan, the same Angel may have shared with Gertrude Simmons.[22]

Folsom later explained Angel's move, saying she had become "conscious of certain deficiencies" while in Philadelphia, so decided on Boston for more training.[23] It seems more likely Angel had other reasons for leaving Philadelphia, though undisclosed, and summoned the courage to tell Folsom and Gertrude Clapp that she intended studying in Boston after she moved in with the Chamberlains.

On September 5, Ida Chamberlain confided to her friend, noted photographer and publisher, Fred Holland Day, she felt "better now."[24] She also told Day about her two houseguests. "Angel de Cora another Indian girl is with me now," she wrote, "and she has brought some Indian rigging with her. It struck me that you might like to use your camera, for Zitkala-Ša is a delight in the Indian costume, with the red on her

cheeks." She also boasted "Zitkala has had an article accepted by the *Atlantic Monthly*. Aren't you glad for her? "The Sick Child" certainly paved the way "for more of its kind."

Angel met her photogenic friend (also photographed by Gertrude Käsebier in 1898) at the Chamberlains or sometime shortly before. Gertrude Simmons might have also modeled for Angel.[25] The women shared many similar experiences, but they could not have been more opposite in temperament. Simmons was an artistic and attractive "mixed-blood" woman. She was assertive, passionate, and outspoken. Her characteristic bravado may have inspired Angel to take risks and stand up for herself, contributing to her decision to leave Philadelphia. As the *Southern Workman* later reported: "Through a Boston friend she was led to enter the art school there."[26] Gertrude was a natural leader.

Gertrude was born in February 1876 and grew up at the Greenwood Indian Agency in South Dakota. Her Yankton mother was Ellen Tate or I yo hin win (Reaches for the Wind Woman).[27] Her absent white father, known only as Felker, may have been a soldier.[28] Since Felker abandoned her before she was born, Gertrude took the surname of her widowed mother, who married twice before Felker.[29] At age eight, Gertrude went to White's Institute, a Quaker school in Indiana. The school took a military approach and practiced corporal and, according to Gertrude, "unusual" punishment. Gertrude expressed contempt for school officials, who, she said, "paraded the students before the community and the politicians" to show how they had been transformed, while they were also "made to perform 'native' dances at local arts-and-crafts fairs."[30] Like Angel, she was sent home in 1887, due to BIA regulations. Finding herself a misfit on the reservation, she eventually convinced her reluctant mother to let her enroll in the Santee Normal School in Nebraska. When she returned home in the summer of 1890, she felt "suspended between two cultures" but, unlike Angel, she did not wait to be "rescued."[31] She chose to leave again, this time to attend Earlham College in Indiana.

Gertrude wrote about her educational experiences in 1899 and adopted Zitkala-Ša as a pen name. Unlike Angel, she chose her Indian name not only to promote her career, but as "an assertion of identity."[32] In January, February, and March of 1900, the *Atlantic Monthly* published her three-part autobiographical series that criticized her Indian education. Referring to her college experience, she said she wished she had returned to the reservation, "to be nourished by my mother's love, instead of remaining among a cold race whose hearts were frozen hard with prejudice." Nevertheless, her talent for oratory landed her the state

championship, which, she said, "was a rebuke to me for the hard feelings I had borne them."[33] She won a scholarship to the Boston Conservatory, but malaria interrupted her plans to finish her degree at Earlham. Instead, she traveled to Pennsylvania that fall to teach at the Carlisle Indian School. Angel may have met her during her eighteen-month tenure at the school.[34]

The feisty, uncensored Yankton woman must been a breath of fresh air for Angel. Modest, soft-spoken, and self-deprecating, Angel was never overtly aggressive. After her trying experience at Chadds Ford with white students who copied their white master, Gertrude, as Zitkala-Ša, offered an alternative response to white, male oppression.

"An Indian-Teacher Among Indians" finished Zitkala-Ša's *Atlantic Monthly* trilogy. Her story charged Carlisle Indian School, though unnamed, with uprooting children from their families and stripping them of their culture and beliefs. She exposed one teacher as "an opium-eater," and the school doctor as an "inebriate paleface," who "sat stupid in a doctor's chair, while Indian patients carried their ailments to untimely graves."[35] Her account concluded with a chilling accusation of the reformers: "But few there are who have paused to question whether real life or long-lasting death lies beneath this semblance of civilization."[36]

Gertrude resigned from her position at Carlisle in January of 1899, keeping her complaints mostly to herself. With the support of an unknown Quaker woman, she moved to Boston to study violin at the New England Conservatory of Music.[37] At first she made many friends in the city. But her fiancé (a Carlisle alumnus) died unexpectedly of measles and her patron withdrew financial support.[38] To ease her despair, she began writing about the plight of American Indians, "the pen being mightier than the sword," as she said.

Angel surely enjoyed vicarious pleasure in her rebellious friend's attack of the establishment. In November, two months before the publication of "An Indian-Teacher Among Indians," Carlisle's school newspaper advertised the first installment of the *Atlantic Monthly* series. The "Indian is entering into the highest and best places," stated the article, and elaborated about Gertrude Simmons's music career. It also introduced her upcoming book, *Old Indian Legends*, a collection of Dakota [Sioux] trickster tales. "We understand that she is writing a series to be illustrated by a Hampton Graduate—Angel Decora, a young Indian maiden of the Winnebago tribe who has been studying in Philadelphia for some time and is making a name and fame as an artist."[39]

§

Angel opened a studio at 62 Rutland Square in a large area of old brownstones, located close to Boston's Museum of Fine Arts on Copley Square and about a half-mile from the art school she was about to attend. Copley Square brimmed with excitement and vitality and Boston rivaled any city in the United States as a thriving art center. The 1890s found Boston painters introducing the country to impressionism.[40] Pyle was not the only artist unwilling to adopt the seemingly formless, obscure style. Most U.S. painters viewed the early French work as "extremist and faddish." Critics complained the theory in practice led to the degeneration of "technical accomplishment" and "artistic sensibility."[41] Thus, Boston painters adjusted the radical style to the more conservative taste of their patrons. In an era "where young painters could scarcely avoid taking sides," the greatest conflict between Angel and Pyle could certainly have been a theoretical one.[42] If she aspired to the impressionist style, then the conflict with her master seems an age-old clash. Angel's choice of Boston at the turn of the century meant she wanted to paint to the pulse of her generation.

Sometime in the fall or winter of 1899, Angel enrolled in the prestigious Cowles Art School.[43] She studied with Joseph Rodefer DeCamp, who had been teaching there since 1893. DeCamp was a founding member of the "Ten American Painters," an offshoot of the Society of American Artists, whose common bond was aestheticism, specifically executed in a modified style of European impressionism.[44] DeCamp specialized in portrait and figure painting as well as landscapes.[45] He also painted in the tonalist style, but the public admired him "for his dark, stern portraits of important business men and academicians" and his "scenes of women in interiors painted in a lighter, more freely brushed style." Given her work from this period, it appears Angel liked DeCamp's brightly colored and "loosely painted" landscapes.[46]

"I had heard of Joseph DeCamp as a great teacher," she later wrote, "so I entered the Cowles Art School, where he was the instructor in life drawing. Within a year, however, he gave up his teaching there but he recommended me to the Museum of Fine Arts in the same city, where Frank Benson and Edmund C. Tarbell are instructors, and for two years I studied with them."[47] Angel began classes at the School of Drawing and Painting at the museum on February 12, 1900.[48] Tarbell, the leader of the Boston school, and Benson also belonged to the Ten. They were close friends and respected painters.[49] Tarbell taught painting for the museum school, while Benson taught how to "draw and paint from the nude model," at the time a risqué class for women.[50] Tarbell became famous for his outdoor figure paintings that showcased his "striking interpretation to the phenomena

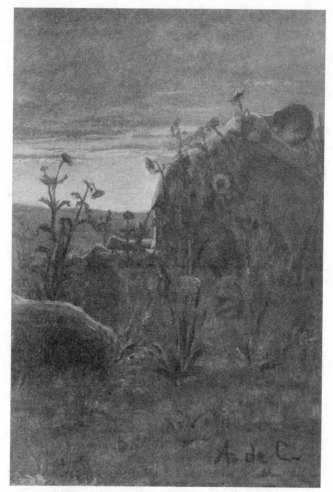

"Great-grandfather give me meat to eat!" from *Old Indian Legends*, 1901.

of light."[51] Benson, known for his "sunny, colorful outdoor paintings of children" and his idealized paintings of young American women, also taught Angel to paint figures in outdoor scenes.[52] Their influence on Angel's illustrative work was immediate.

Angel incorporated the Boston school style with Pyle's attention to detail and Tryon's tonalism for *Old Indian Legends* and for another project that had come her way, Mary Catherine Judd's *Wigwam Stories*.[53] In particular, the twelve full-page illustrations of *Old Indian Legends* demonstrate all three styles, sometimes too much so. Some illustrations show thickly brushed paint, evoking DeCamp's seascapes and Tarbell's

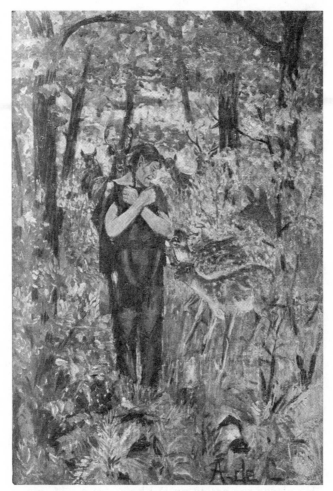

"There among them stood Iktomi in brown buckskin"
from *Old Indian Legends*, 1901.

impressionist landscapes.[54] Some are distinctly illustrative and portray intricately detailed objects and figures, as in her *Harper's* stories. Several depict cloudy sunsets, smoke, steam, and fire, evidencing that she experimented with Tryon's tonalism. The amount of illustrations indicates Angel had too much work to execute well.

Angel's three illustrations for *Wigwam Stories* show these style influences also, but some are rendered realistically as well. She also created several dozen headpieces and decorative initials for each of the book's chapters that reflect the influence of the museum school's decoration courses.[55] Some of these have an art nouveau flourish, popular at the

"He placed the arrow on the bow" from *Old Indian Legends*, 1901.

fin-de-siècle.[56] Angel designed the covers for *Old Indian Legends*, *Wigwam Stories*, and *The Middle Five* in the arts and crafts style, customized for Indian subjects.

By the end of February, Angel became inundated with work, apart from her museum school study. Meanwhile, Gertrude Simmons prepared to perform with Carlisle's popular school band.[57] Angel directed her friend to Alice Fletcher for an Indian dress to wear at her performances. "Miss de Cora has an ordinary one which I meant at first to use," she told Fletcher, "but she has work now which needs her buckskin dress for the model—She told me of your beautiful Indian dress; and so I have

Se-Quoyah, the Indian Scholar frontispiece from *Wigwam Stories*, 1901.

been wondering if you could help me out in the matter."[58] It is unknown
if Fletcher lent her the dress, but Indian costuming lent authenticity
(whether or not it was tribally accurate) both to Gertrude as a performer
and to Angel's artwork of Indian subjects. Angel herself modeled for an
unknown photographer at the Smith College pond. It may have been
while she attended the school or in the years shortly following. Both
women, however, struggled with costuming over the years.

§

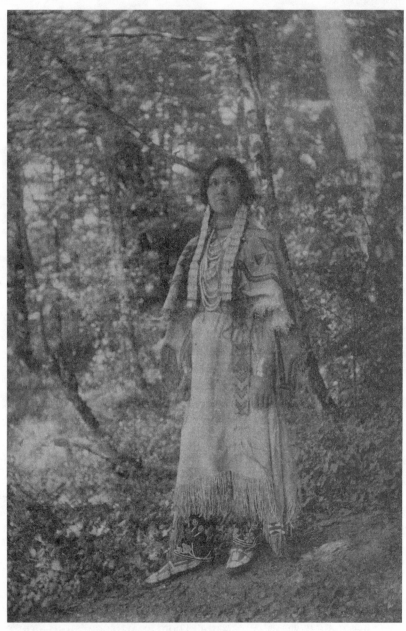

Angel De Cora in Indian dress, date unknown.
(SMITH COLLEGE ARCHIVES, SMITH COLLEGE)

Stress started to take its toll on Angel, but she still received honorable mention for an unidentified work in the museum school's annual exhibition or *Concours* in March. The same month Zitkala-Ša's "An Indian Teacher Among Indians" appeared in print. A shocked and outraged Pratt publicly chastised her. Using Carlisle's school paper as a forum, he charged her with ingratitude for not giving recognition to the "many friends" (and benefactors) who had helped her toward the better life he felt she led. The school paper printed her measured response: "To stir up views and earnest comparisons of theories is one of the ways to benefit my people. No one can dispute my own impressions and bitterness."[59] The debate did not change Gertrude Simmons's plans to perform with the Carlisle school band, however, nor Pratt's, who allowed her to do so.

Gertrude Simmons's solo violin performance from Hiawatha (which Pratt requested) received a warm reception at Philadelphia's Association Hall the end of March 1900.[60] On the 28th the band performed at Carnegie Hall, again with "Zitkala Ša, the Indian Girl violinist from the Boston Conservatory."[61] The popular tour culminated at the Paris Exposition. Few performers enjoyed such magnificent exposure. Gertrude's mercurial personality, her tendency to seek the limelight, and her ambition to make her mark in the world, as well as Pratt's undying commitment to prove Indians could succeed professionally, apparently led the two to reconcile.

About this time, Angel's close friendship with Gertrude Simmons waned. Angel shied away from notoriety, and Gertrude could make great demands on her Indian friends.[62] If that was the case, Angel's patterned response was to silently withdraw. After she married, Gertrude Simmons Bonnin became a prominent Indian rights activist. She and Pratt became allies in later years. Still "suspended between two cultures," she sometimes, apparently, felt her mixed-blood Yankton identity required shoring up. As a result, she struggled to present an authentic Indian image to the public, not always to good effect.[63]

§

In April some Carlisle students came to visit their "artist friend, Angel de Cora." She gave them a guided tour of Boston's Museum of Fine Arts, while Joseph Chamberlain showed them the offices of *Youth's Companion*, where he was editor.[64] During this time, Angel worked on the frontispiece for *The Middle Five*. She wrote to La Flesche in mid-April from the Chamberlains describing her difficulty rendering the traditional Omaha boy without any model. "In regard to the Omaha costume I was *not* very certain of the details so I used the Sioux—however in my earnest attempt I can make any change according to your suggestion—

especially about the hair arrangement.[65] If it is not asking too much of you I would like to borrow any photo or print that will help me out in regard to costume—characteristic faces & also of the scenery. I have no costumes to work with but perhaps I can make something that will answer the purpose."

She complimented La Flesche on the story, saying she found it to be "very characteristic of Indian school life." She expressed regret that the publishers decided to use only one illustration, but was glad to be in competition for a cover design. Angel's frontispiece offered an alternative to the popular before and after photographs of Carlisle students widely circulated at the time. A younger boy, his body open to the viewer's gaze, wears traditional buckskin dress. His hair is hidden, a sign Angel never figured out the "hair arrangement." He hides his face but his despair shows in his posture, as an older boy in school uniform tries to comfort him.

Angel won the competition for the cover design. She created the arts-and-crafts-style cover using abstract Indian motifs. Red, blue, and green forms appear on a beige background. A bow and eight arrows provide the clever border, with four arrows on the spine. On the bottom half of the small book's foreground sits two tepees, side by side. They are decorated with Indian symbols, including a blue thunderbird—a symbol Angel adopted for the rest of her life. In the background, a partially clouded blue sky surrounds green triangles representing the prairie. The lettering of the title and author's name suggests lettering that would appear later in Angel's work.

The May edition of the *Outlook* featured "The Representative Indian," by Jessie W. Cook. Angel's photograph appeared with six other accomplished young people, including Gertrude Simmons and Charles Eastman. Cook characterized her as "an artist who has won her way by the bravest and most persistent struggles." On June first the museum school awarded Angel a scholarship for the 1900–1901 academic year.[66] That same month the *Atlantic Monthly* also advertised the publication of *The Middle Five*, featuring "a frontispiece in color and a cover design by Angel Decora." Today the frontispiece is Angel's most recognized work.[67] Yet, in August, she expressed her dismay to La Flesche for the way the picture turned out. "I should have answered your letter long ago and did attempt it several times but my *fear* of failure in regard to the illustration for your book overcame me each time. The time the publishers allowed me for making the picture was not enough," she confided, "so I was obliged to start right in with what I could scrape up in the line of Indian dress. I know it is not like your tribe's dress, but there was no time for any communication on the subject."[68]

At least she felt satisfied with the cover design. "All my artist friends like the cover of the book & I myself am not ashamed of it," she remarked, "but I truly am of the frontispiece." She hoped La Flesche was not "discouraged" with her work. "I am anxious to have you write something of the Winnebagoes for I am sure you know more about their customs than I do," said Angel, "but I can help you out on the pictorial part." The project never came to fruition.

Certainly few readers of the day noticed Angel's artistic transgression. But her letter reveals the toll illustration work took on her. Struggling to meet Pyle's tenets of realism paled to the responsibility she felt in realistically portraying American Indians. It was one thing for a white artist to misrepresent them, it was quite another for her to do so.

Returned home to the Yankton Agency, Gertrude Simmons wrote La Flesche in August congratulating him on his success and sent him a "whiff of wind from the Dakota prairie to whisper in your very heart 'Bravo!'"[69] Francis E. Leupp (who Angel met at the Lake Mohonk conference) sent a congratulatory letter as well, complementing his book.[70] As Angel's future indicated, Leupp surely paid more attention to the name of the frontispiece artist than its lack of accuracy.

§

That fall William L. Brown, who served as editor for the Indian Department section of the *Southern Workman*, contacted Charles F. Lummis, a prominent and controversial Indian advocate and the editor of a California magazine, *Land of Sunshine*. He reminded Lummis that he had promised to "write for us an Indian article."[71] Lummis informed Brown he wanted to write an article about Angel.[72] "I will be glad to give you what information I can with regard to Miss Angel de Cora," Brown responded. "She is a Winnebago Indian, (I don't know if a full blood, but she looks it) . . . You probably saw her article in *Harper's* magazine a year or two ago." He explained that Angel took art classes in Boston and that the previous year she and Gertrude Simmons lived with "the family of Mr. Chamberlain, a well-known writer and an editor on the *Boston Transcript*." He boasted about her painting for the "frontispiece of La Flesche's book," saying "it really was an artistic bit of canvas." He referred Lummis's "request for a photograph and interesting data" to Angel.[73]

Angel was under too much pressure to worry about drumming up more publicity for herself. She attended half the museum school classes she was scheduled for. The story Lummis hoped to publish never materialized. She had also been contacted earlier in May to participate in yet another Indian school exhibit, this time for the 1901 Pan-American Exposition in Buffalo, New York. As shown in his report of the Omaha

The Middle Five cover, 1900.

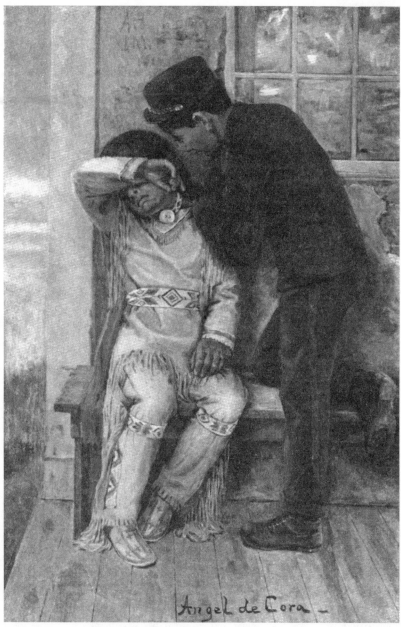

The Middle Five frontispiece by "Angel de Cora," 1900.
(ORIGINAL OIL HELD BY J. ANDREW DARLING)

Fire Light, left panel, ca. 1901, from Natalie Curtis, "Perpetuating Indian Art," *Outlook,* November 22, 1913.

exposition, her artwork caught the attention of the Commissioner of Indian Affairs, William A. Jones. In late September, Angel informed one of the exhibit organizers she would try to borrow some of her illustrations from her publishers, as he had asked. Her work for the exhibit also required her to develop her design skills, only this time for furniture. She agreed to submit a design for andirons; as she told the organizer, "if you will kindly tell me the style of mantel (much decoration or not) and dimensions of fire place."[74]

Commissioner Jones envisioned a room for the exhibit furnished with items constructed entirely by Indian school students. He wanted the furniture to show "good proportion, good finish and graceful outline, with some decoration." "Let the whole design be simple, even to severity," he stressed to one participant, "if only the outline be good and the finish excellent. Fanciful, applied decoration mars the effect."[75] His instructions did not just reflect his tastes. The arts and crafts movement with its simple lines and handmade construction was usurping old-fashioned, intricate Victorian ornamentation all over America.

During the first week of November, Jones verified Angel's appointment to design a mantle and andirons and asked her to provide pictures for the room and a painting for the mantel. He also hoped she had time to submit a design for a high-backed "modernized old fashioned 'settle,'" for use as a partition between exhibits and for "weary sightseers where they may

Fire Light right panel, ca. 1901, from Natalie Curtis, "Perpetuating Indian Art," *Outlook*, November 22, 1913.

be beguiled into looking at the Indian exhibit and to serve at the same time as a worthy part of that exhibit." The commissioner advised her to design the settle before the mantle, so he could send the plans as soon as possible to the Carlisle Indian School to be constructed.[76]

By the end of the month, Angel informed Jones she had completed the designs for the settle and the mantle piece. She would send "the roll of drawings by express" for his approval. She wanted the settle to be made in "straight oak with black leather cushions." As much as she tried to get the proportions just right, the details took up her time, she explained. "I have tried to suggest something of the Indian art in my decorative designs," wrote Angel, "and if it is to be done by Indian workmen they perhaps will have some sympathy with my efforts to introduce in this way some thing of the Indian designs—otherwise I should like to have the work executed somewhere where I could oversee the work—especially of the decorative part."[77] She wanted to communicate with the foreman, so "I may send him samples of material to show him the effect of color I want." Although she completed the working drawings for the mantelpiece, she explained she hadn't completed the decorative designs to match the settle.

The commissioner reviewed Angel's roll of drawings. He thought her settle design was "charming." "The decoration, the color effects and the boldness and originality of the design are particularly pleasing," he

wrote her.[78] He suggested only that she make the settle smaller, because of the constraints of the exhibition space. The proportions were good and he didn't want her to make a new design, but "to make the alterations with as little work for yourself as practicable." He agreed she should supervise the construction at Carlisle.

The installation was a great success. The arts-and-crafts-style room in the Indian school exhibit particularly pleased the many visitors. A copy of the newly published *Middle Five* contributed to the room's arts and crafts ambience. After seeing it herself, Fletcher wrote to "congratulate" Folsom on Angel's accomplishments, telling her, "You who have been as a wise mother to Angel should feel happy in the girl's development." She raved, "The mantle is a poem. The paintings show growth and power and the subject she chose for the mantle frame completes the conception admirably."[79] Commissioner Jones further praised the installation in his annual report: "Miss Decora has combined the native symbolism of fire with our own tradition of the fireside. Upon the space below the shelf, in low relief of redwood, is a conventionalized 'thunder bird,' the plumes of its wings flashing out into flames. On the side uprights, and in a band around the upper part of the mantel, making a frame for the central painting, are conventionalized forms of the sticks used in making the 'sacred fire' by friction."[80]

The praise validated Angel's choice of symbols significant to her own family clan. Jones further praised the painting that made "Miss de Cora's mantel a work of art." It depicted "the rolling prairie at sunset, suggesting the hour of gathering about the hearth." He pointed out the "cluster of Indian tents, each one aglow from the bright fire within" to the left of the composition, as well as the "pair of lovers" standing beneath "golden clouds," which he interpreted as symbolizing "the beginning of a new fireside." He pronounced the piece a "poetic conception" that was "carried out with clearness, simplicity and skill." She named the tonalist painting, which incorporated her landscape from Fort Berthold, *Fire Light*.

The exhibit admirably met the requirements conceived by the BIA: One, to "show something of the native capacity of the Indian and his artistic feeling"; two, to "set forth the methods used in the schools to train him along our lines and activities"; and three, to "present examples of the use he makes of this training to express in forms intelligible to us his artistic feeling and his power of workmanship." The bureau's report claimed the third requirement was made "manifest in Miss de Cora's designs and paintings, in the humor and pathos of Mr. La Flesche's book, and in the skillful handicraft displayed in the various articles of the exhibit."[81]

American Indian objects of art began making their way out of the remote marketplaces of Indian traders and into U.S. homes, where "Indian corners" suddenly appeared.[82] American Indian as a race of artisans resembled the Celtic, Persian, and Japanese. The glowing reception for Angel's design work was a sure sign American Victoriana had seen its last days. But it also highlights something forgotten: Angel's influence on the arts and crafts style imported from Europe. As the new century dawned, an American Indian woman, professionally trained as an artist, incorporated her vision of Indian motifs in her designs. Now that was truly American arts and crafts! Angel continued to receive warm praises for her illustration work, but the Pan-American Exposition marked a shift in the course of her promising career toward what she called "Native Indian design."

Quietly Working her Way in the Metropolis

While Angel studied with prominent artists from the Boston school and applied their teachings to her artwork, she fought symptoms of malaria. In spite of feeling sick, feverish, and fatigued most of the time, she produced more illustration than at any time in her career. Only one photograph of her from this time exists. Like the secret E.S.G. club at Hampton, she is pictured standing on the sidelines with museum school students. The other women, all Euro-American, are young and smiling, some even hamming it up for the camera.[1] She appears older than her peers and is the only one wearing a hat, an unstylish one at that. Her head is lowered and her eyes are downcast. She looks terribly mortified or terribly sick, or both. As Angel later confided to Folsom, she had very "unpleasant memories [about] when I was ill in Boston."[2]

Sometime before the spring of 1902, Angel vacated her Boston studio and moved to New York City, where she opened a new studio on 23rd Street.[3] Angel was not the only artist moving to New York at this time. As a vibrant art center, Boston was out, and New York was in. In 1903, Herbert D. Croly (later editor of the liberal *New Republic*) named New York "the American Metropolis" for the new century. The city provided a haven for artists, he said, "not because it is a very beautiful city, not because New Yorkers are peculiarly appreciative of American art, but almost entirely because the association with fellow craftsmen . . . is essential to artists."[4] These craftsmen, Croly explained, sought out New York's racially mixed and large socially diverse population that represented "the high vitality of American life." In contrast, Bostonians valued birthright and propriety. While some artists thought the "ethnically unified, confident, keenly respectable," and "high-minded" people of Boston had their charm, noted Croly, "others found them to be 'egoists, faddists, snobs, prigs, or prudes.'"[5] Croly found Boston's "lingering nobility" too provincial to maintain a climate of artistic diversity. New

York, however, supported a large "concentration of artists and galleries of diverse styles and visions." This element of the city surely appealed to Angel.

Rejecting provincialism for the greater, and wilder, metropolis was not necessarily a wise decision for a single, working woman. To keep her expenses low, Angel moved into a dangerous neighborhood where she felt the need to keep herself "well armed." She was "not an expert in handling firearms," she told Folsom, but she approached her situation with "the faith that every body else is as much afraid at the sight of one as I am."[6] What she feared most was fire, though, especially after a small blaze threatened to burn down her building while she was in it. Soon after the incident she moved, and the fire department condemned the building.

Angel suffered between the grippe and malaria all through the spring of 1902. Sometimes both illnesses struck her at once. She felt "so shaky" and "generally discouraged" after losing "two big contracts of work," she had to let go of her studio by the summer of 1902. She wrote Folsom that although it was "in the very heart of a very dirty and evil city," and she suffered constantly from chills and fever, she "had a very serene and peaceful time there"—strong evidence that she found New York, and perhaps the solitude it provided, much more to her taste.

Angel moved into a new apartment just off Broadway on 575 W 155th Street. The narrow, five-story, yellow brick building sat in the heart of Jewish Harlem, a neighborhood occupied by German, German Jewish, and Eastern European Jewish immigrants. Angel moved in with her new friends, the Schumms, taking "the largest room they could spare." "The movers had left my boxes & things all in a heap in the middle of the floor," Angel told Folsom, "and on my arrival I was hardly able to stand straight so I threw myself down on something & there my friends found me some hours later. I was sick for sometime, but it was such a luxury to be sick among friends & such a treat."[7] She continued to have "small attacks" of illness that summer, but by the fall felt better than she had since moving to Boston. "I've got rid of the malaria entirely & once more I am trying to get in with the busy world," she announced.[8]

As work came her way, Angel began to feel "lively & gay." She took in a tabby. She thought her yellow cat was a "very handsome animal." Still, he was no substitute for a human companion. Loneliness punctuated Angel's peaceful days in New York, and she began to dream of love. She borrowed the autobiography *The Story of Mary MacLane By Herself*, the most outrageous and sexually explicit book published during the time. MacLane, a precocious nineteen-year-old bohemian from Butte,

Montana, rejected "conformity and Puritanism," and reviled "the sti-
fling boredom and pettiness of middle class." MacLane frankly revealed
her shocking sexual exploits, including those with women, as well as her
fantasy of marriage to the Devil. Angel confessed to Folsom she stayed
up late one night reading the book and rose early the next day to finish
it. "I can't understand wherein her genius lies," she mused. "To me her
philosophy is nothing more than down right sensualism—and it is a
pity that she didn't retire into that hole in Butte after having written the
stuff—for no doubt she will be a little bored by the numerous applica-
tions she shall have from men-devils." Despite her critique, Angel
secretly wished for at least one true "application" for herself. Beneath her
good cheer, she felt time passing her by. Fulfilling the promise of a career
did not fulfill all of the needs of a thirty-three-year-old woman.

Music usually cheered her, so she practiced playing the Winnebago flute
Oliver Lamere (son of her uncle Frank) had recently given her. The cat, the
book, and the flute, an instrument Winnebago men used in courtship,
only emphasized her loneliness in the end. "My yellow cat lies before me
blinking and blinking," she wrote Folsom. "Whatever his ideas are he
always looks very philosophical. He is fine company and I have come to
the conclusion that he has an exquisitely fine soul within him. The only
flaw about him is that he does not appreciate Indian music. Whenever I
play on my flute he spits & growls & even struck me once."[9]

Few eligible men, let alone an American Indian beau, frequented
Angel's circle. If they did, her relationships were short-term and kept
secret from Folsom. She did, however, ask Folsom for the address of
Mathew Ankle, a Hampton alumnus. Folsom, still trying to guard her
pet from demoralization, discouraged the contact, leaving Angel to
respond: "I shall try to have him know some of my friends who will
surely have an elevating influence over him, but I can't help think that
he made a great mistake coming to such a place as New York after devel-
oping habits you accuse him of."[10]

As summer neared its end, Angel traded her cat temporarily for a
friend's dog and left the city with the Schumms for a campout in the
woods. Several German friends visited their camp and wrote about their
experiences in an unidentified German newspaper. They undoubtedly
mentioned the exotic American Indian woman they met. Angel really
enjoyed herself during the month-long outing and felt revived after her
long illness. Conditions were "primitive," but that was exactly "what I
wanted & needed," she wrote Folsom. "The rainy weather stopped the
very morning we started and fall rains began the day we pulled down
our tent so you see we were in favor of some sort of 'Providence.'"[11] Her

friend's little dog, however, wasn't quite as lucky when a rattlesnake nearly struck him. The snake was even less fortunate. He was "killed and skinned by a friend."

Angel found rattlesnakes fascinating. Her observations about the snakes reveal her creative mind. "The country about us was full of snakes—rattlers—and, in a saloon window in the village, were several tremendous ones kept in catavity [*sic*]. Every time I went to the village I used to make for that saloon and hang about the window 'seeing snakes.' I think the people used to look at me there as much as they did the snakes but little I cared for others' eyes than those snakes. O, their wicked flat heads and yellow eyes. I had several nightmares about them," she said. Apparently, the locals found Angel as fascinating as she found the snakes. "I didn't tell of my nationality till few days before we broke up & that only to our land-lord," said Angel. "I could hide it no longer when I began to turn as black but he admitted that he thought me a Mexican Indian."

She returned to the city refreshed and fully recovered. Oliver Lamere came for a visit at the end of September further buoying her spirit, but draining her finances. Angel was glad to see her favorite cousin and enjoyed taking him sightseeing. His visit followed his trip from Winnebago to Carlisle Indian School, where he had just dropped off some new recruits, including Angel's eighteen-year-old half-sister, Mary Sampson.[12]

After Lamere left, Angel grew concerned about money. The coal strike, just as cold weather threatened, aggravated her worries. She had little paying artwork, so took up dressmaking to help make ends meet. The skills she learned in the Indian girls' sewing class had not gone to waste. She wrote a long letter to Folsom, telling her, "I am on the second suit & I am driven with it. I mean to drop the trade after the third suit is done. I am getting too popular in the business."[13] She informed her she had received a check from the lease of her allotment land in Winnebago. She decided to "make an immediate investment of part of it in a coat" as she hadn't had "such a thing with in three years & it is about time I owned one."

Folsom wanted her to visit, but Angel didn't see how that was possible, given she'd need to take a week off from her work to do so. "I would like no place better to go to than H during this coal strike for if it keeps on we will freeze. The Schumms have ordered some wood for the kitchen stove & that's all—A warm reception at H is what I am certain of but I must stay by my work."

Angel further explained that Mary Sampson was homesick and needed her attention. She told Folsom she was trying to decide whether

she could take a few days off work to visit her. "Now that the poor girl is out of her father's clutches I must do all in my power to keep her out of it at least for the five years that she has come for. She has written me a pathetic letter begging me to go & see her at C[arlisle]." This is the only record of Angel's disdain for her stepfather.

Angel also relayed she was doing "publishing errands" for a "literary friend," though probably not for much pay, if any. She did manage to find some artistic work, but acknowledged, "It is all small work but they are the only kind that pay." Folsom, apparently, was trying to sell one of her paintings, but had been unsuccessful. Angel responded in her usual self-effacing manner, "If no one is foolish enough to take it send it back to me & it shall share the same fate that all my former attempts have had. It is at least on good canvas—I can try another nightmare on it." She was also working on a painting for the St. Louis World's Fair. She felt "robust & determined" and was convinced that it would "not look so *sick* & *morbid*" as the previous work.

Finally, she asked: "Who struck that match of Willie Jones & Carrie Andrus. It is a good one and to think at last Annie Dawson is married! I am glad for her but I am glad I am not Byron W. Isn't it he? My cousin Oliver told me that Zitkala Ša was married—Is it so?" If she was envious, she didn't let on. "Remember I still love you. Don't ever think otherwise," she assured her second mother. "Some times it's hard to talk or write about things but upon my hard heart you are one of the very few that have made a deep impression."[14]

Nevertheless, Angel's flute sounded the abyss in her heart. It seemed everyone but she had found a mate. In late June her old schoolmate, Annie Dawson, married Byron Howard Wilde, a Carlisle alumnus, whom Folsom called "one of the strong young men of her own tribe."[15] Wilde attended the Agricultural College in Fargo, North Dakota, where he starred in football and baseball.[16] Folsom's assistant and Angel's friend, Carrie Andrus, became engaged to one of Folsom's pets, William Jones, a Sac and Fox Euro-American graduate of Hampton in 1892. A budding anthropologist, Jones did graduate work under Franz Boas at Columbia.[17] Gertrude Simmons married Raymond T. Bonnin, a Yankton Métis, in October. Her marriage followed a tumultuous relationship with Pratt's "model Indian," Carlos Montezuma, the Yavapai physician who chaperoned the Carlisle band when Gertrude toured with them.[18] They became secretly engaged shortly after the tour, but she broke off the engagement when Montezuma refused to leave his practice in Chicago for a job as agency physician on her home reservation. Gertrude married Bonnin immediately after.

Carlisle's school paper reviewed *Old Indian Legends* just before Gertrude married. The reporter found Angel's illustrations "extremely good" and the book cover "attractive," and claimed "another volume is soon to follow this one."[19] But Angel and Gertrude never collaborated again. The Bonnins joined the Indian service and worked on the Uintah reservation in Utah.

§

Angel traveled to Carlisle in mid December to try to ease Mary Sampson's homesickness. Her visit to "relatives and friends" was featured in the Carlisle newspaper, which boasted she had "attained considerable repute as an artist." She was described as "a plain unassuming young woman who is quietly working her way, in the Metropolis of this country."[20] When Angel returned to the city, she continued working quietly on a new piece for the St. Louis World's Fair. Meanwhile, the Schumms came down with the grippe and diphtheria spread through the neighborhood. A nurse friend of Angel's informed her about "formalin as a disinfectant," and though she wondered if it abated "fear" more than germs, she applied it whenever she took public transportation, sharing some with the Schumms, hoping "to drive out the grippe germs." After her long bout with illness, she determined to be proactive about her health.

At Christmas time Angel visited Northampton. Gertrude noticed that she finally had put on some weight and looked well. Angel's fondness for cooking contributed to her healthy demeanor. Shortly after the new year of 1903 began, she made a chop suey dinner for seven. She described the exotic, Chinese dish to Folsom as "a queer mixture," and explained "it is good when ever I treat myself to a relaxation from my work I like to feast my friends as well as myself. If I had the time now I would tell you how I became such an epicurean."[21] Obviously, she enjoyed a more fulfilling social life in New York than she had in Boston. She kept busy "with work of other people & the few necessary things that I must do for myself such as cooking, washing, no ironing! taking care of my cat and scrubbing the floor for his benefit," and more cooking.

Angel's culinary experiments, even when they led to dinner parties, still left her empty. She began to express nostalgia for Nebraska. As she conveyed to Folsom, "yesterday I felt as divinely lazy I thought it worth while to give up to it so I sat by my window in the warm sun light and played on my Indian flute. I played till I felt quite sentimental & homesick for the west, for you know you can't play anything else than love songs on the instrument." Carlisle's report on her recent visit only added insult to injury, she complained. "I was styled as '*plain* and *unassuming*.'

It reminded me of the story they tell of a farmer & his wife who went to a circus and as they stood before the hippotamus's [*sic*] cage, the farmer made the remark, 'My, ain't he *plain!*' I felt very shy & out of place at C. As the result of my own cookery I *am* getting very fat."[22] Folsom's gift of a photograph of Hampton served as a reminder of her passing youth. It also made her feel "old & 'plain,'" she said, but added graciously, "to think of the years that I was there counteracts all that sad feeling." Nevertheless, her hair was "slowly & surely turning gray." "I pull them out for I don't think it is becoming to an Indian," she confided.[23]

§

Angel worked on several projects in 1903 besides the work she was doing for the St. Louis World's Fair. In February she employed models most of the month. The same month Folsom asked her if "Dr. E" was in touch with her about an upcoming project. She wasn't sure who this was, but it was Dr. Charles Eastman, husband of her old Hampton teacher, Elaine Goodale.[24] Nothing seemed to come of "the proposition" Folsom hinted at, but the interesting couple, whose engagement coincided with Wounded Knee, would provide work for Angel in the future.

By May of 1903 Angel's life was taken up with family affairs. William Clapp died quite suddenly, leaving Gertrude a widow with a young daughter "in quite straightened circumstances." Angel felt the loss keenly after seeing the strong woman who cared for her for over ten years grief stricken and low on money. During the summer, Mary Sampson came "on outing" from Carlisle to stay in New York through the summer.[25] How the two sisters got along is unknown. Angel seems to have felt more responsible than close with her sisters. In particular, her relationship with Julia was troubled.

§

Julia De Cora, one of Hampton's reluctant cultural missionaries, lived a life quite different than her sister. The expectations of Hampton staff put further strain on her relationship with Angel. Julia's employment at Fort Berthold marked the beginning of a long list of unsatisfying Indian Service jobs, made more so by Angel's seemingly glamorous career. As Annie Dawson's substitute in 1898, Julia made rounds to reservation homes to show women how to do modern housekeeping. After some months, she tired of the unsatisfying work and North Dakota's brutal weather.[26] Besides the rugged conditions at Fort Berthold, Julia felt alienated and isolated. By Christmas of 1899, she was back in Nebraska living with friends just north of the Winnebago Agency.

Like her sister, she kept in touch with Folsom, but Julia had no illusion that Folsom was interested in much more than her progress as a returned

student. "I am not doing anything just now but to nurse some rheumatic joints I brought from Fort Berthold," she wrote Folsom.[27] She visited "friends both white and red" on the Winnebago reservation, but she complained that the Presbyterian minister and his wife, who ran the mission school, "do not take to me," a common occurrence for Julia. When she went to a traditional Medicine Lodge dance "to collect some material for Angel from the old people," the minister gave her "a little lecture on morality," she complained. "Have not gone back to the blanket as yet," she joked sarcastically, "may not for a while yet." Julia knew what Hampton expected of her, and this led to her defensiveness. Wearing civilian dress, performing the domestic arts, embracing Protestantism, practicing temperance, and watching carefully the company one kept is what marked a good female returned student. Julia realized quickly, however, that Angel was not required to meet the same expectations as she was.

Like many returned students, such as Julia St. Cyr, Julia De Cora served as a conduit from her reservation to Hampton staff. She often reported on alumni, such as her cousin, Louis Amelle, and his wife, Josephine, who were "doing well." She chastised as well as she praised, however. "I am proud of Hampton's dim lights but not the glaring ones like Tom Sloan and David St. Cyr [Julia's brother]. I may tell you something about Tom some day but not now."

While Angel painted and studied in Boston, Julia stayed home through the summer of 1900 until August, when she became assistant matron for the Zuni school in New Mexico.[28] She requested a transfer the next year, allegedly due to the hot and dry climate, and secured an appointment as assistant matron at the Rosebud Agency boarding school in South Dakota. By the end of 1902 she defended herself to Folsom for having been named in a financial scandal when she was at Fort Berthold, where, she reminded Folsom with sarcasm, "kind friends" had "arranged" for her "to go as Annie Dawson's substitute."[29] She told Folsom she "used all the money I got right back on the people and my rent money went the same road and need I say, my health too?"[30] "Whoever was unkind enough to tell those things (I don't really know what they are) about me was mean enough to tell any amount of untruths," declared Julia. "It is like striking a man down in the dark where he cannot defend himself."[31] Julia's growing feeling that her own sister might be the source of "any amount of untruths" fueled her hostility.

Hampton staff, like Folsom, hounded returned students about maintaining a good reputation. Not only did someone defame Julia's character, but that same someone also accused her of "slovenly habits." Despite her acerbic personality, Julia's ire was justified. "A person can't dress in

the height of fashion doing the work I have done and am still doing," she responded, "and for a time I really did not have a cent to put in clothes." Julia fretted that her favorite teacher, Mary Galpin, "heard all this ill-natured stuff." "I couldn't bear to have her think of me as going to the dogs over a gallop," she said. But deep disappointment lay behind Julia's defensive façade. Not only did Folsom constantly compare her to her older sister, but she made Julia feel that the value of her reputation was how it reflected on Angel's. "Please make some effort to know me as I really am among my own friends," she entreated Folsom. "I actually am human, and I hope, I have some of the attributes of my kind."

Julia found herself thrown into one difficult environment after the other—to sink or swim, while Hampton expected her gratitude.[32] Julia did not have Gertrude Simmons's rebellious fortitude. She, again, disliked her job at the Rosebud Agency. Although the agent and his wife were kind, she felt "too old to be working for so little."[33] "I do not care to work in Gov't schools all my life," she confided to Folsom, after they had made amends. "I mean to go on my farm some day and start a chicken farm," adding with obvious self-pity, "and if I can help poor helpless returned students, I'll do it."[34] By the spring of 1903 Julia left Rosebud for a temporary position as the Winnebago Agency's seamstress. While Mary Sampson spent an exciting summer with her relatively famous sister in New York City, Julia moved in with her uncle, Joseph Lamere, and spent her summer on the reservation.[35] The pattern of frequently changing jobs reflects the instability of the Indian service as much as it shows Julia's unwillingness to silently endure unfulfilling situations. If she had been married, like Annie Dawson or Zitkala-Ša, an Indian service job might do. As it was, it entailed too much work and self-sacrifice for too little reward.

§

Before the onset of winter, Angel left the Schumms' residence for a quieter, warmer place. At first she enjoyed the social life they provided, but eventually it was too much for an introverted, working artist. She moved into the third floor of a brownstone apartment building, ten blocks further up Broadway to 546 West 165th Street.[36] The only other occupant was an unidentified friend, "Mrs. M," who rented her a room and allowed her to share "the kitchen stove."

The holidays provided Angel little relief from work. She visited Gertrude and Louisa at Thanksgiving, but it was not a happy time. Gertrude found it hard "to bear the loss" of her husband. Just before Christmas, Angel wrote Folsom wishing her "all the Xmas joys once more" and asking her to return the "panel picture" from Buffalo, because she

knew "of a place where it is wanted." She did not want to leave her work to spend Christmas in Northampton. She spent December ill much of the time but, in January, she assured Folsom, "I had a beautiful Xmas tho' I had to work all day for others, making 'jim crack' etc but on the whole I am glad people think them must have 'jim-cracks.'" She also thanked Folsom for a Christmas gift, a "pocket book from Germany" that she intended to keep "filled with change at least if not green backs."[37]

Josephine Richards checked up on Angel just after the new year at her "bright & cheery" apartment house. Richards told Folsom the "private" and "retired air" of the place was "so utterly different" from Angel's first New York apartment. "While I was waiting for Angel in the sitting room, which had books & plants, she recounted, Mrs M. "was hard at work on her type writer. Lest we disturb her, Angel took me down the narrow hallway, from which the bed rooms & bathroom open, to the little dining room, its walls adorned with some of her sketches. I did not find out very much about her financial situation, except that I judged money was by no means plenty. You know she does some other work besides her art to help out.[38]

Angel informed Richards she recently "sent some of her sketches for the Government Exhibit at St. Louis & that there was *some* prospect that one would be sold." She also mentioned that Charles Lummis had contacted her to write "something for his magazine." Angel still had not responded to his letter, Richards said, which arrived when Angel was sick, but she was attempting to "write one or two stories" to send to him. "She is very uncomplaining, but I do long to have her life open out more," Richards confided. "As you say, she seems very much alone, & it seems as if she had hardly realized, perhaps, how desirable it was that she keep in touch with people. If only she could have another summer out West, make a lot of new sketches & get fresh inspiration for her work!"

In actuality, Angel was painting "some 'original' works," as she described them, that she planned to have a friend critique.[39] Perhaps, as much to stroke Angel's confidence as to promote Hampton Institute, the February edition of the *Southern Workman* featured its Indian artist alumna as "a convincing refutation of the pessimistic charge of worthlessness." Accompanied by an illustration from *Old Indian Legends*, the snippet reminded readers of the "honorable place in the ranks of magazine illustrators and writers" Angel held. The same month Angel wrote Folsom and again requested she return the panel piece. She decided it was "a meaningless thing with out the surroundings it was designed for," but was not sure what she would do with it. She admitted that the mysterious "Mrs. M." was getting on her nerves. Apparently, her landlady and housemate had been

in charge of running a girl's school and liked to play matron with Angel. "Whenever an indication of this delusion arises," said Angel, "I give her a deliberate 'Wh-a-a-at!' and a steady glare which usually is sufficient. Her school ma'am dignity is a transitory thing and her 'temperament' a calico patch-work."

Financial problems still plagued her. Gertrude sent money for a train ticket to Northampton, but she confessed to Folsom, "I am tempted to spend it for the Sportsmen Show or for a chicken, luxuries that come only once a year. I wish they had kept the money themselves. Every time I open my bureau drawer I have to sing 'Yield to temptation' and I would like to change my tune."[40] Someone had also been sending her Carlisle's school newspaper. "I have thoroughly come under Col. Pratt's hy[p]notic influence & I am a genuine case of 'Stick,'" she joked. "A stick that is stuck in New York and can't promise any visits," she added. At the end of the month Angel again reminded Folsom the "panel decoration is wanted elsewhere," and asked her to send it right away so she could "make some changes on the canvas."[41]

In March the *Congregationalist and Christian World* featured an article by Folsom titled, "The Careers of Three Indian Women," under the magazine's section, "The Home and Its Outlook." Folsom's piece highlighted the accomplishments of Hampton's most successful female graduates: Anna Dawson Wilde, Dr. Susan La Flesche Picotte (sister of Francis), and, of course, Angel De Cora. The careers of the first two women exceeded Hampton's criteria for a cultural missionary. Folsom praised the "quiet, intelligent work" of agency matron Annie Dawson Wilde, and the selfless work of Omaha physician Susan La Flesche Picotte, who "gave her skill to both her Indian and white neighbors."[42] Angel didn't quite fit the missionary bill, but Folsom tweaked the facts to meet the requirements. As "a Winnebago artist," Angel "made her profession serve her people while she herself is living apart from them," Folsom wrote. She praised Angel's character, which Hampton, of course, had a big part in shaping. "For the past two years Miss de Cora has been in New York city, steadily and quietly at work," she wrote. "She is her own housekeeper, cook, and dressmaker, and except for a beautiful cat, she is herself the only member of her cheerful but modest household. How much strength of character this requires in an Indian young woman few white women can know, but strength comes with its exercise and she, with other of her race, is learning this lesson."

Angel was not exactly thrilled by Folsom's patronizing gesture, when Folsom notified her that the article would soon appear in print. "I can't say that I am pleased about being written about," Angel said, "but I can't

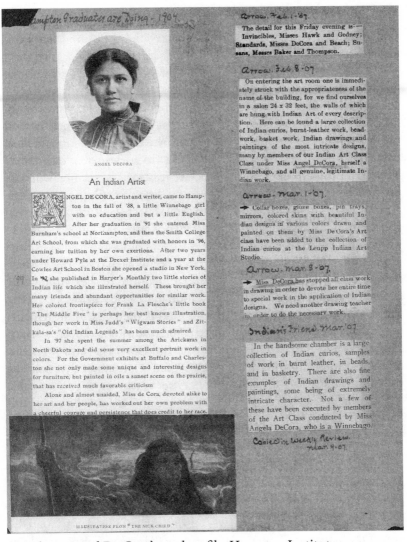

Page from Angel De Cora's student file, Hampton Institute.
(Courtesy of Hampton University Archives)

be *dis*pleased with you only I hope you didn't or the editors won't put me under the head of 'Prominent Colored Women.'" Angel chafed at publicity, especially when it typecast her as a racial being not equal to whites. Hampton tried to develop "race pride," but not always in flattering ways. In a public relations piece titled, "What Hampton Graduates Are Doing," Folsom (probably) similarly sketched Angel's character: "Alone and almost unaided, Miss de Cora, devoted alike to her art and

her people, has worked out her own problems with a cheerful courage and persistence that does credit to her race."[43] Angel found the back-handed compliments tiresome.

Angel decided to fix the panel piece so it would "look more of a picture." She was going to send it to St. Louis, too, although Folsom hoped to purchase it. Angel's heart was not in this work, because it brought back bad memories of Boston. It also made her feel as if she had accomplished very little. To ward off the blues, she took to cooking. "I bake potatoes fine & also short cakes! This seems to be the extent of my ability in the culinary art," she relayed to Folsom. "Well after working steadily & hard all day I felt the need of a little diversion so I went out a[nd] bought a few sticks of rhubarb for a short cake stuffing. It was so good that it fairly melted by the mere glance and Mrs von E & I ate the whole business up, there being little else than the cake."[44]

Angel tried "to get into some larger work." In March she filled "three orders," telling Richards, "It may be too pretentious of me to undertake such things but I have an idea that if good many people now successful were to look back to their amateurish days & their first achievements they would blush."[45] Angel reassured Richards, who had been worried about her social life, "I have undertaken to hold several strings & a friend at the end of each string to help & suggest." Consequently, Richards wrote Folsom, "Angel sounded very brave & plucky."

Meanwhile, her sister prepared for a civil service exam to become head matron. Julia hoped it would lead to a teaching position. She sent "money for school books" to Hampton, and told one staff member that she "was sick and tired of getting positions simply because she happened to be an Indian."[46] Shortly after, however, someone sent Folsom a clipping from a Virginia newspaper titled "Indian Maid Seeks Government Place: Miss De Cora, of Winnebago Reservation, Pretty and Bashful, Takes Examination." The "sensational story" was reprinted from the May 3, 1904, edition of the *Sioux City Tribune*. After reading the article, Folsom was livid and not impressed to learn, "Miss De Cora's one regret is that she did not remain to teach at Hampton, but love for her Indian mother on the Winnebago reservation prompted her to return to the west."

Julia denied ever being interviewed, but someone may have leaked her story. Although a case of yellow journalism, the article was based on true events, as Julia later admitted. The rhetoric of the piece expressed society's critical and racist view of an educated Indian woman. The reporter began, "life on the reservation had lost its charms for the Indian maid, who learned to her sorrow that 'a little learning is a dangerous thing' for a squaw."[47] Caught between her education and affection for home, the

reporter claimed, Julia wished she "had never seen a book, then I might be happy on the reservation." "Now, I am avoided by my own people and the whites have no use for an Indian girl, at least in business," Julia allegedly stated.

The report also disclosed why Angel and Julia were leery of their step-father and told why "kind friends" arranged for Julia to go to Fort Berthold in 1898. One winter night, Peter Sampson brought "the worst Indians on the reservation, and even the lower whites, to our house," the reporter quoted Julia. "What with their threats and language they used, we were afraid to retire for the night." As she and her four stepsis-ters "huddled in a corner too frightened to move," she allegedly worried, "the war dance was next on the program." Julia fled, "walking five miles, barefooted, over ice-covered fields between 3 and 4 o'clock in the morn-ing, to the house of a cousin." The reporter compared her escape to Topsy's in *Uncle Tom's Cabin*. Her "rescue," apparently, entailed remov-ing her to Fort Berthold.

When Julia returned again to the reservation in 1903 as the agency's temporary seamstress, according to the piece, she "kept away from wild-eyed Pete." The reporter complimented Julia's skill as a seamstress, but caricatured her stepfather, who joined other "Indians" in their contempt for an educated Indian maid: "'One good squaw gone daffy,' grunted Bad Pete." The reporter noted the celebrity of Julia's sister, who, he claimed, was educated as an artist by "a wealthy Eastern woman." The article provided a titillating read for the general public, but Folsom was far from amused. For the time being, Angel didn't know of the scandal and had other concerns on her mind.

§

The St. Louis World's Fair, formerly the Louisiana Purchase Exposi-tion, opened on April 30, 1904. Angel received a commission to do a piece for the Indian Industrial Schools exhibit. She had "visionary ideas about St. Louis," she told Folsom, "but I guess I must be satisfied with the visions only for I must stay right here & work."[48] Even though work consumed her, Angel's emotional health was good. She asked Folsom for the address of an old school mate and managed to stay in touch with Gertrude, as well as with Charles and Elaine Eastman. "While I was in Northampton I visited the Eastmans in Amherst," she wrote Folsom. "Jerusalem the golden! but what a handsome brood they've got. It was a feast for the eye [and] a *grand* chorus for the ear!" Angel's tendency to isolate herself diminished for the time being.

She grew more protective of her public image. She read Folsom's piece in the *Congregationalist* and thought it was "all right—what I objected

to was that I was not asked to do it myself." Just as she became more concerned about publicity, however, she wanted to know about her sister. "I have not seen that sensational article about Julia," she told Folsom. "Please send it to me as soon as it is convenient to you—I have written to her again & again but no answer."

During the summer of 1904, Angel managed to get to St. Louis and visited her mother after a long absence.[49] Did she come home because the reservation was relatively close to St. Louis? Or did she visit St. Louis, because she thought she should come home to attend to her family's dirty laundry? Whatever her motivation, she and Julia came to emotional blows that summer. Julia's bitter reaction to the event, relayed to Folsom in January of the following year, is all that remains to document Angel's return home.

"I suppose Angel <u>de</u> Cora has told you of our little 'difference' of last summer," Julia began. "I have my side to that affair and it looks all right to me. All I have to say about her is that *loyalty* to *anything* is an unknown quantity with her. The best people at Winnebago believe in me and are my friends in spite of all the dirty talk she got up about me."[50] Angel's decision to give the name she shared with her sister a French affectation irked Julia (as indicated by the three, bold underlines she marked under "de"). Perhaps it symbolized to her Angel's growing separation from her family, as well as the disparity between Angel's position in society and her own.

Julia denied any involvement with "that sensational article." "There was enough truth in it to make denial impossible but as you know," she added, "There were several strains of 'romances' running thro' the piece. I did go to Sioux City and I stayed with some Sisters at St. Vincent's Home but I never saw a reporter and if I had they are not the ones I'd choose to pour my tales of woe to." Folsom's overbearing vigilance sharpened Julia's feelings of jealousy and sibling rivalry. "I think my life will be smoother and happier than it has been since leaving school now thanks to that 'angelic' (?) sister of mine," wrote Julia sarcastically. "I have cut loose from all my relatives. I shall try and dispose of my allotment and my interest in our heirship lands so I'll be free from the Tribe hereafter."

Julia held a grudge against Angel for years, while Angel's side of the story never emerged.[51] No letters in her student file speak of it. Writing later to another Hampton teacher, Julia remarked on the summer of 1904. "Angel and I had a terrific 'falling out' about three years ago and we haven't exchanged a word as yet but in order to have a kindly outlook towards the world, I think it is best not to have too much to do with

her."[52] She firmly believed her sister wielded power to shape perceptions of her. She wondered, she wrote, if Folsom still had "great admiration for me?" She warned that Angel would be "sure to tell a whole lot of fibs (big black ones at that) to Miss Folsom and my record will be something to bring blushes to the cheeks of Beelzebub." As always, she felt the need to defend her character. "These friends of mine met Angel & they actually preferred me to her. So you see I can't be altogether *satanic*." She further explained that she was not "trying to run her down," but stressed Angel "repeatedly tried her best to turn my most intimate friends against me," even telling "the agent and his wife that I was of unsound mind and very immoral."

According to Julia, Angel, as "A. de C." the modern artist, was not only backstabbing her, but was pretentious and immoral herself. Julia did not suppress her pent up wrath. She compared Angel to their cousin, Louis Amelle. While Angel rejected Christianity, Amelle used it to "cloak his hypocrisy." Julia said she felt "out of place" with her family and charged Angel with being a bad influence on their mother and half sisters. "I have done all in my power to discourage mother from smoking," she claimed. But Angel brought "a jar of strong tobacco" when she visited, and now "mother 'smokes incessantly [*sic*].'" Further, she claimed, Angel's "half sisters took it for approval of tobacco on her part and the youngest girl joined the ranks right away."

Interestingly, Julia also relayed that Angel told their mother "religion was an old worn-out theory and only ignorant people believe in such any more." She hoped to "reason mother out of her narrow Catholic belief and replace it for the 'worship of the *Beautiful*.'" Her accusations support Angel's adoption of aestheticism. How genuine she was in her quest to convert their mother from Catholicism is another matter. Was Angel sincere or was she simply goading her self-righteous sister? "I came away before the fruits of her labors came into evidence so I can- not tell how the new worship is progressing," said Julia. "As Mother has 'worshipped' a very (*un*)Beautiful husband so many years, she may still continue in that direction instead of filling the gap (left by her religion) for the beautiful in Nature and Art."

Was Angel so devoted to the "worship of the Beautiful" that she tried to convert her Catholic mother to aesthetic paganism? It's doubtful, but Angel made a comment to Folsom that suggests that she might have expressed her beliefs to others. Gertrude Simmons provoked Pratt's ire for an attack on Indian missionary schools in her short story, "The Soft Hearted Sioux."[53] Pratt immediately launched his usual very public protest. He condemned her "morally bad" story as "trash," and called her

"worse than pagan."[54] Her response was an essay titled, "Why I am Pagan," published by the *Atlantic Monthly* in December of 1902.[55] The essay not only calls Christianity to account, it pronounces all "fellow creatures" are "akin" and offers the worship of nature as an alternative to the "after-doom of hell fire." While Pratt fumed at her response, Angel wondered to Folsom from whom did Gertrude "borrow" her "ideas?"[56] She may have seen her own influence. Gertrude's ideas sounded much like the aestheticism Angel learned at Smith College's School of Art.

Tainted with resentment and fueled by paranoia, Julia's recollection of the summer of 1904, apart from Angel's credo to "worship of the beautiful," offers some insight into Angel's relationship with her mother and sisters. She may have performed as a role model, even for her mother. Unfortunately, the heated rift that began that summer between Angel and Julia turned to a cold chasm for the remainder of Angel's life. For Angel the issue, besides Julia's jealousy, centered on unwanted publicity and shame on the family. For Julia it centered on loyalty. As much as Julia spoke of cutting family ties after the "falling out," Angel, in fact, would be the sister who distanced herself from her family and the Winnebago reservation, supporting Julia's point. It's doubtful that she returned home for more than one or two visits, if any, for the remainder of her life.

§

The family squabble at Winnebago lost some of its bitter aftertaste when Angel went to St. Louis. President Theodore Roosevelt opened the World's Fair with an address commemorating the centennial of the Louisiana Purchase. Roosevelt's speech pointed to his policy of avid expansionism and gestured to his heroic charge up San Juan Hill. The Philippines, Guam, Puerto Rico, and, to some extent, Cuba, as spoils of the recent Spanish American War, brought an assortment of new indigenous peoples under the "care" of the United States. Roosevelt cloaked his imperialism with the historic land deal of 1803. The Louisiana Purchase validated U.S. expansionism and made it part of a contiguous expression of nationalism and patriotism.

Although intracontinental Manifest Destiny had exhausted itself, the fair commemorated acquisitions from within the continent in order to support those from without. Commissioner of Indian Affairs Jones created a model Indian school, alongside which a "before" group of "uncivilized" Indians were exhibited. Samuel M. McCowan, superintendent of the Chilocco Indian School in Oklahoma, had charge of the exhibition, including the "transfer of Indian families and pupils from their homes and schools to St. Louis."[57]

McCowan gathered resources and American Indian people with their native accoutrements from reservations around the country. He encouraged students and teachers from Chilocco to come to St. Louis and create a blockbuster exhibit. According to the *Final Report of the Louisiana Purchase Exposition Commission*, "The exhibit occupied a reservation of about 10 acres in the northwest corner of the fair grounds and its location at the extreme end of the anthropological exhibit typified the advancement of a primitive people toward civilization. Around the border of the reservation were arranged in a semicircle the native dwellings of the 'blanket' or uncivilized Indians . . . erected by the Indian themselves."[58]

The commissioner's plan stressed reservation over off-reservation schooling, promoting a new emphasis for Indian education. Consequently, he ordered McCowan to assemble "100 pupils of different grades" with as many of their parents "gathered in the family groups" as possible. The commissioner wanted to feature "training the youth in the sight of their parents in order that all may rise together toward the plane of self-supporting and self-respecting citizenship."[59] The purpose of the exhibition was to show "at a glance the contrast between the old and the new, the barbaric and the enlightened."

McCowan and his team recruited 310 participants from tribal groups in Arizona, Oklahoma, New Mexico, South Dakota, Minnesota, and California.[60] The recruits brought with them the makings for bark houses, kees, a stockade tepee, a ceremonial earth lodge, and a grass lodge. Geronimo, "the great Apache medicine man," inhabited a decorated tepee. "On one side the Indians were shown in their native dress engaged in the manufacture of Indian articles of use and ornament," reported the *Scientific American*, while on the other, "the children of the native tribes were shown, dressed in modern costume, handling modern tools, and engaged in modern manufacture."[61]

Among the Native craftmakers Angel could observe were Arapahos beading buckskin, Navajos weaving blankets, basket weaving by Apache women, and Sioux creating decorative buckskin items. Southwestern potters and Navajo silver workers showed off their skills, as well as wampum makers from the west coast. The Maricopas and Pomos were among the basket makers.[62]

The Mission-style, two-story school building was staged on a "reservation." Hallways ran the length of two sides and contained booths for the exhibits. The model school provided McCowan the opportunity to show off Chilocco's brand of industrial training. His female students demonstrated their competency in the domestic arts, such as laundry work and "up-to-date cooking." And they also undertook the finer art

of serving a meal, Euro-American style, in "a very dainty dining room set out with its china and glass." Like Buffalo's exposition, students constructed the furniture.[63] A blacksmith shop performed its craft and a working "printing outfit" offered visitors their own copy of the Chilocco school paper. Another room displayed "native grasses and a model of an educated Indian's farm."[64]

The exhibit wasn't limited to Chilocco's accomplishments. Haskell Institute students from Lawrence, Kansas, demonstrated manual training as well as the domestic arts. The Genoa Indian school of Nebraska hosted a harness-making class. Various schools exhibited works of "penmanship, literary composition, arithmetic, sewing, lace work, bead work, and basketry." Notable, however, was the absence of Carlisle. It represented old-fashioned Indian education and Pratt's views that Indians should separate themselves from their reservations.

The daily schedule from reveille to taps lent authenticity to the model Indian school. Visitors could enjoy classes in music and literature. Students performed dress parades, band concerts, and a "musical-literary programme" that included recitations and an oration titled "Old and New Indians." Between thirty and fifty thousand visitors attended these three events alone. The fair's final report concluded that the "people of the country have seen the progress made by the Indian in the Government schools, and will no longer refuse to give the work their substantial support."

These exhibits were not the first of their kind, as shown by Angel's previous contributions. But something had changed in the way the public received them. Her painting *Medicine Lodge*, which donned the halls of the model Indian school, still represented the apex of Indian reform.[65] But if the intent of the exhibit was to provide a contrast between the "old Indian artisans . . . engaged in primitive manual operations" and the modern pupils of the Indian training schools, then Angel's artwork supported the modern ideals of the Progressive era. Her work not only displayed the primitive elements favored by the progressives, but it promoted "uplift" and proved modern Indians could "progress," despite earlier evolutionary beliefs to the contrary.[66] No longer did Angel represent a special case of Indian education, now anyone could aspire if they rigorously applied themselves.

Angel was not the only talented artist displaying work at the exhibit. "William Dietz, a full-blooded Sioux," gained national attention in the *Washington Post*. "Striking Things Seen at the World's Fair" described his mural that "adorns the wall in the display parlor of the Indian School." The "life-size representation," depicted "a Sioux brave on the

war path."[67] Chilocco's school paper offered more details: "W. H. Dietz an Indian is the artist of a scene done in grains, representing an Indian hunting ground, with an Indian drawing a bow. The drawing is filled with grains of all kind grown on the Chilocco school farm, the moccasins being made of rice and red corn in a checkered pattern."[68]

Angel noticed the mural, and she also acknowledged the muralist. William Henry Dietz was tall and handsome with a friendly, outgoing personality. He was an imposing athlete as well, who participated in "Anthropology Days," a two-day sideshow at the fair to promote the first U.S. Olympic Games.[69] Whether she attended the event, she was introduced to the charismatic Indian artist, who, unfortunately, was nearly fourteen years her junior.[70] Nonetheless, they would reunite in the future.

Why Dietz participated in the Indian School Exposition is unknown. He was brought up in Rice Lake, Wisconsin, where he attended high school. He did not finish his senior year, but his white parents enrolled him as a "special course" student at Macalester College in St. Paul in the fall of 1902, and again in the fall of 1903. During this time he injured his knee playing football. On March 21, 1904, he enrolled for an "unconditional term" at Chilocco.[71] But the following April 1, his hometown newspaper stated: "Willie Deitz [as the family name was also often spelled] who is at Minneapolis taking a special course in the work necessary to perfect him in his drawing has been making some very clever sketches during the winter, and is likely to get a good position, as soon as it becomes known what good work he can do."[72]

Apparently, his parents weren't notified of his change of plans, until at least the summer of 1904 when, on June 17, the local paper reported "Word comes from Willie Dietz that he is at the World's Fair."[73] Strangely, his name does not appear on attendance records for Chilocco at anytime during 1904, even though an illustration by "Wm. Deitz, Sioux, Chilocco" appeared in the December 1904 issue of the school paper.[74] If Dietz ever attended classes at Chilocco, his name was expunged from the records. He was, however, paid as an "irregular employee" for thirty days of work as a laborer for the fair on September 30, 1904, by Chilocco School's clerk, and identified as one of the "football crew."

McCowan's interest in Dietz was not just as an Indian artist, but also as an Indian athlete. "Blake White Bear, Charles Inknish and Wm. Deitz will report to you tomorrow," McCowan alerted a school employee on August 27, 1904. "They are to be enrolled as pupils and will play football . . . Tell Dugan to be particular about training Deitz and don't let him

injure his knee on the start."[75] One scholar explains this was "a time when the school was expanding its football program from intramural to interscholastic status" and that requirements for student football players may have been lax.[76] Many times in his future Dietz claimed Chilocco Indian School as his alma mater. However, immediately after the first and only football game he played for the school team when he allegedly began attending in the fall of 1904, he enrolled as an unclassified major at Friends University, a Quaker college, in Wichita, Kansas, where he resumed playing football.[77]

The mysteries surrounding Dietz's past compounded over the years. The lies from the truth were hard to distinguish. There is no record of Dietz from his days at Friends until 1907, when he made his way to Carlisle. Likewise, did he and Angel correspond after St. Louis? Did they ever meet after the fair? Did he pursue her or did she seek him out? If anything happened after their fateful meeting at the World's fair, Angel kept it to herself.

§

Angel returned from her trip west to New York City by the fall of 1904, accompanied by her ten-year-old niece, Madelyn Rickman, the daughter of Louisa Sampson.[78] Angel took on the task of finding a school for Madelyn, who may have been odd girl out in a household headed by her stepfather. Angel felt duty bound to remove her niece from the reservation. In September she enrolled Madelyn in the progressive Ethical Culture School in Manhattan, where she would remain for the next two years. The school's mission statement must have appealed to Angel.[79] Established by Felix Adler, it emphasized ethical behavior over "religious superstition." Adler was a Jewish immigrant and the son of a rabbi, but he believed in a "reformed Judaism" in which "spirituality is the consciousness of interconnectedness."[80] He also subscribed to German philosopher Immanuel Kant's "categorical imperative," which he transformed to the moral precept, "eliciting the best." Like Kant, he supported an "active moral engagement with the world." This engagement included a respect for the value and diversity of each human being.[81] He encouraged students to express themselves through painting, writing, and other creative activities. Even better, the school was a pleasant walk along Central Park's west from Angel's flat.

That November, while Angel tended to Madelyn, Theodore Roosevelt tended to the country that elected him for the first time. Despite his belief in the "white man's burden," many educated Indians supported Roosevelt's progressive reform agenda and were attracted to his rejection of the aesthete, his ruggedness and love of the outdoors. Roosevelt

attempted to reform the reservation system through promoting coop-
eration between "the workers in the field" and "the Indian Office in
Washington," proposing "a more direct union" between them. This new
policy, he stressed, would help to "lift up the savage toward that self-
help and self-reliance which constitute the man."[82]

In this political climate of cooperation, the U.S. Grand Jury reported
on the condition of the Winnebago Reservation. It found "a large num-
ber of the 1,100 Winnebago Indians are in a sad and deplorable condi-
tion," and concluded such deprivation was "brought about by the
unlawful sale of liquor to the Indians and their utter disregard of any
marriage ceremony." Although the report outlined the destructive effect
of bootlegging on and near the reservation, it emphasized the commu-
nity's disregard for legal marriage. This suggests that the reservation's
Catholic priest offered the brunt of the testimony.[83] He complained that
more and more women were becoming "demoralized." The "deplorable
conditions" further severed Angel's ties with home.

§

The days Angel spent carving out her livelihood in New York were not
easy for the reclusive artist. "Much of the time she lived alone, doing all
her own work," Folsom wrote of her, "and often finding the wolf very
near her door. Too Indian to consider money values and too modest to
push her own work, she made far more gifts than sales," Folsom wrote,
"and her work suffered often for the want of good business manage-
ment."[84] To combat the wolf, Folsom was relieved when Angel discov-
ered designing could be a "lucrative branch of art."[85] With the new year
of 1905, Angel let go of the aesthetics' dream of "art for art's sake." She
turned instead to something more appropriate to the ideals of her pro-
gressive society, the scientific study and the popularization of Native
Indian art.

Creating a School of Design

In early May of 1905 Hampton celebrated its thirty-seventh anniversary, but Angel found herself unable to attend the festivities.[1] She was busy creating designs for a manuscript, titled simply *The Indians' Book*. The book's compiler, Natalie Curtis, described the book as, "An Offering of the American Indians of Indian Lore, Musical and Narrative, to Form a Record of the Songs and Legends of Their Race." She emphatically stated: "Indians are the authors of this volume. The songs and stories are theirs; the drawings, cover-design, and title-pages were made by them. The work of the recorder has been but the collecting, editing, and arranging of the Indians' contributions." In fact, later in June, Curtis met with Mary Sampson, who was still at Carlisle. Sampson apparently helped Curtis in some capacity with the contents of the Winnebago chapter. Curtis gives Mary's father, Peter Sampson or "Wave," credit for several stories and songs in the Winnebago section of *The Indians' Book*.

Two years earlier, the twenty-five-year-old Curtis and her brother traveled to the Southwest, where, she said, she "heard for the first time the music of Native American Indians."[2] Alice Fletcher before her (to whom she pays tribute in her book) recorded Indian music, but Fletcher heard it as an ethnographer, while Curtis had the ear of a trained concert musician. The soulful music of America's first peoples overwhelmed the young woman, and she immediately committed to recording it. Like many Progressive era professional women, including Angel, Curtis functioned as a bridge. Her work popularized the music and folklore of the "dispossessed" during an era when male professionals specialized as elite and aloof producers or practitioners of scientific knowledge.[3]

Curtis came from a prominent New York family. Her father was a respected physician and her uncle was George William Curtis, editor of *Harper's Weekly*.[4] Her "feisty, sparkling personality" drew many to her, including family friend Theodore Roosevelt. How Angel met her is unknown, but she eagerly applied herself to designing the title page and the book's chapter lettering.

Initially, designing helped relieve Angel's ambivalence about illustrating; later it became a satisfying end in itself. After Angel's death, Curtis recalled the ebullient presence of the budding designer, who "started her career by illustrating books of Indian tales," but "later looked down upon these early efforts, for her greatest work lay in decorative design." Her recollections reveal Angel's early role in popularizing American Indian design.

"I asked Angel De Cora to make a design for the title-page of her own tribe, the Winnebago people," recalled Curtis. "When she brought me the finished page, it bore, in addition to the design, the legend, 'Lake Indians—Winnebago,' in letters so beautiful and of such startling originality that my publishers declared: 'We can't have one page looking like this and the others labeled with prosaic printing! We must have this sort of lettering all through the book.'"[5]

According to Curtis, her publisher's designer stated, "I never saw anything like this in my life before." He found Angel's style modern and yet traditionally "Indian." She conceived "the letters as structural ideas for decorative forms . . . something unlike anything that's ever been done with the alphabet before." The designer insisted Angel create all the chapter headings, Curtis recounted, because he believed "no white man" was equal to the task. Angel "invented a different kind of lettering for every Indian picture, and the forms of the letters were composed of motifs from the drawings which they accompanied."[6] In retrospect, it may be difficult to discern the originality of Angel's work, because it was adopted by popular culture.

It is not hard to imagine the effect such grand praise had on a struggling artist with the wolf at her door. Moreover, Angel felt connected to the work she did for Curtis. Like the thunderbird for the cover of *The Middle Five*, Angel chose the "conventionalized form" of an eagle for the title page of *The Indians' Book*, which Curtis described as "the giver of life, the celestial emblem of divine force."[7] At last, the symbols of Angel's "native haunts" could be foregrounded in her work.

The same year Curtis and Angel collaborated, President Roosevelt appointed Francis E. Leupp as Commissioner of Indian Affairs. Leupp was a mutual friend of Roosevelt and Curtis, who introduced him to Angel.[8] But the two probably had already met at the Lake Mohonk Conference in 1896, and, if not, Leupp had no doubt noticed Angel's frontispiece for *The Middle Five* as well her artwork at the various Indian exhibits over the years.

In the spring, Commissioner Leupp circulated his views on "the Indian problem" as "improvement not transformation."[9] Like his president,

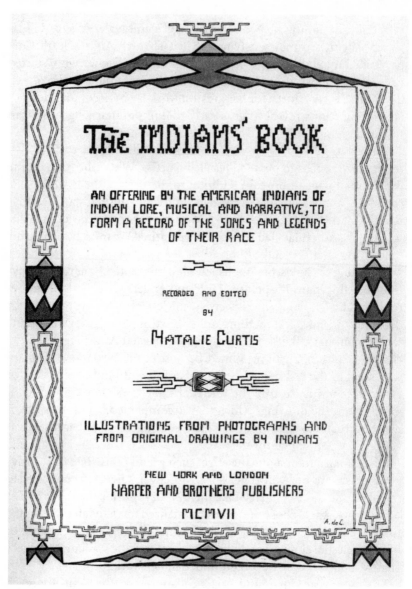

The Indians' Book title page by "A. de C.," 1907.

Leupp subscribed to progressive evolutionism (otherwise known as "reform Darwinism"). Progressive evolutionists denied Christian determinism and, instead, viewed civilization as the "development of man's latent capabilities under the action of favourable circumstances." As one historian notes: "By keeping fit and acquiring new skills, I will thus be able to promote . . . continuous improvement of the race. . . . Sloth and bad

habits, alternatively, spell biological and social degeneration."[10] This philosophy animated Roosevelt's administration, when moral and social uplift was enhanced by physical fitness and rugged individualism.[11]

Both Leupp and Angel believed "nature has set a different physical stamp upon different races of men." They assumed that "variation of types extends below the surface," manifesting itself "in mental and moral traits."[12] With regard to Indian education, Leupp proposed that nature determined what could be nurtured, a philosophy obviously antithetical to Pratt's universalism and more liberal view of the racial divide. Since 1901, when Indian Commissioner Jones deemed "the nation's Indian policy ... a miserable failure," the modern, progressive guard favored a "gradualist" program of assimilation. This shift in philosophy put Pratt's approach to Indian education under harsh scrutiny.[13]

Leupp turned to Angel's alma mater, Hampton, instead, to justify his new, race-based approach to Indian education. "No intelligent teacher at Hampton Institute . . . need be warned to confuse the Indian with the Negro," he asserted. "In his mind the differentiation is distinct. The contrast between the Negro, with his pliant fancy, his cheerful spirit under adversity, his emotional demonstrativeness, his natural impulse to obedience, and his imitative tendency, and the Indian with his intense pride of race, his reserved habit, his cumulative sense of wrong, and his scorn for the anti-patriarchal ways of the modern world, is as marked as that between shadow and sunshine."[14] Unfortunately, many educated Indians were drawn to Leupp's racist color scheme. As Leupp's administration elevated American Indians, it denigrated those with African ancestry, aligning them ideologically, if not biologically, with Darwin's apes.

Angel found herself drawn into Leupp's orb. His gradualist approach appealed to her, but, more than that, Leupp advocated the preservation of Native American art. He agreed with the reformers that the modern Indian should farm, herd, and lumber. He also agreed with the aesthetics that art and beauty uplifted society. But he further believed that America's indigenous art forms were of great value. "The vase has its place in the world as well as the ear of corn," he wrote.[15]

Leupp used Angel's life story to support his agenda. Howard Pyle's discovery of "a Winnebago girl" with "so distinct a manifestation of genius in art" illustrated how the right teacher made manifest Angel's latent talents. He agreed with Pyle's recommendation to send Angel "to live a while among her own people, study their picturesque side, and make drawings of themselves and their life for future use," while he understood why some thought it unwise "exposing this girl to the degrading atmosphere of her childhood home" (even though she went

to Fort Berthold). However Angel "had been trained among good white people; she had reached an age when she would be able to appreciate the difference between the old ways and the new, and to the latter's advantage; and she was a girl of refined womanly instincts and strong character," he explained. "If she were ever going to be able to withstand the bad influences of frontier life, she could do it then."[16]

Leupp applauded Angel's "wholesome pride of race," which, of course, made her distinctly "Indian" (and distinctly from Hampton). This attribute, he believed, "enabled her to enter sympathetically into the line of art study assigned to her, as no one who had not shared her ancestry and her experience."[17] Leupp's portrayal of Angel as an educated, but authentic, Indian artist marked her indelibly as an improved not transformed product of Indian education.

With so much to recommend her, on February 7, 1906, the *Washington Post* reported that Leupp appointed "Miss Angel Decora, a Winnebago Indian" as art teacher at Carlisle Indian School. Her qualifications for the job were unrivaled. "Her forte is reviving and bringing to the attention of the art world the effective and beautiful designs of the various tribes of North American Indians. . . . Miss Decora has labored to arouse interest and appreciation in the art work of the red man. She is an accomplished artist with the brush and pencil, as well as in other respects."

Over the years, Curtis gave two accounts of Angel's response to her appointment, the first in 1912 and the second in 1920. In the first she stated: "Miss De Cora said she would only accept this position with the understanding that she was to be allowed to develop the native art in a characteristic manner and to be left quite free to apply this art to such industries as proved practicable."[18] In the second account, published after Angel's death, Curtis depicted Angel as more adamant about the conditions of her acceptance. "I will take a Government position on one condition only . . . and that is that I shall not be expected to teach in the white man's way, but shall be given complete liberty to develop the art of my own race and to apply this, as far as possible, to various forms of art industries and crafts."[19] Curtis failed to mention whether Angel's words were Angel's, or those Leupp remembered, or words she remembered herself. Leupp's record proves he needed no convincing about the value of Native American art or an American Indian artist, such as Angel.

Just as mainstream United States awakened to the value of Native Indian art, Leupp took the opportunity to revamp the art department at Carlisle Indian School when the old art instructor left the position. How much Angel influenced his decision to do so, or how much he influenced her to help him carry out his vision, is difficult to assess.

Carlisle's art instruction produced objects of Victorian art that were now not only outdated, but could be easily and cheaply reproduced in factories. In Pratt's noble attempt to civilize the Indian, the school had turned perfectly good Indian artists into Victorian manufacturers of "trifles." In contrast, Leupp planned to channel the "natural" artistic abilities of Indian school students to create authentic works of art and to stop "racial degeneration." Moreover, products from the art classes could be sold to supplement financially floundering Indian schools, as well as the BIA.

As the arts and crafts movement changed the tastes of U.S. consumers, indigenous or "primitive" art rose in value. For the purists of the movement, the whole concept of *authentic* Indian art was antithetical to it being reproducible and made with modern machinery. When someone suggested to Leupp that a fund be set up to buy modern looms for the Navajo weavers, he explained that it was exactly the *primitive* Navajo loom as well as the primitive Navajo weaver that gave the Navajo blanket its mark of authenticity. He never explained that both had been highly influenced by Spanish colonialism, however.

Leupp's "desire that the pupils who study any kind of decorative work shall be encouraged and led to employ Indian combinations of line and color" made Angel the perfect candidate for the position. He intended to replace "Caucasian design" with "the characteristic Indian touch" on as many "products of the school shops" as possible.[20] The climate at Carlisle for such a radical move in Indian education was yet tepid—but certainly not as unwelcoming as it would have been during Pratt's tenure.

Pratt thought the BIA was a corrupt, useless institution. He did not like Roosevelt, the new emphasis on civil service reform, or the progressives. Pratt detested Leupp and would never have supported Angel's appointment. He confronted the new administration in 1904 and attacked unnamed BIA officials, stating publicly, the "Bureau is a barnacle that should be knocked off sometime."[21] As a result, he resigned, and Captain William A. Mercer of the 11th Cavalry became Carlisle's headman on July 1, 1904. Many of "Pratt's hand-picked school personnel" were transferred or their positions eliminated. Despite Mercer's military background, Pratt could not have dreamed up someone more repugnant to his pedagogical sensibilities. Mercer served the BIA as an acting agent for the Omaha and Winnebago Agency, when he was placed in charge of the Indian Congress at the Omaha exposition. To the utter dismay of the exposition's ethnologist, James Mooney, Mercer staged a wild-west spectacle, performed every day for two and a half months, in which he personally portrayed a "renegade white man" called "Great

Man Who Fights them All."[22] Mercer supported Leupp's desire for a new Native Indian art department.

§

Angel reported for duty on February 1.[23] She brought along her youngest half-sister, Grace Sampson, who had been attending the Ethical Culture School with Madelyn since November. Angel committed Grace, now eighteen, to a five-year term at Carlisle, hoping to keep her away from the reservation.[24] The *Arrow*, Carlisle's school paper, welcomed Angel, "an accomplished artist with the brush and pencil . . . as one of our teachers." Likewise, Indian school newspapers across the country announced her appointment.[25]

Angel planned to create an innovative school of American Indian design. By late March, the *Arrow* reported, "students were already making excellent progress in native art."[26] Angel felt enthusiastic about her new job, but she later told Leupp, "When I first introduced the subject— Indian art—to the Carlisle Indian students, I experienced a discouraging sensation that I was addressing members of an alien race."[27] Many students were so disconnected from their native traditions that Angel determined to create "an Indian audience if the subject was to continue." She appealed to her students' "race pride" to unify them as a group. She called on them "in mass and individually" for their "Indian history." She didn't mean what white historians wrote in their books. Instead, she wanted them to remember what their "Indian story-tellers" recited to them "by the light of the camp fire." Angel's precious memories of the limited times with her father's parents gave her insight into her students' alienated condition. Some had "lost all their Indian lore," as she told Leupp, "and yet retain the characteristic traits of the race." She hoped to collect more example of "old Indian work" to inspire them, but encouraged her students to study "specimens of Indian work that were at hand," some borrowed from employees. She also used Bureau of Ethnology reports, to "call our minds back to old customs and lore."

Almost instantly, as she informed Leupp, "the decorative instinct" of her students reawakened. Angel brilliantly adapted a Socratic method of teaching (where knowledge is innate and just needs to be recollected) to call forth her students' latent artistic talent. Her job, then, as she conceived it, was to inspire her students to *remember* their own Indian past.

Later she explained her position: "I am convinced that the young Indians of the present day are still gifted in the pictorial art. Heretofore, the Indian pupil has been put through the same public school course as the white child, with no regard for his hereditary difference of mind and habit of life." Moreover, she added that in spite of "the early art instruc-

tion in the white man's art, the Indian, even here, does well and often better than the white child, for his accurate eye and skillful hand serve him well in anything that requires delicacy of handiwork."[28]

But in what form would this latent talent manifest? She clarified: "the Indian art runs in purely conventional lines, so I have been obliged to make this a school of design." Though she loved painting, as a group her students leaned toward design, and designs conceived with purely conventional lines. Although her ideas were certainly influenced by Leupp's economic plan for the art department, and by ethnological studies, Angel uniquely implemented her own ideas. She identified "three distinct styles of Indian designing—the Alaskan, the Southwestern, and the Plains Indian." As her students came from all over the country, she hoped to get them to produce their individual "tribal styles of decoration."

She discovered that her Alaskan students had all but "forgotten [their] lore," as well as "all that goes to inspire the native decorative instinct." Likewise, Indians of the Eastern states had lost access to their traditions. Still they could learn from others, and, in doing so, created their own unique style. Great Plain students worked well, but Angel found them "timid as yet." The best designs came from the Pueblo Indians of the Southwest, who, of course, still worked on their crafts at home, often for the Indian trade. Soon Angel's students made "designs by their own intelligence." They also "unconsciously" created designs crossbred with others in their class

To promote healthy competition, Angel set up weekly exhibitions. She decided not to "burden their minds with any principle of designing or color" initially. Remarkably, in her first year, with only "kindergarten colors and paper," Angel's students produced "600 designs for borders and centers" that she felt were "fit to preserve" as "pure inspiration of the artists." A majority of the designs "suggested weaving," Angel noted, so she decided to use them for Navajo blankets and rugs. She also wanted to introduce students to "the Persian method of weaving," because it facilitated more intricate designs.

Behind the doors of Angel's classroom, all sorts of newfound old ideas were finding expression among her reconstituted "Indian audience." Oddly, the school newspaper reported little about her activities at this time. The only news was that she told the tale of "A legend of the trees" for an Arbor Day celebration, that in May she made "a flying trip [a quick trip] to New York City" (probably to check on Madelyn), and that in early June Madelyn visited from the Ethical Cultural School.[29]

Angel reported to Commissioner Leupp on "the possibilities as well as the needs for our work" the first week of June.[30] She sent him a few

samples of her students' designs, which she thought should convince him "the work might develop into a weaving industry of some kind." She assured him, "I am more than interested in it, and am willing to go to any trouble to learn the art of weaving to help the students along." Handmade rugs provided a "practicable" and "permanent industry," she said, though she was only saying exactly what Leupp wanted to hear. Weaving required a minimum of expense, only for the material, and for the looms, which "some ingenious Indian might make," she added. Because her students enjoyed learning from each other, they had already created "a very interesting design of a composite Indian character, well adapted to such an art as rug-making."[31]

Angel intended to reproduce some of her students' designs "in draperies or rugs," she said, "as soon as I have the material to use, and have mastered some of the technical phases of the art." She requested art materials, as well as an educational leave for the summer in order to learn "the technical side of the art" at a "Persian rug establishment in New York City." She believed her students were well suited to the industry. But she was not willing to exploit them. "Any design that is seen to be good and capable of being used, repeatedly, should be copyrighted and the student should realize some gain from it," she advised Leupp. She also requested "drawing materials" and other supplies so that her students could "make fancy articles that can be put on exhibition in a salesroom or other suitable place." Finally, she recommended recruiting Navajo weavers as Carlisle students to teach students their craft.

Leupp responded with enthusiasm, "I am much interested in this experiment."[32] Although an idealistic Angel hoped it would "become as traditional as it is with the rug making people of the East" and eventually benefit "the whole Indian race," Leupp focused on its commercial potential for the Indian Bureau. He asked a colleague to "please give Miss De Cora all the freedom the law will allow & the money your command will stand." He also decided to recruit only one Navajo weaver. He granted Angel one month's educational leave to study Persian rug weaving in New York. He managed to replace the "kindergarten crayons" with more sophisticated media. It is doubtful her students' designs were ever copyrighted for their benefit.

That summer Angel returned to New York. She studied weaving, most likely at the Persian Rug Factory on Broadway, and discovered that the rugs of the Kazak were similar "in line and color" to "American Indian designs."[33] In late August she withdrew Madelyn from Adler's school to enroll her at Carlisle.[34] She packed up the rest of her things and left her New York apartment for good. When she returned to the fall term with

her niece in tow, the *Arrow* reported she was "looking well and glad to get back."[35]

Angel's reputation in the field of design spread beyond Carlisle and the BIA. In early September she and Natalie Curtis were invited to speak at the prestigious Fifteenth Congrès International des Américanistes in Quebec. The *Nation* reported on the conference, explaining that presentations and discussions concerned the "geography, history, and ruins of America, the life and customs, languages and traditions, arts and industries of the aborigines."[36] Attendees included North Americans (from the United States, Mexico, and Canada), as well as scholars from France, Germany, and England. Angel found herself among an illustrious group, including the Mexican archaeologist Leopold Batres, anthropologist Franz Boaz, folklore expert Charlotte Osgood Mason of New York (later known as the "white patroness" of the Harlem Renaissance), and, of course, musicologist Natalie Curtis. Boas likely invited Angel to attend as he headed the program committee.[37]

Batres presented the first evening. He shared research on his eighteen-year-long excavation of Teotihuacan, the pyramid city located twenty-five miles north of Mexico City. Batres's work offered a radical new perspective on Native American culture, comparing Teotihuacan's civilization, with its temples, "buildings and courts, vestibules, and peristyles, adorned with frescoes and sculpture," to ancient Egypt. At a time when indigenous Americans were deemed culturally inferior, Batres's findings proved otherwise."[38] The incredible artwork produced by the civilization at Teotihuacan offered Angel inspiration for teaching her art courses.

The *Nation* noted that the Mexican government appropriated $1.5 million for Batres's work, "a sharp contrast to the indifference the United States has towards its inheritance of antiquity."[39] Exemplifying this "sharp contrast," Boaz made an entreaty for more archaeological, ethnological, and particularly linguistic research in Canada. He declared that Indian languages "furnish the key to knowledge of the distribution of population and diffusion of culture."[40] Following Boaz's talk, Mason, Curtis, and Angel presented papers concerning the "Indian of the future," and "outlined a plea for the resuscitation and development of all that is of value in the Indian as an Indian." Osgood Mason, an avid collector of Native and African American folklore, introduced the idea that the modern Indian could "occupy the place now held by foreign immigrants," using his "native genius" to work "in metal, wood, and glass."[41] Osgood Mason was also (or soon would be) a patron of Natalie Curtis, spending months with her among Plains Indians.[42] Following her address, Angel and Curtis explained how native talent could be encouraged and, in particular,

Curtis's address emphasized that the songs, poetry, and music of American Indians were a "great gift to the civilized world."[43] Angel herself was an example of such encouragement, as shown by the *Nation's* report, which touted her as "the first of her race to address the Americanists." Despite being educated among whites, Angel "exemplifie[d] the gifts of her race," and her job at Carlisle would help other Indians to join the position Osgood Mason described.

Angel's own presentation more than impressed her audience, particularly when she displayed her students' design work from the past year. The *Nation* concluded that Angel should "be regarded as a pioneer." Her appointment at Carlisle "marks a new departure in the education of the Indian." As a Winnebago Indian, Angel was a welcome and compelling presence at the conference.[44] Her presentation granted her expert status in Native American design among the top anthropologists of the world. When Angel returned to Carlisle, the *Arrow* featured an item about Quebec, stating only that she was "flatteringly referred to." Again, the school paper reported nothing of her cutting-edge work for the rest of the year, though in mid-November it reported she and another teacher "took a few of the girls out for a short walk and they enjoyed it very much although it was cold."[45]

§

Apparently, Angel's rising star was not yet visible from the Carlisle campus, proof that she had indeed entered the Indian service and also evidence of her modesty. Still the quality of her life was beyond what her sisters experienced. Julia worked at the Klamath Agency in southern Oregon. Sadly, she was still trying to maintain what little reputation she felt she had left with Hampton staff. Her feelings of insecurity and depression dominated a letter to one of her former teachers, not only in her version of the summer of 1904, but in fishing for an answer to her question: Was she worthy of affection at all? She admitted a "great spell of homesickness for dear Hampton and all the teachers whose patience I used to tax to the 'last notch.'" The Klamath agent and his wife showed her kindness and "a more saintly woman" than the head matron "never lived," but Julia justified the latter's affection for her, saying, "I know that it is not because of any merit on my part but 'charity that covers a multitude of sin.'"[46] The falling out with her well-connected sister severely dampened her spirit. It also shrunk her social and career opportunities for the rest of her life.

§

During the holiday break in December Angel returned to visit friends in New York and probably spent Christmas with Gertrude and Louisa

Clapp in Northampton.[47] By the first week of January she was back to work. The *Arrow* highlighted her mundane activities, such as leading a prayer meeting, where she talked about "Unselfishness" to a large audience of girls. Extra curricular activities were part of her job description, though not something she necessarily enjoyed.[48]

After she returned from the holidays, these duties seemed less burdensome when she spied what welcomed her at the entrance of the school. There, near the trolley stop, was a brand new art studio designed for her art program! Modeled after a medieval battlement, the building's doors and windows were illuminated with stained glass.[49] George Balenti, a Cheyenne alumnus, was the architect, or at least the draftsman for the plans. Carlisle students, supervised by teachers of masonry, carpentry, plumbing and heating, painting, roofing and tinning, helped to construct it. Allegedly, only the stone façade in the front of the building was not made on the school grounds.[50]

"One of the most unique aspects of the building was that its construction and materials had been completely funded by the Athletic Association," the *Arrow* declared. Carlisle's popular football team brought in most of the revenue.[51] Named the "Leupp Indian Art Studio," the building honored the commissioner's "friendship, interest, and careful nurturing of Indian Art."[52] Leupp's studio also included "one of the finest and best equipped photographic studios in the state," supervised by former Carlisler Albert M. Venn, though later that year it was turned over to a professional photographer, Gustave Hensel.

Besides its tribute to the Commissioner of Indian Affairs, the studio's arts and craft style signified its aesthetic and ethical purpose. It was characterized as "a magnificent monument to the industrial training to be obtained here by the Indian youth who seeks to better his condition and to make of himself a self-supporting, universally respected craftsman." The ideal of the universally respected craftsman served as a wellspring for all of the work done in the early years of the studio.

Underlying Carlisle's new appreciation for indigenous crafts and their makers, however, was the same old "Indian problem." While the *Arrow* introduced the modern concept of Indian student as *craftsman*, in the same article it concluded, "every student at the Carlisle Indian School is a *producer*." The juxtaposition of the artist with the producer signified the conflict Angel faced as the head of the art department.

Leupp's Art Studio opened sometime before February of 1907. The studio featured a 768-square-foot salon decorated with "a large collection of Indian curios, burnt-leather work, bead-work, basket work, Indian drawings and paintings of the most intricate designs."[53] On the

"Leupp Art Studio and Main Entrance, Indian School, Carlisle, Pa.," postcard, date unknown.

walls "hung rare prints of the famous chiefs of old," likely copies from the McKenney-Hall American Indian portraits, which included Angel's great-great-grandfather, Wooden Ladle.[54] All sorts of Navajo rugs made "the heart of the connossieur [*sic*] beat faster," stated a press release for the salon.

A photo of the salon suggests Angel modeled its look after Fred Harvey's Indian Building, in Albuquerque, New Mexico.[55] Mary Colter, one of the founding architects of the Santa Fe style, designed the Indian Building's interior, which was completed in 1902.[56] One reviewer noted, Colter's salon "combined the abundance and eclecticism of the Victorian interior with the ethnographic exhibit." Navajo rugs covered the floor, large Indian baskets hung from above, and pottery and smaller baskets adorned the shelves. Handmade rugs and blankets lay artfully strewn about, while pots of cactus, animal skins, and "locally crafted furniture" accented the space.[57] Like Leupp's salon, Colter's space was a "curiosity cabinet writ large." In addition to Colter's influence, the various World Fair expositions Angel participated in also influenced the salon's interior.

Along with studio work and regular teaching duties, Angel continued as an advisor in student activities, particularly among the four literary societies on campus. Carlisle employees were expected to visit by turn the societies and report their observations to the assistant superintend-

ent.[58] At the end of February 1907, with Angel's guidance, the Susan Longstreth Literary Society put on a lavish production of *Hiawatha*. Angel's students decorated stage scenery, and she convinced the play's actors to wear authentic Indian costumes including "family relics" that had been "handed down from generation to generation."[59] Not many productions of the popular *Hiawatha* could make such a claim to authenticity. The dramatic production received raves from the Carlisle critics.

Angel's students created new "Indian curios," destined for the modern market. They applied colorful Indian designs to collar and glove boxes and to pin trays and mirrors, all displayed in the salon.[60] Angel also directed her students to produce items for the BIA exhibit at the 1907 Jamestown Tercentennial Exposition in Virginia.

Since Angel was going to Jamestown to oversee the exhibit, she planned to visit Hampton in late April and have a nice visit with Folsom. "I am interested in my work," but Carlisle "has little or no interest for me," she admitted to Folsom. "I need a vacation from here awfully and I am more than happy to think that Hampton is to be the change."[61] Overworked and overwhelmed by the busy and highly structured life at Carlisle, Angel needed to get away.

The Jamestown exposition celebrated the city's three hundredth anniversary as the first permanent English settlement of the United States. It ran from April to November at Sewell's Point, Virginia. An interesting highlight of the event was its catch phrase, "the solidarity of the race." Exemplifying the group-oriented spirit of the Progressive era, a reviewer observed, "[n]ever before have there been so many societies for binding men together, for organizing labor, for civic education and enlightenment, for ameliorating the conditions of the poor and enlightening the criminal classes."[62] For Angel, Jamestown meant this time she had charge of the work she sent there. By early March the school required another drawing teacher because she needed to "devote her entire time to special work in the application of Indian designs" for items going to the exposition.[63] A dress featuring a waistband embroidered with "an Indian design," made by one of Angel's pet pupils, Grace Primeaux, was one such item.

Near the end of March, Angel invited Dr. Gordon B. Gordon, an ethnologist from the University of Pennsylvania (who had joined her at Quebec), to speak at Carlisle on "Primitive Art." Besides the task of teaching art to Indian students, the demand to produce for Jamestown tested all of Angel's resources. From her Quebec experience, she hoped Gordon's visit would "bear fruit" among her more "latently" talented

students. Gordon brought pictures of various carvings and hieroglyph-ics from his explorations in Central America. He also showed students how the serpent design as a motif had evolved. He explained that the "series of curves and straight lines" used "on their blankets and on the pottery of the Indians of to-day" were not just randomly placed, but "the direct carrying out of the schemes found upon the monoliths of time beyond record."[64]

But would Angel's attempt to inspire her students pay off in time for Jamestown? She took no chances. Within two weeks of Gordon's visit she managed, with the help of noted Boston reformer and her friend, Dr. Edward Everett Hale, to borrow the Peabody Museum's sixty-volume set of *The Necropolis of Ancon, Peru*. Angel hoped the exotic, rare prints would boost her students' race pride and offer proof that Indians could claim "a high state of civilization long ere history records their existence." As the *Arrow* reported, the prints illustrated "the artistic side of civilization and industries" in which the Inca's "designs on tapestries, vases, urns, etc., show the highest class of art."[65]

As Angel encouraged her students to produce for Jamestown, Leupp's studio became the center for a Navajo rug business. A lengthy adver-tisement appeared in the *Arrow* assuring collectors they would receive the genuine article. The blanket included a guarantee and a record of its production date and location, as well as the name of the maker. The advertisement also explained why 1907 was a good year to invest in Navajo blankets, warranting its claim with the recommendation of Her-man Schweizer, a manager for Harvey's business in Albuquerque. It listed the attributes of an authentic Navajo rug, echoing Leupp's expo-sition on the subject. The advertisement highlighted the primitive aspect of the Navajo artist and her means of production. The sheep, its wool, the handling of the wool, the tools, the loom, the colors used, and even the hogans where the Navajo resided were described in great detail, and the composite rug compared to the degenerate, machine-manufactured modern-day versions of the same.

The advertisement claimed that the blankets, priced at $10 to $100, rivaled "the most costly oriental rugs." Why would a government school become involved in such an enterprise? "We are not, commercially speaking, in the blanket business," stated the *Arrow*, "but we are inter-ested in the Navajo Indian. We want to help him by selling his blankets. We want to do what we can to get people to appreciate the art of the Navajo weaver."[66] Regardless of this sentiment, economics preceded phi-lanthropy. Carlisle's intent to suddenly highlight and sell Native art was a financial decision.

In April of 1906 the *New York Tribune* published "Football and Art." The report stated that Leupp's Indian Art Studio "is an art school and museum of Indian curios, and was built by Indian boys from the proceedings of the football games of last year, in which the redskin experts on the gridiron did so well."[67] Art and football remained intimately entwined through Angel's tenure at the school.

That same month Angel traveled to Jamestown. Leupp, however, did not feel eager to promote the event. He thought it was too similar to "other expositions," because it still focused on "the ability of Indians to assimilate" the instruction they received in the government schools.[68] Juxtaposing the old and new Indian was still standard fare. Everyday items at Jamestown were displayed with a photographic exhibit of "Indians and Indian life" taken by the up-and-coming American Indian photographer, E. S. Curtis.[69] Like its predecessors, the exhibit contrasted authentic handiwork of Native peoples, such as Navajo blankets and Pueblo pottery. In spite of downplaying Jamestown's relevance to the new Indian education, Leupp made special mention of Angel in his annual report, noting a wall frieze and "a rug of oriental weave" that her students contributed. He also noted the use of applied designs on picture frames and pillowcases.

After supervising the exhibit, Angel visited Hampton. She brought some of her students' design work, "which attracted much attention in the school Museum."[70] After a relaxing visit with friends, Angel returned to Carlisle to finish the school year. School life challenged her patience, but the publication of *The Indians' Book* that year raised her spirits. Her name began appearing in newspapers, such as the *Washington Times*, on lists with "the educated Indian" such as Charles Eastman, Francis La Flesche, Senator Charles Curtis, and, the only other woman, her old friend, Zitkala-Ša.[71]

Although she felt ambivalent during her first year at Carlisle, Angel's uplifting presence on the morale of her students, particularly the females, was tangible. Never before had there been a better time to claim one's Indian identity. Of course, Leupp's motto "improvement not transformation" set the tone for Angel's influence. A story published in the *Arrow*'s June edition, however, shows that Leupp on his own could not have caused such a rise in self-esteem. "Winnebago Camp" exemplified the new romanticized, Indian (suffragette) womanhood spreading through the campus.

As the account began, Angel and "three winsome Indian maidens" took the trolley to the base of nearby Mt. Holly.[72] Exhibiting "true Indian instincts" they "located a long-abandoned trail and wended their

way through a thick under-growth and deep forest to a spot described in tradition as 'the place of solitude.'" As they hiked, the maidens "gathered roots and various fruits known only to the Indian mind." Soon they came upon an abandoned "olla to use for cooking." Adding the "small game" they "ensnared by primitive Indian methods" to the plants they gathered, they were ready to cook. "Fire was kindled with great ceremony, combining rites of Winnebagos, Nez Perces, and Sioux Indians." When the stew was ready, "the quartette seated themselves on the ground and enjoyed a good old fashioned Indian feast." After their meal "an old time dance to the native Indian songs was indulged in." Their story ended as the modern Indian maidens "reluctantly" and, of course, "silently," returned "to the border of civilization, having voted a glorious day's sport."

Pratt's era was passé. Angel's portrayal as primitive was nothing new, but during this period it took on a particularly aesthetic and highly idealized tone. The vision of an authentic, educated Indian artist, accompanied by her maidens-in-waiting, especially appealed to Carlisle's newest generation. Later that month, a journalist "gathering material for an article on Primitive Indian Art" chose to interview Angel. The *Arrow* exclaimed that *anyone* interested in that subject would naturally seek out Carlisle's art teacher.[73] School pride, usually inspired by the athletic talents and prowess of Carlisle's "Indian warriors," now extended to the school's "winsome Indian maidens," who, it seemed, at last, were not all condemned to domestic servitude or the nursing profession.

§

Feeling more old maid than Indian maiden, Angel taught art during the summer to make ends meet. She also prepared to represent Carlisle (and Leupp) at the Educational Convention in Los Angeles, California, held July 2–12. She sewed her own clothes, painted, and weaved "a good deal too." She wrote Folsom in early summer, telling her, "I wish with all my soul tho' that I were going to return to Hampton now for two or three weeks at least. It is cold here & I hardly know how to keep warm." Most of the students went home or on outing for the summer and, she confided, among them were "some of my best friends," perhaps a reference to the winsome Indian maidens, like Grace Primeaux. "I am dead broke just now," she admitted. "Some traveling musicians came 'round at noon & I lent money right & left. I tried to charge compound interest but it takes a thousand Indians to get ahead of one Dutch," she joked in good humor.[74] Besides the departure of Angel's best friends, Mary Sampson and Madelyn Rickman, also left Carlisle that summer. In fact, the administration discharged Sampson as a "deserter" on June 30.[75]

Likewise, Madelyn, who left on July 4, was eventually discharged because "she failed to return from leave," according to her school record.[76] It's possible Angel accompanied at least one of the girls back to Winnebago herself; still, they did not return to Carlisle again. Given how busy the school year had been, Angel probably found little energy or time to prevent them from returning to "the clutches" of their father and grandfather.

With most of Carlisle's design work still at Jamestown, Angel arrived in California with "a small though creditable exhibit of class-room papers, art needlework, basketry and pottery." Leupp's annual report covering the Los Angeles event cites Angel's exhibit as a draw to conference attendees, "especially the specimens illustrating aboriginal ideals in decoration."[77] He was not the only one to find her exhibit "an interesting feature." The *Los Angeles Times* reported the same thing.[78] The *Times* also claimed that the "old-fashioned school teachers were actually shocked" by Leupp's "new method of instruction." This "new method" included, on the one hand, Leupp's support for the traditional view that all Indian children have the right to learn the "Three R's," while, on the other, his controversial emphasis on industrial rather than academic training. Still Leupp stressed Indian students should be afforded "the opportunity" to further their education, if they so desired.

The *Times* focused on Leupp's support of Native Indian art and specifically on his Carlisle appointee, "Miss Angel DeCora . . . one of the most interesting figures connected with Indian education now in Los Angeles." The report described her as a "handsome young Indian woman," and erroneously, as a "full blooded Winnebago." "Miss DeCora has made a special study of Indian art," the newspaper stated, "and she has made a most complete collection of original Indian designs. She has studied in many of the large cities of the country, and is an enthusiast upon the subject of preserving native Indian art designs."[79]

After the conference, a new photograph of Angel, "Our Teacher of Indian Art," appeared on the July 26 cover of the *Arrow*. The portrait, taken and developed by Gustave Hensel in the new photography studio, is the best known and most beloved of Angel. She is pictured wearing a buckskin, Great Plains–style dress, decorated with quillwork and a geometric design on the bodice. She wears a bead and quill necklace and her hair is in braids. The strikingly dignified image of Angel became imprinted on the minds of a generation of Indian school students.[80]

From August to October, Angel's Los Angeles presentation, "Native Indian Art," appeared in newspapers, both Indian school and mainstream, across the country. While Leupp shocked old-fashioned school

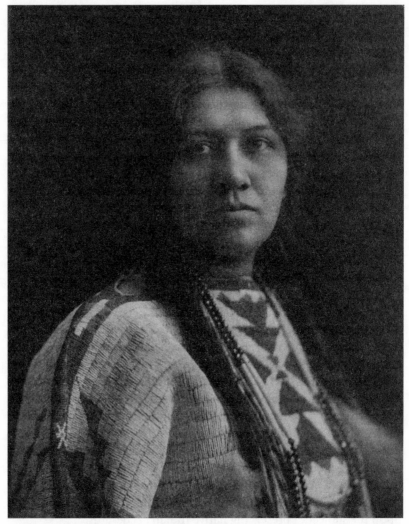

Portrait of Angel De Cora, Carlisle, Pa., 1907, photograph by Gustave Hensel.
(CUMBERLAND COUNTY HISTORICAL SOCIETY, COLLECTION #12–02-02)

teachers with his new principles of Indian education, Angel inspired the same with her views on educating Indian pupils about their own art forms. Her ideas excited the public, because she bridged the gap between worlds that had before been completely distinct, again making esoteric knowledge available to mainstream United States. What for Leupp was hypothetical, became for Angel something that could be "put into prac-

tice." What for Leupp was an idea whose time had come, for Angel was an idea she'd already executed. She had already supported herself through creating Indian designs. She understood the appeal, and she had honed her own abilities, beginning at least as far back as the cover she designed for *The Middle Five*. She also had first-hand experience of the disparity between the old, traditional ways of "being Indian" and the "modern-day Indian."

An important link between Leupp and Angel was their shared belief in the ideals of the U.S. arts and crafts movement as it fused with the art of Native America—though Leupp's attitude was more akin to an Indian trader's than the artist the trader often exploited. Angel's presentation, "Native Indian Art," mirrors Leupp's views, while it reflects them from the viewpoint of a formally educated American Indian woman. It also revealed something of her educational experience.

> The method of educating the Indian in the past was to attempt to transform him into a brown Caucasian within the space of five years or little more. The education made every effort to convince the Indian that any custom or habit that was not familiar to the white man showed savagery and degradation.... The Indian, who is so bound up in tribal laws and customs, knew not where to make the distinction, nor what of his natural instincts to discard, and the consequences was that he either became superficial or arrogant and denied his race, or he grew dispirited and silent.[81]

Angel proposed that there was an intimate connection between her art students at Carlisle and "the Indian woman, untaught and unhampered by the white man's ideas of art, making beautiful and intricate designs on her pottery, baskets and beaded articles." She realized conventional Indian educators degraded their students' natural sense of the pictorial, because they misunderstood the context of Native art. But (not unlike the impressionists), an Indian woman does not paint in artificially lit studios. "She sits in the open, drawing her inspiration from the broad aspects of Nature." She applies colors from nature and natural dyes "under the glare of the sun," though they might appear garish in other settings. Traditional colors "softened into tints" under the sun's brilliance, in contrast to "the strong, glaring colors" of aniline dyes that had replaced them.

She explained that the zig-zag line employed by Indian woman was conventional to Native art. It "indicated the line of the hills in the distance." Other conventions included a blue-and-white background for the sky, as well as "bold touches of green, red, and yellow," which the Indian woman "learned from Nature's own use of those colors in the

green grass and flowers." The "soft tones that were the general tone of the ground color in the days of skin garments" represented "parched grass and desert." Angel's discussion shows she was thinking in these terms when she designed the cover for *The Middle Five*, where abstract green triangles represented the prairie. Angel stressed that the Indian woman painted abstractly, not realistically, echoing elements of the conflict she had with Pyle. Consequently, she discouraged "floral designs such as are seen in Ojibway [*sic*] beadwork."[82] "Indian art seldom made any use of the details of plant forms," Angel pointed out, "but typified nature in its broader aspects, using also animal forms and symbols of human life." The difference should be valued, she implied.

She said the "Indian instincts" of her students had "only lain dormant." The examples of artwork Angel displayed at the convention, she felt, clearly showed innate talents had been "roused." The quality of the work was unlike any produced by white students. "No two Indian drawings are alike and every one is original work. Each artist has his own style." Again, her words point to her conflicts with Pyle (or at least the conflicts in retrospect expressed later by Natalie Curtis).

Angel explained her progressive pedagogy. She told her audience of teachers and educators that her students did their best work *without* her supervision. "They came to me for material to take to their rooms and some of the designs for rugs that you have seen were made in the students' play hour, away from the influence of others—alone with their inspiration, as an artist should work." Her students did not require "practice paper." "With steady and unhesitating hand and mind," she explained, "they put down permanently the lines and color combinations that you see in their designs." Angel concluded her speech exclaiming that "the Indian workman" could easily join the ranks of America's producers. His or her art rivaled the art of the Japanese, which was renowned "throughout the civilized world."[83]

Angel's support of the Indian craftsperson was personal and political. But she also had a deep interest in fine art. Her theory that abstraction was a binding principle of "Native Indian art" was timely in 1907, particularly since Pablo Picasso painted his revolutionary *Les Demoiselles d'Avignon* that year. After exploring primitive art, Picasso painted "an utterly new and visual language" that energized the modern art world, while it disrupted "pictorial space" and opened "a route to total abstraction."[84] Yet for Angel this "route" had already been discovered and used by American Indians, and now it was nearly abandoned.

Angel's trip to California was a remarkable success. She later claimed she did not like the west coast, but the first fall issue of the *Arrow*

reported she returned to school smiling, brown, and beautiful. "The California sunshine made an excellent impression on her but with the cool breezes from the Japan current, the fragrances from the many varieties of flowers, [and] the fruit growing all around her could not stop her complexion from turning to a beautiful brown." Angel's trip was not limited to Los Angeles. She stopped at Long Beach and also visited the Sherman Institute in Riverside, an Indian school located east of Los Angeles, where "she was entertained by an eagle dance" performed by Hopi students. Still, it may have been more than California sunshine that created Angel's healthy glow.

On her way back to Carlisle, Angel stopped in Albuquerque "to visit friends," the *Arrow* reported. Perhaps she visited Natalie Curtis and made a stop at Harvey's Indian Building for inspiration and Indian wares. She took the opportunity to observe Navajo rug makers and Pueblo pottery makers. Later she noted, "While among the Pueblos in New Mexico" that summer, "I showed a woman a pair of linen curtains that had in applique [*sic*] a Pueblo border design, made by a Carlisle student whom she knew." She visited the Sioux (though which branch is not specified) as well, and gave the women "some practical suggestions by which they could find a more ready sale for their beaded articles." She encouraged them to turn traditional tobacco pouches into sewing purses and opera bags. She also made a visit to her family in Winnebago, Nebraska, where she picked up a grandson of Joseph Lamere and brought him back to Carlisle.[85] It's possible that she also met, again, that summer the handsome Sioux, William H. Dietz.

The *Arrow* reported on Leupp's presence at the Los Angeles conference. Leupp urged the audience to be sure to read Angel's paper, since she had a throat condition and was speaking quietly.[86] He also made it clear that not only did Angel's work at Carlisle have his full support, despite the disbelief of some, but also some credit for that work should be given to him. "As the idea of reviving, or perpetuating, Indian art and its ideals, was one of my earliest aspirations," he said, "I had to struggle hard with Miss De Cora to induce her to leave the private practice of her profession and come in with us and take up this task." Credit certainly was due Leupp. The strong support Angel received during his administration would not be passed on to the next.

At the end of July the magazine section of the *Washington Times* featured a full page spread titled "Away with Your White Man's Art! Angel Decora, Sioux, After Ten Years Study Teaches Her Race on Aboriginal Lines." The highly romanticized piece, probably inspired by the Los Angeles conference, took liberties with Angel's words, but the images on

the page are spectacular and include rare designs from some of Angel's students.[87] That fall, the *Southern Workman* also featured Angel's participation in the Los Angeles convention. The article documented her academic and artistic career and detailed her particular and "natural" talents. "In addition to her skill with the pencil she developed a depth of artistic feeling and her work showed much originality," it stated. The source for Angel's "keenness of insight into Indian character," as well as her "poetic appreciation of the picturesque side of Indian life," however, shows Hampton's racial bias had "evolved" from plain old evolutionism to the new progressive evolutionism. "It could come only from generations of Indian ancestry and could be developed only amid the associations of such a childhood as was hers, passed in Indian camps," pronounced the *Southern Workman*.[88]

The positive acknowledgment of Angel's authentic Indian childhood was ironic, given that Folsom persuaded Angel to reject anything that smacked of an "Indian camp" when she was allegedly rescued from her grandmother's home. But the new attitude signified the waning of the Indian reform era (and may also signify Carrie Andrus as the article's author). Now the United States required a traditional Indian childhood from its prominent Indians. Much like Leupp's sentiments regarding the value of an authentic Navajo blanket, the distinct composition of the new Indian included a pure origin. The developmental years should be untouched by white influences. With this component the new Indian's entry into civilization (in the form of an Indian school, such as Hampton or Carlisle) could not harm his or her essential Indian identity. Apparently, the racial uplift so important to the progressives could only work on pure stock. The *Southern Workman* also announced that Angel's progressive approach to teaching "might well be adopted by all the Indian schools." How Angel felt about Hampton's sudden public change of position can only be imagined. But a change had surely come.[89]

In October, New York's *Sun* reviewed *The Indians' Book*. It had "substantial and real merit," and it had been commended by "the Great White Father" (Roosevelt), whose autographed letter graced the book's front matter. The *Sun* called Angel's illustrations "very good" with the qualification that she was "sophisticated enough to understand the white man's requirements of art while she preserves the character of the aborigine's drawings."[90]

In November Angel's art classes began rug weaving. It was a lengthy process. Nevertheless, the *Arrow* claimed the students enjoyed it.[91] Also in November, the National Indian Association made special mention of Angel's design work in *The Indians' Book*. Her "beautiful and often intri-

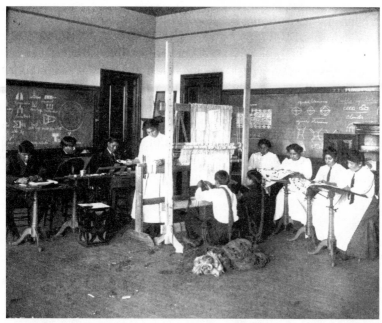

Teaching weaving at the Carlisle Indian School, ca. 1909, photograph by A. A. Line.

(Cumberland County Historical Society, Carlisle, Pa. [314A #30])

cate Indian designs and symbols," stated the association, were executed "with such accuracy and such evident desire to make the artist's meaning clear to the minds of those to whom Indian ideals, Indian modes of thought, and Indian methods of expression are quite alien."[92]

Near the end of the month, Hensel's photograph of Angel appeared in the *Atlanta Constitution*. The accompanying article noted that Angel's students were working on "ancient legends and picture writing of the Indians" so "that some records of the early history of the race may be preserved." Angel was to be featured in *Human Life*, a publication about celebrities "from all classes and climes," the report also noted. According to *Human Life*, Angel's career "had been literally from tepee to studio." She was characterized as a "picturesque and notable example of the success that can be achieved by an Indian girl winning her way into the White Man's civilization."[93] As the media transformed her wigwam into a teepee, so her brief, traditional childhood expanded into a picturesque bridge to her career in art.

Now that Angel had established her career, she turned in a new direction. Earlier that fall the young muralist she met in St. Louis in 1904

enrolled at Carlisle. Some wondered if Angel "lured the poor boy east," but it is more likely he was recruited by Glenn "Pop" Warner for Carlisle's football team.[94] Dietz's enrollment form shows he was born on August 17, 1884, to Wm. Dietz and Julia One Star or Julia Dietz. His white father was still living, but his one-half Oglala mother was dead.[95] The place for an Indian name was left blank, as was the place where a student listed his previously attended schools. His signature, which obligated him "to abide by all the rules and regulations for Indian schools," promised he would commit to Carlisle's three-year regular term. He would commit to much more than that in the days that followed.

Mr. and Mrs. Dietz
and the Indian Craftsman

During the Christmas break of 1907, Angel accepted an invitation to stay with her illustrator friend, Alice Barber Stephens.[1] Alice, her husband, Charles Howell Stephens, with their son, D. Owen, lived in a progressive arts and crafts colony in Rose Valley, Pennsylvania. Rose Valley's resident architect, Will Lightfoot Price, designed their charming bungalow that included cypress interiors and an octagonal stairway.[2] An old fieldstone barn, converted to the couple's studios, connected to their living quarters. The "Stevens [sic] have a beautiful place," Angel raved to Folsom, and "they were just as fine as ever if not better."[3]

Charles was a photographer and illustrator, specializing in the American West.[4] He taught at the Pennsylvania Academy of Fine Arts, where he met Alice as his student. Shortly after they married, Charles journeyed to Montana in 1891 and spent three months living with the Blackfeet Indians, taking photographs and keeping a journal.[5] His collection of American Indian artifacts enhanced the Stephens's home, appropriately named "Thunderbird Lodge." A thunderbird-shaped fireplace warmed Charles's studio, and a thunderbird, made of Moravian tiles, decorated its exterior. Angel's use of the symbol preceded the home's construction, and she may have lent her influence. On January 3, the *Arrow* reported that "Miss DeCora spent a most enjoyable season in Philadelphia and other points, returning much improved in health and spirits."[6] Apparently, no one knew Angel had just married.

William H. Dietz, alias "Lone Star," was also in Philadelphia. He left Carlisle on an outing during the first week of December to take courses at the Philadelphia School of Industrial Art. Carlisle rarely, if ever, offered such a unique opportunity, but Dietz was an unusual student, to say the least. On December 20, the *Philadelphia Record* reported, "the lusty right tackle of the Carlisle football team," Lone Star, provided the best entertainment of the season for the art school. "The lights were

turned low and with a mystic Indian song," Lone Star in "full Indian costume with war-bonnet of eagle feathers and buckskin garments made a striking figure in the half light." He gave a lecture in "excellent English" on the Indian's "scalping proclivities" (which he explained were introduced by the white man) and then performed a "picturesque war dance" thrilling his audience.

The school's director, Howard Fremont Stratton, also lived at Rose Valley and may have invited Dietz to visit over the holidays. Whether Dietz met Angel at Thunderbird Lodge, or planned to meet her at all over the holidays, the couple eloped the day before New Year's Eve. With only the wife of the Justice of the Peace to witness, they married in Camden, New Jersey, just across the river from Philadelphia.[7]

There's no evidence they planned the event. Maybe it was a spur of the moment decision. Maybe the timing seemed right. But even if they had made plans, Angel, nearly forty, married a twenty-three-year-old football player who had just enrolled in the school that employed her. Several women on the Winnebago reservation married much younger men, at least by Indian custom. But this was not the reservation, and their husbands were not their students. Still, Angel was an independent woman, an artist, and passed for a much younger woman. Why limit herself to a conventional marriage? Her chance for a lifetime companion was here and now. She did feel compelled to lie about her age on her marriage certificate, however. Instead of thirty-eight or so, she became twenty-five.

Dietz fudged the application as well, but his lie would not become public for a decade. Nevertheless, the December-May couple took their vows and ushered in a bright New Year as man and wife.[8] Dietz continued his studies in Philadelphia, while Angel returned to Carlisle, keeping her marriage secret. In late January she began preparing Folsom for the news: "I wrote to you once and I received not a line of encouragement to write the second one so I have been kind of waiting for another chance to see you and be with you to get 'acquainted' again. I wish I could really have a visit with you now. I don't seem to be able to make friends with any one I've met in the Indian Service except one of this fall's football players here and he is away in Philadelphia studying in one of the Art Schools there now."[9]

Changing the subject, Angel discussed Carlisle's "unsettled conditions" referred to in the newspapers. "I don't suppose really that Carlisle school was ever in a more flourishing & healthy condition than now," she wrote. "The students are healthy & content and the place has been made very attractive and sanitary by Major Mercer and now he is going to leave us." Mercer had resigned the end of December due to alleged

health problems. One news report stated Mercer's "retirement" suggested that Congress planned "to abandon the school and transfer the Indian students to the West." "It is generally thought in Carlisle that the Indian school will soon be a thing of the past," the report concluded.[10] However, Mercer may have been forced into retirement for "a serious moral offense." His clerk was found guilty of embezzling, but it is unknown whether Mercer engaged in criminal activity.[11]

An important aspect of Mercer's administration that would eventually elicit criminal charges, however, was the development of Carlisle's athletic program, particularly football. In 1907, Mercer convinced Glenn "Pop" Warner to return to Carlisle, after a four-year absence, to head athletics and Carlisle's Athletic Association. Warner decided to pump up his small-framed football team by ignoring BIA rules and giving team members special meals while housing them in separate quarters. As a Carlisle historian found: "Warner's reappearance . . . meant a shift in recruitment, at least as far as athletes went. Under Warner's guidance a prototype of modern sports scholarships emerged—students were brought to Carlisle on the basis of their athletic ability and kept there for the same even if they did not fit the official profile. Mercer seemed to have turned a blind eye to Warner's bending of the rules."[12]

Angel's new husband certainly benefited from Warner's liberal approach to recruitment. Dietz's athletic ability, and perhaps Angel's influence, allowed him to stay at Carlisle for years without any documentation that proved his tribal enrollment.

§

The New Year brought many positive changes to Carlisle Indian school. The *Arrow* reflected Leupp's philosophy of Indian education as "improvement not transformation." Ethnological reports, such as "The Baskets of the Zuni," appeared on the pages to foster "race pride." The fine collection of Zuni baskets "on display in the art studio" was likewise featured.[13] Not everyone liked the new attitude. The same day the *Arrow* featured its piece on baskets, Pratt implored his local U.S. Representative, Marlin E. Olmstead, to add an amendment to the year's Indian Appropriation Bill. He also constructed its wording: "no part of the money appropriated herein shall be used in payment for salaries of instructors or managers, or for material of any sort, for instructing or promoting the manufacture of so-called Indian art, or Indian curio."[14] Pratt wanted Olmstead to stamp out the BIA's new policy to train teachers in Indian art. This policy was part of a nationwide "Indian curio trust," he accused, "a crushing, trust monopoly, fostered, if not inaugurated by the Indian Bureau itself."

Pratt's complaints focused on four issues. First, the "so-called Indian art" was "in very small proportion the real product of Indians." The overpriced products were completely "directed by the agents of the trust," and should not be considered "Indian at all." Second, he used the progressive's social justice rhetoric and rejection of industrialism, likening working conditions to sweat shops. To "sit upon the ground or floor" day after day making crafts was not only unhealthy, but was clearly "a commercial grind" for Indians who before had taken pride in seeing family members "wearing the products of their own thought and industry." Third, he claimed the work encouraged a return to the blanket. "It emphasizes the old life and absorbs the attention of the young to the detriment of their acquiring the knowledge of civilization, and often keeping them from the field, garden and outdoor life." "The Indians were far nobler and far more manly in their old Indian camp life," he declared, but now they were grinding out products that were uncharacteristic of their tribes. Angel's "weaving industry" certainly fell well within his concerns. Finally, he believed Leupp was "absolutely destitute of any right ideas in regard to the Indians." Not only did he mislead, but statements were "untruthful." Pratt pronounced Roosevelt's appointee "a great mistake."[15]

In his letter to Olmstead, Pratt disclosed that the Indian Bureau's new policy on art production led to his own resignation in 1904. "I refused to become a part, knowing the deceit of the proposed business. Immediately after the orders were issued I received, from various dealers in New York and elsewhere, propositions to sell me all the material for blanket weaving, basket making, bead work, pottery, etc. I would need. Such was the zeal of the superintendents of Indian schools and the Bureau, that I questioned whether there was not a partnership in the business." Pratt thought if the new policy continued, it would "destroy the school." He also thought "it well" that Mercer "relinquished his position at Carlisle."

Some of his criticisms were valid. How would Indian "producers" be compensated? How much did the Navajo rug makers receive of the $10 to $100 the rugs sold for in Leupp's Indian Art Studio? Did Angel's students ever receive the copyrights on their designs? What about the quality of working conditions? Angel's art department might have passed muster, but what about Indian schools in more remote areas? Pratt was right. "Indian curios" were in fact created specifically for the market place and not authentic articles, as Angel's work showed. On the other hand, as usual, Pratt was over zealous. Wasn't most industrial school-work just as tedious and just as much a grind? Also, as Angel's teaching

methods illustrated, students often created composite designs, not specifically tribal ones. But what was more preferable, creating a pan-Indian rug when you are a Lakota person, or embroidering Victorian pansies on a dresser scarf when you are a Cheyenne? Pratt's Americanization policy disavowed such questions, but Angel chose the former. It was hard to develop race pride in the latter activity. Pratt would not get his amendment, but the controversy was far from over.

Angel was probably oblivious to Pratt's politicking. In mid-January Franz Boas contacted her, and they deepened their professional relationship. While Angel asked Boas to help her obtain ethnographic material for her art courses, he asked her to provide him with students for his linguistic work. "I am very anxious to get a little information about some special points in the language of the Shoshone," he told her. "Have you any intelligent young man or woman at Carlyle [*sic*] from whom you think I might get such information?"[16] Angel recommended one of Carlisle's two Shoshone students, who "seems to be a young man of good sense and understands and speaks fair English."[17] She in turn requested another copy of "the works of Alfred L. Kroeber on the Arapaho," since the one Kroeber gave her was "completely worn out by constant use as a text book." She hoped Boas could provide or recommend similar works for other tribes.

Boas decided it would be more advantageous to come to Carlisle, and wrote Angel, "I should be very glad if I could talk over a number of matters that are of common interest to us."[18] The next month he visited the school. The *Arrow* reported that "the most famous anthropologist of the day" was also Angel's "friend of many years," suggesting they met before the conference in Quebec. Boas offered Angel's students a lecture on Native American art, describing how a "well-designed plan and scheme" of "one general design" could be identified in a variety of "basketry and pottery from different sections of the world." Boaz also interviewed several students, including the Shoshone student.[19]

Boas contacted Angel again in mid-March about another potential informant, Archie Dundas. With the changing of the guard at Carlisle, Boas was having difficulty getting a commitment from Dundas. Mercer was leaving February 1, but his replacement, Moses Friedman, would not take charge until late March.[20]

Boas reminded Angel of their discussion during his visit. "I have been thinking over the offer of your old Winnebago friend to come East, and I am planning the following arrangement. I should like to send one of my students out to the Winnebago Reservation during the summer to do some Winnebago work, particularly with your old friend; and if it

turns out that the work proceeds well, I think I can arrange to let him come East in the fall, perhaps in October or November." He asked for her response, adding, "I should be very much indebted to you if you could give the student an introduction that might be helpful to him. Of course I expect him to settle down and learn the language first."[21]

Angel promptly replied. She informed him that Dundas would eventually be able to come to New York. "Now about sending a student out to Winnebago Reservation," she said. "It would be the best plan and I would give him an introduction to different ones and let him find out who the best one [is] to get information from before transporting them east."[22] Boas assured Angel in late April that his work with Dundas was proceeding "very nicely." He also informed her that his student, Paul Radin, "intends to go to the Winnebago Reservation about the 10th of May." "Would you do me the great favor," he asked, "to send for me his letters of introduction to some of the people you think may be able to help him?"[23]

Clearly Boas and Angel considered themselves as colleagues. Moreover, their relationship culminated in Paul Radin's definitive study of the Winnebago, though Angel's role in Radin's research is generally unknown.[24] Boas also discussed "the particularities of Winnebago language" with her and passed on her comments to Radin (who found them quite accurate), but, more importantly, Angel introduced Radin to his interpreter and primary informant, Oliver LaMere (as he chose to render his name).

Meanwhile at Carlisle, Angel was anxious for the new administration to get underway. Referring to Friedman's appointment, she shared her hope for the school's future with Boas. "We are getting along better now that we have a new man to lead us on. I think he is going to do really good work for the Indians. At last we are hoping that Carlisle will live up to its reputation in educational matters." She also noted that Friedman, who was an educator not a military man, "likes actual work better than the mere sound of things."[25]

Angel was more candid with Folsom. "The evil reports against Major Mercer were groundless and didn't even require any court proceedings to make his accusers retract."[26] Angel resigned herself to the new appointment, telling Folsom, "Mr. Leupp has thought best to give us another kind of man to handle the bunch here." She was not as optimistic about Friedman as she had diplomatically expressed to Boas. "Poor Man! He looks nervous and so do we all. I was on the verge of prostration had he delayed in coming."[27] Angel also referred to "shocking reports" about Chilocco in her letter to Folsom. McCowan, the

superintendent who hired Dietz for the St. Louis World's Fair and recruited him to play football, was suspended for undisclosed reasons. In response, Angel exclaimed, "What a chance for avarice the Indian Service is!"[28]

Dietz returned to Carlisle from his outing on February 15. One week later he was "discharged" from the school and employed as his wife's assistant in the art department.[29] That certainly helped Angel's image, but in spite of his change in status, Dietz continued to be identified as a Carlisle student through the years, taking "special courses" as "William Lone Star." Friedman was probably too new to understand the details of Angel's marriage, or perhaps he recognized Dietz as a commodity. Angel (and Carlisle) still did not make her marriage public. But sometime in the early spring of 1908, she sent an affectionate letter to Folsom, setting the stage for her announcement: "Don't tell please but to ease your mind, I took to serious thoughts on matrimony. Now consider how considerate I am for as you told me that often you had accused yourself of having kept me away from the reservation—thereby causing me to loose [sic] all the chances of marrying. But you never took to account that there may have been some one who was *specially* reserved for me."[30]

Finally, she got up her nerve to tell Folsom outright. "I have always been kind of an unceremonious creature so you won't be surprised over this unceremonious announcement that I have entered the state of matrimony. William Henry Dietz is the gentleman and some day when you meet him you will not wonder."[31] She said she would keep her maiden name and her husband had approved. "I have worn it so long," she said, "I think myself it would seem kind of queer to dicard [sic] at my time of life." Her short missive ended with an attempt to dismiss her greatest concern. "Of course he is younger than I, most anything will have to be that."

Folsom was not going to let her off that easy. She wanted to know more about the new husband. She scribbled a note on Angel's letter to Joseph Blackhawk, a Winnebago friend of Angel's doing "postgraduate" work at Hampton. "Do you know this man Mr. Dietz? Is he an Indian? Come over & see me sometime—and return this letter please."[32] As much as Folsom concerned herself about Angel's middle-aged welfare, Angel sought her blessing—which was, apparently, not at first forthcoming. In her next letter to Folsom she wondered, "Are you glad I got married at last?"[33] To take the edge off her direct question, she joked that Leupp and Estelle Reel, superintendent of Indian Education, "got alarmed last summer because they feared I might marry Schulz, the author of 'My life as an Indian.' He is a fierce drunkard! And looks like a raw beet minus the sugar."[34]

Why was Angel timid about announcing her marriage? There were probably many reasons besides the obvious age difference. The *Arrow* never announced it, probably because neither she nor Carlisle, or BIA officials, wanted to call attention to it. One day in May the paper simply referred to her as "Mrs. DeCora Dietz" and that was that. Still, Angel seems to have worried more about Folsom's reaction than anything else. In fact, the *Arrow*'s reference to her married name was printed shortly after she finally broke the news to Folsom.

Folsom always stressed that Hampton's reputation was on the line, but Angel's second mother dedicated her life to Indian reform and grew used to the control she wielded as she parented the gifted "Indian child." Angel certainly took into account Folsom's response to Addie Stevens years ago. Her guardian could rage like the furies when crossed. She also knew a husband would change the dynamic of their relationship, and she realized that Folsom might feel abandoned. It's not that Folsom wouldn't fret over Dietz's young age and lower status, but Angel's feelings of obligation significantly compounded the awkwardness she felt explaining her husband's background.

Angel informed Folsom of a change in plans, "William and I are trying to get out of the Indian service but find it hard work so we are here still. We both think there is a better chance to make a livelihood out side but Mr. Friedman, our new Supt. wants us here and we have given in for the present on condition that he allows us to take in outside work too. I think it only fair." She said Leupp wanted Dietz to join the Indian service "officially some day." However, Angel's deepest hope was that she would make a new career collaborating with her artistic husband and leave the Indian service for good.

She also said her husband was "smart as well as fine looking" and "just the 'man at the top.'" Unfortunately, he was also a racist, typical of his times. As Angel delicately put it to Folsom: "I would suggest William [take] a trip to Hampton some day only he has strong feeling against the Afro-Americans." Angel felt she could live with this flaw, but it presented a challenge to maintaining relationships with those at Hampton. "I try to make him think that at Hampton they are different but he generally twists my arguments into a muddle every time." Dietz had a real knack for making people believe his fallacious arguments. He honed the skill his whole life long.

Already Angel depended on her gregarious husband to ease her social anxiety. "I am going to N. E. A. [National Education Association] Conference this July to 'demonstrate Indian Art.' They didn't include William in this trip & I can't tell how well I'll demonstrate without him,"

she confided.[35] Angel preferred the background, while Dietz enjoyed front and center. They made a match.

May was a busy time for Angel. Estelle Reel came to Carlisle to see Angel about the annual National Education Conference to be held in Cleveland, Ohio. She wanted to observe Angel's classes, because she planned to send some of Angel's students to the conference to demonstrate their work.[36] On May 12, Angel presented "Indian Art, Its Present and Future Use" to the American Anthropological Society at the men-only Cosmos Club in Washington, D.C. She illustrated her talk with products made by her students, including tapestries, rugs, leatherwork, and beadwork, "inspired by primitive designs."[37] Paul Radin visited Carlisle just three days later. Boas probably introduced him to Angel in Washington D.C. The *Arrow* reported Radin intended to make "a study of the [Indian art] question and is here to see the classes and interview Mrs. DeCora Dietz" (the paper's first use of her married name). Radin really came, though, to discuss his trip to the reservation with Angel. He left directly after his visit.[38]

Radin arrived safely in Winnebago, Nebraska. "The Indians at present all live in cottages," he wrote Boas, "but near them they generally have one or more of their bark houses and occasionally a reed house, used as a storage place during the summer." Radin noticed the shrinking reservation, "largely settled by white people." Many allottee descendants, including Angel and Julia, leased or sold their land to Euro-American farmers.[39] The diminished Indian-owned land resulted in more white influence than Radin believed had ever been the case. Still, Radin planned to meet with the elders who still carried knowledge of the Winnebago's "clan organization," though "little trace" of it was left, he explained.[40]

He discovered that the new "mescal religion" replaced "such dances as the scalp and medicine." His observations revealed the conflicts in Angel's own family between adherents of the old Medicine Lodge tradition (such as Good Old Man) and those who adopted the new peyote religion (such as Oliver LaMere). He witnessed a secret Medicine Lodge dance, one among many that were held that summer. Forbidden to attend the "very private" initiation ceremony, however, Radin thought he'd encounter little difficulty getting a description of it "from some of the mescal users or half-breeds who have left the lodge." Rivalry between the two religious groups created a backlash, which he used to his advantage. Much of the data on Winnebago culture Radin managed to gather, he informed Boas, came from the new "mescal eaters," who felt freer than their elders to violate taboos on esoteric knowledge.[41]

Radin managed to gather a great deal about the "extremely rich" Winnebago language. "I have found an excellent interpreter in Oliver Lamere [LaMere] a cousin of Angel de Cora's," he told Boas excitedly. LaMere "turned out to be an extremely faithful and valuable informant," said Radin, and he hoped "to keep his services until August."[42]

After only ten days, Radin sent three pages of linguistic findings to Boas, including his discovery of Ho-Chunk's unique verb position. Boas quickly responded, "You have hit upon one of the most important characteristics of the language. Miss De Cora told me about this matter last spring."[43] Over the summer LaMere spent six weeks with Radin, translating 115 Winnebago folk songs, as well as "several chiefs speeches."

The Winnebago town newspaper credited LaMere with helping Radin "get a base of a written language for the tribe, something heretofore never accomplished."[44] The report characterized LaMere in ethnographic terms as a "splendid specimen of the Winnebago tribe." He could speak "perfect English and is one of the most cultured and accomplished members of the tribe." But LaMere wanted to distinguish himself from educated Indians, like his cousin, stating emphatically, "I am not a graduate of any school. What I learned I have picked up myself and without the aid of the schools and colleges of which so many of the tribe members have taken advantage." LaMere also confronted the media's tendency to primitivize American Indians. He claimed that newspapers in New York "told a lot of lies about me, how I was dressed and that I was afraid of automobiles and street cars. I can run an automobile myself, and I don't think that anything like that would scare me."[45] No doubt Angel admired her cousin's candor and ability to fend off the kind of stereotyping that she experienced all of her public life.

§

Just as Angel's married name first appeared in the *Arrow*, she sent a picture postcard of herself and her new husband to Folsom (indicating she kept the *Arrow*'s staff from revealing her marriage). Her message was brief: "Will write later. Mr & Mrs Wm H. Deitz [*sic*]."[46] Not long after, she officially announced her marriage to Hampton's patriarch, Hollis B. Frissell, Armstrong's successor.[47] "I am writing to tell you that I am married. The young man is part Indian and has had art school training and we hope to work together and surely I feel more hopeful for my work than I ever did before. I am very happy."[48] Once Angel alerted Hampton to her marital status, the *Arrow* announced an addition to Carlisle's faculty: "Mr. Dietz and his staff of designers are very busy preparing Indian designs for the Carlisle Indian School magazine which will make its appearance in the fall."[49] Angel had finally learned how to manage her public image.

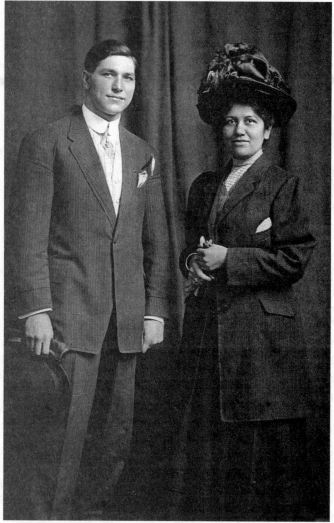

Mr. and Mrs. Dietz, ca. 1907–1908.
(Courtesy of Hampton University Archives)

By the end of June, she departed for the conference in Cleveland. Her husband's participation was not funded, but she brought him along anyway, making the trip a belated honeymoon. As Reel hoped, Angel showed "what the Office is doing for the preservation of Indian art," and "explain[ed] to the teachers how best to carry on this work in the schools." She and her students gave demonstrations in weaving and design, showing how "a larger field for the sale of the products of the

Indian" would eventually open.[50] Reel commended Carlisle on its "splendid showing."[51]

Angel fascinated Cleveland. The *Plain Dealer* reported on the "Indian Woman Famed as an Artist" and noted that she had "married another Indian artist, who is connected with the Carlisle Indian School."[52] The Hensel photograph of her illustrated the article. Apparently, the national publicity forced Folsom to acknowledge the marriage of her gray-haired child. In July, nearly seven months after Angel said "I do," the *Southern Workman* announced her marriage. Rather than his wife's assistant, the announcement identified Dietz as an "instructor in mechanical drawing at the Indian School at Carlisle, Pa."[53] He probably received this training in Philadelphia.

Dietz was more than a mechanical drawing instructor, however, or his wife's assistant. By the fall of 1908, the revamped school newspaper sparkled with his touch and the direction of E. K. Miller, the new head of the printing department.[54] The *Arrow* became the *Carlisle Arrow*, and the publication donned a refreshing new look. It advertised that all its artwork was "done by Indians in the Carlisle Native Indian Art department," aligning the paper with arts and crafts print aesthetics.[55] Angel contributed to the paper sporadically, but Dietz made it a showcase for his talents. The first edition featured "An Initial Letter Cut by the Carlisle Native Indian Art Department" by "Lone Star."

Near the end of October, Angel returned to the annual Lake Mohonk conference, this time with Moses Friedman and his wife. A. K. Smiley hosted them, and they participated in his program's "Indian day."[56] Commissioner Leupp was there to introduce his star appointee, taking the opportunity to summarize Angel's approach to her Indian students, "to draw out—what is in their minds." Angel presented another paper on "Native Indian Art," outlining Carlisle's experimental program as well as advocating for all Indian schools to reassess their own art programs. There were far-reaching consequences to her method of teaching, which she explained exploited the "general revival throughout the country of the old handicrafts." As Leupp's policy proposed, "skilled hands are in demand," she said.

She also told her audience about her visits to reservations "the last two summers," and how she sought "an insight into the Indian woman's life and her natural tendencies in domestic life." She did not want to change the women's habits, she explained, "but to find out the kind of work she does in which she employes [*sic*] her nature designs." She in turn showed Native women how to apply their pottery designs to curtains, teapots, lamps, and so on. She concluded her presentation with heart-felt words:

"The simple dignity of Indian design lends itself well to ways of conventional art and I think the day has come when the American people must pause and give recognition to another phase of the Indian's nature which is his art."[57]

Perhaps more than anyone of her era, Angel offered a viable, opposing view against Pratt's prohibition on Native art in Indian schools. She pointed to economic self-sufficiency as a tangible goal for American Indians, particularly women, but her deepest motive was to nourish "an Indian's self-respect." "When he is told that his native customs and crafts are no longer of any use because they are the habits and pastimes of the crude man," his "self-respect is undermined," she stated. "If he takes up his native crafts he does it with the sense that he has 'gone back to ways of barbarism.'" To counteract this prejudice, *her* students did "not study any of the European classics in art," she emphasized.

Angel gave her version of her response to first meeting with Leupp. "Unsuspicious of any design on his part, I talked freely." As an "Indian artist," she identified with Leupp's cause and understood, intimately, "the secrets and pangs that the educated must suffer." Not only was her "natural" way, like that of many educated Indians, disrespected, but she was completely alienated from her origins. The pull of family, friends, and culture had to be resisted, because "barbarism" was waiting for one at home, especially for young and vulnerable females. Angel dealt with this childhood trauma by reconnecting with the "universal" Indian woman. She hoped to uplift her, as well as to learn from her. The latter, especially, nurtured Angel's own work and reflected her reverence for the traditional Indian woman.

When Angel returned to Carlisle, the improved *Carlisle Arrow* featured a "distinctly Indian-design heading" created "after a Thunder-bird design of the Winnebagos."[58] As Angel's empathy for "the Indian woman," grew, she began reclaiming her lost heritage through her design work. Now her clan animal served as a badge of honor. Through her efforts, the thunderbird became an iconic symbol for the dignity and survival of American Indian cultures.

Angel also promoted the popularization of the "Indian craftsman." This modern persona represented more than the Navajo rug weaver or the Pomo basketmaker who worked for Indian markets across the land. It came to represent the "producers," who daily toiled with their hands at Indian schools. By late November, the "finest print shop in the Service" occupied a new mission-style structure on the campus, made of white brick. It featured popular weathered-oak furnishings. Some machines were salvaged from the old printing department, but new

equipment, "all modern and labor-saving," arrived to update the new "Indian press." The press boys and young men, including Lone Star, introduced the Indian service to the arts-and-crafts-style printing methods, setting Carlisle a cut above other Indian schools.[59]

Of course, Angel experimented with lettering as early as 1900. Britain's Kelmscott Press, founded by William Morris, inspired the new printing methods. Americans liked Morris's style, but Elbert Hubbard's Roycroft Press, established in upstate New York in 1895, "brought the Arts and Crafts book to more American homes than did any other enterprise."[60] Following Roycroft, Gustav Stickley, famed arts and crafts furniture designer, started the *Craftsman* magazine in 1901. By 1908 a second wave of American arts and crafts printing emerged that was simpler in decoration and less gothic in style than Kelmscott.[61] Carlisle's press imitated professional presses, particularly Roycroft's, but there was something unique about the merging of arts and crafts printmaking with the demands of Indian industrial training. The National Indian Association gave its stamp of approval for the school paper's new look, observing that the talents of "The Native Indian Art Department" were shown in the "beautiful work by illustrations in the *Arrow*, at once artistic in conception and striking in execution."[62] Before the close of the school year, products from the Indian Press impacted the nation's Indian schools. Genoa acknowledged appreciation for "several beautiful posters designed by the students of Carlisle's Native Indian Art Department and printed by the Carlisle Indian Press."[63] With the new press, a new printing director, and a talented designer in Lone Star, the exciting era of Carlisle's Indian craftsmen (and women) began.

§

Christmas break passed with no record of the Dietzes' activities. When classes resumed in January, the *Carlisle Arrow* reported that the art department "completed the study of Sioux Symbols" and was following with those of the Arapaho. Art students were applying the school colors and Indian symbols to things like "fancy pillow-tops," fulfilling Leupp's mission to incorporate Indian designs on saleable items.[64]

Pratt still made waves behind the scenes. He wrote to President William Howard Taft in November, criticizing the BIA, the degenerate "Wild West shows," and the teaching of Indian art in Indian schools.[65] "Indian schools have, of late years," he exclaimed, "been greatly perpetuating Indianism through the adoption of a fad claiming that training young Indians in the schools to manufacture their old-time bead-work, baskets, pottery, etc., was providing a reliable industry and resource."[66] He repeated his concerns to Taft about the "Indian curio trust," claim-

ing his son had been overcharged for a blanket by one of the Indian school curio stores (perhaps at Carlisle). He hated the backward and nomadic lifestyle curio making encouraged. He explained that curio dealers recruited Indians during the holiday season, dressed them in "native costumes," and used them to sell "their 'fraud ware.'" Pratt wanted the government to stop the "deception" of the "so-called 'Indian Art' training." "I would not take from the Indians any resource for making honest money," Pratt claimed, "but I would end the false idea that 'Indian Art' training means substantial and permanent income and betterment."

Pratt had no sympathy or understanding for the ideology of the American arts and crafts movement as it related to Native artists. He wanted Indians to return to more "civilized industries," and he exaggerated the detrimental effect of making Indian curios. Given the market, it was not a bad way to earn money. Why not take advantage of the high consumer demand? Pratt had certainly promoted Carlisle's band and football team for revenue. Although Pratt was a visionary, he couldn't see the benefits of transforming Indian industrial students into Indian craftsmen and women.

Unlike Pratt, Howard F. Stratton from Philadelphia realized Indian designs were "the coming things in American Art." He was "wonderfully pleased with the work being done in the Art Department." He boasted that two Carlisle students at his school influenced designs of his other students.[67] During this time, Angel's friend from Hampton, Carrie Andrus, came to visit the school. As acting curator of Hampton's museum, she also showed great interest in the work of Angel's students.

In February of 1909 the print shop debuted the *Indian Craftsman*, Carlisle's new monthly magazine. The fine collaboration between the Indian press and the Indian art department featured in-depth articles about Indian life inspired by "improvement not transformation." "The cover page, embellishments, initial letters, and borders," said the editor, were "designed by Indians, and indicate that after all the art of the aboriginal American has much in it that is beautiful and valuable."[68] Dietz designed most of the magazine's covers for the next five years.[69]

The first issue featured an article on "Native Indian Art," introducing readers to Leupp's pedagogy, as well as introducing art instructors, "Mrs. Angel DeCora-Dietz, a Winnebago Indian, and her husband, William Dietz, a Sioux." The magazine advertised "the handwork of our students and the products of the older Indians on the reservations." "The Studio is not conducted for making money," the editor emphasized, "but rather in order to assist in the development of Indian art and Indian handicraft."

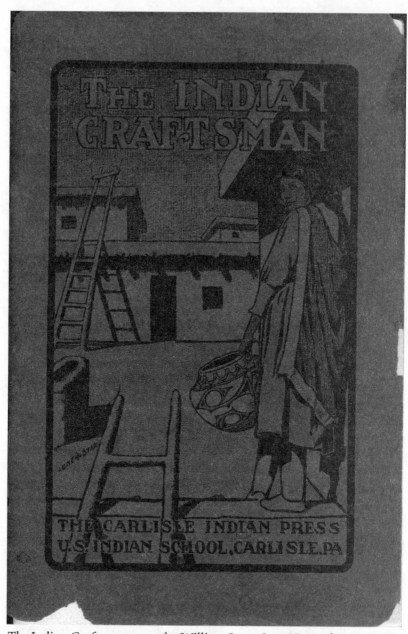

The Indian Craftsman cover by William Lone Star, November 1909.

The first edition elicited a positive response. The school paper for Flandreau Indian School in South Dakota sent congratulations to Carlisle on its "excellent magazine," and its "first-class workmanship."[70]

In early March the superintendent of the Indian school at Fort Defiance, Arizona, brought a "nice class of Navajo students" to Carlisle's art department. Some just happened to be "excellent Navajo silversmiths."[71] The carpenter shop constructed special benches, and Dietz traveled to Philadelphia to purchase silversmithing tools.[72] Dietz hoped the new students would contribute their expertise to the art department. Like the Navajo weavers Angel had requested from Leupp, experienced silver workers broadened the production capabilities of the art department.

In April the *Philadelphia Ledger* reported on the exciting artistic scene at Carlisle with "Indians to Foster Their New Art."[73] The article featured the Carlisle students who attended the School of Industrial Art in Philadelphia as well as the arrival of the Navajo silversmiths, who would "carry on their craft at the Indian school." Friedman was probably the source of the article. The report gave him undue credit for the success of the art department, stating he did "wonderful work in developing" Leupp's plan to "study and foster" Indian art.

Stratton was also interviewed. He contrasted the government's past Americanization policy, "to stamp out all natural tendencies, fancies, traditions and feelings, and all individual spirit," with the new progressive universalism, "the opportunity for studying the transition of a primitive people from their peculiar elemental art to a more advanced type."[74] The article completely neglected Angel's role in establishing the art department. Not only did Leupp and Friedman usurp her importance, but the article left her husband's subservient position ambiguous: "The art department at Carlisle is under the direction of Mrs. Angel de Cora Dietz, a Winnebago Indian, and her husband, William Dietz—Lone Star—who are working to develop the arts of blanket weaving and working metals."

§

The spring of 1909 offered Angel a variety of activities and opportunities, but, as she confided to Folsom, "*teaching* is not any more agreeable than it ever was." She prepared classroom work for the Exposición Nacional, in Quito, Equador, and hoped to send two rugs, one woven by Hopi technique and the other using the Persian method with which she had been experimenting.[75] Her personal life appeared more fulfilling. She and Dietz moved into the new on-campus married employee quarters. Each flat, featuring steam heat, consisted of four rooms, a bathroom, and

a basement. The living room had a fireplace with a mantle and a "tile hearth."[76]

Angel received the patent for eighty acres she had inherited in Nebraska. It was issued directly to her, showing that the government deemed her a "civilized Indian." Land speculators immediately contacted her. She intended to sell it, but for more than they offered. Meanwhile, her husband became a local item. The *Judge*, a weekly New York political magazine, featured a "comical picture" drawn by him.[77] Carlisle's town newspaper reported Dietz was "becoming famous," something Dietz strived for.

In the spring of 1909, Angel enjoyed a pleasant visit with Folsom at Hampton and found their mutual friends, the Darlings, "good medicine" for her troubles. Mrs. Darling, formerly Mary (Mollie) Gorton, had been a young teacher at Hampton from 1886 to 1891, until she transferred to the Fort Belknap agency in Montana. After her marriage, Mollie settled permanently in Virginia and maintained close contact with the school's Indian department staff. She took a great interest in Angel's art, purchasing the painting for the frontispiece of *The Middle Five*, but probably for little money.[78] When Angel returned to Carlisle, she wrote Folsom, revealing her contentment in her marriage, despite, or maybe because of, her role as her husband's caretaker:

> I felt very reluctant in leaving you and all the dear old friends but there was Billy you know at this end just a wallowing in dirt—as I imagined you remember. Well, the sight & smells that greeted my return was no disappointment to my vivid imaginings but *he was* so glad to see me back and moreover seemed so utterly unconscious of the condition of his surroundings & made no appologies [*sic*] that I forgave him, & bright & early the next morning (tho' it was Easter Sunday) I began to dig him out—and have been digging ever since. The conditions in the art students' work room was no better & have more diggins there & a pile of correspondence to attend to for our department.[79]

Angel added, "Will says he would like to see you." How long he adhered to his "principles" regarding Hampton's African American students is unknown. To smooth things over, Angel enclosed a copy of the *Indian Craftsman*. "The art work is all done by Will & his pupils," she boasted. "The pupils do all the designs & he does all the sketches. I do none."[80]

She closed her letter inquiring about Carrie Andrus. Carrie's fiancé, William Jones, had just been brutally murdered in the Philippines. The press portrayed him as martyr, but today some believe Jones misjudged his power over the Illongot, his subjects of study. Chicago's Field

Museum asked Jones to bring back a variety of handmade crafts, though his mentor, Boas, doubted Jones was ready for such an undertaking. Boas was right. Jones, over anxious for a good collection, insulted the Illongot and demanded better-made items. After one bad incident, three Illongot men armed with bolo knives killed him.[81] His death illustrated all too clearly why Pratt's concerns were valid. "Primitive" handmade crafts were often valued over their makers. Andrus never married, but her friendship with Angel deepened.

§

When the school year closed, Leupp resigned unexpectedly due to his "fagged nerves." Leupp thought "there could be no more opportune time than the present" to leave, because, as he stated to President Taft in his resignation letter, "the Indian Office is now in fine working order, and its machinery in the hands of a competent corps of men, all identified with the progressive policies we have been pursuing."[82] Leupp's resignation would have far reaching consequences for Angel.

Despite his support of Carlisle's art program, Leupp supported the new view against off-reservation boarding schools, especially Carlisle, which was so far from where its student body originated. "It is a great mistake to start the little ones in the path of civilization by snapping all the ties of affection between them and their parents," Leupp insisted, "and teaching them to despise the aged and non progressive members of their families."[83] The damage done to Angel's generation became common knowledge.

§

When the Dietzes returned to their duties in the fall, the husband was still employed as his wife's assistant.[84] The Carlisle Indian Press established itself as a unique presence in the printing world, "receiving daily requests for samples of work from the noted printing establishments of the country." "Three leading exponents of typographical art," the *American Printer*, the *Inland Printer*, and the *Printing Art* acknowledged the quality of its craftsmanship.[85] Dietz often received credit for the publications that the department produced. In particular the Lone Star–styled *Indian Craftsman* received critical attention, so much so that the Indian printers were frequently asked to share "art work to be used in executing the higher and better grades of printing" with other print shops, such as the Winona Technical Institute in Winona, Indiana. The institute borrowed "Indian initial letters, borders, illustrations, tail pieces, etc." from Carlisle's press to issue an "Indian edition," reportedly "a work of art and a great compliment to Carlisle." A newspaper from Wilmington, Delaware, reported that the magazine "would do credit to

any high-class establishment" and was "a work of high art, not only in the matter of reading matter, which is well selected and well written, but also in the make-up and press work as well."[86] Praise came from Milwaukee, Wisconsin, whose newspaper noted "William Deitz, a Sioux known as 'Lone Star'" designed the June cover of the *Indian Craftsman*.[87]

The creative climate at Carlisle had never been as exciting or as vital, in spite of Leupp's resignation. Dietz became the new instructor in silversmithing, working closely with the recent Navajo recruits to design and make jewelry and belt buckles. Creative expression infused the holidays. Halloween found employees celebrating in the gymnasium with a masked ball. "Spirits and sprites, black cats and other creatures of mystery held high carnival." Students and faculty decorated the gym with "shocked corn and chrysanthemums," and "apples hung on strings and bobbing in tubs of water." A "grand march of all masqueraders began the program," followed by a contest where Angel, dressed as a black cat, won the prize for "the most ridiculous costume."[88] When the Christmas season neared, the art department offered "many timely suggestions to the Christmas shopper." The carpenter shop built two large cases that were set up in the new lobby of the print shop to sell "a variety of articles, including rugs of various weaves, cushion covers, Hopi scarfs [*sic*], and bead watch fobs."[89]

§

After the New Year of 1910, Carlisle's faculty met as usual to present their scholarly papers to each other, and the year's batch "aroused great interest . . . among all who heard them." In the past Angel presented on the importance of "Native Indian art" preservation. Now her colleagues urged cultural preservation as well, including Claude Maxwell Stauffer, the band instructor, and Mary Y. Henderson, the history teacher.[90] The reception of these papers revealed that Carlisle embraced "improvement."

Such improvement did not suit Pratt. He expressed contempt for the new order to Carlisle school physician, Dr. Charles F. Himes. He offered Himes his own, worn-out, bizarre three-year-plan "to settle our Indian problem." Indians should be first "distributed" across the country—no more than one to a "neighborhood," and no more than "nine to a county." Once distributed, they should "work for and live with our people." After three years, "they will have the language and enough skill and industry, courage and desire to continue that life to enable them to go on to perfection," but they must be "turned loose" from BIA control.[91] He accused his foes of calling Indian students "back to tribal life." He also displayed paranoia, saying "my enemies succeeded against me

largely by whispering 'Pratt's crazy.'" Worst among Pratt's enemies were those who no longer taught students "to handle the tools and create the things of our life," but substitute the teaching of "Indian Art." "Turn the very teaching of 'Indian Art' loose to make a living among our people out of it," said Pratt, "and they will starve into other employments in a jiffey [*sic*]."[92] His conclusion, despite many of its quirky premises, was a point well taken.

Angel concerned herself with other things. She contacted Carrie Andrus to comfort her and also to give her advice on Navajo rug making. She asked Carrie to congratulate a mutual friend at Hampton who was expecting a baby. She confided, "I got a little gray kitten and a Russian wolf hound as a surplus of my family—(best I can do unless Uncle Sam pays us more salary)."[93] This is the only evidence Angel considered having a child. She was already forty-one, and only Russian Wolfhounds would be added to her family. "Carlisle with all its gay *social* (?) life does not hold my interest any more than it did when you saw us here," Angel confided, " but we stayed thro' the fall months because they needed Billie for the foot ball season. He was one of the team and they are asking him to play next fall again—Like the starling I still cry 'I want to get out' but he is weak when it comes to foot-ball & we may find ourselves here next fall—but I hope not."

The *Indian Craftsman* continued gaining recognition across the country. In response, Gustav Stickley took legal steps to have the magazine's name changed. By the end of January, Carlisle's town newspaper reported that the *Indian Craftsman* would become the *Red Man*, because "the New York contingent felt that the use of the word 'Craftsman,' although in connection with the word 'Indian,' was detrimental to their interests." This "was a distinct compliment," the report accurately concluded. If "such a powerful magazine as the Craftsman" took notice, then it must view "our local periodical" as its "competitor." Stickley's attorney's claimed the similarity of names caused too much confusion. "It seems that, in many cases, the newspapers of the country, in quoting from articles and editorials of the Indian Craftsman, inadvertently credited these excerpts to the Craftsman, and consequently with many people the two magazines, in a way, were merged."[94]

That week Elbert Hubbard visited Carlisle's printing department. His Roycrofters produced arts and crafts furniture and household items, but it also produced two magazines that Hubbard edited himself, the *Fra* and the *Philistine*. "'The Fra' Visits Us" reported the *Carlisle Arrow*. Was this visit a coincidence, or did Hubbard intend to defend "the *Indian Craftsman*" against *his* competitor?

A fascinating and ethically minded human being, Hubbard became famed for his inspirational lectures and his personal and business credos. His words melded arts and crafts idealism with the tenets of U.S. capitalism, making him a model progressive. His personal credos included such beliefs as "God is here, and ... we are as near Him now as ever we shall be" and "salvation through economic, social and spiritual freedom." He considered John Ruskin, William Morris, Henry Thoreau, Walt Whitman, and Leo Tolstoy to be "the Prophets of God."

According to the *Carlisle Arrow*, Hubbard "was very much interested in our shop and did not hesitate to say, in no uncertain language, what he thought of our work—and what it was doing for the Indian Service and the Indian. Mr. Hubbard's words were very encouraging and his visit an inspiration. He spent a couple of hours going through our institution, and a number of our teachers and instructors enjoyed his lecture that night at the Carlisle Opera House."[95]

Hubbard's recognition of *their* work certainly inspired Carlisle students—as well as their teachers. It seemed, however, as if he had been there before. His philosophy animated the values Carlisle espoused during this era. If any place merged capitalism, secularism, and self-esteem with the ideals of the arts and crafts movement, it was Carlisle's Native Indian art department. By the next week the department received boxes of "casts, masks, architectural ornaments and animals in bas-relief" from the Philadelphia School of Industrial Art in Philadelphia.[96] Was this a show of support? It was, but it also represented admiration. The creative work at Carlisle obviously resonated with those in higher places than ever before.

§

As Carlisle's fame grew, Angel was still doomed to the circuit of extracurricular activities. She participated in various school groups and functions, such as attending a Catholic students' meeting with her husband, as well as visiting The Standard's meeting, where the debate centered on U.S. possession of the Philippines.[97] She also taught her students such practical and boring skills as making "bead fobs," used for carrying pocket watches. She attended the "C" letter celebration, headed by Pop Warner. Oliver LaMere came to the event, as "First Chief," "in gorgeous Indian costume." To make his presence more authentic, he "gave a clever and interesting talk" in Winnebago that his interpreter translated.[98]

In March the *Arrow* called Dietz "our silversmith," but he was still his wife's "Assistant Teacher of Native Indian Art" on the employee roster.[99] Dietz undertook odd jobs around campus, such as helping Warner

retouch stage scenery. He continued designing the covers for the freshly titled *Red Man*. The March edition featured Stratton's essay, "The Place of the Indian in Art." The piece romanticized "the American Indian," who Stratton claimed was "an artist-artisan and not a mechanic, a farmer, or a trader. His life has been picturesque and his products decorative, and these works of his hands constitute the only original art we can claim—to look back upon, or to look forward to developing."[100] A Sioux profile in headdress with the caption "Indian Art—Study from their own Life—By Lone Star" illustrates the last page. Meanwhile, Angel held her place in Carlisle's Indian art market by having her students combine Navajo style with Persian weaving techniques.[101]

Warm weather and the commencement ceremony brought visitors the last week of April. Mount Holly still provided Carlisle's Indian maidens with natural entertainment. Angel chaperoned another group of girls for an all-day picnic. The school paper, of course, highlighted the primitive aspects of the event.[102] Gertrude and Louisa Clapp, along with Flora Quimby, finally came to visit the Dietzes.[103] How Gertrude felt about Angel's marriage is unknown, but her visit indicates she tried to be supportive.[104]

The Dietzes took separate vacations in the summer. Angel attended commencement at Smith College and spent the rest of the summer at Carlisle and Amherst, New Hampshire, while Dietz ventured west to "the Dakota country and visiting relatives—in Wisconsin and Minnesota."[105] Their summer activities raise several questions. How was Angel received in Amherst, where she visited Mrs. Richard Henry Pratt? Why didn't she go with her husband to meet his family? They could easily have visited her family in Nebraska as well. Was money an issue? The answers are unknown. The couple made separate vacations a habit in their future, however. And when they returned in the fall, football habitually awaited William Lone Star.

Misrepresenting the Indian

Angel made the rounds to the literary societies when the school year resumed. The duty was not unpleasant when her lively, irrepressible husband came along. Likewise in October, Lone Star accompanied Angel and some lucky female students to "the Cave." Cave Hill Park provided ice skating in the winter and boating in the summer. To get there, the group boarded the trolley that stopped at the school's entrance, rode it to the northern edge of town, disembarked, and walked to the pavilion to the boats. Usually they rented the canoe called "Winona," especially reserved for Carlisle students.[1] Angel loved gliding on the scenic Conodoguinet Creek, and Dietz loved being the center of attention, so it was fun for both of them. The art students enjoyed spending time with their trend-setting teachers. The stylish couple embodied the best attributes of Carlisle's Indian craftsman and woman. Angel's ready wit was always an unexpected delight and her sensitivity and gentle personality complimented her handsome husband's more obvious charms. Dietz's position at Carlisle was still inferior to his wife's, however.[2] Although Angel hoped to partner with her husband outside of the Indian service, his love of football inhibited their art careers from thriving much beyond Carlisle's orb.

For the first time since enrolling, William Lone Star made Carlisle's starter team for the 1910 season. His eligibility, like several others recruited for the team, was more than questionable and depended on his taking "special courses." It was not the first time Dietz played football under the guise of a student. His ambiguous position on Chilocco's football team rose to the surface in 1904 after a Thanksgiving Day football game between the new school he attended, Friends University, in Wichita, Kansas, and its local rival, Fairmount College. The day before the game a local newspaper reported, "William Deitz, of St. Paul, Minn. will hold down the position of left half back. This is a new man in Wichita football circles and is considered one of the Quakers' most valuable acquisitions."[3]

The Friends' student body welcomed Dietz with open arms. They recognized him as an artist, on and off campus, and regarded him as "our great Indian athlete." He even entertained the football team the night before the Thanksgiving game with "Indian songs and dances," just as he did later in Philadelphia.[4] But the day following the game, the *Wichita Daily Beacon* ran an item questioning his eligibility.[5] "The matter is something like this," reported the newspaper, "Fairmount contends that Dietz having played on the Chilocco Indian team earlier in the season, and not being a graduate of that institution since he played, is ineligible."[6] Why Dietz left Chilocco was not mentioned, but the president of Friends University offered a rebuttal. Since Chilocco was an Indian school, the rules of the Topeka conference did not apply to it. Besides, he claimed, although Dietz "played one or two games" for the Indian school, he "was never a student" there, he was an *employee.*[7]

Friends University continued to welcome Dietz despite the deception. In the spring of 1905, he played shortstop for the baseball team.[8] From this period until he showed up at Carlisle, his whereabouts has been unknown. The question, however, is why did he choose to attend Indian schools, when his education superseded the grade levels of both Chilocco and Carlisle? Football undoubtedly brought Dietz to Carlisle and may be what compelled him to highlight the schooling he (never) had at Chilocco, while neglecting to mention he attended Friends University.

That fall Warner's "Redmen," as they called themselves, won eight games and lost six. Teams such as Villanova, Syracuse University, Princeton, Johns Hopkins, Brown University, Harvard Law School, and Navy played against them. They played their first game at home with a local team. The event drew a great number of spectators. Carlisle wowed the crowd, beating its rival 53 to 0.[9] By the third game of the season when Carlisle beat Muhlenberg College 39 to 0, Lone Star received media attention.[10] His membership on the wildly popular team afforded him glamour, a dynamic coach, exciting teammates, thrilling and prestigious competition—all under the rapt gaze of hundreds, and sometimes thousands, of spectators.[11]

Dietz continued his design work, which became better and better. Besides his work on the *Red Man,* he designed "a very beautiful cover" for Carlisle school's annual report.[12] While the *Carlisle Arrow* often praised *instructor* Lone Star's work, it appropriately acknowledged Angel's *students* far more than her. In October, the school paper reported, Cora Battice "brought from her home in Oklahoma various kinds of beautiful bead work which was made by her mother who is an expert at that kind of work."[13] The next week Anna Miles, "who has been

studying art under the instruction of Mrs. Dietz," left for Philadelphia, "where she will continue her studies in one of the art schools."[14] Both students were favorites of Angel's and were often mentioned in reports of the art department's activities.

On the other hand, her husband's role at Carlisle was as ambiguous as it had been at Chilocco. Was he a student or an employee? Was he an instructor or his wife's assistant? Angel kept silent on the matter, but Dietz offered no proof of tribal enrollment until 1914. Carlisle publications covered the ambiguity and Friedman co-opted the deceit with Warner's approval. As Angel had informed Folsom, Friedman wanted *both* of them to stay at Carlisle. Administration-directed adjustments allowed Dietz to retain his student status, probably because he made a good impression for the school.[15]

In December, a report by Carlisle's town newspaper responded to Warner's assertion that he would have a stronger team in 1911. The article countered Warner, saying the team would not "be able to hold quite the pace set by the teams of two or three years ago, on account of her eligibility rules." Athletics should not "interfere in any way with school work," it was now decided, and only "legitimate and representative students" would be allowed to play football. "The Indian office rule against enrolling students over 21 years of age will also tend to handicap Carlisle."[16] Still, Dietz continued playing well through the fall season, when even a losing game with Pennsylvania was cause for celebration. "Everyone who saw the game could not help but realize the fact that the Indians put up one of the grandest struggles every seen on a football field," reported the *Carlisle Arrow*. Lone Star "stood out prominently as always being in the thickest of the battle."[17] On the gridiron, Dietz expressed his "fighting spirit," but he also enjoyed performing for such a large audience.

Angel kept up her own appearances throughout the fall. Carlisle held another masquerade ball that Halloween, noted to be one of the "finest 'get-up's ever given by pupils." Angel and one of her students took the prize for best couple, "dressed in hobble skirts with enormous peach-basket hats." Their costumes exaggerated the fashions of the year. The new brimless, peach basket hat, designed for motoring in a car, covered all the hair and did away with hat pins. The short-lived faddish hobble skirt enclosed the ankles with a band, impeding walking.[18] Other costumes at the party reflected the great influx of immigrants coming into the country, or caricatured African Americans. Girls and young women dressed as "gypsies, Swiss girls, Scotch girls, and many other quaint characters," while boys and young men "represented Indians, monkeys, girls, darkies, tramps, rustic lassies and happy sons of Erin."[19]

After Halloween, the Redmen traveled to Providence, Rhode Island, to play Brown University for the Thanksgiving Day game. They lost 6 to 15, but the game was played "before the largest crowd ever to attend a Brown game."[20] The year ended on a positive note. According to Carlisle's local paper, the players were "quite jubilant over their successful season, notwithstanding several defeats." Significantly, the paper also acknowledged that even though Warner had "quite a bit of green material" to work with (as most players were new that season), the "Indians outside of their good work are a big attraction and a good money maker."[21] Warner was savvy. He knew even "green Redmen" could produce *green*.

With no end of the Indian service in sight and Christmas around the corner Angel taught the intricacy of basket making.[22] The baskets served as Christmas presents, though it's unknown if they were sold in the salon. Angel made Christmas cards as well, and sent one to Carrie Andrus or may have given it to her personally.[23] Perhaps she finally talked her husband into visiting Hampton over the holidays. But he, at least, was back by the New Year. The Carlisle employee bachelors and married men rang in 1911 with a friendly basketball game. Unfortunately, the six-foot Dietz found himself on the losing team.[24] Nevertheless, he was a shrewd competitor in all kinds of sports, whether football, baseball, tennis, or basketball, enjoying the performance as much the game.

§

Angel's last sister left Carlisle by February of that year. The school officially discharged Grace Sampson, but she had actually been "on leave" since the summer of 1909. She received very good marks for her conduct throughout her school days. The *Arrow*, without indicating she was Angel's sibling, portrayed her as quaint and childish though she was in her early twenties. "Who says Grace Sampson isn't getting ahead of the poor little squirrels in gathering nuts?" or "Last Saturday after the sociable Grace Sampson went into her room and she saw a whole lot of June bugs so she gathered a whole box full."[25] Angel could not manage to keep Grace away from her father's "clutches," anymore than she had Mary Sampson or Madelyn Rickman. Consequently, Grace returned to the reservation and married Phillip White, Jr., by 1917.[26] If she had children, they didn't survive long. Apparently, Angel's lifestyle held little promise for her half-sisters, or she did not hold them close enough to her heart for them to want to stay.

§

Eventually the Dietzes developed a social life outside of the provincial town of Carlisle. Mr. and Mrs. Hallet Gilberté, as well as the wife of New York stage actor Thomas E. Shea, were their guests in February. The

Arrow said Mrs. Gilberté was "an actress of note," and her husband was "a noted tenor singer as well as a composer of acknowledged merit." The visitors were said to be "deeply interested in the school and in the work which was shown."[27] Dietz felt closer to the Gilbertés than did Angel. Even if they provided a glamorous reprieve from the day-to-day grind at Carlisle, Angel neglected to mention them to Folsom in a letter written shortly after their visit. She did mention that money matters kept her from visiting Hampton again, and that she still hoped to leave the Indian service someday. "We are dreaming & building air castles of getting out of the Indian service—I don't gain any thing but ill experiences and I am loosing even that which I had before. Will & I are getting rusty & if we can strike upon something for a while—we hope to say good bye to my Pennsylvania dutch friends."[28]

Angel planned to take "vacation trips northward" that year, while "Wm is talking of going up to the Canadian woods for '*gold prospecting*'!" Dietz, like his football coach, loved to gamble. Angel received vicarious pleasure from his daydreams, telling Folsom, "In my mind I've already spent half the gold mine." She fretted about her age, even more now because she pretended to be about thirty to appear closer in age to her husband.[29] "I hear rumors that some of my name sakes might be turning up at Carlisle any time now & I believe that would age me fast so I am anxious to get out," said Angel. "Avoid being god mother to any more pappooses [*sic*] & thereby preserve your youthful age."[30] Her signature reflected her frustrated state of mind. "I am always the Same Angel De C."

In the spring an Ohio women's club presented papers written by prominent women. Among them was "Jane Addams with Honors from Yale" and "Mrs. Angel DeCora Deitz on Indian Service."[31] Certainly, Angel's paper did not convey the sense of dread she felt on the subject, but the fact that she is compared to such notable philanthropic peers shows she was known for more than Native Indian art.

The same month the *Red Man* featured "Angel DeCora—An Autobiography."[32] A progressive, "new Indian" narrative encapsulated her life story. This new Indian no longer represented complete assimilation. She could even represent the interests of traditional or "blanket Indians." In contrast, the educated Indians of Angel's generation chose between assimilation and the family they left behind. The new Indian didn't have to make such drastic choices, because, as a progressive, she should be concerned with issues of social justice for her people.[33] Ideally her character included "dignity, fidelity to one's work, love and reverence for nature, cooperation, artistic expression, respect for age and wisdom, bravery, belief in a higher being, an aversion to crass materialism, inde-

pendence, self-respect, and pride."[34] She partook "of the best attributes of the tribe," but she "would no longer be bound by tribal parochialism." Like the new U.S. immigrant, the new Indian "adopt[ed] the best qualities of the larger society" and her "Indianness and Americanness would complement and refresh each other."[35]

The establishment of an *authentic* Indian origin became paramount to the narrative of the new Indian. In order to make this origin ring true, new Indians emphasized certain aspects of childhood and de-emphasized others. Whereas the fledgling artist highlighted her French-Canadian origins, writing her name "Angel de Cora" or "A de C," Angel's autobiography de-emphasized her mixed ethnicity. Angel stressed she "acquired the general bearing of a well-counselled [*sic*] Indian child," but her demeanor was more pan-Indian than tribally unique.

In portraying her artistic nature, Angel wrote: "I also did some designing, although while in art schools I had never taken any special interest in that branch of art. Perhaps it was well that I had not over studied the prescribed methods of European decoration, for then my aboriginal qualities could never have asserted themselves." Her latent aboriginal qualities lay dormant until the she rediscovered the "aboriginal quality" of her creative self. Angel's autobiography, just as her Hensel photograph had done, inspired a generation of new Indian females.

§

During the spring break, Dietz renewed his friendship with Gilberté.[36] He left his wife behind and spent a week with the composer at his home in New York.[37] Dietz fancied the lifestyle enjoyed by his illustrious friend. He was such a fashionable, dramatic fellow himself, and so entertaining, he fit effortlessly into Gilberté's social circle. Soon after his return to Carlisle, the sporty Dietz ordered a tennis court installed behind his flat, just in time for Gilberté's visit in May.[38]

In the meantime, Angel developed a friendship more suited to her reticent tastes. She introduced this friend to Folsom, after Folsom requested "a good type of an Indian of the Algonquian family" to serve as a model for an unknown project. Angel referred Folsom to the Smithsonian, explaining, "I've looked since & all the Chippewas here are white and no Sac & Foxes & we have no costumes peculiar to the tribes of the Algonquians."[39] She told her instead about her "very dear" Chippewa friend, "Mrs. Baldwin of Washington." Angel planned to make an appearance at Hampton's upcoming commencement with Baldwin, but her finances were low. Mrs. Baldwin, however, intended to go anyway. "Please be good to her," Angel requested. "I am sorry I am not going along with her, but she is charming—She will do it all for me."[40]

Marie Louise Bottineau Baldwin worked for the BIA, beginning in 1904 when Commissioner Leupp appointed her as clerk in Minneapolis.[41] By 1910 she and her father shared a residence in Washington D.C., where Marie took up law studies. Marie seems to have been the only American Indian woman outside of Hampton with whom Angel sustained a long-term friendship. Their personalities and careers were quite different, but they shared similar backgrounds. Marie was born in 1863 either in Pembina, Dakota Territory, or near Minneapolis.[42] She was the daughter of Marie Renville and John Baptist Bottineau, both Ojibwe Métis. Her mother's father worked in the fur trade, and her father was the son of an early Minnesota settler.[43] Bottineau became an Indian lawyer and represented the displaced Ojibwes and Métis of Turtle Mountain, which is why he resided in the nation's Capitol.[44] Marie advocated for Indian rights, but she was also a suffragette. Angel surely admired Marie's strength, independence, and directness, since they remained close throughout Angel's life.

Angel's financial situation was not the only thing preventing her from going to Hampton. She and Dietz shared a lively social life that summer. This reflected either contentment or compromise. They "motored to Big Spring" with the Warners in early June, and in midsummer they went to Lincolnville Beach in Maine to stay with the Gilbertés.[45] They also "took some delightful trips by auto and motor boat to Bar Harbor, Castine," and visited "friends in Massachusetts." Undoubtedly, they visited Gertrude Clapp in Northampton and the Eastman family in Amherst.[46] They had just finished four illustrations, each signed with both of their names, for Elaine Goodale Eastman's work of fiction, *Yellow Star: A Story of the East and West*, to be published in the fall.

Goodale Eastman's youth novel showed she was still an old-fashioned reformist. The story's protagonist, Yellow Star, was a Sioux girl, "found clasped in her dead mother's arms on the bloody battlefield of Wounded Knee."[47] Sent to be educated in the east, Yellow Star overcame adversity with "grace" and "native nobility," and finally returned to "her people" as a field matron. Reviewers agreed that Goodale Eastman was "well acquainted with Indian life and character."[48] Not only had she married a Dakota man, but she also had the task of bringing up their four daughters and son. One reviewer also noted "the interesting names, Angel de Cora and Wm. Lone Star, attached to" the book's "four attractive illustrations."[49] The project gave Angel hope the future held hope for more artistic collaboration between she and her husband.

With summer's end came the same dilemma: Lone Star returned to football, and Angel put her ambitions on hold. The 1911 season proved

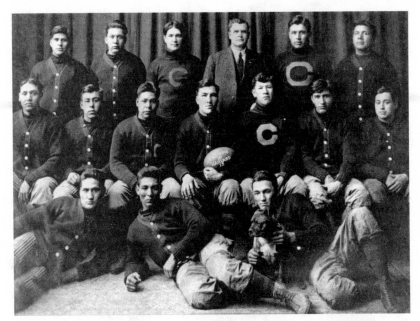

Carlisle Indian School football team, 1911. Jim Thorpe (middle row, fifth from left), Dietz (back row, third from left), and Coach Pop Warner (back row, fourth from left).
(CUMBERLAND COUNTY HISTORICAL SOCIETY, CARLISLE, PA. [15A-1–14])

Carlisle almost undefeatable, making the Redmen "the toast of the nation." The future Olympic gold-medalist, Jim Thorpe, became a rising star that season. His performance as left halfback led to an All-American player award. As one historian notes: "Jim wasn't the entire team, but his presence rounded out a roster that would make a modern coach's mouth water and allow him to sleep free of nightmares."[50] For the Penn-Carlisle game of November, Lone Star received special recognition as one of two star tackles whose moves "simply dazed Penn."[51] If Angel felt let down by her husband's dedication to football, it was certainly lost on him. His team was the victor in every game but one that year.[52]

In April Dietz designed costumes for *The Princess Ndaniss*, a vanishing Indian-themed play, performed at the Carlisle Opera House. The lead played "herself," though her identity is unknown ("ndanis" is Potawatomi for daughter). Dr. Bryon S. Behney played "To-nek," and Hugh R. Miller, a reporter for the *Evening Sentinel*, played "Nar-ko." The male characters in red face made the opera's plot even more inane: "Ndaniss leaves her tepee on hearing the second call of her lover's flute. She is surprised by To-nek who shows the nobility of his character by

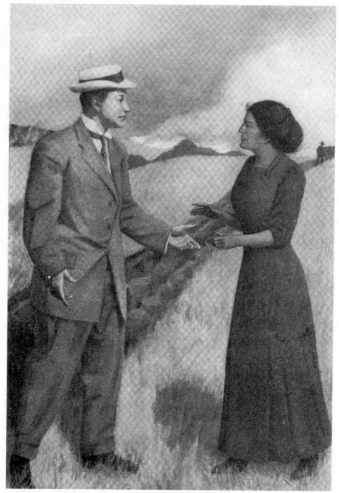

Yellow Star frontispiece by "Angel de Cora" and William Lone Star, 1911.

offering to free her. Nar-ko enters surprised to see the couple together but Ndaniss presents him to To-nek and the two sing of the passing glory of the Red Man's race. Nar-ko parts with Ndaniss leaving To-nek disconsolate."[53] It's difficult to believe that Angel, who was given an "acknowledgment of courtesy" in the program, sat through the production with a straight face.

Later in the year, a reporter from Charles A Dana's human-interest newspaper, the *New York Sun*, interviewed Dietz. The lengthy article that followed was picked up by the *Philadelphia Press* as "Preserving the

Indian's Art," and became the basis for an article, "How Art Misrepresents the Indian," published in the popular magazine *Literary Digest*.[54] The first page of "Preserving the Indian's Art" displays a cropped and lightened version of Angel's Hensel photograph on the far left of the page. Towering over her oval bust portrait is a miniature full-bodied Dietz in profile on the right. His right arm is extended directly over her head, and he is adamantly pointing what appears to be a peyote fan toward the west. Dressed in Plains Indian attire, he dons an eagle-feather headdress. Nestled low between both images is a cartoonish landscape, with two tepees in the foreground haphazardly decorated with symbols, including the tribally incongruous Navajo swastika. The caption under Dietz reads, "Lone Star, in Graceful Indian Attire Properly Made." The second page of the article shows a handsome headshot of a well-clad Dietz in European dress, captioned, "Lone Star, The Indian Artist."[55] Representing the unequal gender politics of the day, the caption under Angel's portrait simply reads, "Lone Star's Wife, Angel De Cora."

Two black-and-white photographs of Angel accompany the *Literary Digest* article. In the first, she is in braids and beads wearing a buckskin dress, carrying a bucket. The caption erroneously states, "Lone Star's Wife In Her Tribal Dress." The second image shows Angel as an Indian maiden seated placidly in a canoe on the pond at Smith College, either while she attended the School of Art or soon after.[56] The caption reads: "An Indian Idyll. Angel DeCora in a birch canoe." A subcaption reads "'The Indian woman never wears feathers,' says her husband, Lone Star; 'it is the man's sole right as a warrior.'"

The pictures portray Angel and Lone Star as romanticized Indians with the male in charge. The introduction of "How Art Misrepresents the Indian" pronounces the couple as "the only Indian artists of America," the kind of distinction Angel would never have made. "In a plea for the preservation of the art of the American Indian, for the picturing of the Indian and his life as they existed, and not as a majority of the country's illustrators have imagined them," the *Literary Digest* article began, "Lone Star and his wife, Angel DeCora . . . have expressed a criticism in which they declare that the common idea of the artist who depicts Indian features and customs is wrong, all wrong."[57]

The writer credits Lone Star with many of Angel's ideas, as well as some of her experiences, including Pyle's confusion about Indian costuming. While Angel is acknowledged in the piece, the interviewer for the original newspaper article obviously talked only to Dietz.

"Of all the things the Indian has been, first of all, he has been an artist," declared Lone Star (paraphrasing his wife). "He lived with nature, he

loved the wild things about him, the mountains, prairies, rivers, forests, and all wild creatures. He made symbolic records of his thoughts. In the course of evolution these symbols developed into a system of decorative designing. His garments and utensils used in daily life bore record of his art."

Dietz expounded upon Indian "costumes," explaining how they differed from tribe to tribe, although "there is always a certain careless grace and individuality that sets off the aborigines rugged features." He insisted the traditional hairstyle with two braids draped "over the shoulder" was "no chance style." It epitomized this "careless grace." So did the use of fringe, which "lends grace to the gestures," and compliments the Indian's "established skill with the sign language." Dietz said the Indian's aesthetic nature showed in "his gala dress," in "his pose," in "his spirit," and in "all of his personal possessions," which the "Caucasian artist" mistakenly perceived as artistic effect rather than cause. The Caucasian artist "missed the vital point," claimed Dietz, which was that the Indian *personified* art, not just *produced* it.

Underlying Dietz's illumination that the Indian personifies art is a clear expression of his own dandyism. Just as Charles Baudelaire ethnocentrically referred to American Indians "done up in feathers" as cross-cultural dandies, Dietz reveals himself as a dandy with a fetish for Indian costuming.[58] As will appear later, his Indian identity lacked a traceable authentic origin. His engrossing exposition on the details of Indian costuming sets him apart as an expert in an era that favored specialization, but it also makes "Lone Star, The Indian Artist" ambiguous. He was, like a dandy, art personified; he was an artist of Indian subjects, but was he an American Indian himself?

The "white artist" viewed the Indian as "an outsider," Dietz went on, and couldn't possibly represent him, let alone understand him—even if he traveled to the reservation. The Indian held something "in reserve" when he posed for the white artist, which he only did because he was "beggared with want." Justifiably, Dietz criticized the white man's tendency to call this "Indian stoicism." To break this reserve took "years of constant association," according to Dietz, and he believed Frederick Remington was the only white artist who met this qualification. The imperialist nostalgia of Teddy Roosevelt's favorite artist mirrored Dietz's own, however. But maybe Dietz was really speaking of himself to begin with.

Dietz further attacked "theatrical managers" who "suit the fickle fancies of their patrons." These fancies included "disorderly hooping and whooping" and the "colored chicken feathers upon the heads of

females." In traditional culture only men wore eagle feathers, said Dietz, and like "a medal or college letter," they were tokens "of some distinguished act or deed of bravery." Further, he stated emphatically: Only the Indian *man* was "gorgeously attired." "No man ever spent more time over his toilet than the Indian." This aspect of Indian manhood particularly appealed to Dietz's updated aestheticism.

Dietz showed he chose his mate wisely. Like Angel, the Indian woman's "general air and effect" was "one of modesty and gentleness." Females might be "brightly clad," and wear dresses "heavily beaded and fringed," but their attire was less elaborate. She did, however, have the opportunity to ornament men's clothing "in the intricate designs she wrought with porcupine quills and beads."

To shore up his Indian identity, Dietz concocted a marvelous origin tale. This "romance of romances" began with an exciting captivity narrative featuring his heroic, white father forty years earlier. Dietz was born in 1884, but the story puts his birth about 1872. In fact, the problem with the captivating narrative is its anachronistic historic details and other modifications.[59]

His story portrayed his father, who was actually a sheriff for Barron County, Wisconsin, as a civil engineer captured by Red Cloud's warriors while he was surveying "the route of the Union Pacific." Chief Red Cloud, impressed by the elder Dietz's bravery, offered him "a lodge and an Indian wife to grace it." In time, Dietz's father became an Indian trader, while his Sioux wife bore him two children, the eldest an unnamed daughter and the youngest, Wicarhpi Isnala, or Lone Star.

Having "grown wealthy as a trader," Dietz claimed his father returned "to his home in the east," and married "an old sweetheart." In fact, he married Leanna Ginder, whom everyone in Rice Lake believed was Dietz Jr.'s biological mother, particularly one person who saw Leanna nursing her baby the day after his birth. In the story, however, his fictional father fetched eight-year-old Lone Star from Red Cloud's village five years after he had departed. He enrolled Dietz, Jr., in "an eastern school," where he soon "overcame the handicaps of a strange language." In the story, after Lone Star finished high school, his father sent him off to college and then to art school. Although his fictional father (as well as his real father) wanted him to study art, "the Indian boy himself halted these plans. He longed to return to the people of his mother." His father forbid it and "threatened to cut off his son's inheritance." His "heart strings," however, compelled him to return "to the land of the Dakotas." He stayed for a time, he said, but did not want to become a "blanket Indian," so he entered a new college, "studying art and working his way toward an education."

When he finished, he worked "as staff artist on a Chicago newspaper." He became "acquainted with Angel DeCora," at the St. Louis World's Fair in 1904 and in 1908 took the position of instructor at Carlisle.

The article concluded with the other "half of the romance," excerpted from Angel's autobiography (although she became the daughter rather than the granddaughter of a chief). Ironically, the articles, particularly the widely circulated "How Art Misrepresents the Indian," created a marvelous smokescreen for the misrepresentations of Lone Star Dietz. It also granted him an authentic Indian identity as it crowned him an authority on Indian art—and artifice. Whatever Angel thought about the publicity, she kept to herself. She left no record indicating whether or not she believed such a fabulous tale.

The Most Cultured Members of Their Race

For the remainder of 1911 one event dominated the lives of several prominent American Indians, the establishment of a progressive organization to work toward social justice for their people. Carlos Montezuma had discussed the idea of a pan-Indian association for several years, but it was a Euro-American professor of economics and sociology at Ohio State University in Columbus, Fayette McKenzie, who served as the catalyst for the organization.[1] McKenzie, committed to the idea of "native leadership," felt it should be "based on race rather than on tribe," an idea suited to Angel and others who had been educated far from home. In the spring of 1911, McKenzie invited Montezuma, Charles Eastman, Thomas L. Sloan, Charles E. Dagenett (Peoria supervisor of employment for the Indian Bureau), Laura Cornelius (Oneida linguist and orator), and Chief Henry Standing Bear of the Ogalala Sioux to Columbus.[2] The "historic six" deemed themselves the "Temporary Executive Committee of the American Indian Association" and set to work.

The American Indian Association, with politically symbolic intent, held its first conference on Columbus Day in Columbus that year. While most U.S. citizens celebrated America's "discovery," the fifty-plus Native Americans who gathered for the four-day event advocated "a new beginning." They sought ways to support the "aim and motto" of their organization: "The honor of the race and the good of the country will always be paramount." Arapaho Reverend Sherman Coolidge articulated the ideals of the so-called Red Progressives:

> The convention means that the time has come when the best educated and most cultured members of the race should come together from the silence to voice their common demands; to interpret correctly the Indian heart, and to contribute in a more united way their influence and exertion with the rest of the citizens of the United States in all lines of progress and reform, for the welfare of the Indian race in particular, and all humanity in general.[3]

Like their white counterparts, the Red Progressives supported a democratic process with a group platform as a means to change conditions for Native peoples. Initially, the group espoused a Horatio Alger philosophy, believing "in education, hard work, and in adapting their attitudes, values, and habits of life to those of the larger American society."[4] Since, the name American Indian Association could be confused with the non-Native Indian Rights Association, the new organization became the Society of American Indians (SAI) "to stamp it unmistakably as an Indian movement."[5]

The SAI elected Seneca-Euro-American anthropologist, Arthur C. Parker, as secretary. He also became editor for the society's journal and, thus, significantly shaped the SAI movement.[6] His light-hearted coverage of the first conference, with a photograph of nearly thirty of the active members, including a fashionably dressed Angel, quickly dissipated the pow-wow stereotype some Americans imagined. He relayed the acknowledgement of one visitor, who claimed, "The Indians at Columbus were most truly a superior class of men and women," even "above the class of pale invaders," who attended the meeting. "Headquarters were at the most exclusive hotel and every Indian had money to burn and used it as cultured people would." "Columbus was discovered this time by the Indians and the town was surprised," Parker cleverly surmised.[7]

McKenzie realized his dream. Indians came from "the fourquarters of the land" to represent "the native peoples" and "to labor for the welfare of all the tribes."[8] The requirement for active membership was "Indian blood," loosely defined. "Indian associates" were American Indians from outside of the United States. The society also admitted non-Natives as associate members, such as Elaine Goodale Eastman and Carrie Andrus, who joined Angel at the conference.[9] New Commissioner of Indian Affairs, Robert G. Valentine, presented his ideas. He urged the attendees to freely express their disparate views, but he hoped for fusion, declaring, "We need an All-Indian public opinion."[10] This was not a very realistic goal, given the diversity of American Indian cultures, as well as the changing face of educated Indians. Dissident voices were respectfully silent in order to lend support to the new association. Conferences following would not be as amicable.

Montezuma did not attend. He wanted the BIA terminated as soon as possible, and he abhorred the idea of BIA employees in SAI leadership, such as his colleague Dagenett. He boycotted the first meeting against Pratt's advice to "remain involved and make the gathering as big a success as possible." However, he and Pratt participated in subsequent con-

ferences.[11] Eastman came but felt the SAI did not adequately represent tribal Indians (and Montezuma agreed). Eastman, a true progressive, hoped one day the society would be composed of tribally elected delegates, and that it would provide "social services to less fortunate Indians who had not received the opportunities that he and other SAI members had."[12]

McKenzie gave "The First National Conference of Indians" a glowing report. He tried to downplay its "spectacular" element, explaining, "delegates were there to wrestle with serious and difficult problems." Still he complimented Angel's "rare exhibition of blankets and pottery," which "drew sightseers and purchasers."[13] McKenzie's report on presenters included "Mrs. Deitz" [*sic*], who "demonstrated anew both the existence and value of Indian art in our modern life."

The conference sessions were divided into three concerns: (1) industrial, (2) legal and political, and (3) educational. The latter received the most discussion. Angel's presentation fell under this realm, yet in many ways it fit the industrial category. The study of "art for art's sake" was not an option for the vast majority of Indian art students.[14] Angel's art department focused generally on industrial training, rather than academic preparation. The SAI was the most critical audience Angel had ever faced. Some attendees rightfully questioned her generalization of the latent artistic talent of Native Indians and its practicality. Many active members found little solace in the preservation of Indian art and artifacts when day-to-day survival was at stake.

Angel's presentation covered many of the same points she made in other forums, but her peers required a different emphasis. She opened with the historical perception of "the Indian," who, she stated, was both a subject for the scientist and a source of inspiration for the artist. She elaborated with many points covered in "Misrepresenting the Indian." Environment influenced art, she said, and all art was "founded on the primitive efforts of people's needs in their daily life." She explained that artistic merit was culturally relative, equal among all "the designs of antiquity," whether it be the "oak leaf and acorn," which "adorn the coronation robes of British Sovereign," the "Thistle of Scotland," the "Shamrock of Ireland," or the "Swastika of the Southwestern Indians." Angel posed two rhetorical questions whose answers reflected her expertise: How much could Americans learn if they understood the "true significance of these designs?" And wouldn't it be important to use these designs appropriately, in their "correct form"?

She broached the practical purpose of Carlisle's art department: "To train and develop" the student's "decorative instinct . . . and apply it on

up-to-date house furnishings." Here she acknowledged her colleagues (regardless of their race). "The Indian's training for keen observation makes him an apt pupil in the pictorial art as those of you who have taught in Indian schools can readily verify."[15]

She explained that "the American Indians had two art systems, the sign language and a decorative art," and referred to the Indian's great influence on "the hand manual of the deaf mutes." Highlighting the association's pledge to "the honor of the race," she expressed thinly veiled sarcasm: "However this little blessing of the Indian's to the human race does not eclipse his glorious record as preserved by the War Department."

Still Carlisle's mission was to train good industrial workers to become producers of practical and saleable objects. Her presentation proved Carlisle's art department had entered the market place not the academy. In exchange for "impart[ing] some of their native ideas of designing," she admitted, only the chosen few could "receive the full technical training" of Philadelphia's School of Industrial Art. More to her point, she stressed that mainstream U.S. "artists and manufacturers" had come to realize that North American Indian art was competitive with Eastern art, both in execution and in value. And this condition would only become more pronounced in the future, she promised.

However hopeful the future appeared, Angel's presentation demonstrated that financial concerns were more than a challenge. She admitted "in all probability" none of her students would "ever find their way to any art school for a finished training." Angel gave her audience a wornout consolation: "should one care to look into their future homes, however modest they might be, one will find there a sense of harmony peculiar to the American Indian." Yet, manufacturers who exploited the "deteriorated forms" of Indian design could benefit by learning the authentic "system of decoration." Stratton and Hubbard could have authorized this claim, but she did not mention them. "An Indian with the technical training of a good art school would readily find employment with establishments that employ designers," she said. Even though the study of fine art held little promise, some students could at least become design professionals.

Her presentation reached its crescendo. "The Indian in his native dress is a thing of the past, but his art that is inborn shall endure. He may shed his outer skin but his markings lie below that and should show up only the brighter."[16] Angel ended her talk with the same old Leuppian rhetoric: "His art like himself is indigenous to the soil of his country, where, with the survival of his latent abilities, he bravely offers the best productions of his mind and hand which shall be a permanent record of the

race."[17] Perched upon an unsteady precipice, Angel's presentation revealed her best and her worst perceptions. At best she expressed a deep commitment to the preservation of Native art and the products of American Indians. She supported her views not only by her insider status, but also, as a prominent progressive, with her professional expertise. Her belief that the survival of the Indian race rested in the survival of his art or in "the best productions of his mind and hand" contributed to a new respect for the Indian artist or craftsperson and to preserving Native American art forms in the future. Furthermore, no Euro-American anthropologist could match her authorization for Native American art as an academic discipline in the distant future.

At worst, Angel was a product of the Indian reform movement and of overlapping epistemologies of race and culture. On the one hand, her concept of race reflected the nationalist paradigm espoused by the European Arts and Crafts movement. The products of the Celts, the Finns, the Austria-Hungarians, the Russians, or the Japanese each reflected the "national characteristics" or "race character" of their makers. On the other hand, her choice of serpent imagery to represent Native people now appears derogatory. Her speech also left the impression that only an Indian's artistic talents were worth preserving.

Charles Eastman was the first to respond. Considered a national expert on Native art, Eastman's commentary appeared in Stickley's *Craftsman* from 1905 through 1914. He particularly supported Angel's argument on authenticity, complaining of the ignorance of "white teachers," who "have mixed the different characteristics of the different tribes."[18] Horton G. Elm, a New York Oneida, on the other hand, declared insightfully: "Nobody appreciates more than I do that this matter of Indian art is important, yet at the same time, we as a race cannot all be artists."[19] Responding to Angel's evolutionism and Eastman's suggestion for a "return to the old ideas that are really uplifting," Horton delivered an anti-separatist rebuttal that might have come straight from Pratt's mouth: "The Indian race is like any other race if they are subject to the same environment. . . . I want the Indian to advance on his merits, not on what he has done in the past. The past is dead. We cannot recall it. The past should be in the museum, and there we can look back and trace our history."[20] His universal appeal, "that in this century . . . the unity of the human race is becoming more and more realized," received applause. After much discussion, educator and Presbyterian minister Henry Roe Cloud, Yale's first Native American graduate and Angel's Winnebago colleague, attempted a tactful consensus: "it is the sense of the conference that whatever is purely true native Indian art ought by all means to be preserved."[21]

Potawatomi Emma Johnson, a teacher, offered an overview of the three "types of Indians" in attendance at the first SAI conference. First, the "educated" "lived most of their lives in the midst of civilization and are more 'white man' than Indian, in desires, aims and experiences." Second, those raised and educated "among Indians," including those who "received higher education in our Public Schools, mingled with educated and business people and know the conditions, needs etc. of several or many tribes on the reservation." And finally, the "semi educated" "have the Indian's interest deep in their hearts, yet are not broad enough to realize the things which are really best for the Indian."[22] Johnson asked earnestly, "Which of these types is most competent for leading our movement during its infancy? We certainly need the best efforts of all three types, but we need them in the places they are best suited to serve."

Johnson first category best represented Angel. She served as one of SAI's early female leaders along with Marie Baldwin and Laura M. Cornelius (Wisconsin Oneida). The *Washington Post* reported on these three "Indian women, who took an active part" at the conference. Baldwin's paper, "Modern Home Making and the Indian Woman," provoked interest with its assertion that "the American Indian woman as a home maker is at least the equal of her white sister." The report also noted her rejection of the myth that the Indian woman was "the abject slave and drudge of the men of her tribe."[23] Reverend Coolidge confirmed Baldwin's statement, boasting that the conference's female leadership exemplified the higher status of women in Native American culture.[24] Sexism was still prevalent in U.S. society, however, and "Indian blood" did not make SAI men immune.

The SAI appointed Parker, Cherokee John Oskinson (an editor of *Collier's* magazine), and Angel to create the SAI emblem.[25] At first Parker wanted Dietz for the job, "but as he was not a member of the committee of the whole, you were given the place," he told Angel.[26] Dietz's role in the SAI was ambiguous as usual. He was a self-promoter, and his wife made little objection to his acting for her, so it appears he did not want to call attention to whether or not he should be given an active membership. He seemed more comfortable elucidating on Indians to Euro-Americans than to Native Americans.

Parker suggested Angel "look up some of the sun symbols, such as those used by the Peruvians and see if some such symbol cannot be worked into a suitable emblem." He also thought she might consider "a number of eagle patterns such as were used by the mound builders in their copper ornaments, which are distinctly Indian and yet are of a good proportion and good examples of Indian conventional art." If she

needed books, he would provide them. He preferred the sun symbol though. "It was a universal object of attention and was used by all the Indian tribes from Point Barre to Patagonia," he informed her, "and was revered as much by the Sioux and Iroquois as it was by the Mexicans and Peruvians." He also thanked her for coming to Columbus, adding, "Your paper on Indian Art was most interesting, and you probably know it received much favorable comment."[27]

The SAI work ushered in a new phase of Angel's career. Now she designed for and lent her voice to an all-Indian political organization. After Thanksgiving, Parker contacted her again about the emblem. He still expressed a wish for her husband's contribution. "I am trusting, more, however, to your own ingenuity, in conjunction with Mr. Deitz, of course, and believe that if you will work out the design consistently we shall have a successful one. I know that you are insistent upon unmixed designs and will not confuse the Aztec with the Esquimaux [Eskimo] or Zuni as many modern non-Indian designers have done to my infinite horror."[28] Parker was diplomatic. He may have deferred to Dietz simply because he was Angel's husband.

Angel became overwhelmed with her duties at Carlisle, SAI activities, and particularly the stress of public speaking. As a result, her health suffered. Her Christmas card to Folsom described her condition: "This is to greet you and also to tell you I am O.K. now—I had a slight operation performed on my throat & have just got out of the Penn. Hospital where I have been this whole week."[29] Folsom knew more than anyone how vulnerable Angel was to respiratory problems. She probably worried even with Angel's assurance that she was "O.K." By the end of January, Angel recovered nicely from her operation, fortunately, and her pet student, Anna Miles, came for a Sunday visit from Philadelphia.[30] As one of the chosen few, Anna received a scholarship from the governor of Pennsylvania to study at the Philadelphia School of Fine Art.[31]

Soon after Anna's visit, Angel wrote the long letter to Folsom about her abduction to Hampton. It was intended, no doubt, to address fallout from the publication of her autobiography. Angel's revealing story was not good press for her alma mater.[32] She assured Folsom she understood why "Hampton doesn't want any thing like this laid to its door," but "I don't see why you or Dr. Frissell should think this a blot on Hampton," she naively remarked. Seemingly aware her letter would be passed around to concerned persons, she kept it formal and quite detailed, making it much longer than anything she had ever written to Folsom before. She carefully explained what most knew, that her abduction was not unusual for the "pioneer" days of Indian education. Since "Indians were

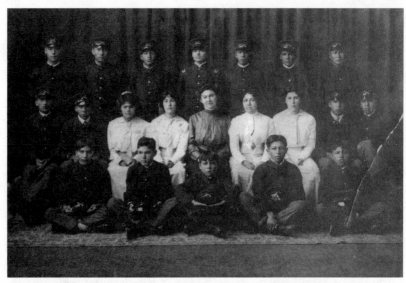

Angel De Cora (second row, sixth from left) and Lola Pierson (second row, fifth from left) with Winnebago students at Carlisle, ca. 1911. (Courtesy Ho-Chunk Historical Society, Winnebago, Nebraska)

loath to give up their young people into the hands of the whites to be trained in ways totally strange to them," said Angel, what recourse was there? "I have an idea that there had to be a good deal of just such kidnapping done by schools," she admitted. "I am not laying other cases against Hampton, you understand, but I *was* told that some of the non-reservation schools went so far as to give so much per head to their recruiting agents and they used to get the children by hook or by crook."[33]

Her letters reflect the political climate at Hampton. Congress threatened the school's federal funding. From 1878 to 1912 Hampton fought public opposition to eastern off-reservation boarding schools, including charges that returned students "returned to the blanket"; criticisms related to health, discipline, and training, battles over government funding of sectarian schools, and biracial education. In 1912, aggressive opposition to the latter reared its ugly head.[34] John Hall Stephens, U.S. Representative from Texas and chairman of the House Committee on Indian Affairs led the charge. "Why humiliate the Indian boys and girls, our wards and dependents," he asked, "by educating them in the same school with negro children? It seemed to your committee that we should use our own schools, our own teachers, and separate these two races, and thus elevate the red race to the level of the white race and not degrade and humiliate him by sinking him to the low plane of the negro race."[35]

Indian boys and girls rose from cultural obscurity and deserved better than to be humiliated by their association with "negro children," Stephens pronounced. His view was not as surprising as the criticism Native American leaders lodged against Hampton at this time. An equally powerful voice against resuming appropriations came from Oklahoma's Chickasaw Representative, Charles D. Carter. As a Hampton historian writes:

> Pointing out that Virginia prohibited whites and blacks from mixing in public schools, he pled with his white colleagues to leave his race at least its dignity. Recounting concessions forced upon the Indian until "he has nothing left but his self-respect," he charged, "you come to him with the Hampton school and ask him to surrender his self-respect by placing his children on a social equality with an inferior race, a level to which you yourself will not deign to descend."[36]

Thomas L. Sloan, lawyer and Hampton alumnus of 1899, supported his alma mater during its crisis. He was SAI's first vice president and also lobbied unsuccessfully to become Commissioner of Indian Affairs in 1913. Sloan began his legal career working for the Indian Service on the Omaha and Winnebago reservations for several years. Following that, he entered private practice, where he represented American Indians, mostly in heirship cases.[37] Rumors circulated that he exploited his clients. Sloan also converted to the peyote religion. Angel's sister, Julia, could have disliked this "bright light" from Hampton, as she told Folsom earlier, for one or both of these reasons. Still, Sloan rallied behind Hampton in its hour of need, as did Angel.

As a last ditch effort, the eighty students enrolled in Hampton's Indian department sent a petition to Congress, explaining that no other school effectively trained cultural missionaries of which the reservations were in dire need. "Nowhere, except at Hampton, can Indian boys and girls receive normal training for teaching at the expense of the Government."[38] But the plea of those who represented "twenty-one tribes and fourteen states" fell on deaf ears.[39] The government's enthusiasm for training cultural missionaries had waned. In May of 1912 Congress dropped Hampton's Indian department from its appropriations bill.

In October Columbus, Ohio, again welcomed the SAI conference. Just before the event, Parker suggested to Angel, "Mr. Deitz really should submit that paper even if he cribs most of it from his former splendid article" (from the *Literary Digest*) "and gives it merely a new introduction and a little different ending, just to give it a new dress."[40] Although Parker hoped Dietz would come to Columbus, Angel went without him,

though she may have traveled with Superintendent Friedman who also attended the conference. Dietz stayed home, perhaps, for a variety of reasons.[41] No one would fund his trip; he had taken on a part-time job teaching design at the School of Industrial Art in Pennsylvania for the 1912–1913 year; he wanted to avoid the event; and, perhaps more importantly, the annual meeting was held during football season.[42]

Already a member of SAI's advisory board, Angel served on the resolutions committee that year, along with Marie Baldwin, Sloan, and Rosa Bourassa La Flesche (Ojibwe wife of Francis). The SAI resolutions that year included petitioning for a president-appointed Indian Code Commission to review, create, and codify laws for Indians of all classes; improving relations with the BIA to facilitate better jobs for Indians in the Indian service and equal representation of Indians on the Board of Indian Commissioners; lobbying for a progressive Indian Commissioner whose sole concern was "the uplift and promotion of the Indian," rather than for "surrounding citizens or commercial corporations"; calling for public hearings and president-sanctioned investigations to hear "Indian complaints"; improving and standardizing education for Indian children; "more efficiently safeguard[ing] health conditions in Indian communities"; and establishing "American Indian Day" as a national holiday "devoted to the study of the true history of the Indian, his true character and habits before the coming of the white man."[43] The latter was Parker's vision, but Montezuma, who attended the conference that year with Pratt, considered it a superficial goal.[44]

After the conference, the resolutions committee dutifully drafted letters to thank Friedman and Pratt for services "rendered in making the conference of the Society a success."[45] Angel also joined a grievance committee with her cousin, LaMere, and Stella O'Donnell (a Pawnee) to help eliminate "lengthy discussions on various grievances."[46]

Despite the general nature of the resolutions passed and publicized by SAI's journal, the Hampton crisis took center stage at least once during the conference. Sloan proposed a resolution that the government at least fund "transportation to and from nonsectarian Indian schools," such as Hampton, as traveling expenses across the country could be costly. He championed his alma mater by stating he overheard a member of "the Indian Committee of the House" (probably Carter) say that Hampton school was "higher in many ways than any similar white school, that it was modern and up to the highest standards, but he opposed it on account of the mingling of the races." Sloan conceded there "might be a question of miscegenation," but "during the thirty-four years of Indians being at Hampton there has never been a case" (as if he could know). He

emphasized the good behavior of the Indian students, rather than the unjust accusations lodged against "the negro." "The Indian students hold themselves proudly as Indians," he stated, "and I think it is a credit to the Indians that they do."[47] The resolution passed SAI scrutiny, but the government never granted transportation funding.

Carter, the vice president in charge of legislation for the SAI that year, was the only SAI leader to publicly voice opposition to Hampton's biracial program.[48] Still, Parker, Baldwin, LaMere, and, of course, Angel's absent spouse, all promoted segregation. As a Hampton alumnus, Angel was not as prone to support their view. Nonetheless, the attitude of her husband, close friends, and associates reflects negatively on her feelings and expressions of "race pride."

For example, Baldwin spit nails over "the employment of the negro in the Indian field service," as shown by a disturbing letter she wrote to Parker the next year. She wanted the SAI to "stir up" the subject.

> The Indian does not know the negro, he has not had that experience with the negro that enables him to judge as to how he should treat and act with the negro in order that the negro can be kept in his place and if he had it would be of no avail since he is expected to treat the negro with the same consideration and equality that is accorded the white or Indian employe [sic] and very often the position of the white and Indian is subordinate to that of the negro.[49]

She blamed Uncle Sam for leading "the Indian" to believe "the negro" was "equal to the Indian and white" by placing them in "positions of equality." "The Indians of Florida were made to take their slaves with them when moved to Indian Territory," she added. "There the negro was set free." As a result, "There are enough Indians with negro blood in their veins now," she complained. Undoubtedly, her claim matched Carter's fears, since his Chickasaw tribe included many freedmen.

Baldwin thought there were too few vacancies in the Indian service as it was. This claim was valid, especially in regard to Indian school employment. By Leupp's administration, "the use of Indians in the Indian School Service had become almost incidental," according to one scholar.[50] In 1899 American Indians made up 45 percent of the staff. By 1905 their numbers receded to 25 percent, and "the positions they held had declined in importance." The hiring of Hampton students, considered the best educated, declined 60 percent.[51] Reel's administration employed a few American Indian teachers, but that was it.[52] Obviously, Angel's position at Carlisle, initially supported by Reel, was not the norm, but it was declining in importance too.

To some degree, the dwindling significance of the cultural missionary in Progressive-era society fueled Baldwin's racism. She wanted to boycott "the employment of the negro in the Indian field service," even if it was against the wishes of Pratt, Frissell, and Andrus, people whom she admired. But her racism arose from a more common, middle-class, Euro-American phobia, the fear of miscegenation and the myth of "the negro" as sexual predator. "Think of this and grind your teeth," she said to Parker. A negro *physician* is employed at one Indian reservation and a *number* of places are negro bosses over boys and girls." Baldwin implored Parker to respond to her letter and to forward it to Reverend Sherman Coolidge for his response as well.[53]

It is sadly ironic that Baldwin is honored today as Washington Law School's first "woman of color" graduate. She received a bachelor degree and a Master of Law degree in 1915.[54] Baldwin, herself of mixed ancestry, articulated the abject fear of many Americans of her time when she told Parker "the negro is immoral—dangerous!" Parker certainly sympathized, but above all was a politician.[55] In May of 1912 he wrote Frissell at Hampton, "assuring him that Carter was not speaking for the society." Frissell inferred from Parker's letter, however, that the neutral stance adopted by the SAI might easily sway against Hampton's Indian department if the "question of color" came up for discussion with SAI members. Frissell's reply to Parker was appropriately terse: "If Hampton can not be of real service to the Indian we have no desire that the appropriation should be continued, as there is plenty of work for us to do with the negroes. But it seems to me that the Indian needs all the friends he can get, and I believe that Hampton has in the past and may be in the future of great service to him."[56]

There is no evidence that Angel, or, likewise, her sister, Julia, expressed race hatred toward African Americans, but their opinions of "Negroes," as well as themselves as *Indians*, was bound and severely determined by the limits of their education and their era. Hampton reformers had cultivated the sisters' evolutionist worldview. As late as 1956, Julia still supported the racial stereotypes she learned under Armstrong's administration. "Once a very rational dentist told me he detested colored people but he had always had a love and admiration for Indians," she wrote Andrus. "I laughed at him & told him that his reasoning was askew. His dislike for Negroes was their wanting to ape the white people. I told him that the Indians were killed by the wholesale because they didn't want to be like white people & the poor Negroes were anxious only to take on the ways of the Pale Faces."[57]

Even though Hampton's African American students had never received federal funding, some Native American students complained that "treaty assurances guaranteeing free education" should be honored. If Angel held her tongue during this time, it may have been that she agreed with progressives and many SAI members, such as Henry Roe Cloud, that it was time for Indians to "stop taking hand outs." After Congress withdrew appropriations, about half of Hampton's Indian students returned home, but the other half "worked to meet the expense of their board and clothing while continuing to rely on scholarships for tuition," just as their African American schoolmates had always done.[58] Carrie Andrus believed this "determination to help themselves marked a new era in Indian education." Eight new "plucky" Indian students entered Hampton the following year, but enrollment steadily declined until the Indian department closed. Ironically, the withdrawal of appropriations created a much more integrated social environment. An eastern Cherokee woman who attended the school during the years of transition remarked: "We didn't mix very well because we were absolutely forbidden. . . . But after we got to know each other, after the government took away its appropriation we got along very well together."[59]

§

Anna Miles came for another weekend visit with Angel in March of 1912. She was "getting along splendidly" and "the directors" of the Philadelphia School of Fine Art "speak well of her work," said the *Carlisle Arrow*.[60] The recognition spoke well of Carlisle's art department. April's *Red Man* took the opportunity to extol the success of "the most distinctively Indian of Carlisle's institutions." Student creations attracted the attention of artists, it noted. Neither students nor artists were named, but Anna probably represented the former.

The *Red Man* featured an interesting addition in April, "the study of Indian folklore and the manners and customs of various tribes." Like the *Southern Workman* had many years before, Carlisle's Indian press now encouraged students "to put into writing the historical and mythological information that has been imparted to them by the older members of their tribe" for publication in the *Red Man* and the *Carlisle Arrow*.[61]

Dietz continued receiving praise for his design work, while his wife continued to support him. The National Indian Association credited "Mr. William Dietz-Lonestar" with the "attractive cover" of its 1911 annual report.[62] But Dietz's artistic interests went well beyond graphic art. He became interested in performing. In late March as "William Lone

Star," he answered a letter from Sallie Eagle Horse at Pine Ridge reservation.[63] Sallie could not write, but found someone who could to correspond for her. William told Sallie that he "might leave the Indian school and go in vaudeville on the stage." He hoped to "make lots of money" and send her some "every month." He wanted to make her happy, so she could buy "pretty clothes" and have "plenty to eat." He explained that a "white man in New York city is writing me a sketch," assuring her that it "would make lots of money." Well at least he hoped so, "for I know," he told her, "you need lots of things that you can not afford to buy now." He signed the letter, "With lots of love, I am, yours truly, brother."[64] Sallie Eagle Horse was thrilled to hear from him, because she had not seen her brother for more than twenty years.

§

Natalie Curtis gave a presentation in Saratoga, New York, in May, promoting the preservation of American Indian music and art. A loyal and admiring friend, she lauded "Miss De Cora" as "a woman of singular strength, character and talent" who "always asserted, however, that she had no more real talent than any other member of her race (although Mr. Pyle declared she was a genius)." Curtis relayed that Angel believed "the same gift was latent in any Indian woman who chose to develop it." Curtis also recalled Leupp's appointment and Angel's response to it. "She is doing a great work at Carlisle," she observed, "and her influence is being felt in Indian schools throughout the country."[65] Her friend's commendation didn't change the fact that Angel still longed to leave the Indian service.

That summer Angel and Dietz camped at Laurel Lake, near Mt. Holly.[66] As before, spending vacations together signified something positive. Soon after their return, both the school and Carlisle's town newspapers reported that "the leading Indian artists" in the world had been "retained by a German firm" to create "twelve paintings of Indian scenes and designs in six colors" for a calendar. Natalie Curtis would provide philosophical "Indian sayings" from "famous Indians" to accompany the illustrations.[67] Unfortunately the calendar, to be distributed in America, was probably never produced.

Another project in the wings was the badge for the SAI. Angel based her design on a burial mound copper eagle held by the Smithsonian Institution. As Parker stated, the eagle was "the grandfather of all the Indian thunderbirds." He liked Angel's preliminary design and agreed with her use of "copper red and wampum purple" for the colors. He also felt that the badges worn by active members should be distinct from

those given the associates. He wanted red silk badges for the active members and agreed with Angel's idea to use an American copper stamp. For the associates he wanted "blue stamped in aluminum." "Let the Associates have, however, a more distinctive color than bronze. Why not silver? It is not expensive." Then he added, "You sure are no Jew. Husbands are pretty much inclined to say bad things. Tell Mr. Deitz that a Hebrew would have subbested [substituted?] brass shined up like re-al go-ld and made the design look like a stingy bunch of three grapes."[68] Race pride had many expressions, not all of them positive. Its doubtful Moses Friedman became aware of Dietz's antisemitism (and Angel's tolerance of it), but the issue would arise in his future.

A feature story, by Hugh Miller of "Princess Ndniss" fame, appeared in mid-September in the local Carlisle newspaper, headlined: "Team of 1912 Will Be a Strong One." Miller announced Dietz was no longer a player, but would assist with the second squad. "Lone Star is eligible to play on the team this year, but Coach Warner thought he could use him to better advantage as assistant coach," fibbed Miller. "[H]e was one of the headiest players upon the squad the last two years."[69] Carlisle's Athletic Association paid Dietz a whopping $500 that season as assistant coach, only $40 less than he was making per annum as his wife's assistant.[70] The healthy athletic fund also paid Hugh Miller to advertise the team's activities.

Miller's prediction for the season came true. The team reached its apex with the 1912 season.[71] The Redmen won twelve games, tied one, and lost only one game to the University of Pennsylvania. What a thrill for the team when Jim Thorpe, just after winning both the decathlon and pentathlon medals at the Olympiad in Stockholm, came back to the lineup in the third game of the season.[72] Carlisle beat its rival thirty-four to zero. The season ended with excitement when Carlisle beat its old adversary, Brown University, thirty-two to zero on Thanksgiving Day.

With a successful coaching season behind him, Dietz taught landscape art and design for "cuts and initial letters" to students. He also created covers for two more Indian Association pamphlets.[73] Angel surely felt despondent about her husband's new position as assistant coach, though it meant more money in their bank account and was a more appropriate position for the now twenty-eight-year-old Dietz. Her Christmas postcard to Carrie was brief, unaffectionate, and unrevealing of her personal life: "Dear Carrie—I am O.K. but very busy. This is wishing you a Merry Xmas From Angel." The postcard photograph imbues the bland message with humor. A woman with braids and a buckskin

dress diligently works beads onto leather. The woman, surrounded by completed work, is Angel. Dietz used the photograph for the cover of the November issue of the *Red Man*, perhaps to placate his unhappy wife.

§

The holiday season passed without record, but, in early February of 1913, Angel became the first woman listed under "Indians Who are Prominent" in the *Indian News*. Philadelphia's *Inquirer* also pronounced her the "Greatest of Redskin Painters." While marked a "redskin," an unflattering term that was originally applied to Carlisle football players, she appears in a white, high-necked Victorian dress in the accompanying photograph.[74] The highly edited, pompously toned article offered the usual message. Americans borrowed art from everywhere, Native Indian art used conventional designs, and Indians were natural artists who contributed "art to America." The piece highlighted Angel's teaching method and its practical application. The Indian craftsman also received a plug.[75] The pictures accompanying the article include Dietz and Carlisle's sewing room, but the caption under Angel's photograph reads "the wife of eminent artist Lone Star."

The February issue of the *Red Man* followed with front billing for Dietz in "The Story of Two Real Indian Artists," by E. L. Martin, another reporter compensated by the Athletic Association.[76] Dietz fulfilled Parker's wish to give a "new dress" to "How Art Misrepresents the Indian." "Joseph De Camp, Howard Pyle, Edmund Tarbell, and Frank Benson" now trained *both* Dietz and his wife. Another change romanticized Lone Star's trip back to his childhood home after he graduated from high school. "But life on the plains was calling to Lone Star. It almost always happens so! For were not his people there—his beautiful Indian mother, who loved her boy as devotedly as the white mother loves hers, and the sister they left behind? So, back the Indian youth went to see them all." Other sources state Dietz's Indian mother died long before he reached high school, and Sallie Eagle Horse wouldn't reunite with her brother for several years. Martin also embellished the first meeting of "The Two Real Indian Artists" in St. Louis in 1904. "Nothing could have been more productive of their greatest good than the meeting of these two young Indian artists. Fate must have anticipated what was in store for them when she brought them along the paths which finally merged into one long road."

§

Later in February, the Athletic Association gave a banquet and reception for the football team to honor the "Varsity boys and other who have won their C's." The seventy-five guests included Coach Warner and his

wife, along with "Mr. Dietz," who, apparently, was not accompanied by Mrs. Dietz.[77] This event marks the beginning of the split in "the long road." Soon after the celebration, Angel took a trip to nearby Harrisburg, Pennsylvania, to visit her friend, Mrs. William Newashe.[78] Even though William Newashe played on the football team with Dietz and, like him, was "a star tackle," Dietz did not come along. Near the end of April, Angel "returned from a very pleasant visit to Washington, D.C."[79] Likely, she visited with Marie Baldwin. By summer a pattern emerged. "Mrs. Dietz sojourned at Chautauqua, N.Y., where for the two weeks of her educational leave she studied designing and arts and crafts. Mr. Dietz journeyed to Wisconsin, where he remained for awhile, after which he went to Booth Bay Harbor, in Maine, where there is quite a colony of artists. While there he studied methods of teaching."[80] Dietz's trip to Wisconsin was, again, to visit his family without the wife they had never met. Gilberté probably met him in Maine.

When school resumed in September, Dietz took charge of the mechanical drawing classes. The "carpenter boys" felt "enthusiastic over the prospects of learning to draw their own plans." Angel returned to visit the literary societies—the Standard, the Susans, and the Mercers.[81] Dietz still designed monthly covers for the *Red Man*, though Angel designed the September cover, titled "An Indian Nurse."

In September, the American Type Founders' *Bulletin* mentioned Carlisle's publications "as some of the most interesting among magazines and typographically far above the average."[82] During this time Superintendent Moses Friedman received "an elaborately illuminated diploma" from the U.S. State Department for an Indian school exhibit. It's likely Angel contributed to the awarded exhibit, which was displayed at the 1911 International Exposition held in Turin, Italy.[83] Despite this honor, however, trouble brewed for Carlisle, and particularly for Friedman.

In the meantime, the SAI held its third annual meeting in Denver, Colorado. The theme was "What the Indian can do for himself, for his race and his country." This time no one from Carlisle or Hampton attended, suggesting that "Eastern boarding schools, which had educated so many SAI members, had seen their better days."[84] Perhaps, Angel felt adequately represented by her cousin Oliver LaMere, who took on a leadership role at the event. The proceedings moved the SAI from a hopeful mood of new beginnings to the hard work of creating policy. LaMere spoke inspirationally as he promoted the new Indian. He proposed merging aspects of U.S. civil life, such as "her practical sense, her energy, the courage with which she faces the problems of life

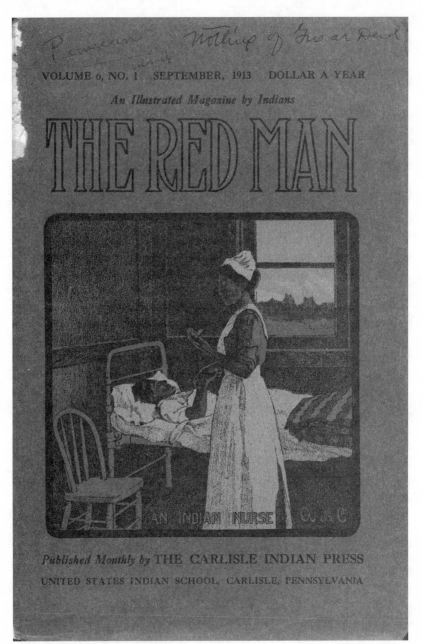

The Red Man cover by "A. de C.," 1913.

and conquers them" with the "ethical ideals" of traditional Indian ways.[85] The "open life," warrior culture, and "superstitious rites" must be sacrificed, he argued. Nevertheless, he supported peyote rites, as he rejected the rites of traditional Native religion. He had already informed Paul Radin about the secret, sacred ceremony of the traditional Medicine Lodge and apparently sold its ritual paraphernalia to the Wisconsin State Historical Society.[86] Like many religious people, however, LaMere believed a higher power condoned his actions, but he informed the gathering that he preferred "to stand with the romantic elders of our race and die." He believed "in twenty years it may be too late, and our younger generation will have grown up completely demoralized, having neither absorbed the worthy features of American life nor preserved those of their ancestors."[87]

LaMere demonstrated his devotion to the peyote religion (which incorporated Christian beliefs and is now called the Native American Church) when he spoke of what aspects of Native culture could be saved. "They are a love of nature and an acquaintance with nature which few whites know; ethical and moral teachings fully as high as those of Christianity, and in fact coinciding with them." He also showed his affinity with his cousin when he stressed preserving "Indian art, whether in the form of decoration, sculpture or wood carving, or whether in that of music or literature."[88] LaMere urged "a union of parts" that somehow (like the races) retained "a separate individual existence" with "distinctive life and ideals." Clearly the SAI had made an inevitable turn westward, where most reservations were located. The now common view that Indians should be educated closer to home hurt Carlisle's reputation. As 1912 marked the decline of Hampton Institute's Indian department, so 1913 harkened the decline of Carlisle Indian School.

Carlisle football continued to thrive, however, with an enthusiastic Dietz as Warner's assistant. As one town resident recalled, while a horse-drawn bakery wagon sold pastries to the football team, he viewed Pop Warner and his assistant Lone Star Dietz, "a big man," as iconic figures.[89] That fall Pop Warner and Dietz led the Redmen to win all their five first games, allowing only one team to score. But the next game with the University of Pittsburgh ended with a twelve-to-six score loss for the team. Just before Halloween, the Redmen played the University of Pennsylvania in Philadelphia. Lots of Carlisle students used their own meager allowances to attend the game.[90] Even Mrs. Dietz couldn't stay away from the big game and accompanied the Warners and several teachers to support the team.[91] "Individually every man outplayed his opponent," reported Carlisle's *Evening Sentinel*, "although outweighed 11 pounds to

the man, and it can be truthfully said, despite the tie, that it was a victory for Carlisle.... The players have developed a 'pull-together' spirit."[92] The game ended seven to seven, but Warner's method of playing football "triumphed" as Penn's coach "admitted after the game that the system the Indians used was entirely different from what had been expected."[93] Carlisle's pull-together spirit lasted the entire season, as the team continued to win all five remaining games, allowing only two more teams to score.

The last game played on Thanksgiving Day with Brown University took on mythical proportions. Little did anyone know that this game, played in "heavy wet snow," was the climax for Carlisle football. "The heavier Brown team forced the Indians back on their own goal line and then fumbled the ball, which was promptly recovered by a Redskin," according to a Carlisle football expert. "Thorpe, standing on his own goal line, in punt formation, instead of kicking as was expected, went right through the middle of Brown line and ran 110 yards for the winning touchdown, in spite of the hazardous condition of the field. It was said that every man on the Brown team touched him but could not stop him."[94]

When the season ended, Dietz stayed busier than ever. The *Red Man* continued to be worthy of public recognition. A November issue, which included an article by Franz Boas and a "striking cover" by "William Dietz (Lone Star) of the Sioux tribe," might have been describing Dietz when it stated, "there are few people who realize how much the Indians of today are doing for themselves and how extremely well some of them succeed."[95]

Artfully fashioning himself as a cultured "Indian of today," Dietz, by virtue of his charisma and gender politics, nearly replaced his expert wife as a compelling spokesperson for Native Indian art. Eventually the widely read *Atlanta Constitution* took notice of his (hers?) provocative theory that "cubist art was founded by an American Indian." "Lone Star, with his wife, Angel De Cora, a beautiful Winnebago Indian girl ... [has] many examples to substantiate their assertion that the Indians founded the cubist school some two hundred years ago. The eagle, which is a common figure in Indian art specimens, is but a square which is shaped totally unlike an eagle, yet immediately impresses the observer with the conviction that it is an eagle. This, declares Lone Star, is the height of cubist art."[96]

While Dietz served as Angel's mouthpiece, Natalie Curtis again sang the praises of Angel's talents and contributions in the nationally popular *Outlook* magazine. An art class at Carlisle, Hensel's portrait of Angel, and Angel's painting *Fire Light*, graced the article. Curtis characterized

Fire Light as "an example of Indian art applied to modern style." It was also the last painting of Angel's to be published, and, sadly, represented the dream she left behind. Instead, as Curtis stated, Angel "inspired her Indian pupils at Carlisle Institute to the creation of a *new school* of applied design and decorative art, unique in that it is thoroughly Indian." "In time," Curtis hoped, "the example of Angel De Cora's effort may broadly permeate our teaching of primitive peoples."[97] Curtis's wish came true, but Angel's efforts permeated so well, they became invisible over time.

The Dietzes' sixth anniversary marked the transition of their marriage from slightly troubled to seriously so. The new year of 1914 found Dietz's social ascent on the rise. With Angel's assistance, he began raising Russian Wolfhounds, a new, fashionable breed in America. A kennel was constructed behind the couple's residence to house the dogs.[98] Ever the dandy, Dietz added dog shows to his list of performance venues. He joined the Russian Wolfhound Club of America and began traveling to shows, leaving Angel (willingly or not) behind. The wealthy "dog fanciers" suited Dietz's tastes, and he enjoyed their society. He also thrived on yet another form of competition. When Dietz created a bas-relief cast for a medal, so the dog club could advertise the Wolfhound breed, New York's Board of Governors of the American Kennel Club "decided to adopt it as a standard." The *New York Herald* featured an item titled "Indian Designs Wolfhound Medal" and reported the medal was modeled after "a young dog owned by Lone Star, which is expected to be a sensation at the coming show in the metropolis." The designer "as seems appropriate in an Indian," spent "the last few years" devoting himself to raising "as nearly as possible the ideal type of wolfhound."[99]

A prime example of the "cultured Indian," though not necessarily SAI material, Dietz's breadth of talents seemed unrivaled. Angel's desire for an artistic and charismatic partner, who could also protect her from society's glare, only satisfied her husband in the end. Consequently, the story of "Two Real Indian Artists" had no fairy tale ending, because one of them really wasn't and yet wanted to be much more.

Farewell Carlisle

As Angel returned to her duties at Carlisle as the new year of 1914 began, Matthew K. Sniffen, secretary of the Indian Rights Association, alerted newly appointed Commissioner of Indian Affairs Cato Sells to the troubling "moral atmosphere of the school."[1] He charged Friedman with incompetence and "mismanaging" the school and alerted Sells to the lack of discipline and the liquor problem on campus. Carlisle students signed a petition against Friedman's administration as well.[2] An anonymous source claimed "the superintendent became so offensive to the scholars that they hissed him when he appeared before then."[3] On January 19 the secretary of the interior instructed Indian Office agent and inspector E. B. Linnen to make a preliminary, independent investigation. Hearing the news, Friedman traipsed off to Washington, D.C., to confront the charges head on. He told Sells that he believed Pratt "instigated" the trouble. Commissioner Sells refused the bait and ordered Friedman to return to his post. He came to Washington "without sanction of the bureau," Sells declared, and "his place was at Carlisle and not in Washington." A week later, Carlisle's town newspaper made a report sympathetic to Friedman. It was too late. The investigation had begun.

But Carlisle wasn't the only BIA institution under scrutiny. The previous year's Congress approved an act to make "inquiry into conditions in the Indian Service, with a view to ascertaining any and all facts relating to the conduct and management of the Bureau of Indian Affairs."[4] A Joint Commission to Investigate Indian Affairs formed, with Senator Joe T. Robinson of Arkansas, as chairman, and Senators Harry Lane of Oregon and Charles E. Townsend of Michigan, Representative Charles H. Burke of South Dakota, and the two Representatives who investigated Hampton Institute, John H. Stevens and Charles D. Carter. Congress authorized the Commission "to visit any Indian agency, school, institution" of the BIA or Department of the Interior. Their findings would be heard before the Joint Commissioners from September 13, 1913, through December 16, 1914.[5]

Some believed the Jim Thorpe scandal caused the investigation at Carlisle.[6] On January 28, 1913, Thorpe, a close friend to Dietz, pleaded guilty to playing professional baseball. He lost his Olympic medals and his records were expunged. The committee who investigated the charges declared Thorpe "deserved the severest condemnation," but since he was "an Indian of limited experience and education, . . . those who knew of his professional acts" deserved still "greater censure for their silence."[7] Of course, Friedman and Warner denied any knowledge of Thorpe's professionalism, though the investigation revealed Warner knew.

"The investigation of Carlisle was only one of the many conducted by the new commissioner who has announced his policy of reorganizing the Indian Bureau and freeing it from politics and incompetence," stated a BIA spokesperson. If the Thorpe scandal brought undue attention to Carlisle, Friedman realized the situation was, in fact, more complex. He pointed fingers in four directions: to Pratt's politicking, to Woodrow Wilson's Democratic administration, to Leupp's movement against Eastern off-reservation schools, and toward his own faculty, particularly John Whitwell, whom he claimed incited the students and school staff to petition. Inspector Linnen's preliminary report led to an official investigation by the Joint Commissioners, conducted February 6–8 and March 25. "I will welcome any fair investigation, and the more thorough the better," responded Friedman.[8]

Town residents worried the school would be shut down. Many businesses and individuals provided the school services. Supporters rallied around Friedman, claiming he had "vigorously prosecuted charges of illegal sale of liquor to Indian students" and that he raised academic and athletic standards. They claimed his attitude against incompetence provoked school staff to persecute him. "Mr. Friedman is held in the highest personal esteem," stated the local paper's editorial. "He has been energetic in broadening the curriculum of the school and extending its practical courses, adopting several new and valuable ideas. He has worked constantly in upbuilding the school. . . . To-day the campus and its adjoining structures are models of neatness and architectural beauty."[9]

To dispel fears about the school's closure, the BIA announced, "The policy of the bureau is fixed. Carlisle School will be continued. It is one of the best in the country, and the Government has too much money invested there ever to consider its removal."[10] To a certain extent, he was right. Congress had just approved appropriations for the year, as well as "a more advanced curriculum and manual training features of broader scope." But the school was not immune to government closure. Leupp's gradualism had taken root, promoted not just by the BIA but now also

by SAI leaders. All believed American Indian children should be educated close to home.

On Friday evening, February 6, the Joint Commissioners arrived on the campus unannounced. The next day, the newspaper reported, "a number of persons recognized as unfriendly to Friedman and the school, either or both were heard." Angel confided that conditions at the school were "very bad as to discipline, morals, and drinking," and "that many of the boys and girls have been unjustly treated." She tried to assure Linnen, "Principal John Whitwell is a good, honest, faithful employee, who has the best interests of the school and the student body at heart," adding, "a new superintendent is needed in the best interests of the school."[11]

When the Commission arranged a public meeting, minus the press, students and teachers voiced their dislike of Friedman.[12] Only a few teachers, and no students, came to his defense. Charges against him included "laxity of discipline, unjust expulsion of students, misrepresentation of the school to the public generally by the school authorities and to the Indian bureau; alleged unsanitary conditions; complaints as to the quality and quantity of the food, and also complaints against alleged unjust punishment."[13] By Tuesday Chairman Robinson concluded that conditions at the school were "unsatisfactory" and decided to make "a more thorough probe." Robinson informed the press that students, employees, and several townspeople agreed. The investigation, he said, would focus on "the general disciplinary and moral conditions prevailing in the school, the academic and demonstration work, and the method of disbursing the athletic funds."[14]

Testimony demonstrated that Friedman's interest in appearances eclipsed his commitment to the industrial training the school was supposed to provide. The BIA still maintained Pratt's policy to teach "practical trades that will fit" the American Indian "to take his place beside the white boy."[15] Investigators discovered, however, that Carlisle teachers taught little in the way of practical trades these days. "The fact is that athletics at said school rank first, the band second, and commencement exercises third," Linnen reported. "Everything was done for advertisement, show and glitter, all at the sacrifice of the schooling, farming, gardening, dairying, trades, and industrial teaching."[16] Besides Linnen's findings that students and faculty found Friedman unapproachable, unfair, and inconsistent with discipline, Linnen suspected he did not discourage corporal punishment and committed fraud with funds and student record keeping. He also believed Friedman did nothing as the Indian school's industrial programs dematerialized one by one.

Even the programs still in existence were not set up to properly train students. Students went from department to department and many never really learned a trade. The agricultural department had shriveled to bare bones, except for a small model farm where authorities deployed students for punishment. Many testified that students would not have learned anything had it not been for the outing program, which, nonetheless, was overused and substituted for in-house education. Most of the faculty felt the only solution was to replace the superintendent. Friedman did not have the respect of the students, who had begun to call him "Mose" and "Jew" and "Christ Killer" behind his back (though this was no wonder, given the attitude of some of the teachers). Some also complained about Mrs. Friedman's inappropriate behavior. She lifted her skirts to dance to the band, and she and her husband used profanity when arguing.

The students complained most about discipline. Punishment administered for infractions involving sexual relations, stealing, and drinking varied widely. Friedman expelled some girls, but didn't record the expulsion in order to keep enrollment figures high. Cumberland County Judge Sadler sentenced a Carlisle student couple to jail, with Friedman's urging, for "fornication," a crime that was punished only by fine in Pennsylvania. Drinkers were thrown into the guardhouse on campus, unless they belonged to the football team. One boy went to the town jail for stealing pies. Linnen thought the latter punishment too extreme, given students' complaints about poor food and lack of bread.

Some faculty employed corporal punishment, which Friedman claimed he did not condone. After Claude M. Stauffer, the band teacher, sent four boys to the on-campus guardhouse for refusing to play, he and four others, including Warner and Dietz, all "went down to the guardhouse and whipped those boys," one student testified. "There is three of them who have gone home, but one is here yet, and I was speaking to him and he said he had scars on him yet."[17]

The most scandalous case of corporal punishment involved an eighteen-year-old Potawatomi student, Julia Hardin. Stauffer repeatedly beat her after she refused to go on yet another outing. Stauffer "had a stormy interview with Inspector Linnen," defending his actions because he had Friedman's approval. He claimed there had been "a serious infraction of discipline in the school and that the matron asked that the girl involved be spanked." Stauffer spanked the girl with a piece of wood "broken from a soap box" "in the presence of the head matron, the school principal, and the outing manager." Unnamed witnesses claimed "the punishment was very light," and said Stauffer even received a

thank-you letter from the girl, "expressing sorrow for her misdeed" and "declaring herself that she deserved it."[18] Hardin's gratitude had receded by the time the Commission questioned her.

Angel's testimony focused on the school's "moral conditions." SAI colleague, Representative Carter, urged her to talk about "the discipline and the general conditions in the school at Carlisle." She said it had "been more or less neglected." Students were "herded together" and were never given "advice or counsel." "The general outward discipline has been kept up, punishments and that sort of thing," she said, "but there is the underlying general neglect of advice and talkings-to they would seem to need."[19] When Carter asked about the morals at the school, Angel handed him a list of twenty-eight female students, whom she claimed were the minimum number "ruined morally." Carter asked if the girls had "all been ruined in the institution and sent back to their several homes." Angel said some had been ruined during outings and some during school, but she was not sure of the proportion. Female students gave her the first twenty-two names. The last six were ones she knew of herself. Friedman knew of these "transactions," she testified, and "they punished the girls—put them in the lock-up. And in cases where it was impossible to keep them in the school I think they sent them home."

She elaborated on one case involving a cousin of her mother's.[20] "When she was sent here," Angel explained, "she was sent somewhat in my care, and I kept my eye on the girl for a couple of years." When the girl "went wrong" Friedman decided to send her on an outing for punishment. Angel told him that would do no good, "the girl rebels against that, and she threatens to do worse. She has got to the point of recklessness." Friedman also forbade the girl to marry the Carlisle boy with whom she had sex, even though "they wanted to get married," said Angel. Friedman softened when he found the girl was Angel's relative. He asked her what to do, but Angel felt Friedman should take charge of the situation. She could only "suggest" to Friedman, "that no punishment would be great enough for a girl who went wrong, because she had learned better before she came here." She advised Friedman "if the school rules had failed to keep her straight it was time she was under the care of her mother and grandmother." Angel believed her relative was "the first case ever expelled" for such behavior.

Angel testified next about a boy who came to school specifically to study under Dietz. Friedman only let the boy stay half days in the drawing department. When asked about other cases of "discrimination," Angel again brought up a family member, probably Charles Lamere. She said he wanted to go to Hampton but "made the mistake of coming here." He dis-

covered he had already done the same work as the senior class, so he wanted to go home. Friedman demanded reimbursement for his fare from Sioux City, then "changed his mind again," Angel stated, even though the boy's father was willing to pay back the fare. "He would not let the boy go," explained Angel, "and the boy was kept on here doing nothing . . . after a while the boy got sullen, and it just kept on, and he was punished more or less. Finally, he went home just two or three weeks ago."[21]

When Carter inquired about the students' attitude toward the superintendent, Angel replied, "Why, they have no respect for him at all." She attributed this to "just his personal bearing toward the students." She did not think he cared about them and that he had "not led them as head of the school." Carter inquired, "Do you think he is very much interested in or has any respect for an Indian?" "I do not think so," replied Angel. She assured him that hers represented the typical complaints among the student body. She was correct. As Chairman Robinson reported: "The relationship between Supt. Friedman and the pupils generally appears to be strained and unfriendly. The same is true between the superintendent and the majority of employees. . . . The superintendent seems to have lost the respect of the student body, and is unable to exercise a wholesome influence over them."[22]

The investigation revealed more than Angel's concern about school morals and morale, however, it also uncovered the abolishment of several school departments, including Native Indian art! Supporting the claim that Friedman intended to mislead the public, Carlisle's publications led readers to believe that the art department thrived. One ex-employee was asked whether he knew if "basket making and blending the Indians' art with the art we have at the present time" was still being taught. He answered, "I understand that certain features of it have been dropped. Painting and certain features of it have been retained, I believe, under Mrs. De Cora and Mr. Dietz."[23] A frequent visitor to the school testified that the Indian art department had in fact been abolished, "so far as the studio was concerned." He asked Carter, "Indian art in the other department is surely going on, is it not, under Mr. Dietz?" "No, Mr. Dietz teaches painting," Carter responded.[24]

Carlisle still had an art department and Angel still headed it, but the curriculum no longer offered the study of Native Indian art. This was news to Stevens, who asked Friedman if the photography program was still intact.[25] Friedman said no. Stevens asked about the actual building that housed the art department. Friedman responded, "That building was put up before I came, and was for art work and photography. There were no facilities for teaching photography, and it was being used more

or less as a loafing place, and my plans are to remodel the building and use it for teaching the girls cooking." "You eliminated also Indian art?" asked Stevens. Friedman replied that the BIA abolished the department. Stevens asked when the order was given. Friedman wavered, "Some years ago they asked me about the abolishment of the two positions occupied by Mr. and Mrs. Dietz. I told them I thought they were an asset to the school and I did not think the positions ought to be abolished."[26]

Friedman's desire to retain the positions prevented the public from knowing that his famed Indian art department no longer existed, explaining why Dietz took over as mechanical drawing teacher. Principal teacher John Whitwell expressed frustration about Dietz's promotion. He testified that Mr. Collins, the former mechanical drawing teacher, had been "detailed by the superintendent to the farm," and Dietz "with little or no experience" took over the job from the "experienced teacher." In a letter dated August 13, 1913, Friedman directed Dietz "to take charge of the mechanical-drawing classes in the shop building in the room which has been outfitted for that purpose." He told Dietz to consult with Collins "to get a close insight into the work," and to "prepare" himself over the summer for his new job.[27]

Angel may have been unsatisfied with Friedman's administration, but her husband reaped its benefits. He gained job security as a teacher, as well as an additional $500 per year as Coach Warner's assistant, paid by the Athletic Fund.[28] The fund took great care of Warner as well, insuring him a whopping salary of $4,000 per year, exceeding Friedman's by $1,500. Over the years, the Athletic Fund provided Warner (who was not a government employee) his home, constructed on campus, and free utilities. "All of his expenses of every character have been met," found the Commission, "amounting to thousands of dollars per annum. The majority, or nearly all, of his trips have been made as a coach or in connection with athletic business presumably."[29]

Warner took the hot seat. He was accused of cursing, abusing athletes, and directing "payments for professional football" to Thorpe. The most damning testimony came from E. K. Miller, the head of Carlisle's print shop. "It was easy to imagine 'Pop' Warner the real superintendent," he stated. Warner had "no interest in the moral welfare of the Indians," he believed, which made "it next to impossible" for the other staff "to achieve character-building results."[30] Other teachers agreed. Miller's testimony revealed the source of Dietz's ambiguous position. Miller claimed "certain football boys were enrolled at said school for the specific purpose of playing football," and added there was "absolute power

in the hands of a man who had no connection with the service other than to make athletes." He further claimed:

> I never knew of Coach Warner's orders being countermanded. His power after Mr. Leupp left the service was absolute. When it came to members of my department joining the athletic teams or the boys going to practice at all hours, [or] being away on trips, I had no voice in the matter. Social affairs were carried to the extreme. Expenditure of money by students to dress and the cost of parties were beyond all good sense. . . . It was no uncommon thing for the boys of the athletic teams to be drunk and cause trouble. Thorpe was among them. . . . Both the athletic director and the director of music seemed independent of other departments.[31]

Warner's glory days at Carlisle were over. According to Linnen's findings, football took precedence over academic and industrial courses; the athletic fund was improperly dispersed; "professionalism was employed in the athletics" (not just with Thorpe), and ex-students were reenrolled "as members of the student body for the express purpose of playing football and taking part in athletics"; football players "received payments in cash or indirectly in some other manner"; and football players and "certain employees" were shown "favoritism," including tolerance for bringing and drinking liquor on the grounds, while the other students were "severely disciplined for trivial offenses."[32]

William Newashe's testimony elucidated some information about professionalism and cash payments among the football players. Newashe (whose wife Angel visited the year before) played Carlisle football from 1909 to 1911. He agreed that Warner "curse[d] the football players," but, more importantly, he said, Warner persuaded him to return to the team after he'd left the school, though "it was generally given out and supposed he was a student at Carlisle during those years."[33]

Strangely, Dietz never testified! How he avoided the Commission's interest is beyond perplexing. He was certainly in no position to be questioned about his relationship to Friedman, Warner, football, or the art program. For someone who thrived on attention, he managed to lay low throughout the proceedings.

The Commissioners discovered Carlisle's incorporated Athletic Association controlled a veritable slush fund. At the time of the investigation it contained $25,000, collected mostly from the proceeds of football games. Three board members, Friedman, Warner, and Carlisle's financial clerk, Will H. Miller, had sole charge of its disbursements. The money accomplished some good on campus, such as Leupp's Art Studio

and other campus improvements, but no strict policies guided its use. Several employees and townspeople received payments from the fund, including a lawyer, a policeman, and the two local journalists, Hugh Miller and E. L. Martin. The Commission found the reporters kept track of "clippings" and gave the football team favorable press. It also discovered that Hugh Miller was "constant and persistent in his writing of articles for the public press, which he has printed at Carlisle and elsewhere, complimentary to Supt. Friedman and derogatory to the Government and its officers."[34]

Linnen pronounced that the management of the Athletic Association funds went against BIA regulations. Any money collected for "athletic contests" as well as for "school entertainments, band concerts . . . sales of curios or fancy articles manufactured by pupils, subscriptions to school journals or advertising there from, job printing, or any like enterprise," should have been accounted for under the Bureau's "Class IV funds," and, as such, were government property.[35] The Commission could find no fault with Will H. Miller (and recommended his salary be raised), but it believed Friedman and Warner both used the funds indiscriminately. Friedman even seemed to be charging his travel expenses to the fund at the same time he charged them to the government.

Commissioner Sells suspended Friedman and Stauffer. Charges against them were "preferred to Congress."[36] He reprimanded the girls' matron, who supervised Julia Hardin's beating, and transferred her.[37] While "earnest in her work," the Commission found her demeanor "harsh and unkindly." The boys' disciplinarian, who participated in the band members' beating, was also reprimanded. Sells allowed him to stay at the school, but forbid him to ever perform corporal punishment again.

Although Inspector Linnen's report recommended that Warner, along with Friedman and Stauffer, should be dismissed "in the best interests of the school," the Commission decided Warner could remain if he toed the line.[38] With his influence over Friedman exposed, his reign at Carlisle ended.

"Surprised" by his suspension, Friedman "did not care to talk for publication," except to say, "he hoped to have the opportunity of showing that his administration was effective and did not merit condemnation in any instance."[39] Sells assigned Supervisor Oscar C. Lipps as his temporary replacement. Commissioner Lane, performing political cleanup via Carlisle's local newspaper, stated "the attempt made by Friedman to win sympathy, on the ground that the inquiry was undertaken to effect the school's removal was absolutely groundless." "The committee and every one interested in Indian affairs are convinced that the school

should remain at Carlisle. Its efficiency and management will be strengthened as the result of the impartial inquiry under way," he concluded.[40]

The investigation wasn't quite over. On March 25, Chairman Robinson returned to Carlisle. The night before his arrival, Angel sent a telegram to Carrie Andrus at Hampton. "Come by all means," she said. "Bring Comfort and Peace. There will be talk on Indian Education by Indians."[41] Robinson held an open meeting the next day. Angel expressed her satisfaction to Carrie that this time *Indians* could talk about Indian education for themselves.

Robinson questioned Friedman's chief clerk, Siceni Nori, a Laguna Pueblo who had been at Carlisle since he was six years old. Nori, who earlier jumped ship to testify against Friedman, gave Robinson the impression that he, "like most Indians," "followed blindly the instructions of his superintendent and did largely as he was directed to do."[42] Robinson did not find Nori "blameless," after questioning him, but he became more convinced of Friedman's guilt. Nori was suspended and indicted. In reaction to embezzlement charges, Nori gave state's evidence against Friedman, who claimed that Nori had used money deposited by students for their transportation costs. Nori's lawyer "wanted the proceedings quashed." He argued that because Nori was an American Indian, he "was a government ward answerable to Uncle Sam alone." Friedman's attorneys rebutted, stating Nori should not be considered a government ward, because "the reservation was under state law for criminal causes."[43]

§

In the midst of all the chaos and upheaval, but before Robinson's return to Carlisle, William Lone Star answered another letter from Sallie Eaglehorse on February 12, after nearly two years of silence. He explained he had been "traveling a great deal," but was glad to "know there is some one who loves me." Apparently, Sallie questioned him about his life after he left Pine Ridge, South Dakota, as a boy. He told her he "lived with some white people who were good to me and wanted to adopt me, but father died suddenly and left all his money to his other relations before he had time to change his will." Since then Lone Star had "been to school a great deal and with several wild west shows," until he "learned to draw pictures and got money for that." "I made mostly Indian pictures," he said, "and sometimes get good pay." "I feel lonesome for my people and want to go home," he confided. Sallie must have asked about his allotment at Pine Ridge, because he mentioned he "never tried to get my land, but just let it go."[44] He never visited his sister, either,

though he traveled to the Rosebud Reservation in 1904 and 1910 to visit his and Sallie's maternal uncle, One Star, who once performed in Buffalo Bill's Wild West Show. Rosebud was only a few miles from Pine Ridge.

Dietz wrote the letter to Sallie exactly two weeks after Friedman received the following letter from Pine Ridge, suggesting Friedman or someone alerted him to the correspondence.

> Dear sir.
>
> Please I want you to do little thing for me. I like know where is one star or lone star i think name is james one star or lone star. he left the oglala reservation many years he is going to school. some where i think go to carlisle ind sch.
>
> and he never get home and last i heard he was out to soldier some where-but i heard come back to school again.
>
> he only got one sister lives so she like to know where is he now. i think he is 40 or over years old by this time i want you to do that right the away and you let me know you try to finde out please.
>
> your truly
> Chas Yellow Boy[45]

On February 2, two days after Friedman first "welcomed" the Congressional investigation to his campus, he answered Yellow Boy's letter. "I beg leave to advise that James One Star was enrolled at this school from January the 1st of 1889 to August the 10th of 1892. Our records indicate that on the latter date he enlisted in the United States Army and that later he died in Cuba. However, we do not have any detailed information on file regarding the circumstances of his death."[46]

Military records also offer no detailed information except that IRA's Sniffen, as well as Pratt, sought the military's assistance in 1908 and 1909 to track down James One Star. All they learned was that One Star served at Fort Sill well before the Spanish American War and was dishonorably discharged from the Army in 1894 at Mt. Vernon Barracks in Alabama.[47] After that, he disappeared. The dates on One Star's student record agree with Friedman's letter. He came from Pine Ridge and enrolled in 1889 at age 17, a member of Red Shirt's band (Red Shirt was a popular Buffalo Bill performer), but there is nothing to indicate that he died in Cuba. The word "dead" is simply written on the top of his enrollment card. Perhaps, Friedman wanted to save One Star's sister, Sallie Eaglehorse, the shame of his dishonor.

The Lakota Name for "One Star" Wicarpi Wanjila is also translated as "Lone Star." On March 3rd, the superintendent of Pine Ridge sent a letter to One Star at Carlisle. "Enclosed find cards and ink," he wrote. Please

send your right and left thumb marks and English name on each three cards."[48] The BIA had just recently required thumb prints for annuity applications. But none existed when James One Star received his last annuity payment.

<div align="center">§</div>

The first week of April, Lipps hosted a wedding in his parlor to lift campus morale. Cherokee Samuel Saunooke, an employee of the Pennsylvania Railroad, married Pearl Bonser, a freshman, and the "honored president of the Susan Longstreth Literary Society." Angel, without her husband, was part of the "small and select company of friends and admirers of the young people."[49] Angel supported Lipps's mission to lift student morale. In mid-April, she attended a meeting of the Invincibles, making a special point to "congratulate the members on the spirit they had shown in the meeting."[50]

Morale boosting did little to change the campus climate. At the end of April, Lipps informed Sells that a Carlisle cook took "one of the Indian boys to a saloon in Carlisle and bought him liquor." The Indian Rights Association grew impatient with Sells. IRA members urged him to take immediate action against those charged. Lipps undoubtedly shared their concern. He told a reporter "the demoralization at the school has grown, because the Indian pupils believe that pressure had been brought to save the men they think should have been dismissed long ago."[51] Did he mean Warner? On the other hand, Dietz came out of the investigation unscathed, perhaps due to his relationship to Angel. In fact, he became president of the Carlisle Indian Athletic Association with W. H. Miller as secretary-treasurer.[52] However, without its slush fund, the Athletic Association was rendered powerless, as Dietz came to realize.

A special officer sent by the BIA "apprehended five men selling liquor to Indian students" in mid-May. Less than two weeks later, Friedman and Nori sent their resignations to Sells.[53] In July, the U.S. Attorney General brought a new twist to the proceedings with his determination that the statute of limitations had run out "against the most serious offenses alleged to have been committed by Mr. Friedman."[54] But Friedman wanted the investigation to continue, he said, until "my reputation is vindicated."[55] He intended to prove his resignation was the "result of a carefully planned persecution at the hands of the Bureau of Indian Affairs, under Commissioner Sells." He denied allegations that he was incompetent and that he had participated in financial "irregularities." He accused Nori of "shifting the blame for his defalcations upon me," and stated that "not one penny" of the $2 million of school funds he had charge of during his tenure at Carlisle had ever been "misappropriated."

"I have absolutely nothing to fear from the most searching inquiry that can be brought to bear upon the matter," he said. "I welcome it."[56] Of course, the BIA couldn't possibly know how much of the Athletic Association fund had been misappropriated.

§

A rainy summer passed in Carlisle, while Dietz traveled alone to Wisconsin to visit his divorced parents. His father, William Wallace Dietz, very much alive, lived in Rice Lake. Leanna Ginder Dietz, now the wife of Frank Lewis, lived in Lodi near Madison. His father remarried Elizabeth Lasher Johnson just two weeks before William Henry Dietz married Angel. Leanna's marriage followed two and a half months after her son's. The new Mrs. Dietz had children from a previous marriage, but the only child, a daughter, she and Dietz, Sr., had together died as an infant in 1909.[57] Dietz, Jr., remained Leanna's only child.[58] Angel never met her husband's family, but a picture of their son and her hung in her father-in-law's house.

When Dietz came home, he and Angel chaperoned five students during a week's sightseeing trip to Philadelphia, New York, "and other points of interest."[59] Dietz returned to Carlisle after the trip ready to assist the deflated Warner. Carlisle's roster of employees still listed Angel as the Native Indian Art teacher, and Dietz as the mechanical drawing teacher. It would never occur to anyone reading the *Carlisle Arrow* that the Indian art department was long gone. The studio was up and running by the end of September, and the paper advertised its non-Native wares, which included "a large and attractive array of pennants, table scarfs [*sic*], and pillow covers in the school colors, besides scarf and hat pins, cuff links, watch fobs, and other desirable trinkets." A thunderbird emblem, similar to the eagle Angel designed for the SAI, decorated the items.[60]

The Little Buffalo Robe, written by Nebraska author Ruth Everett Beck, and illustrated by "Angel DeCora and Lone Star," was published in October. Angel created the four full-page illustrations, only one of which was also signed by Lone Star. There were several chapter headings and feature sketches he may have had a hand in, but little is known about the publication.

The fourth annual SAI meeting came to the University of Wisconsin in Madison. Angel attended with Marie Baldwin. As a sign of the times and her recent accomplishment of receiving a bachelor degree in law, Marie spoke about the need for public rather than industrial education. "Many times I have been weary and discouraged, but I felt as if I must go on for the sake of my sister women," she stated. "It was to show them that they, too, could accomplish what I did, and to prove myself as an

"The Yanktonai is carrying me to the others of his tribe" by "A. de C. and L. S.," from *The Little Buffalo Robe*, 1914.

example, that I unflinchingly kept to my studies. I hope and pray that my efforts will have some influence [on] the future lives of my Indian sisters."[61] Angel and Marie also addressed a Madison women's club meeting, where Angel discussed Indian design and its application to household items. She also concurred with Marie that Indian girls must pursue higher education to enter the larger society. Carlisle girls

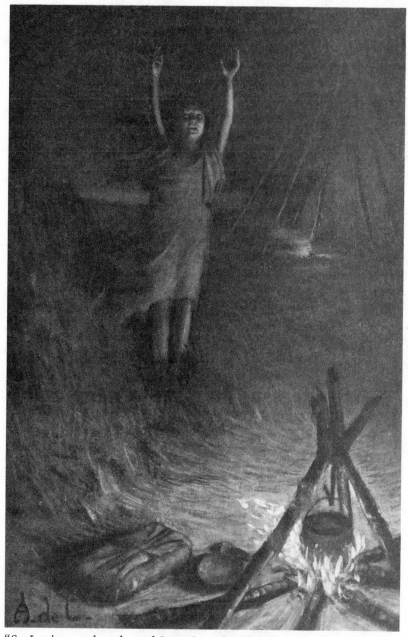

"So I raise my hands and I say in voice that begs, 'Wakondah'" by "A. de C.," from *The Little Buffalo Robe*, 1914.

received academic courses only half day, she explained, and "they bake, wash, sew and mend for the whole institution" the remainder of the day. Although they were "excellent housekeepers," they needed to learn business skills and to work off "superfluous energy" like the boys. "There isn't a lazy girl among them," Angel boasted.[62]

Upon her return to Carlisle, Angel offered an account of the SAI meeting to the school paper. She relayed that "reservation grievances" from the neighboring Menominee and Ojibwe "were laid before the Society," and that the previous year's officers had been reelected. She also complemented the SAI.[63] "In four years they have built an organization based on pride and race development. By wisely and judiciously considering every phase of educational development for the Indian, they have gained for us the sympathy of the best intellect of the white race." She urged that "every Indian who has the true American heart" should step forward and support the society "for the good of the race."

Unfortunately for Dietz, 1914 turned out to be one of the two worst football seasons in Carlisle's history. The team won only four games, tied one, and lost seven, giving a few rivals the first victory they'd ever tasted against the team. The Chicago game, where Dietz assisted against Notre Dame, further degraded Carlisle's image, just where it needed the biggest boost—in the west. Carlisle lost forty-eight to six. The school paper highlighted the trip to Chicago and "the pretty Indian maidens who called upon the football team."[64] The annual Thanksgiving Day game against Brown University found Carlisle lacking fourteen to twenty. The Congressional investigation not only dampened school spirit but extinguished the spark for Carlisle football. With the bandleader dismissed, the Native Indian art department defunct, and football soon to be never more, very little—if anything—distinguished Carlisle from other Indian schools. Having exposed the corruption underlying the "show and glitter" of the Indian and Industrial School, the Congressional investigation presaged Carlisle's farewell.

§

As old European empires crumbled, Serb radicals assassinated the heir presumptive to the Austro-Hungarian throne, Archduke Franz Ferdinand, and his wife, in Sarajevo on June 28, 1914, precipitating the Great War. While Lipps sought to arrest the demoralization at Carlisle, on July 24 Serbia frantically sought Russian support just three days before an angry Austria-Hungary declared war. In early August, just after Friedman resigned, Germany declared war on Russia and France, and invaded its neighbor, Belgium. On August 4, as Angel and Dietz prepared to take their students sightseeing, a reluctant Great Britain

declared war on Germany. All throughout the summer and fall as festering wounds and secret accounts came to light at Carlisle, one devastating battle after another erupted in the Old World. If the atmosphere at Carlisle seemed electric, it was a tempest in a teapot compared to the great storm galvanizing across the sea. In the microcosm of the Dietz marriage, stalemates also began to give way. The U.S. position of "unchangeable neutrality" and "splendid isolation" mirrored Angel's attitude toward her marriage.[65] But that was about to change.

The election two years previously brought former Princeton president, Woodrow Wilson, to replace Roosevelt's disappointing hand-picked successor, William H. Taft. Republicans joined Roosevelt's newly formed Progressive Party to defeat Wilson, but when the new party collapsed, "thousands defected to Wilson and the Democrats." Wilson's election platform attacked big business and special interest groups. As one follower put it, the issues were divided between his "regulated competition" and support of the small businessman, and Roosevelt's "regulated monopoly," which supported the great U.S. corporations.[66] Roosevelt still spoke softly and carried his big stick, but the soon-to-be "thinking man's president" spoke eloquently. His campaign speeches, accented with wartime rhetoric, moved the masses and eerily touched upon themes that echoed Carlisle's situation. "The government, which was designed for the people, has got into the hands of bosses," Wilson asserted. He likened Roosevelt's administration to an "invisible empire," one "set above the forms of democracy." Wilson claimed "great allied corporations and their special interests," now controlled government. This resulted in "vicious systems and schemes of governmental favoritism." Such systems and schemes, warned Wilson, were "far-reaching in effect," and created "impossible handicaps upon competitors, stifling everywhere the free spirit of American enterprise."[67] No wonder Friedman became paranoid. Unchecked control, special interests, and favoritism certainly characterized Carlisle's "invisible empire."

Wilson's administration advocated the investigation of corruption in Indian institutions. But it also emphasized educational reform, resulting in an attempt to raise Carlisle's academic standards. Angel and Marie's presentations at Madison attested to this new attitude. Wilson achieved his victory over Roosevelt, however, through his platform to keep the country out of war. Later he felt this "misrepresented his position and compromised his freedom of action."[68] Wilson walked a fine line, but a rigid stance of neutrality was not his, he claimed. He sympathized with the Allies, especially Britain, but, when Mexico and Japan

threatened the United States, his desire "to make the world safe for democracy" overcame his commitment to neutrality.[69]

In its early years the war was kept at bay by a mighty ocean and a blind eye. The United States, rapt in its progressive-inspired "illusion of peace" stood apart from the estimated twelve million men fighting in Europe. On November 1st, two weeks after Canadian troops arrived in Britain and three days after Turkey joined the Central Powers, a feature story titled "Emblem Is Thunder Bird," appeared in the *Washington Post* and other newspapers across the country. Angel De Cora Dietz, "a Winnebago of aristocratic lineage," authorized the article's claim. She had "delved deeply into Indian legends" and designed a thunderbird emblem for both Carlisle and the Society of American Indians.

As the war raged in Europe, thunderbird insignias embellished European military uniforms and banners. The practice was "hardly civilized," and from Angel's perspective there were "no good reasons why America, Germany, and Russia should place a bird on their national emblems." Angel explained she "learned about the thunder bird as a child," and believed it was as "ancient as the legend concerning the last mammoths." The symbol was almost universal among Indian tribes, she claimed.[70] To show its prehistoric origins, the *Post* recounted the Winnebago legend of the battle between Thunder Bird and Water Spirit, a story symbolizing current events. Angel explained that the Thunderbird, who defeated Water Spirit, was "a symbol of authority and social rank" and had been "appropriated by the Europeans from ancient America." It stood "for authority, dignity, arbitration and, most important of all, peace," she said. It is an "unfortunate perversion," she insisted, that "makes the symbol of arbitration and peace the banner which leads to war and devastation."[71]

Angel's declaration that warring Europeans misappropriated her clan symbol aligned her with the country's progressive pacifists, such as Elaine Goodale Eastman. The marriage between her ancestors, Wahopoekaw and Sabrevoir de Carrie, promoted diplomacy, mediation, and peace. Angel's commitment to the ways of her "grandsires" at last rang true. Her clear admiration for the significance of the thunderbird, since it first appeared on the cover of *The Middle Five*, reflected a newfound pride in her Winnebago identity, her De Cora roots, and her growing empowerment as an American Indian woman in a world cruelly divided by contrived race theories, gender inequality, and now war. The *Washington Post* heralded Angel as an arbitrator, a mediator, and a cultural broker, just as her ancestors had been. An American Indian symbol became the literal and figurative medium to express her nonviolent resistance. As an

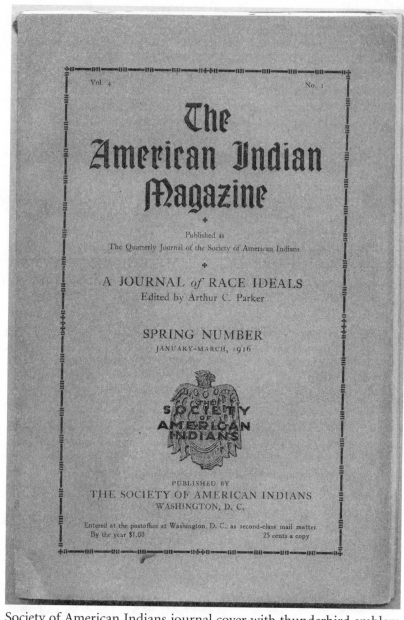

Society of American Indians journal cover with thunderbird emblem designed by Angel de Cora.

authority in *representation*, she understood the harm *misrepresentation* could do. Leaving the "Indian girl" behind her, a mature Winnebago woman emerged to make her mark modestly, but resolutely, on the world.

§

In December of 1914, Angel and several of her Carlisle colleagues traveled to Washington D.C. for an important meeting of the SAI.[72] They met Charles Dagenett who took them to tour the BIA, after which Commissioner Sells welcomed them to the nation's capitol.[73] The next day, they gathered with other SAI leaders and prominent associates at the Powhatan Hotel. Forming a group of about fifty, they proceeded to the White House to meet with President Wilson. After shaking hands with the president, Dennison Wheelock, Carlisle's old bandleader, read the SAI's memorial. It sought "a code commission" and requested that the federal Court of Claims have jurisdiction over all Indian claims. The presentation represented an early plea for tribal, or at least pan-Indian, sovereignty. "We believe that you feel, with the progressive members of your race, that it is anomalous permanently to conserve within the nation groups of people whose civic condition by legislation is different from the normal standard of American life," Wheelock read.[74] After the presentation, the group convened for a discussion on "Indian subjects" in "the Indian room of the hotel." Speakers included Sniffen; Sloan's Omaha law partner, Hiram Chase; Chippewa priest Father Gordon; William J. Kershaw, a Menominee lawyer from Milwaukee; and Pratt.

Although Wilson felt "instantly impressed" with the memorial, the coming war impeded "the enactment of fundamental remedial Indian legislation."[75] Upon her return home, Angel received Parker's "fraternal regards" and gratitude for her participation. He also encouraged her to remain active in the SAI with the politically charged terms of socialism. "The very presence of our old workers is a most emphatic demonstration of their deep interest. We hope that from now on that matters will go forward with a greater degree of success."[76] Dietz's name did not appear among those who attended the proceedings, but the *Carlisle Arrow* reported students "were glad to have Mr. Deitz [*sic*] return from the South, so that they can continue with their lessons in mechanical drawing."[77]

By the last week in December, news from the Department of the Interior reminded faculty and staff of their tenuous condition. There would be "no let-up in the prosecution of charges of mismanagement at the Carlisle Indian School" and "bills of indictment will be presented to the grand jury at Scranton, within the next two weeks."[78] The school paper tactfully ignored the mood on campus, while Angel seemed outwardly relieved and hopeful with the new administration. She supported Sells

and even collaborated with his wife on a Christmas card, printed by the Carlisle Press and sent out to all employees of the Indian Service. Her four-color design of a peace pipe now appears trite—made more so by the card's insipid poem written by Mrs. Sells.

> Open-armed the Red Man welcomed
> Paleface pilgrim to his shore;
> Greetings glad as his, I send you.
> And goodwill, forevermore.

> Let us strive to help this broth&[er]
> Greed and graft. Injustice. Cease;
> Let us seek his lodge of council:
> Let us smoke the pipe of peace.

The card sent a clear message to Indian Service employees that Sells refused to tolerate greed, graft, and injustice. Interestingly, Angel took the opportunity to send a message of peace with another symbol of diplomacy from the Thunderbird clan. She knew the fighting had spread beyond Europe. Soon South Africa would take up arms. The only good news that came from the western front these days was a brief truce on Christmas Eve.

§

As Christmas approached, Angel set to work making cloisonné pins to sell. Dietz probably spent the holidays with his family in Wisconsin. Just before Christmas, William Lone Star wrote a third letter to Sallie Eaglehorse. "I have not for one moment forgotten you," he assured her, "and so before Christmas brings joy to all our hearts, I am writing this letter with the hope that you will not think badly of me." He sent "the shawl which I promised you last spring," and hoped it would "keep you warm when the wind blows cold." "Remember I think of you often," Lone Star reminded her, and "my spirit is with you even though I can not be." As always, he closed with the Indian salutation, "I shake hands with you with a glad heart." He signed off his letter "With all love to you, from your long lost brother."[79]

On Christmas Eve, his hometown newspaper reported: "Will Dietz has been appointed to act as football coach at the Carlisle Indian School." Noting Warner's salary of $4,000, the report stated "the former Rice Lake boy will probably start in with a salary near that mark." Dietz's belief he would be hired to replace Warner was not much of a stretch, but at the salary paid from the now defunct Athletic Fund? The article also explained that Dietz had been working at Carlisle in one capacity or another for several years and that both he and his wife were popular

at the school. Dietz appeared especially fitting for the new coaching job, since he understood, "as well as any person," the Indian nature and football tactics.[80] The report did not disclose how exactly the hometown boy, whom everyone believed was the son of William W. and Leanna Dietz, *understood* "Indian nature," but his letter to Sallie Eagle Horse later proved he at least knew how to *speak* in the manner of an Indian.

The annual banquet and reception of the Athletic Association went on as usual on New Year's Eve in the brightly decorated gym. Lipps, Warner, Dietz, and each of their respective wives attended as honored guests to pay tribute to trophy winners in "track, diamond, and gridiron." Everyone put up good appearances, but a strange, foreboding ambience permeated the celebration. The passive mood that followed the investigation and preceded the days before the United States entered the war reflected more a state of denial than a commitment to peace. An observer of the evening tried to capture the mood of the festivities, but only mirrored the turbulence hiding just beneath the surface.

> At twelve o'clock the bells began to ring, the band played out in the moonlight, and those in the Gymnasium, imbued with the spirit and presence of the New Year, entered into it with enthusiasm manifested by handshakings and mutual good wishes. The last waltz, "Dream of the South," played to the final strains of "Home, Sweet Home," brought the joyous occasion to a close.[81]

In a bizarre twist of selective memory, while the world suffered from afar and many had lost faith in Carlisle's mission, American Indian dancers dreamed of the South to a ragtime waltz without regard for those who had arisen from its nightmare. The uncertainty of the future surely provoked the celebrants' amorphous, mawkish emotions, but they were blind if they believed race pride justified oppression as much as it supported their equal rights. Further, for the elite among them, or at least for Angel, "Home, Sweet Home" lived only as a memory. Some could never really go home again. Despite Leupp's intent, they had been transformed.

The first Great World War felt "personal and impersonal, a turmoil from within as well as from without," wrote one historian. "Where are we? What are we? The War in our souls broke out. We were the Cause of the War; the violence and inconsistency of our emotions, the impotence of our ideas."[82] Did Carlisle students and their teachers feel the war in their souls that New Year's Eve? If so, their internal battle erupted from a crisis of identity, one fueled by blood quantum and spurious race theories unconsciously devised to keep them in line.

The new year of 1915 was a transitional one for the country. The war raged on as the United States held aloof. The thunderbird story appeared again in newspapers across the land with a different headline: "Is Wrong Emblem: No Place for Thunder Bird on European Flags."[83] Angel felt committed to educating Americans about the correct use and meaning of Native symbols, regardless of her political views. Fortunately, she did not live to see how the swastika would be misappropriated in the future.

At the beginning of the new year, Commissioner Sells, upon the recommendation of the head of Smithsonian's Bureau of Ethnology, announced: "the American Indian should not be classified as a Mongolian." Inspired by the Smithsonian's revelation, the commissioner sent instructions to all of the Indian Schools, prohibiting teaching Indian children they belonged to the "Mongolian race" and announcing "all school books containing such classification will be dropped from the authorized list." The commissioner concurred that the "Red Men" were a distinct race from the "White, Yellow, Brown (Malay) and Black."[84] The *Christian Science Monitor* joined the debate. "If the red Indian of the United States is a distinct race, not derived from any of the major subdivisions of the human family, but authentically aboriginal and separate, why, of course Indian youth on entering schools and beginning the study of history in its broader and more general aspects should not be taught otherwise."[85] Some ethnologists still held to "the Asiatic origin of the Indians of the north Pacific tribes now found in both British and United States territory," the report stated, but the other Native peoples who inhabited the continent were racially distinct.

The new theory still held fast to old-fashioned evolutionism, but it invited American Indians to move one or two or three rungs up the evolutionary ladder. "A race pride that makes a man quit aping another race and assert his own powers and those characteristic of his race is wholesome in the main and within reasonable limits," it stated. "The wisest of the Afro-Americans now stress race self-respect and independence." The "pure and mixed strain" of individuals who made up the SAI, the article acknowledged, now consisted of "educated leaders, college and university graduates" independently expressing their needs in Washington, D.C. to become "race champions." The astute reporter did notice, however, that the BIA made a strategic move. "No wonder then that . . . they insist that the race be rated as other than derivative. Since proof to the contrary is not accessible, at least in a form that closes the door to debate, the government is both shrewd and just now in deciding that so far as it teaches history the red Indian is a distinct type."[86]

Commissioner Sells ordered school superintendents to drop the Mongolian race classification and replace it with "the Indian as a distinct race." On the authority of the Bureau of Ethnology, he also ordered contrary text books removed from the curriculum. The Commissioner recommended supplementing early U.S. history books with "instruction as to the actual conditions of the Indian today."[87] The Indian of today included those who "professed Christianity," were "self-supporting," lived in "permanent homes" and took "up the white man's way," those who could read and write English, wore "citizen's clothing," were farming, and, finally, BIA employees. Sells mentioned nothing about retaining any part of Native culture. If "the red Indian was a distinct type," he wanted the "Indian of today" to behave like a conventional white citizen.

How did Angel translate these instructions? The *Arrow* reported she gave students an "interesting talk on the history of art, showing that much of it can be traced back to the Egyptians."[88] Whatever distinction the new red race could claim, Native Indian art was no longer high on its list of achievements. Was the "distinct race" a diversionary tactic to make American Indians feel they had progressed like their white brethren? Certainly. As the Old World fell into ruins, America discovered a new race, authorized by the Bureau of Ethnology and endorsed by the BIA.

§

By mid January the Federal Grand Jury found "three true bills" against Friedman and Nori: (1) "willfully destroying and burning records and papers in the form of written receipts for moneys," (2) embezzling "public moneys" in the form of Carlisle students' travel funds, and (3) "embezzling receipts from the sale of tickets at athletic games."[89]

Soon after the formal charges were made, Cora Folsom received a welcome letter from her gray-haired child with no mention of the trouble at Carlisle. Angel told her about pins she painted with Indian designs," including "Sioux, Navajo, Hopi, etc." as well as a Zuni piece she had shown to Carrie. She earned enough money from their sale to cover a pledge she had made to the SAI. "Foolish things sell better, always," she said, and she promised Folsom a piece, as there was "some satisfaction in wearing cheap jewelry."[90] She also paid for lessons to learn "mineral colors for china painting." "It's lot of fun but costly," she explained. "That's why I happened to land on small pieces like pins." The work was taxing on her nerves, so she was "loafing now for a change."

Two days after Angel wrote Folsom, journalist Frederick J. Haskin lauded Angel's "efforts to perpetuate and develop the native arts of the Indian," but expressed concern that the work to "restore Indian art" had

"deteriorated in recent years."[91] He did not mention the demise of Carlisle's Indian art department. The SAI's commitment to Native Indian art had also receded, but, thanks to Wilson's support, its interest in advanced education for American Indian girls and boys expanded. The organization held its first student essay contest, awarding the first prize to one of Hampton's plucky Indians, Lucy E. Hunter. Hunter was a Winnebago girl, related to Addie Stevens, who was "preparing herself for a life of larger usefulness to her people." Her prize-winning essay highlighted "higher academic training for the Indian."[92] Times had certainly changed since Angel attended Hampton.

In early February, Mrs. Warner invited Angel and other faculty to a tea to say goodbye.[93] Likewise, at the end of February the "C" men held a farewell reception for the Warners. Bessie Eastman, niece of Charles, accompanied Angel.[94] The event honored Pop Warner as "the man who made Carlisle famous throughout the land." If the investigation left him slightly tainted, no one acknowledged it. One speaker recalled the "Glories of Carlisle under 'Pop.'" He took young men with no previous athletic training, he said, and turned them into some of the best athletes in the country. The list of guests included these athletes: Pleasant, Dillon, the Houser brothers, Balenti, Johnson, Rogers, Lubo, Welch, and Bender, as well as Olympic winners Thorpe and Tewamina. The *Carlisle Arrow* reported that the reception "marked an important event in the annals of the school—a farewell tribute to the man who not only trained and developed athletes of ordinary reputation but the world's greatest athlete, James Thorpe."[95] Dietz was noticeably absent.

§

Dietz sent a request for One Star's annuity to the Pine Ridge agency on February 2.[96] He received $61.20 in April and $14.70 the next year. He shared $50 with Sallie Eaglehorse.[97] This money didn't seem to interest him as much as Sallie's devotion. Strangely, however, the day before he made the application, his father signed a notarized affidavit in Rice Lake, Wisconsin, affirming William Henry Dietz was indeed his son and "a voter in the City of Rice Lake, Barron County, Wisconsin." Three days later six Rice Lake citizens, who were "personally acquainted" with Dietz, Jr., signed a second affidavit. They attested that he resided "at the Carlisle Indian School," but he was "formerly a resident of Rice Lake, Wisconsin." They also claimed he held "his legal residence in this City," was a local voter, and a U.S.-born citizen. Dietz, Sr., wanted to validate his paternity, but his specific motives for the affidavits never came to light.[98]

§

Commissioner Sells formally appointed Lipps as the new superintendent of Carlisle in May.[99] The appointment came with the tragic news that Elbert Hubbard and his wife died when German torpedoes sunk the *Lusitania* off the coast of Ireland.[100] The Federal Grand Jury indicted Friedman and Nori, but the jury acquitted Friedman on June 17.[101] The court found Nori's testimony unreliable, simply because he owed his ex-wife alimony and child support.[102] The jury convicted Nori, and the judge sentenced him to the penitentiary, while he vindicated Friedman of all charges. Was this simply a case of another worker crushed by "an invisible empire" or good old U.S. race prejudice? Whatever the cause, the BIA assigned Friedman "to a most responsible position" elsewhere and doubled his salary.[103]

During the summer of 1915, Dietz resigned from his position as mechanical drawing instructor and headed for the Pacific Northwest. He accepted a position as head coach of football at Washington State University at Pullman. Before he left, Thorpe, who was playing for a Harrisburg baseball team, came to visit as an "over-Sunday guest." Angel was not home for the occasion. She and Bessie Eastman had already departed for Keen, New Hampshire, where Charles and Elaine opened a summer camp on July 1st. The Eastmans hired Angel to teach Native arts and crafts.[104]

The entire Eastman family ran Camp Oahe ("The Hill of Vision"), advertised as "The Summer Camp with a Difference." Camp Oahe for girls touted Eastman as a "real Indian" and "expert woodsman, trained in the unsurpassed school of the open air." He also oversaw "the health of the camp." His five daughters staffed the camp and served as counselors. Campers could participate in "traditional Indian celebrations of great historic interest," and they would produce an "original play or pageant" to be performed when camp season ended.[105] The authentic Indian camp included instruction in "Indian signaling and sign language, archery, trailing, ceremonial dancing, the Sioux language and literature," all "taught by Dr. Eastman himself."[106] But daughter Irene Eastman embodied "the real spirit of the camp." A beautiful, talented and trained soprano, she taught music and swimming to campers and starred in and led the production of the camp's pageant.[107] Irene's "remarkable enthusiasm for life" touched everyone.[108]

The more demure Angel taught handicrafts in the morning and afternoon. She is pictured in the camp's brochure supervising a group of "pale faces" making baskets. Her serene expression, with downcast eyes, might be perceived as boredom. Most of her female students dressed in Indian costumes with braids and Indian headbands. She dressed in

regular garments but donned a headband. The brochure identified the girls as "college graduates and experienced travelers."

When camp ended in August, Angel drove to Northampton to stay with Gertrude. A visit to her old home always cleared her mind, so much so that by September she resigned from Carlisle. Without much ado the *Carlisle Arrow* noted: "She is at present at Northampton, Mass., but does not state anything as to her plans for future work. Needless to say, the very best wishes of her many friends here go with her wherever she may be."[109] Angel did not follow Dietz to the west. "I just about lived in autos all summer," she wrote Carrie, "eating meals in 'road houses,'" ("getting fat" from it) and "reading a detective story a day just to kill time." Killing time was all she could do until she made plans for the future.

Angel returned to the town of Carlisle in the fall. She moved into the Mansion House Hotel. "I am back here as you see but not with the School," she informed Carrie. "I am so happy that I am at last free from the Indian service."[110] The conditions of her new-found freedom tempered her happiness. "Billie is away out in Washington coaching football, but I didn't see just where I'd come in on that," she confided, "so I remained east and I shall try to get back my last opportunities if such a thing is possible." These opportunities predated her marriage. She wanted to move to Northampton, but living expenses there were too high. She rented an apartment in town and moved in the first week of November. She did not have to find work, it found her, and she had enough "to keep me busy all winter," she told Carrie. Her "only companion" now was the champion Khotni, the last of the wolfhounds. She expressed her love of dogs, as well as her loneliness, exclaiming, "but O, how I miss the woeful Siberian wail of the whole pack!"

Angel stood at a crossroads. Dietz chose football and the west coast, when she, for so many years, dreamed they could make a career together in the east as soon as they could extricate themselves from the Indian service. "I was to say the least down and out nervously," Angel explained to Carrie, "but I am just O.K. now thanks to my gay friends in Mass." She tried to keep up her good humor, joking with Carrie about the old days of Indian education. "If you were nearby I could put in some time on your stockings and missing buttons but don't take the trouble to ship them this long distance perhaps the finished result won't pay you for the trouble. You see I am somewhat rusty in my domestic training. Wouldn't you like to sample one of my meals tho'!"

The Indian school went on without her. "I haven't been out there and they haven't been here and so far neither side has suffered any loss." She closed her letter, expressing the uncertainty of her future and eluding to

the tenuous state of her marriage. "I shall not be able to say for another six months just what my next move will be but I shall plan for much and as soon as I can see my way clear for *action* and provided it is for good I shall tell you of them. If it is for worse probably some one else will tell you of it before I can."

One teacher at Carlisle noticed her rocky marriage earlier, but attributed it to Dietz's traveling to dog shows. Although the couple was living together, she remembered, they weren't seen together often. When Dietz and Angel resigned from the school, it was already apparent to many that "their marriage was not going too smoothly."[111]

Just before Thanksgiving, the *Carlisle Arrow* reported Lone Star started a "most successful" football season at Pullman. His team appeared undefeatable. The report on Angel stated she had resigned from the Indian service with plans to do illustrating.[112] Such plans had always included her husband, but now those "aircastles" finally vanished. While Dietz began to carve a name for himself in the Pacific Northwest, coaching a downtrodden team, his retiring wife remained in the east and slowly, passively, and permanently disappeared from his life.[113]

What She Dreamed

Dietz wowed Pullman with his spectacular coaching skills, but his show-manship was not just limited to football. Away from his wife's desire for privacy, he became a shrewd self-promoter, catching the public's rapt attention both on and off the gridiron. In December of 1915, Seattle's *Post-Intelligencer* took notice and offered "Three Views of Unique Pullman Coach." "Mr. Deitz in football togs," "Lonestar in Indian costume," and "William Lonestar Dietz, in his 'Glad Rags'" illustrated the newspapers report. Dashing in any costume, Dietz, a natural actor, loved thrilling an audience. He posed, he pontificated, and he bragged. If "everybody loves a winner," as the *Intelligencer* observed, Dietz was undefeatable.[1]

That fall Coach Lone Star Dietz paraded down Dressy Avenue in Port-land, Oregon, in top hat and tails. "You might imagine that the stares of the startled pedestrians would bother the ex-Carlisle hero. Not so," stated a reporter. "I'm like Lillian Russell," Dietz replied ("in perfect English"). "I don't care what they say about me just so they say some-thing."[2] Dietz loved playing the dandy. The reporter embellished this aspect of his persona, writing, he "could wear a diamond stud in a gold tooth setting," or "sleep in a silken boudoir and bathe in a pool of goats' milk," he could dress in "brocaded satin pajamas" and "walk the streets of Pullman," he could "drink demitasse for breakfast," and "pick his teeth with a golden quill." In fact he could do almost anything with impunity, because Lone Star Dietz "own[ed] Pullman, body and soul."

Not everything was going his way, however. Angel remained in the east, and his father died in December from an enlarged heart. Dietz, Sr.'s obituary revealed he sold life insurance and "was twice elected sheriff of Barron County and was chief of police in Rice Lake for a number of years."[3] He and a younger brother were born in New York to John and Almira (nee Swartz) Dietz. John emigrated from Germany and Almira's family descended from German-Hollanders who early settled in New York's Mohawk Valley. Another son was born to the couple after they moved to Wisconsin. All three brothers settled near Rice Lake where they raised their children.[4]

On Christmas Day, just one week after his father's death, the *San Francisco Chronicle* reported Dietz and his underdog team were headed for the Rose Bowl in Pasadena, California, to play Brown University. Rumor had it Dietz was up for a coaching position in Berkeley at the University of California. Lone Star "would neither deny nor affirm" whether he was "considering an offer to handle the blue and gold eleven during the 1916 campaign." His contract expired, and though he claimed Pullman had offered to double his salary, he looked forward to "any proposition from California." "I will not decide upon anything," said Dietz, "until we have played Brown at Pasadena on New Year's day."[5]

Dietz loved fueling the rumor mill, but his interest in relocating to California was genuine. He didn't get the job at Berkeley, but his connection to Warner and Carlisle and his reputation for "snap and inside football" at Pullman impressed the reporter. "The record of the Washington State team during the past season is fitting testimony to the ability of the former Carlisle star," the newspaper stated.

It rained hard on the Tournament of Roses on New Year's Day, when Pullman beat Carlisle's old adversary Brown University, 14 to 0. What a fantastic victory, but Angel did not share in her husband's glory. She tried to decide what to do next, and she had come down with the flu.[6] "Here I am, neither here nor there," she wrote Folsom. "I've got grip and had to cancel my engagement at Phila too and I am sorry I am not at Hampton for I would like to have good care." Khotni, her husband's champion wolfhound, still kept her tied to Carlisle. "I am trying to sell him now," she explained, "if I can get my price for him of $1,000." She said she hoped to relocate in the fall, "if Billie remains west for another season." "I don't care for the Pacific coast," Angel confessed, "and he would rather remain east too but work is there for him."[7]

Dietz obviously sought fame and fortune in the west. Angel didn't let on to Folsom about her marital or financial problems. "What do you think about my boy out on the Pacific coast? Billie is Jack London's kind of a sport—clean thru and thru," and "has turned out one of the greatest football teams in the country and did it with an old battered team." She relayed what a friend in Portland, Oregon, told her. Her husband had become "the idol of the State College students of Wash. Just now he is singing and playing the leading role in the College Glee Club they are going to travel some too." Dietz may have been Jack London's kind of sport, but a middle-aged wife could not have been pleased when her younger, handsome husband joined the college Glee Club! Dietz, as usual, occupied an ambiguous position.

In March a headline "A German Indian is Dietz," appeared in newspapers across the country, including Portland, Oregon. The report from

St. Paul, Minnesota, stated the "former football star at Macalister College here, is regarded today as the only German-Indian in sporting circles. Dietz said he was German when he went to school here, but later played with the Carlyle [*sic*] Indians."[8] The report did not just question his Indian identity. By 1916 many German Americans faced discrimination because of the war. Dietz ignored the report's innuendo and revived the tale of his German father and Indian mother in Pullman's alumni magazine. He also identified his sister as Sallie Eaglehorse for the first time. "[U]ntil I was well in my teens everybody supposed I was the child of his second marriage," Dietz explained. "Father kept his romance to himself."[9] Fortunately, for Dietz, Father kept everything to himself these days.

§

The spring SAI journal featured "News Notes About Members and Friends," including Angel, who "had opened a studio." Carlisle lost "an important member of its teaching staff," when Angel "severed her connection," the report stated. As for her husband, he should have been given Warner's position at Carlisle. Instead, he was coaching for Pullman, whose "scores last fall proved out the merits of Billy Deitz."[10] The *Carlisle Arrow* featured Dietz and Pop Warner's victories as well. Warner coached expertly in Pittsburgh, and his protégé, Lone Star, became the "Beau Brummel of the western coaches."[11] The two coaches "have come through without a single defeat . . . taking the scalps of everything that came their way," the report added. If any dishonor came from the 1914 investigation, the school paper kept it under wraps.

The producers of the silent movie, *Brown of Harvard*, discovered Beau Brummel and his team at the Rose Bowl and used them in a scrimmage scene for the film.[12] They were also used as extras in the "five part photodrama" titled *The Craving*.[13] Dietz "devised" the plays for the star, played by William Russell. By the end of January Dietz hoped to become more than the idol of Washington college students, he wanted to be a movie idol as well.

While Angel worked through the spring trying to make ends meet, Dietz visited Los Angeles in April trying to land a movie career. He spent the summer acting in silent films for Santa Barbara's American Film Company, but his acting roles were limited to bit parts.[14] It's doubtful whether he sent money to his wife, even though his pay substantially increased to $4,500 when he renegotiated his contract with Pullman in the fall.[15]

In late August, Marie Baldwin visited Angel at Carlisle hoping to persuade her to attend the next SAI conference in Cedar Rapids, Iowa.[16]

Angel couldn't afford the travel expenses, wasn't up to public scrutiny, and may not have wanted to feel obligated to visit her family in nearby Winnebago. Without her, only three women served as SAI leaders: Baldwin as treasurer; Margaret Frazier, a Santee Sioux, as vice president of membership; and the new secretary, Gertrude Simmons Bonnin, who was also a contributing member to the journal. "Closing the Indian Bureau," "Schools for Citizenship" (led by Pratt), "Liquor Traffic an Evil," and "Health Conditions on Reservations" made up the conference platform. The SAI also reaffirmed the issues from the memorial Wheelock had read to President Wilson in 1914, which included defining the legal status of Indians, individualizing trust funds, and allowing for the "early adjudication of all tribal claims."[17]

Reverend Sherman Coolidge rebutted Montezuma's argument that American Indian BIA employees couldn't possibly serve both the Bureau and their race at the same time. Baldwin, still a clerk for the BIA, and Montezuma's old fiancé, Bonnin, agreed that the BIA should eventually be abolished, but supported Coolidge because they believed, like most progressives, in social regulation as well as social justice. The bureau was still a necessary evil until all Indians became citizens. Angel probably agreed with them. Although she remained in Carlisle, she still supported the SAI's efforts to uplift her people.

Indian school papers began publishing criticisms of old-fashioned methods of Indian education. Pratt's philosophy, "To civilize the Indian, place him in civilization, to keep him civilized, let him stay," no longer appealed to the Indian youth of 1916 (though he reaffirmed the slogan during his SAI presentation). Angel's path from reservation life to an off-reservation, eastern boarding school—with no looking back—had become an antiquated goal. Pratt's intentions had been all well and good, the Indian papers stressed, but he did not understand the essential emotional ties between a student and his reservation, "despite its downward pull." In order to meet the old-fashioned objectives, "There must be born a generation of Indian boys and girls of iron," the writer declared. How else could American Indian students reject reservation life and turn a deaf ear to "the call of kindred"? The old days of Indian education forced youths "to stifle the home yearning in their own breasts until they have made new homes of their own in an adopted environment." If these were the conditions of Indian education, the article concluded, then such a "generation will not be born."[18]

But indeed that generation had been born, although its members were aging. Rather than ask what the consequences were of an iron-clad life, the article denied the reality of so many older educated Indians,

including SAI founders. How had they adapted? How had they survived? As one such girl of iron, Angel understood well the sacrifices made to "hasten the civilizing process." But she also discovered what sacrifices she would not make, or continue to make, as she reclaimed her "aboriginal" artistic self.

Angel spent the holidays in Northampton, enjoying her second family and glad to be away from Carlisle. Gertrude Clapp now lived on Henshaw Avenue in Flora's boarding house for Smith girls. In late December they hosted a wedding for Louisa, who married George Blaisdall on Angel's ninth wedding anniversary. Dietz was supposed to give away the bride, but remained out west, so Gertrude played the patriarch. Angel thought the wedding was "a beautiful affair," and the groom "a fine young man." Mostly, she felt glad to see "every one was happy."

She remained a while after the wedding to comfort the grieving mother, who had a hard time accepting her only daughter was leaving home to start her own life. Louisa was "the only child and the last of the family on every side." Angel believed she would be the family's heir if something happened to Louisa. She hoped her "little sister's" marriage would be happy with "many children," unlike her own.[19]

Angel wrote Folsom from Northampton in January. Aging plagued her, but her letter sounded hopeful as if she and her husband would soon be reunited.

> I was glad to get a note from you, but why should you call me old. I just felt like taking the very next train to you that you may see me in all my glorious youth. You may call it clever make up but at least I am trying to ward it off . . . Were I with you I'd go right into the class rooms and sit and learn and progress. In other words I'd do any thing to hide signs of old age. The very effort itself may be the chief sign but I don't feel that way at all. Since I gave up the work at Carlisle I have felt like a new woman and I may yet have some future aspirations.[20]

Angel assured Folsom that Dietz promised he would try to get a job coaching football in the east. She hoped to move to Northampton, which had "a wonderful municipal (sp.?) theater," perfect for the "dramatic fellow" who was "very much stage struck." "Friends here are ready to help him on so he may yet shine as a Lone Star," she added with forced wit. She was still tied down with the "the best wolf hound in America," and couldn't get away to Hampton for a visit. "I can't leave him alone long at a time and I knew you wouldn't want my dog 'round altho' he is 'just like a person' as dog lovers say. However I am considering selling him now and then you may see me." She signed her letter "with a lot of

love from your wayward child," and added a postscript that made life seem more exciting than it really was: "Most any time you can find out our doings in the sporting columns Billie's or mine."[21] This was the last letter Folsom received from Angel.[22]

§

The country found more important things to report than the couple's doings. On April 6, 1917, the United States declared war on Germany. The first few months of wartime left no record of Angel's activities.[23] She may have gone to Hampton at the end of August, when the principal, Hollis B. Frissell, died. "His sympathies extended to all classes," one Indian school newspaper stated, "and through modesty, meekness and sincerity he won the friendship of rich and poor everywhere."[24] Dr. Anson P. Phelps Stokes, former secretary of Yale University, became his replacement.

Angel and Marie Baldwin maintained their friendship as Marie became identified as the nation's leading Indian suffragette. They were pictured in Indian dress in the fall issue of the SAI journal (now called *American Indian Magazine*), over the caption "Art and Progress as Seen by Two Indian Women." The photograph shows Angel instructing her colleague on "the meaning of designs on a beaded blanket strip." The accompanying article declared Angel was "to modern Indian art what Dr. Eastman is to modern literature," and that Marie, who agreed on the value of Native American art, filled her home "with rare products of Indian handiwork."[25] Marie also seems to have agreed with Angel that Gertrude S. Bonnin could be a handful, especially after Gertrude moved that year to her resident city, Washington D.C., and set up the SAI office in her new apartment.[26] Parker tried to maintain peace between the two, but both women, themselves also "girls of iron," had developed strong opinions and even stronger clashing wills.

In November, Angel moved into a modest, second floor, two-bedroom flat in downtown Carlisle on 21 North Hanover, a couple of miles from the Indian school and just above a buzzing sewing machine shop. She furnished the apartment with arts and crafts style furniture, including a settee.[27] She put up lace curtains on most of the windows and placed a collection of Harvard Classics in the bookshelf.[28] Her brass teakettle sat on the kitchen stove, next to a table and chairs set. She arranged the brass bed, chiffonier, and bureau, in the now very empty bedroom.

Angel lived modestly, but nearly every niche in her flat reflected her interest in Native American art. She owned several rugs, including an Oriental, an "Axminster," a "Kiskillen," and five Navajo creations, including one with a swastika design. She collected Hopi vases and Indian baskets

Plate 7

A group of members of the Sixth Conference on the steps of the Carnegie Library,
Cedar Rapids, Iowa, September 29, 1916

Society of American Indian members, September 29, 1916, including
Carlos Montezuma (front row, far left), Gertrude Bonnin (front row,
far right), Marie Baldwin (second row, far left), and Richard H. Pratt
(second row, far right).
(Photograph from *American Indian Magazine*, 1916)

and mats. Her drawers and closets overflowed with material for making
things. She kept an easel and several drawing boards, a wood carving set,
beads, and Kodak supplies. Leather, fur trimmings, burlap, linen, raffia,
and yards of fabric had been through or awaited her creative hands. She
made quilts, knitted, and used her sewing machine to make clothing and
other items.

Angel's apartment also displayed her love of music. She still had her
beloved piano as well as a violin. A Victrola with eighty-eight recordings
entertained her. Her old Winnebago flute still sounded when she felt blue.
Did she still play it to remember the "haunts of home"? If so, she could not
dwell on the past too long, or think too far into the future for that matter.

Angel sent Carrie a handmade card at Christmas with a simple senti-
ment. A girl on point with a ponytail placed a Christmas garland around
a candle on the mantel. "Christmas Greetings" flowed from her face in

profile.[29] Angel also sent Carrie a letter.[30] Angel, "ever the same," made jokes, shared dreams, expressed worries, and tried to appear optimistic about her future. As always, she apologized for not being able to visit Hampton, though she wanted to. She told Carrie "you know how things unforeseen rise up and so it is only a case of setting the date and starting. I would lay it to causes of war if that wasn't a holey chestnut but it's no joke either." She may have been dreaming of taking up painting again. "I want to go to France in the worst way," she confided, "and it doesn't look now as if there were any other way."

Carlisle's new superintendent, John Francis, Jr., seemed to be doing a "fine" job, she informed Carrie, though "still with the same contingency and therefore hampered." "I hardly ever visit the School," she said, "for you see I live in town and have become one of the independent freaks of Carlisle." The letter was Angel's last to Carrie.

§

While Angel lived quietly and independently, Dietz became more involved in the motion picture business. When Tyrone Power, Sr., silent film actor, purchased an old resort in Spokane, Washington, to turn into a movie studio, he arrived to a whirlwind reception.[31] Mesmerized by his star presence and taken in by his promise, "returns of millions for investments of thousands," locals helped the actor launch the Washington Motion Picture Company.[32] The budding actor, Lone Star, invested $2,000 in the company. In exchange Powers gave him a role in his first project, appropriately titled, *Fool's Gold*.

At the end of January 1918, the *Spokesman Review* ran a large feature titled "'Lone Star' Dietz Hopes to Picture the True Indian in Spokane-Made Films."[33] Dietz planned to make his home in Spokane in the spring, stated the report, where he hoped to fulfill his "burning ambition" to introduce "the original American, to Americans." The article came with pictures of Dietz in different guises: "As a French count," "Ready for the opera," "As a pirate character," "in gay civilian togs" and "In the full regalia of a Sioux chieftain." A still from an unknown movie also adorned the page, with the caption: "Lone Star Dietz and Frank Borzage, showing the exaggerated Indian parts Lone Star has been forced to play."[34] Like "How Art Misrepresents the Indian," the article focused on Dietz's criticism of the portrayal of Indians in movies. "The moving picture has never given the Indian a square deal," Dietz was quoted. "It almost without exception portrays him as a savage, burning white folks at the stake, committing hideous crimes."

Dietz was certainly well ahead of his time in his criticism of Native American stereotypes, but his biographical details had been stretched as

usual. He starred in Rodman Wanamaker's *The Vanishing Race*, the report erroneously stated. Dietz also claimed that while he was at Carlisle, he received a recommendation to act in a D. W. Griffith film. But "Edmund Breese, the actor, of '*Strongheart*' fame, and others advised" him "to let the motion picture game alone." Breese allegedly warned Dietz that motion pictures were a "5-cent business" that would never take him anywhere. "Stick to your ambition to win on the legitimate stage," advised Breese. Dietz "went back to Carlisle without ever seeing Griffith," but he worried he had "missed the opportunity of a lifetime." He also said he turned down a part in 1916 at Universal City. The terms were good, but he had no say in the type of movies he would appear in. The producer only wanted him if he would portray "the sun dancer, the torturer, the slinking, degraded savage that films have persistently set forth." "I may die a poor man with my ambitions far from realized," Dietz declared, "but I will never attain them or wealth by portraying the savage Indian again."[35]

Angel's public life paled in comparison to her glamorous husband's. In March, a former Hampton student wrote a piece in honor of Indian Citizenship Day, focusing on three "American Indian leaders," the late Dr. Susan La Flesche Picotte, Henry Roe Cloud, and the "influential" Winnebago artist, "Angel DeCora"—notably devoid of her married name.[36] Angel continued to be recognized as a prominent American Indian, though her career remained in limbo.

The spring and summer passed. Angel may have returned to Camp Oahe that summer to work or just relax. She did some illustrations for Charles Eastman's SAI journal article, "The American Eagle an Indian Symbol."[37] She portrayed Eastman in an eagle headdress, rendered a thunderbird-type eagle symbol and several single eagle feathers. During wartime, the eagle apparently comforted all Americans, regardless of race.

Race also made no distinction in the deadly influenza pandemic that first appeared in a military training camp in Kansas early that spring. As one historian noted, the "flu owed its name to the chances of politics and war." The U.S. didn't respond much to the outbreak in its training camps, and European countries fighting in the war "chose to suppress reports of the epidemic for reasons of intelligence and domestic morale." The illness spread to the neutral country of Spain, where it killed about eight million people in May and, consequently, became known as the "Spanish influenza." As the pandemic spread, so did the fear, in spite of the news that the conflict overseas neared its end.

The end of the summer of 1918 marked a truly chaotic period for the world. As the Central Powers collapsed and Wilson announced his Four-

teen Points, returning U.S. soldiers carried the deadly Spanish influenza virus back again to the states. In just two months time, forty million people became infected, and one-half million succumbed to the illness. Reservation Indians seemed especially vulnerable, dying at four times the rate of victims in large cities.[38] The onset of the disease was sudden and spread rapidly, particularly in the fall of 1918, when the second more deadly wave hit the country, arriving through the port of Boston in September.

The flu's victims came down with a sore throat and runny nose, which quickly turned to pain and a high fever, leading to pneumonia or meningitis.[39] Cardiac arrest could follow in no time. The flu struck Carlisle in late September when two infected soldiers arrived by train. Churches, saloons, and schools closed to retard the pandemic, except Carlisle Indian School, which had already been shut down.

Although Carlisle's new superintendent attempted to salvage the institution, the BIA no longer supported it. Enrollment had declined with the war and many young American Indian men served as soldiers. By the summer of 1918, the War Department exercised its right to revoke the original property transfer that had created Pratt's Indian school.[40] Students were sent home over the summer and the military transformed the original old army barracks into a war hospital. On the first of September, one year shy of its fortieth anniversary, the Carlisle Indian and Industrial School closed forever.

Five days later, Angel wrote to John M. Clarke, director of the paleontology department of the New York State Museum. Parker, employed there as an anthropologist, had recommended her for a temporary job in the drafting department. "While I have never worked for any museum," she informed Clarke, "I feel confident that I can do the class of work required . . . I do nearly every class of work in drawing and designing also modelling [sic] and am willing to qualify for new lines."[41] Clarke responded two weeks later. Would she "accept a position as draughtsman" for $1,200, beginning on October 1? Mr. Barkentin filled the regular position, but he was serving in the military. Her job would last until he returned. "I am somewhat familiar with your work and have learned more regarding it from my associate, Mr. Arthur C. Parker," said Clarke. "It is not at all likely that you or, indeed, anyone could do at first hand the kind of work that we have required of our experienced draughtsman, but I am disposed to think you can do it as well as any one."[42] Angel responded that she understood the conditions and would accept his offer to report to the museum on October 1st.[43] Clarke addressed her as "Angel DeCora Dietz," but she signed her name simply, "Angel De Cora."

Goodale Eastman later described Angel's job in Albany. "She made drawings of fossils for a forthcoming memoir of the Devonian fauna, and although the work was new to her and very exacting, her performance was regarded by experts in paleontology as 'equal to the best.'"[44] The job provided a healthy change for Angel. It took her mind off her own troubles, it got her out of Carlisle during the worst of the pandemic in October, and it provided her with steady income.

Not long after Angel took the job, Goodale Eastman discovered that a stance of neutrality offered a mother no protection from the casualties of war. First, Ohiyesa, her nineteen-year old son, joined the Navy in February against her will.[45] But far worse, her daughter, Irene, succumbed to the Spanish flu while Elaine and two of her other daughters visited Washington D.C. On October 18, Irene arrived in Munsonville, New Hampshire, to visit her dad with wonderful news. The Metropolitan Opera in New York wanted her to sign a contract. Later the same day, however, she felt ill, so Charles, wary of the pandemic, called an ambulance. Five days later, the daughter he adored died in a nearby hospital.[46] He and Elaine never recovered from the loss of their child and eventually separated.

Carlisle lifted its health bans on November 6. Across the ocean, the war approached its end. Kaiser Wilhelm II of Germany abdicated, fleeing to Holland on November 9. Two days later the terms of the armistice were decided. The Western Front was to evacuate in fourteen days and all prisoners of war returned immediately. Shortly thereafter, Angel received a letter from Clarke. "I have had word from Mr. Barkentin that he will be discharged from the service at once and expects to be here by December 1st. The sudden and unexpected ending of the war has necessitated the inevitable change of plan much sooner than any of us would have thought, but we are compelled to adjust ourselves to the changed conditions."[47] To try to boost her morale, November's *Southern Workman* featured the same old news about its beloved alumna, accompanied by the dated picture of her in the white Victorian dress.

Meanwhile, in the Pacific Northwest, it was Angel who surrendered. On the last day of November 1918, a judge in Spokane granted Dietz a divorce. The defendant did not appear at the final hearing, so by default, the plaintiff won his case. The couple had no children or community property to contest, and Dietz claimed his wife "deserted and abandoned" him by remaining east. The defendant had refused to live with the plaintiff since July 1915, Dietz claimed, though he was "able, willing and ready to provide for her." The plaintiff had "repeatedly requested defendant to join him," but she "persist[ed] in refusing to join him with-

out just cause or provocation."[48] Angel's passive resistance no longer held her husband at bay.

The timing of the divorce coincided with the demise of the Washington Motion Picture Company. Although *Fool's Gold* began filming in 1918, Tyrone Power, Sr., left for New York under the pretenses of a nervous breakdown just one month into the film's production. His Spokane investors found themselves holding their own bag of fools' gold. Losing the film's star significantly reduced the investors' profit margin.[49] Power's replacement did not have his box office appeal.

Nevertheless, Dietz appeared in the film, which involved a love triangle between two partners in a western gold mine and a schoolteacher. The man who first got the girl was not the man the girl loved, but she eventually got the man she loved and the miners got a safer mine. Lone Star Dietz played "Chris Kuhn" a minor character. Dietz's investment was far from minor, however, and he ended up with $50 to his name.[50]

Just after Christmas, Angel's sister, Mary Sampson Yellowcloud, probably stricken with the Spanish flu, died in Winnebago.[51] Angel couldn't afford to go home or just chose not to. Sometime that winter, she headed for Northampton to stay with Gertrude and Flora. No doubt, she felt depressed. In less than two months time as she neared the dreaded age of fifty, she lost her job, lost her sister, and lost her husband.

With the end of the war, soldiers returned home broken and weary. In the midst of her own life crisis, Angel felt drawn to them. Despite "heavy sorrows and many disappointments," Elaine Goodale Eastman later wrote, Angel's "courage was undiminished and her artistic powers in their prime." She decided to teach "art handicrafts to crippled soldiers," but Angel never realized her plans.[52]

On Sunday the first of February disturbing news hit the presses. The Federal Grand Jury indicted William Lone Star Dietz for falsifying his draft registration. "The contention was that Dietz was not the Indian he claimed to be," one newspaper reported, "but was of German parentage. A claim for exemption was made by Dietz based on his alleged Indian origins."[53] "There's nothing to it," Dietz responded from Los Angeles, where Pop Warner's brother had paid his bail. "Somebody framed it on me. I'm being persecuted and they're trying to kill me in the public eye." "If they want the truth as to whether I'm an Indian," he further declared, "they can look me up in the records of Pine Ridge, Dakota Indian reservation, or at Carlisle where I played football."[54]

Did Angel read the news? And, if so, was it news to her? Already weakened by emotional stress and a lifelong struggle with bronchial afflictions, Angel came down with the Spanish flu. If she heard about her

ex-husband's indictment, she would not have felt vindicated. Her Hampton days and her retiring nature made her abhor scandal.

Five days passed with no record of her response to Dietz's predicament. When she came down with pneumonia, Gertrude admitted her to the Cooley Dickinson Hospital in Northampton. The virus worked quickly. Angel had no time to worry about scandal, help soldiers, or revive her career as an artist for art's sake with a trip to France. Instead, she took her final belabored breath February 6 on Friday afternoon.[55] No one from her Winnebago family came to watch over her. Not even Folsom could make it in time. Only Gertrude, and perhaps Flora and Louisa, offered comfort as she lay dying.

Gertrude held a funeral for Angel a few days later in Northampton's Unitarian church parlor. If there was a procession afterward, it ended at Bridge Street Cemetery. Gertrude had Angel buried in the Clapp family plot near William's immense stone.[56] She provided her no headstone.

Angel's apartment at Carlisle still awaited her return. Her things were sold and distributed by her landlady, the executor of her estate. Marie Baldwin inherited her Winnebago flute. Later, as a representative of the SAI, she presented "the historical flute owned by . . . the greatest painter of her race," to Thurlow Lieurance, a famed Euro-American composer of American Indian music, to use in his concerts.[57] Oliver LaMere claimed some of his cousin's possessions and at least her painting of her great-grandfather, Chief White War Eagle Decorah. He gave it to Julia, who hadn't seen her sister for years.[58]

Carlisle's *Evening Sentinel* announced the passing of "one of the most widely known artists in the country." The paper misrepresented some details of Angel's life, but it disclosed truthfully that she "was a descendant of the hereditary chief of the Winnebagoes." "She was particularly talented in Indian art," the obituary also stated. "In fact this was her especial field."[59] Indeed, she was.

That summer the SAI journal announced that she left $3,000 to the organization to continue its work.[60] As most realized, this was an enormous amount of money for someone of Angel's means to bequeath. At this time Charles Eastman headed the SAI as president and Gertrude Bonnin was secretary-treasurer, replacing Baldwin. Bonnin also replaced Parker as the journal's general editor and probably wrote the tribute to her old friend: "The gift is a sacred trust! Such faith in her own race inspires us to our uttermost effort. Angel DeCora Dietz, living and dying, has left us a noble example of devotion to our people. Let us take heed. Let us prove our worth even as she has done."

Angel did not set herself apart from other American Indian women. She saw her talents, whether expressed in art for art's sake, illustration, or Native Indian design, as a modest reflection of theirs. "Angel always insisted that she had no more talent than any other Indian woman," Natalie Curtis wrote, "because they had been natural crafts people and artists from prehistoric times." "The only difference between me and the women on the reservations," said Angel, "is that I have chosen to apply my native Indian gift in the white man's world." Unfortunately, as Curtis noted, "there is little tangible evidence that now can be shown of what Angel wrought, and above all, of what she dreamed."[61] But what she became, whether it was a girl of iron who well knew the secret pangs the educated Indian suffered, or the first real Indian artist, who inspired a generation of American Indians to remember their history and honor their contribution to civilization, Angel, as she once characterized Indian artists, bravely offered the best productions of her mind and hand and created a permanent record for her race.

Epilogue

An Indian Love Song

Some day you will remember me—
Some day, some day,
You will at last remember me
And say
"I was so dear to her—so dear to her!"
Hay-ay-ay-ay!
You will remember me
Some day!

—Goodale Eastman, "In Memorium:
Angel De Cora Dietz"

Julia De Cora finally met her match and married Marvin Lukecart sometime during the year after Angel died. They settled down on the reservation, making a simple life, but Julia was at last content.[1] Shortly after the second anniversary of Angel's death, in February 1921, Julia wrote to Carrie Andrus, announcing her marriage and telling her that she and her husband worked together at the Winnebago hospital, she as head matron, and he as a janitor. "These are hard times and work is so scarce," said Julia, "so we are fortunate to be holding any kind of a job at all." She also told Carrie she had actually met her husband long ago when she worked at Fort Berthold. They "could have gotten married then," explained Julia, but neither "felt the necessity of a life companion until we felt old age clutching us." Julia described her husband lovingly as "just a laboring man but good and honest." She asked Carrie to tell her "teachers and old friends" that she was "very happy" in her "belated romance." Then she turned her discussion to her sister.

> Angel & I used to plan some queer air castles when we were girls and one of the most important things we talked of was that the *heroes* of those air castles *must* be Indians but they had to be *super* men also. Alas! poor Angel got her man but he was very much of a sub. instead of a super and

252

where my man appeared, he was a white man. I do not think that any Indian man could be as much to me as he for I am used to civilized life to the extent of expecting all the delicate attentions that only civilized men give to their women.[2]

Julia thanked Carrie for the annual Hampton calendar and letter, and told her, "if I seem silent and unappreciative, it is only on the outside, at heart I am as loyal as ever." She asked Carrie to give her love "to Miss Folsom and any of the others that may be there."

Julia lived a long life and continued to write to Carrie on and off through the years until 1960, seven years before she died. Although she realized her sister's husband had been "sub"standard or even a "sub"stitute, it appears she knew very little about him, though his indictment led to a spectacular trial in Spokane at the end of June 1919.

The charges against Dietz centered on his claims for exemption from the draft, the papers that he filed in 1918 during one of two draft signups for World War I.[3] First, he claimed exemption as the owner of "the American Indian Film corporation," "an industrial enterprise necessary to the maintenance of the military establishment." No such organization existed, but he stated he had fifteen employees, and his "enterprise furnished entertainment to soldiers and sailors and spread war propaganda in the United States." The prosecutor did not pursue charges against these fraudulent claims during the first trial, but they were reintroduced for the second hearing.

The first trial focused on Dietz's last ground for exemption, as a noncitizen Indian with an allotment. His questionnaire stated "he was born on the Pine Ridge Indian reservation," his "nearest relative" was "Sally Eagle Horse, a Sioux Indian," "his parents were born in the Dakotas," and though his name on tribal roles was "One Star" he used "Lone Star" instead. He also "claimed to have left the reservation 28 years ago," returning intermittently, "but had not been back for 15 years." He stated he "left the tribal life" in 1890, and he was unsure whether he had received an allotment. He also stated he "spoke the Sioux language in addition to English."[4]

When Sallie Eaglehorse finally met Lone Star in the courtroom, she realized he wasn't her missing brother, One Star, and said so when she was called to the stand. Dietz did not accept her rejection. He approached her later in the courtroom corridor, according to the *Spokesman Review*, and "tried to tell her in his limited knowledge of the Sioux tongue that he really was her brother." Sallie became confused and began to cry. She held his hand until "her Indian escort induced her to leave." The district attorney warned that Dietz's "little effort of theatrical work" was "an

Julia De Cora Lukecart in Winnebago dress, date unknown.
(Courtesy Ho-Chunk Historical Society, Winnebago, Nebraska)

attempt to interfere" with one of his witnesses. Dietz also tried to speak
Sioux to William White Bear, who went to Carlisle with James One Star
long ago. White Bear asked him a question in Lakota. When Dietz
attempted an answer, White Bear replied: "You can't talk Sioux; you are
no Sioux."[5]

To prove that Dietz was the "son of the late W. W. Dietz and his divorced wife, Mrs. Leanne Lewis," the prosecution produced certified copies of his birth certificate and his father's probate records.[6] According to the former, he was born on August 17, 1884, in Rice Lake, Barron County, to Leanna nee Ginder, and W. W. Dietz.[7] Dietz gave the same birth date on his Carlisle enrollment form and his marriage certificate. The prosecution also produced photographs "to show that no trace of Indian blood existed in the family," although his grandmother, Almira Dietz, "was shown to be black haired and of dark complexion."

The next witness, Chris Kurschner, who knew Dietz as a child and was close to the family, testified he never heard that Dietz was "an Indian," until after he went to Carlisle. He stated that when he asked W. W. Dietz about it, he replied, "his son was posing," and he "seemed greatly worried by his conduct."[8] Asked about Dietz's appearance, Kurschner replied, he "looked darker now and his hair was straighter and blacker than when he knew him."

A wife and two sons of John F. Dietz, W. W.'s youngest brother, made affidavits in Wisconsin before the trial, claiming that Dietz, Sr., made vague remarks to them that his son was "an Indian" after he went to Carlisle. However, this side of the family had no love for the law. John became a Wisconsin folk hero when he refused access through his property to a powerful lumber company from 1904 until 1910. Finally, a shootout with the local law enforcement resulted in two of his children being shot and the death of a deputy. He died in 1913 after serving time in prison.[9]

The defense called "the flaxen-haired Mrs. Leanna Lewis" to the stand. With tears, she testified she had given birth to a still-born child, and the infant Dietz, son of her husband, W. W., and a mysterious Indian woman, was secretly substituted. The testimony of neighbors and family members disproved her claim. Dietz testified he was a teenager when his father admitted his real name was One Star and that while he was his father, a Sioux woman was his mother.

The hung jury reflected the bizarre testimony and the contradictory evidence in the case, but it also showed the jury members lost sight of the specific charges. While newspapers branded Dietz a "faker," "impostor" and "impersonator," his attorney argued that he truly "believed he was an Indian and answered the questions of the government in good faith." The judge advised the jury to consider Dietz's Indian school enrollment and his marrying an Indian woman "as evidence of his intent and belief as to his parentage and Indian blood." Regardless of what they felt about his mother's testimony, the judge instructed the

jurors *not* to decide what was *true*, but to try to determine what Dietz *believed* to be true. No wonder they couldn't reach a verdict. After the judge discharged the jury, the frustrated prosecutor immediately reindicted Dietz and rearticulated the charges. Whether or not Dietz was an Indian, he stated, he was a U.S. citizen and, as such, not exempt from the military.

Dietz's attorney claimed he couldn't afford to pay for his witnesses to return, which was the requirement at that time, so Dietz pleaded "no contest." The sympathetic judge sentenced him to thirty days in the Spokane County Jail "without fine or costs" on January 8, 1920. Dietz began his confinement at 4:00 P.M., two days following the one-year anniversary of Angel's death. The year's turn of events may have prevented him from grieving fully her loss. He was, apparently, not remorseful over Sallie's loss, which he continued to deny. He promoted himself with her brother's heritage for the rest of his life.

After serving his sentence, Dietz returned to the east, taking a temporary job at the Philadelphia School of Industrial Art in "Design and Lettering" for the 1920–1921 academic year.[10] Perhaps he missed Angel, but football was still his first love. In 1922 he was hired to coach at Purdue University in Indiana. The next January, just a week after Purdue fired him for illegal recruiting, he married Doris O. Pottlitzer, a thirty-eight-year-old, part-time journalist, and "Jewish heiress." He continued coaching for two more decades and even did some artwork for advertising. He also painted occasionally. One painting of Angel still exists today, but it appears Dietz tried to forge her signature to make it look like her self-portrait.[11] In 1964, still married to Doris, "William 'Lone Star' Dietz," as his headstone reads, died a poor man in Reading, Pennsylvania.

The Eastmans and others affiliated with the SAI may have suspected something fishy about Lone Star's childhood story, though Charles characterized Dietz as "a fine manly fellow," a "great football player," and "an accomplished artist."[12] Someone may have even confided in Angel. Angel certainly knew her husband was *not* "a non-citizen Indian," but did she realize that he was not "clean thru and thru"? Could she forgive his intentional fabrication? Of course, the question remains would she have forgiven him for not being the "Indian hero" of her dreams at all, but for being a highly imaginative German-American boy from Wisconsin, who just wanted to be special?

§

Several people wrote eulogies for Angel after her death. The first, by either Folsom or Carrie, came from the *Southern Workman*. It recounted Angel's early days at Hampton, where her "unusually bright mind" and

"her ready wit," "marked her at once as a leader of young girls."[13] It also reviewed her years as a struggling artist, when she was "[t]oo Indian to consider money values and too modest to push her own work." Highlighting her generosity as an Indian tendency, the article stated she made "far more gifts than sales." The eulogy also honored Gertrude Clapp as Angel's "staunchest friend." Angel remained married to "a young Indian illustrator and athlete," the piece stated, whom she had met at Carlisle. He had "worked on the school paper and did more or less football coaching." The latter activity took him to the west coast, "where he has since remained." Hampton's goodbye to its beloved student acknowledged that Angel "as girl and woman" showed "not only great talent but a strength of character and loyalty to her ideals that has made her an inspiration to others." Regretfully, though, she also "failed to win for herself all the fame that her artist friends feel was her due."

Smith College offered "In Memoriam" to Angel. It described her career and her work at Carlisle, where her students had a "racial talent for color and design."[14] It lamented her loss, as one who was "so fitted by birth and training to revive" Native American art.

Wisconsin historian, Louise Phelps Kellogg emphasized Angel's ancestry, explaining the Decorah family had "stood preeminent for nearly two centuries furnishing chiefs, statesmen, warriors and philosophers, to the Indian race."[15] "Greyheaded Decorah, or the War Eagle," said Kellogg, "was a model of tribal honor and dignity, and for years held his people in the paths of rectitude, and of alliance with the United States government."

Kellogg commended Angel's involvement with the SAI and her work at Carlisle, "developing native ornamental designs and preserving some that were in danger of extinction." Kellogg also noted: "Mrs. Dietz had a very attractive personality, her bright face, her warm humor, her simple breeding, her well chosen dress all marked her as an American lady of both the primitive and modern type." She insisted that Angel's "enthusiasm for her people and for her work was unbounded." "Truly hers was a noble life," she wrote, "nobly lived—the gift of the Winnebago people to America."[16]

Kellogg also recalled Angel's presence at the Madison Woman's Club she attended with Marie Baldwin in 1914. When the chairwoman introduced Angel to the audience as "a descendant of Glory-of-the-Morning and a daughter of the aborigines of Wisconsin," Angel "responded with emphasis and earnestness 'I am not ashamed of my ancestry.'" Someone in the audience reminded Angel that Madison's Four Lakes area "was her ancestral home." Angel, who had never before

visited the place where Oliver and Henukaw Amelle and their children celebrated the city's first Fourth of July, responded with emotion, "This is the home of my spirit."

§

Natalie Curtis's tribute to Angel agreed with the *Southern Workman's* that Angel's personality kept her "from greater efforts and from wider recognition."[17] Yes, Angel was gifted, but Curtis believed her acclaim reached only "the few to whom her gifts as decorator and designer were fully revealed as an artist of strong originality and racial character." Curtis recalled when Angel became inspired by a white teacher from an Indian school in Canada who couldn't pay workmen, so gave her students "a brush and a paint-pot" and let them paint their rooms. The "beauty of color and originality of decorative conception" astonished her. Similarly, she set her Carlisle students to paint the school wagon, and caused a great commotion "when it drove into a near-by Quaker town!"

Curtis believed that the "weight of inertia in a great Governmental educational machine . . . gradually killed the spirit of Angel De Cora's work." She asked how "could a shy Indian girl" make headway "against avalanches of red tape?" She revealed that Angel's struggles at Carlisle "against inevitable conditions of traditional discipline and routine" led to her "resigned pessimism."

Curtis blamed "mechanically minded Americans" as "another reason why the gifted Indian girl, with all that she stood for, passes to-day without public recognition."[18] Angel "blazed a new trail," Curtis declared, but "she now treads the 'Pathway of Departed Spirits,' wept only by the few (and these either Indians or artists) who know how rare was the quality of her work and who realize how fruitful to the Indian people and to America at large might yet be the prophesy of her life."

In the spring following Angel's death, the SAI journal published a beautiful eulogy written by one of its associate members and editors, Elaine Goodale Eastman. Her tribute was personal, poetic, and poignant. "Every race owes its deepest debt to its most gifted and aspiring souls, those who care less for what is called success than to be true to the best that is in them," she began. "The worth of such a life can not be measured in terms of actual accomplishment, and its close brings a keen realization of the essential greatness of the human spirit."[19] Elaine's reflection on her friend's life transcended Angel's lack of "accomplishments" or her "retiring nature" and highlighted her exceptional "human spirit." Elaine recalled Angel's "eager, appealing little girlhood in the eighties at the Hampton School." She found her to be "an idealist and an

artist to her fingertips." Angel's "extraordinarily sincere" and strong character, "remarkable" in its "independence and initiative," set an example that drew others to her as a representative of "the Indian race"—a race "whose needs and wrongs she carried upon her heart."

Like Curtis, Elaine believed red tape hampered Angel's work at Carlisle. Nevertheless, she "succeeded in developing marked artistic ability in her pupils." She was a vital presence up to her life's end and, besides her plan to help soldiers, she hoped to create more books on Indian subjects. In closing Elaine referred to her $3,000 gift to the SAI. "Life is gone, but its inspiration remains. Living, she loved her people; dying, she left them all that she had to give."[20]

Elaine's poem, "Indian Love Song," immediately followed her eulogy. A romantic ode to star-crossed lovers, the poem's was "written for 'Everywhere.'" The poem seems to hold a final message to Dietz. It tells of an Indian "maid with her bucket," who "steals forth to the spring" and is surrounded by the sounds and images of an idealized primitive Nature, calling up the photograph taken of Angel long ago. A lovelorn Indian maid, like "the sob of the flute," cries for her lover who has gone away, "far, far away!" At the end of the sentimental verses the maid "voices the sorrow of love," with the final hope that she will not be forgotten. "Some day you will remember me—Some day, some day."[21]

Angel's nocturne painting, *Fire Light*, follows the poem at the bottom of the page.[22] As Curtis described it in 1913, the painting represents "the silent meeting of two lovers" at "an Indian encampment at dusk." "[F]ire-lit tepees like glowworms in the dark" warm the landscape. Elaine's prose offers the painting narration. "You will at last remember me And say, 'I was so dear to her—so dear to her!'" Yet if it was her intent to broadcast an "Indian Love Song" to Angel's husband, the graphic layout on the SAI journal's page echoes otherwise. Another Indian love song whispers softly on the page for all the things Angel left behind. As the two lovers stand in the twilight, with the young man just about to depart, *Fire Light* recalls Angel's yearnings for home. Like the incongruous images she painted in the background of her artwork at Chadds Ford, the painting recalls the landscapes of her youth. Idealized through childhood memories, the painting manifests the restorative power of place—of twilight on the Nebraska plains she loved, of firelight illuminating a simple shelter where the promise of an Indian girlhood was left behind but never, ever forgotten.

Abbreviations

ADSF	Angel De Cora student file
AFFLP	Alice Fletcher and Francis La Flesche Papers
CANC	Chronicling America Newspaper Collection, 1900–1910, Library of Congress
CCHS	Cumberland County Historical Society, Carlisle
CSR	NARA RG 75.20.3, Carlisle Student Records, 1879–1918, Record Number 1327
GLSU	Green Library, Stanford University, Palo Alto
HFSL	Helen Farr Sloan Library and Archives, Delaware Art Museum, Wilmington
HHS	Ho-Chunk Historical Society, Winnebago, Nebraska
HPC	Howard Pyle Manuscript Collection
HUA	Hampton University Archives, Hampton, Virginia
JDSF	Julia De Cora student file
JEP	John C. Ewers Papers
KSHS	Kansas State Historical Society, Topeka
NAA	National Anthropological Archives, Smithsonian, Suitland
NARA	National Archives and Records Administration
NARA-DC	NARA, Washington, D.C.
NARA-CPR	NARA, Central Plains Region
NARA-PAR	NARA, Pacific Alaska Region
NSHS	Nebraska State Historical Society, Lincoln
PRDH	*Programme de recherche en démographie historique* (Program in Historical Demography), University of Montreal, www.genealogie.umontreal.ca/en/leprdh.htm
PRP	Paul Radin Papers
RG	NARA Record Group
RHPP	Richard Henry Pratt Papers, Beinecke Library, New Haven
RLM	Raynor Library, Marquette, Special Collections
SAI	Society of American Indians

SC	Frank Schoonover Manuscript Collection
SIA	Smithsonian Institution Archives, Washington, D.C.
SMHC	Southern Minnesota Historical Center, Minnesota State University, Mankato
THP	Thomas Hughes Papers
WHC	*Wisconsin Historical Collections*
WSHS	Wisconsin State Historical Society, Madison

Notes

Preface

1. The author discovered an early work on the Great Lakes Métis too late to incorporate in this work, but too significant to neglect mentioning. See Houghton's *Our Debt to the Red Man* (1918), which includes a section on Angel De Cora.

2. Livingston and Parry, eds., *International Arts and Crafts*.

Introduction

1. Hill, Tom, and Richard W. Hill, eds., *Creation's Journey*.

2. Waldman, Carl, "Zotom," 399. For digital images of Zotom's pictographs, see http://plainsledgerart.org (accessed December 29, 2007). See also Landis's collected research on Zotom at http://home.epix.net/~landis/zotom.html (accessed December 29, 2007).

3. Ewers, Manglesdorf, and Wierbowski, *Images of a Vanished Life*, 10.

4. 264–65. See also Crary, *Suzette La Flesche*, 264.

5. See Crary's illustrations inset, "Two views of the Thomas H. Tibbs home," for photographs of La Flesche's paintings. Crary, *Suzette La Flesche*, n.p.

6. Trenton, *Independent Spirits*, 264–56, 268.

7. McCormick, "Evaluating the Progressives," 370–71.

8. Muncy, "The Female Dominion of Professional Service," 252.

9. Parezo, "Indigenous Art: Creating Value and Sharing Beauty," 227.

10. Ibid., 229.

11. Ibid., 228.

12. Ibid., 229.

Chapter One

1. "David Decora No. 2," Angel's father, was also called "Tall," after his paternal uncle. The author does not know the translation of his Indian name. Ruth's name probably means Fourth Daughter. Little Decora's other wives were: (1) Mahkekaw (Digger); (2) Henuksheshickkaw, the mother of Rueben Decora (Standing Day) and Younkkaw (Queen Woman); (3) Wankonchawkoowinkaw (Coming Thunder Woman), mother of David Decora No. 1 and Yank Decora (Heirship Findings, 1910–1911, 47–54, Roll 89, NARA-CPR RG 75; Little Decora, 197, and Ruth Decora, 227, "Land allotments, death dates, family histories," NARA-CPR RG 75; and Hughes, *Indian Chiefs of Southern Minnesota*, 164). See Rolls 101–104, NARA-CPR RG 75, and the U.S. Indian Census Rolls, 1885–1940, M595, NARA-DC RG 75.

2. Hexom, "Geneology [*sic*] and History of the Decorah Family," *Indian History of Winneshiek County* (pages not numbered).

3. Ibid., "Preface." His name is also recorded as Lemoire, Lemire, and other variations. Hexom interviewed Oliver LaMere, Joseph's grandson. See also Boxes 10–12, Reserve File A, RG 75.7.4 for the Amelle family and the Winnebago Treaty of 1829. Peterson and Brown state that although métis "was rarely used by English speakers before the 1960s," today it has "burst its linguistic and geographical confines" (*The New People's*, 5–6). Following their example, the author chose a lower case "m" except for broad categories.

4. From County Court Records at Rockford, Illinois, "Illinois Marriages, 1790–1869," http://ancestry.com (accessed December 29, 2007). Catherine and Le Mire requested the patent due her six years after they married (Boxes 10–12, Reserve File A, RG 75.7.4).

5. Her name is also shown as Henu Wyna Nashaka, according to an HHS genealogical record. The only thing recorded about her origins was that Chonewinkaw, wife of French-Canadian Joseph Thiebault, was her cousin (Heirship Findings 1910–1912, 106, Roll 91, NARA-CPR RG 75).

6. See Rentmeesters, *The Wisconsin Fur Trade People*, 243, and Waggoner, *Neither White Men Nor Indians*, 63–64. In 1838 Amelle claimed he was "a native of Canada, but ... a naturalized citizen of the United States for the last ten years." On census records, he is also listed as John Emel, Oliver Hamot, Oliver Aimel, Oliver Amel, Louis Amele, and Oliver Amill (also born in either Massachusetts or France) (1836 Wisconsin Territorial, Iowa County, District 5; 1840 Illinois, Winnebago County, Township 46 N R 2 [Pecatonica]; 1850 Minnesota Territory, Wahnahta County, Long Prairie; 1857 Minnesota Territory, Blue Earth County, Winnebago Reservation; 1860 Minnesota, Blue Earth County, Fox Lake Township; and 1870 Nebraska, BlackbirdCounty, Winnebago Indian Reservation).

7. Amelle stated that his "name is sometimes written Hamel and sometimes Amel." His first name appeared as Olivier on the 1829 treaty. Olivier Hamel's parents were Joseph Hamel and Marie Catherine Morrisau. He was baptized at St. Jean Baptiste de Rouville near Montreal (PRDH).

8. Waggoner, *Neither White Men Nor Indians*, 63.

9. Ibid., 63–64.

10. De La Ronde, "Personal Narrative," 360–61.

11. See David Lee Smith, "Treaty with the Winnebago, 1829," Article V, *Treaties and Agreements with the Winnebago Tribe*. The 1829 treaty provided allotments for mixed-blood descendants of Indians. See Boxes 10–12, Reserve File A, NARA-DC RG 49, Catherine and Oliver, Jr., Amelle. At this time Amelle was residing next door to two former Four Lakes Métis families. A Vermont-born trader, Stephen Mack, and his Winnebago wife and children were also neighbors (1840 Wisconsin Territorial census).

12. She died August 15, 1896 (Heirship Findings, 1910–1911, 290, Roll 89, NARA-CPR RG 75; Mrs. Catherine Lamere, 281, Land allotments, death dates, family histories book, NARA-CPR RG 75).

13. De Cora, "Angel DeCora—An Autobiography," 279–80, 285.

14. Julia De Cora Lukecart Correspondence, October 29, 1920, THP, SMHC.

15. Ibid.

16. See Lurie, "A Check List of Treaty Signers by Clan Affiliation."

17. According to Spoon, Decorah's village was near the old Caffrey School house, in Caledonia Township, Columbia County (Spoon Decorah, "Narrative of Spoon Decorah," 448–62). The old Indian burial ground is nearby. Portage resident Andrew Jackson Turner (father of historian Frederick Jackson Turner) also noted: "DeKaury (Scha-chip-ka-ka) . . . founded a village about three miles above the 'portage' (Sec. 10) on what afterwards became known, locally, as 'Waggoner's Bluff'" (*The Family Tree of Columbia County*, 45).

18. According to De La Ronde (Decorah's French Canadian son-in-law) Decorah's brothers were: Ruchkaschaka (White Pigeon), nicknamed Black Dekaury; Choumenekaka, nicknamed Raisin Dekaury; Kokemaneka (He-who-walks-between-two-Stars, or the Starwalker); Young Dekaury, called by the whites (on account of his trickish character) Rascal Dekaury; Wau-kon-ga-ko (the Thunder Hearer); and Ongskaka, (White Wolf), "who died young" ("Personal Narrative," 347).

19. The war began when the Sac leader, Black Hawk, led his so-called British band back into Illinois to re-inhabit land (contiguous to Winnebago territory) that was ceded by an 1804 treaty. He insisted the treaty was fraudulent and refused to honor it. See Quaife, *Life of Black Hawk*; Remini, *Andrew Jackson and His Indian Wars*, 258–61; and Marks, *In a Barren Land*, 59–66. See also Kinzie (*Wau-bun*, 318–90) who witnessed the war's immediate effect on the Winnebagos.

20. Diedrich, *Winnebago Oratory*, 44.

21. See Lucy Murphy's *A Gathering of Rivers* and "Autonomy and the Economic Roles of Indian Women" for an analysis of Winnebago women's role in lead mining.

22. Diedrich, *Winnebago Oratory*, 27.

23. Visitors can visit the restored agency house and the old Fort Winnebago site.

24. De La Ronde, "Personal Narrative," 356.

25. Kinzie, *Wau-bun*, 63–64.

26. Ibid., 88.

27. Spoon Decorah claimed the Winnebago felt only "friendly pity" toward their old neighbors, the Sac, "not a desire to help them fight" ("Personal Narrative," 453). Kinzie confirms this: "The Winnebagoes in council had promised to use their utmost endeavors to preserve peace and good order among their young men." Consequently, "they were abandoning their villages and corn-fields and moving north, that their Great Father, the President, might not be dissatisfied with them" (*Wau-bun*, 321–22).

28. Forced to cede their territory in the 1829 treaty that followed the Red Bird War, as David Lee Smith states, "the southernmost Winnebago had reason to sympathize with Black Hawk" (*Ho-chunk Tribal History*, 51–52).

29. Kinzie, *Wau-bun*, 384.

30. Ibid., 385–86.

31. Ibid., 386–87.

32. Ibid., 390.

33. Paquette later recalled that the "medicine men soon abandoned their futile attempts to stay the ravages of the pest, and the survivors simply fled before it like a herd of stricken deer, leaving their dead and dying behind them unburied," (Paquette, "The Wisconsin Winnebagoes," 401–402). John Kinzie wrote to Secretary of War Lewis Cass on August 27, 1832, informing him that he and the Winnebago interpreter Pierre Paquette (father of Moses) vaccinated more than six hundred Winnebagos and Menominees (Roll 931, M234, NARA-DC RG 75).

34. Although the second wave hit the Dakota people in southeastern Minnesota hardest, it spread to Winnebago friends and relatives who lived nearby. See Tanner, Hast, and Peterson, *Atlas,* 169–74 and Catlin, *Letters and Notes,* 183.

35. Hansen, unpublished "Records of St. John Nepomucene Catholic Church." His sponsor is listed as Pierre Grignon. Mazzuchelli says Grignon was "an old Canadian" who, like Decorah, spoke the Chippewa dialect (the lingua franca of the fur trade) (Mazzuchelli, *Memoirs,* 137). Perishe Grignon was the eldest son of Wisconsin fur trader, Pierre Grignon, Sr., and a Menonimee woman, and the second husband of Decorah's sister, Echauwaucau or Marie (Waggoner, *Neither White Men Nor Indians,* 44–48). De La Ronde said, "the old chief's resting place cannot be identified," since the original burial ground by the Portage courthouse was abandoned ("Personal Narrative," 357).

36. Mazzuchelli, *Memoirs,* 137.

37. One Anglo-American observer of the time offered his perspective: "The volatile manners of the French have more in sympathy with the character of the savages, with whom their pioneers have readily intermarried; the French settled among the Indians for the purposes of trade and sociability, and their interests, like those of the Indians, lay in the direction of keeping the fur preserves intact" (*WHC* 13:284).

38. Lukecart, THP, SMHC.

39. De Cora, "Angel DeCora—An Autobiography."

40. Radin, *Crashing Thunder,* 69.

41. De Cora, "Angel DeCora—An Autobiography."

42. Little Decora's band was the second largest of the fourteen bands.

43. Pettitt, "The Ancestry of Charles Raymond," 5, and Learning allotment schedule, entry 93 (Elizabeth Arnell [sic], age 65), allotment schedules, oversized book (untitled), Winnebago Agency, NARA-CPR. Oliver's allotment caused great confusion to several officials many years after his death. They thought it must have been a mistake and was intended for his wife. They, apparently, did not have access to allotting agent Learning's records of 1871.

44. Correspondence from G. J. Cox to His Excellency U. S. Grant, Portage, Wisc., Sept 6, 1871, Roll 943, M234, NARA-DC RG 75. Cox, a lawyer for the Wisconsin Winnebago, described a meeting with Little Decora. The month Little Decora died, Spoon Decorah, who remained in Wisconsin, told a historian, "life on the reservation is hard. The Winnebagoes in Wisconsin do not want to go there. They want to

die on their own land. They like best the streams and woods where their fathers and uncles have always hunted and trapped" ("Narrative of Spoon Decorah," 462).

45. Smith, David Lee, conversation with author, 2000.

46. Lukecart, THP, SMHC.

47. Two of David's daughters born in Wisconsin survived into adulthood. They were Mary Cloud (daughter of Laygonewinkah, otherwise known as Mrs. John Fireman) and Lizzie Cloud or Lizzie Decorah (daughter of Nahjupawinkah or Pretty Hair Woman) (Heirship Findings 1910–1913, 242–49, Roll 92, NARA-CPR RG 75).

48. Heirship Findings, 1910–1911, 463, Roll 89, NARA-CPR RG 75 and Alice Fletcher Allotments, "Peter Sampson," 151, HHS.

49. Lukecart and "Individual History Card," Angel Decora Dietz, He nuk makhe we he nuc kaw, Allotment No. 863, THP, MHS.

50. See the 1880 Nebraska, Blackbird County, Winnebago Reserve and Agency federal census; Heirship Findings 1910–1912, 403, Roll 91, NARA-CPR RG 75.

51. Among prominent scientists disseminating the notion of degenerate "mixed-stock" people were Josiah Nott ("The Mulatto a Hybrid") and Robert Knox ("An Inquiry into the Laws of Human Hybridité").

52. Smith, David Lee, *Ho-Chunk Tribal History*, 5. Smith believes the proto-Winnebago created the effigy mounds in Wisconsin, Iowa, and northern Illinois. Jonathan Carver, who came upon the Winnebagos in 1766, believed they originated in New Mexico (*WHC* 13:281). See also Radin, *The Winnebago Tribe*, 1–5, 28–55, and Lurie, "Winnebago."

53. The Otos call themselves Chiweres. Ho-Chunk is also distantly related to the languages of the Omahas and Lakotas. There are less than three hundred speakers today.

54. Smith, David Lee, *Folklore of the Winnebago Tribe*, 9, 17. Also see Radin, *The Winnebago Tribe*, 159–64.

55. Radin, *The Winnebago Tribe*, 165.

56. The Thunderbird clan had four divisions (David Lee Smith, conversation with author, 2000). See also Radin's "The Thunderbird Clan," *The Winnebago Tribe*, 159–74.

57. Radin, *The Winnebago Tribe*, 161–62.

58. Ibid., "How the Winnebago First Came into Contact with the French and the Origin of the Decora Family," 17–21.

59. The lake is located in Winnebago County, Wisconsin.

60. Radin, *The Winnebago Tribe*, 19–20. Some sources say Wahopoekaw, whose village was located at present-day Doty Island on Lake Winnebago, was the sister of the chief, rather than the daughter. The author uses De La Ronde's phonetic representation of her name ("Personal Narrative," 347). De La Ronde's first and second wives, Agathe and Elizabeth Decorah (two of Wahopoekaw's great-granddaughters, born in the early 1800s), lived contemporaneously with Chougeka. Lukecart, who shared her illustrious ancestor's name, translated it as "Coming of the Dawn," rather than the popular "Glory of the Morning." According to the author's extensive genealogical research of the Winnebago, however, many in the nineteenth and

early twentieth century who shared a similar sounding name were called "French woman" and "French man," perhaps a later connotation of the name. The legendary man who headed this family seems to have been Joseph De Carrie, son of Michel Descarris Lehoux and Marie Cuilliere Leveille, baptized in Montreal in 1706 (PRDH, *Bapteme*, Montreal, 1706–11-01, No. 43103). Editor of the *Wisconsin Historical Collections*, Reuben Thwaites, noted, "Joseph de Cary was probably the French ancestor" of the Decorahs (*WHC* 18:472). Louise Kellogg, a Wisconsin historian who was acquainted with Angel, agreed that Wahopoekaw was the widow of "Joseph des Caris" (*The French Regime in Wisconsin and the Northwest*, 435). James L. Hansen, genealogical and reference librarian for the Wisconsin Historical Society, also thinks Joseph and Sabrevoir were "likely the same man" (correspondence with author, 2003). See David Lee Smith, "The Legend of Ho-poe-kaw," *Folklore of the Winnebago Tribe*, 155–56, for a contemporary version of the story. See also Augustin Grignon (who fathered two children with one of Wahopoekaw's granddaughters), "Seventy-Two Years of Recollections," 286; Kellogg, "Glory of the Morning and the Decorah Family"; Hexom, "Geneology [*sic*] and History of the Decorah Family"; and Lukecart, THP, SMHC.

61. See also Horan, *The McKenny-Hall Portrait Gallery*, 288–89. McKenny (*Sketches of a Tour to the Lakes*, 37–38) calls him "Amisquam, or "the Wooden Ladle." Radin stated, "before the advent of the whites," the Winnebago believed "tools were of the poorest kind." French woodenware replaced shells for bowls and ladles ("The Influence of Whites on Winnebago Culture"). The younger son's name is pronounced "Chau-monk-ska-ga," also translated as "White Breast" or "White Shoulders." Oak Leaf has endured in English only. In Lukecart, as well as in De La Ronde's version of the story (Lukehart, THF, SMHC), de Carrie took Oak Leaf to Montreal "to be educated according to his people." De La Ronde recalled that she was married to "Laurent Fily, a Quebec merchant, whose son, of the same name, was long a clerk for Augustin Grignon" ("Personal Narrative," 347). Thwaites claimed Laurent Constant Fily, born to Constant Kerigoufili and Angelique Metivier in 1764, "married into the De Kaury family" (*WHC* 19:70). This may be true, but Oak Leaf was too old to be his wife. According to PRDH records Kerigoufili was born in 1710. Perhaps an elder son married Oak Leaf, or he married her himself before marrying Metivier.

62. Radin, *The Winnebago Tribe*, 20.

63. Peterson, "The People in Between," PhD diss., 245.

64. Explorer Jonathan Carver recorded meeting the aged "chieftess" at her village on September 25, 1766. She was a "'queen' . . . presid[ing] over the tribe, . . . an ancient woman, small in stature and undistinguished in dress" (*WHC* 18:281). See also *WHC* 6:224–25 and Kellogg, *The French Regime in Wisconsin*, 435.

65. Cox to Grant, September 6, 1871, Roll 943, M234, NARA-DC RG 75.

66. Longtime Fort Winnebago resident Henry Merrell insisted that Washington D.C. officials took advantage of the Winnebago delegates, who, without their own funds, feared the onset of winter would leave them stranded in Washington. Merrell claims, after they were plied with liquor, "they yielded, not their judgments, but to the pressure brought to bear upon them; and while reluctantly signing the treaty,

yet all the while stoutly protesting against having any show of authority to do so." They also believed they had four years to remove, rather than the eight months signified on the treaty they could not read (Merrell, "Pioneer Life in Wisconsin," 393). Decorah's brother, Black Decorah, also complained to officials: "the Fool Agent took some of us to Washington kept them all drunk and made a treaty.... We must have another agent that don't drink," he added (Roll 698, M234, NARA-DC RG 75).

67. De La Ronde, "Personal Narrative," 356.

68. Peterson stated that "by the mid-nineteenth century, the Métis communities of the Great Lakes had all but vanished" ("The People in Between," 260).

69. Hexom, "Genealogy and History of the Decorah Family."

70. Diedrich, *Winnebago Oratory*, 66.

71. Correspondence from Henry M. Rice to Hon. Orlando Brown, Commissioner of Indian Affairs, June 27, 1850, Roll 932, M234, NARA-DC RG 75.

72. 1850 Minnesota Territory, Wahnahta County, Long Prairie census. Joseph Lamere was born in Montreal about 1849.

73. "Little Decarré — Chief" was among those who placed their X marks on the document (Roll 932, M234, NARA-DC RG 75).

74. Correspondence from Sub Indian Agent Bruce To Hon. Orlando Brown, Commissioner of Indian Affairs, March 22, 1850, Roll 932, M234, NARA-DC RG 75.

75. Minnesota's territorial governor, Willis Gorman, interceded, calling for a council in the summer of 1853. The Winnebagos asked to move to nearby Crow River. Gorman agreed, a treaty was signed, but Gorman changed his mind for political reasons (Diedrich, *Winnebago Oratory*, 79).

76. Ibid., 82.

77. Ibid., 83.

78. Receipt Roll Winnebago 1857, Box 5, NARA-CPR RG 75. Le Mire does not appear on the 1857 Winnebago Agency census. In 1887 or 1888 Catherine stated she and Le Mire had been "separated for 20 years or more," and that he died in 1884 (Alice Fletcher Allotments, HHS).

79. Good Old Man (allotted in 1871 as "Thomas Lemon") was the son of Little Thunder (Findings of Special Agents Regarding Heirs, 1899–1901, 111–13, Roll 85, NARA-CPR RG 75; Mrs. Catherine Lamere, Family Register, 474, HHS).

80. Schraeder, *The Heritage of Blue Earth County*, 100.

81. Three hundred of five hundred who were missing lived in Wisconsin (Hughes, *Indian Chiefs of Southern Minnesota*, 163).

82. Winneshiek's experience with the fraudulent 1837 treaty gave him reason to be wary. Diedrich gives well-researched accounts of all the Winnebago chiefs and notes that Winneshiek was replaced by the "bread chief," Baptiste, for refusing an honorary medal during the 1859 treaty negotiations (*Ho-Chunk Chiefs*, 141–42).

83. Diedrich, *Winnebago Oratory*, 86.

84. Anderson and Woolworth, *Through Dakota Eyes*, 19. See also Wozniak on the role of the Dakota métis in the "alliance network" (*Contact, Negotiation, and Conflict*).

85. Anderson and Woolworth assert, the "degree of Indian or white blood did not necessarily determine an individual's loyalties" (*Through Dakota Eyes*, 6). Upon

news of the attacks, a peace-party of mostly Dakota farmers quickly formed. First governor of Minnesota, Henry Sibley, commanded U.S. forces. He instructed the Dakota prisoners: "all those that had committed murders and other outrages against the Whites would be punished and all those that had been friendly and acted as such would be duly considered and protected as such" (Ibid., 185).

86. Cox to Grant, September 6, 1871, Roll 943, M234, NARA-DC RG 75.

87. Hughes, *Indian Chiefs of Southern Minnesota*, 152.

88. Ibid., 153. Also, "Notes on the Winnebagoes," THP, SMHC.

89. *Mankato Independent,* untitled, May 15, 1863.

90. Jackson, *A Century of Dishonor*, 231.

91. Lurie, *Handbook of North American Indians*, 690–707.

92. Diedrich, *Winnebago Oratory*, 92.

93. "Notes on the Winnebagoes," THP, SMHC.

94. Smith, David Lee, *Ho-chunk Tribal History*, 56–57.

95. Lamere appears on the 1865 Minnesota Blue Earth County State census living with another métis family. He eventually settled in Nebraska.

96. Waggoner, "When Great Grandma Became a Naturalized Indian in St. Paul."

97. Conversation with David Lee Smith (who did not remember the source).

98. See Szasz for an analysis of the performative role of the cultural broker, *Between Indian and White Worlds*, 22.

Chapter Two

1. De Cora to Cora Folsom, January 29, 1912, ADSF, HUA. See also De Cora, "Angel DeCora—An Autobiography."

2. DeCora to Folsom, January 29, 1912, ADSF, HUA.

3. Julia St. Cyr Student File, HUA. See Paulette F. Molin, "To Be Examples to . . . Their People," (Part I).

4. Molin, "To Be Examples."

5. William Hedges, born in Ohio, was a "trader at Winnebago Agency for ten years" before he died in 1897 (*Emerson Enterprise*, "News in Three Countries, June 11, 1897, and Nebraska State Census 1885, Dakota County, St. John's Precinct).

6. Tribal census and annuity records show she was born about 1868. As an adult, Angel always fibbed about her age.

7. Carrie Alexander, Grace Decora, Fannie Earth, Addie Stevens, and Willie Harrison Student Files, HUA.

8. Student Record, ADSF, HUA.

9. Goodale Eastman quotes Anna Garlin Spencer, *Pratt*, 157.

10. De Cora to Folsom, January 29, 1912, ADSF, HUA. Julia told a historian in 1920 that Lamere put Angel "in school first at home then at the Hampton Institute, Va.," but Angel did not corroborate this story (Lukecart, THP, SMHC).

11. According to David Lee Smith, the reservation school burned down in 1892 (and again in 1898), destroying all records, but the 1880 census shows a seamstress for the school (1880 Nebraska census, Blackbird County, Winnebago Reserve and Agency).

12. Julia St. Cyr student file, HUA.

13. See Lomawaima's account of how children blended their own pan-Indian identity at Indian schools (*They Called It Prairie Light*).

14. Thomas J. Morgan, Indian commissioner at this time, partook in the colonialist discourse of his era when he stated, "half breeds" (a derogatory term) "are more willing to go to school" (Thomas Morgan Papers, Folder 7, RLM). Achebe's character, Nwoye, inhabits a no man's land on the border of his society, making it easier for the missionaries to gain his trust.

15. Postcolonial criticism is a useful tool for framing Angel's situation, but it's still a hermeneutic tool. Elizabeth Hutchinson employs Marie Louise Pratt's postcolonial concepts "transcultural aesthetics" and the "contact zone" to characterize Angel's "indigenous experience of colonialism" without an adequate understanding of her mixed-heritage family or her particular tribal history ("Modern American Art").

16. Muncy demonstrates that women in the 1890s, particularly Jane Addams, created a professional culture by not competing with men. They mastered the art of networking and creating fellowships to support "budding professionals." Hampton staff clearly used these strategies. "Only by justifying an occupation in terms of service to the dispossessed," however, "could professional women solicit . . . support" (Muncy, "The Female Dominion," 253). Folsom often highlighted her students' service to garner support for them. Muncy further explains that an important aspect of women's professional lives was to "popularize scientific knowledge." Angel adopted this roll when she became an expert spokesperson for the appreciation of Native American art.

17. Goodale Eastman, *Pratt*, 65.

18. Molin, "To Be Examples" (Part One), 11.

19. *Southern Workman*, November 1883, HUA. In 1879 Plains Indian students created pictographs included with a subscription to the *Southern Workman*. See Ewers and Mangelsdorf, *Images of a Vanished Life*.

20. Hultgren and Molin, *To Lead and to Serve*, 45.

21. Goodale Eastman, "Miss Cora M. Folsom."

22. Some personal letters may not have been retained in her file.

23. Goodale Eastman, "Miss Cora M. Folsom."

24. Details of Folsom's life were garnered from "Cora Folsom, Teacher of Indians, Dies," *Berkshire County Eagle*, June 2, 1943; Goodale Eastman, "Miss Cora M. Folsom"; Knowles, "John Folson and His Descendants," http://ancestry.com (accessed December 29, 2007), and census records from the places mentioned. Folsom is listed as "Flora Folsum" on the 1880 Middlesex Co. Lowell census.

25. "Cora Folsom, Teacher of Indians, Dies."

26. Ibid.

27. Cora Folsom, "The Careers of Three Indian Women."

28. *Southern Workman*, March 1885, ADSF, HUA.

29. De Cora to Folsom, February 17, 1886, ADSF, HUA.

30. Talbot, *Samuel Chapman Armstrong*, 3.

31. Armstrong was promoted to Brevet Brigadier-General and attained honors for distinguished service upon his discharge on November 10, 1865 (American Civil

War Soldiers Record and General Officers Record, http://ancestry.com [accessed December 29, 2007]).

32. See Talbot, *Samuel Chapman Armstrong*, 101–32, 154.

33. Pratt, *Battlefield and Classroom*, 192.

34. Ibid., 120.

35. Pratt, *Battlefield and Classroom*, 126, 171, and Lindsey, *Indians at Hampton Institute*, 28–29.

36. Goodale Eastman, *Pratt*, 66. According to Ahern, Hampton "served as the most advanced and well-funded nonreservation boarding school under contract with" (but not under control of) "the Office of Indian Affairs" (Ahern, "An Experiment Aborted," 266).

37. Lindsey, *Indians at Hampton Institute*, 41; Molin, "'Training the Hand, the Head, and the Heart,'" 84, and "To Be Examples," 6; and Goodale Eastman, *Pratt*, 71. Lindsey claims Armstrong hoped the "additional prestige Hampton received through its Indian work" would translate into funding and offset the waning "public interest in black reform" that began in 1871.

38. Molin, "To Be Examples," 6.

39. David W. Adams summarizes, "In an era when many were predicting the complete disappearance of the race, Richard Henry Pratt and his Indian school offered a path into the future. To be sure, the choice Pratt offered was a terribly problematic one: assimilation or extinction" (Adams, "Foreword," in Pratt, *Battlefield and Classroom*, xvi).

40. Goodale Eastman, *Pratt*, 252.

41. Ibid., 112.

42. Tingey, "Indians and Blacks Together," PhD diss., 113.

43. Pratt was born December 6, 1840 (*Battlefield and Classroom*, Introduction, xvii).

44. Lindsey claims Pratt was not "anti-black" (*Indians at Hampton Institute*, 39–40).

45. Goodale Eastman, *Pratt*, 222.

46. Lindsey, *Indians at Hampton Institute*, 40.

47. Hultgren and Molin, *To Lead and to Serve*, 12.

48. Goodale Eastman, *Pratt*, 71.

49. Jacqueline Fear-Segal claims Christian reformers who called themselves "the 'Friends of the Indian'" seemed to share a common vision" and "single voice," but they "did not all hold the same assumptions about Indian capacity and the place the educated Indian would find in American society" ("Nineteenth-Century Indian Education," 325).

50. Ibid., 330, 323.

51. Talbot, *Samuel Chapman Armstrong*, 280.

52. Ibid.

53. Goodale Eastman, *Pratt*, 191, 203.

54. Fear-Segal, "Nineteenth-Century Indian Education," 330.

55. De Cora, "Native Indian Art," *Weekly Review*.

56. Fear-Segal, "Nineteenth-Century Indian Education," 334.

57. See Caudill ("Social Darwinism"), Fiske ("John Fiske Reconciles Evolutionism"), Sumner ("William Graham Sumner Elaborates the Principles of Social Darwinism"), and Ward ("Lester Frank Ward Attacks Laissez Faire") on arguments for and against social Darwinism and laissez faire, the social gospel movement, and reform Darwinism.

58. Slave narratives demonstrate a desire for literacy motivated many to escape from slavery.

59. Lindsey, *Indians at Hampton Institute*, 106.

60. Ibid.

61. Ibid.

62. Ibid., 107.

63. The few non-English speaking black students from Cuba, Latin America, and Africa attended the remedial Indian classes.

64. Lindsey, *Indians at Hampton Institute*, 118–19.

65. *Catalogue of the Hampton Normal and Agricultural Institute*, 1883–1884, HUA.

66. Later Angel stated, it "is not so well known that the hand manual of the deaf mutes was the outcome of the Indian's sign language" ("Native Indian Art, By Mrs. Angel De Cora Deitz," ADSF, HUA).

67. Prucha, *Documents of United States Indian Policy*, 175–76.

68. Ibid., 177.

69. Lindsey, *Indians at Hampton Institute*, 200. See also Molin, "To Be Examples," 18.

70. Adams, *Education for Extinction*, 140.

71. Hultgren and Molin, *To Lead and to Serve*, 46.

72. De Cora, "Native Indian Art," *Weekly Review*.

Chapter Three

1. Hultgren and Molin, *To Lead and to Serve*, 31. Almeida believes Armstrong started the outing program, but Goodale Eastman claimed Pratt was the "father of the plan" and Armstrong "endorsed and used it" (Almeida, "The Role of Western Massachusetts in the Development of American Education Reform," EdD diss.; Goodale Eastman, *Pratt*, 222).

2. Lindsey, *Indians at Hampton Institute*, 37, and Almeida, "The Role of Western Massachusetts," EdD diss., 74. When enrollees were more conversant in English in later years, outings enhanced social and vocational skills. Year-long outings to attend local schools, or for employment, also became more frequent.

3. Pratt said off-reservation Indian boarding schools were "artificial" environments. He believed placing students in white homes was essential to their assimilation (Adams, *Education for Extinction*, 157).

4. No Leicesters appear in the 1880 federal census for Egremont, but Leicester was an early Dutch farming family name in the area.

5. Almeida, "The Role of Western Massachusetts," EdD diss., 88.

6. Ibid., 93.

7. Hultgren and Molin, *To Lead and to Serve,* 31.

8. Study hours were not coed. Teachers helped students with their work (*Catalogue of the Hampton Normal and Agricultural Institute for the Academic Year 1888–1889,* HUA).

9. Hultgren and Molin, *To Lead and to Serve,* 28.

10. Trennert says until the 1920s, and particularly after the 1928 Meriam Report, American Indian female education focused on domestic training, but failed in the assimilation mission. "Girls were still taught skills of doubtful value," he claims. They "were hired out as maids through the outing system, did most of the domestic labor at the schools, and returned to the reservation either to assume the traditional life or accept some menial government job" (Trennert, "Educating Indian Girls," 230).

11. Lindsey, *Indians at Hampton Institute,* 225.

12. Ibid.

13. Heirship Findings, 1910–1911, 47–54, Roll 89, NARA-CPR RG 75; Paquette, "The Wisconsin Winnebagoes," 429.

14. 1886 Winnebago Annuity Roll, Coffrin Library, Green Bay Area Research Center.

15. Paquette, "The Wisconsin Winnebagoes," 429.

16. The *Southern Workman* of March 1919 states she returned after five years "in compliance with government rules," but according to Hultgren, the law was after three to four years (ADSF, HUA, and correspondence with author, 2003).

17. De Cora to Folsom, January 29, 1912, ADSF, HUA.

18. Mark, *A Stranger in Her Native Land,* 192.

19. See Murphy, *A Gathering of Rivers,* 24–29.

20. Carlisle school sisters, Nellie Londrosh Nunn and Cecelia Londrosh Herman served as census takers, government informants, agency teachers, and recruiters for Carlisle and Christian organizations. Their activities appear frequently in the local papers. Cecelia belonged to Carlisle's first graduating class of 1889. See the *Arrow,* October 6, 1904, for a photograph of Cecelia's graduating class. "One of your girls in a western home is thankful and glad that there has been such a man as Col. R. H. Pratt," wrote Nunn, "and such an institution as the Carlisle Indian Training School" (*The Redman and Helper,* Dec 5, 1902). Nunn also taught school at the Winnebago agency (Heirship Findings 1909–1914, 251–53, Roll 86, NARA-CPR RG 75).

21. Murphy, *A Gathering of Rivers,* 25.

22. Antoine Grignon, "Recollections," 213.

23. Murphy states this was "in part because they exercised control over major resources and forms of production" (*A Gathering of Rivers,* 25). See also Shoemaker, *Negotiators of Change,* and Sleeper-Smith, *Indian Women and French Men.*

24. The many affidavits included in the Winnebago heirship records support this (Heirship findings, Rolls 85–94, NARA-CPR RG 75).

25. Student Record, ADSF, HUA.

26. Government Documents, *Record of Indian Student's Returned from Hampton,* 2.

27. Morgan to the Secretary of the Interior, November 30, 1892, Thomas Morgan Papers, RLM.

28. Julia St. Cyr wrote several personal letters to Fletcher before her visit, but left for Hampton before Fletcher arrived. See Alice Fletcher Papers, Incoming Correspondence, 1874 to 1898, AFFLP, SAA. See also Government Documents, Fletcher, "Indian Education and Civilization." Fletcher's report was prepared under the direction of the commissioner of education.

29. Mark, *A Stranger in Her Native Land,* 167.

30. Ibid., 168.

31. Ibid., 160.

32. Ibid.

33. She inherited from Little Decora, Ruth, David, and his brother, Rueben. Her mother was the heir to her allotment (Departmental Findings, Angel Decora, 120, Probates 1910–1927, NARA-CPR RG 75).

34. Mark, *A Stranger in Her Native Land,* 160.

35. She attended a ceremony and sketched the seating arrangements (Alice Fletcher Papers, Other Tribes, 1882–1922 [26]: Winnebago Field Notes to Winnebago Manuscript; Publications Collected [27]: A thru G, Box 31, AFFLP, NAA).

36. Charles Perry, a white husband of a mixed-blood Winnebago woman, sent a letter to an eastern newspaper claiming Fletcher deceived the Indians, who "wanted to remain Indian." Later he publicly apologized. Perry to Fletcher (Alice Fletcher Papers, Other Tribes, 1882–1922 [26], AFFLP, NAA).

37. Lukecart, THP, SMHC.

38. Mark, *A Stranger in Her Native Land,* 161.

39. Ibid.

40. *Southern Workman,* March 1919, ADSF, HUA.

41. Radin, *Winnebago Tribe,* 341.

42. De Cora, "Gray Wolf's Daughter."

43. He died in July 1888 (Estate of David Decora No. 2, Heirship Findings 1910–1913, 242–50, Roll 92, 242–50, NARA-CPR RG 75).

44. Ibid.

45. Curtis, "An American Indian Artist."

46. DeCora to Folsom, January 29, 1912, ADSF, HUA.

47. Thomas J. Morgan Papers, Folder 7, RLM.

48. De Cora to Folsom, January 29, 1912, ADSF, HUA.

49. *Catalogue of the Hampton Normal and Agricultural Institute for the Academic Year 1888–1889,* HUA.

50. *Southern Workman,* 1889, ADSF, HUA. Angel inherited her sense of the ironic from her grandfather. After Minnesota Governor Ramsey claimed white men had "quit drinking," Little Decora nonchalantly waited until Ramsey added, "in a great measure." The interpreter, unfamiliar with Winnebago idiom, translated this phrase literally as "a large-sized vessel." With a twinkle in his eye, Little Decora responded: "Perhaps they had, but most of them still use a small vessel" (Notes on Winnebagoes, March 15, 1850, THP, SMHC).

51. *Talks and Thoughts,* December 1889, ADSF, HUA.

52. Hultgren and Molin, *To Lead and to Serve,* 42.

53. Sparhawk was born in 1847 in Amesbury, Massachusetts, to reformists parents. A close friend of the family was John G. Whittier, U.S. poet and abolitionist.

54. *Talks and Thoughts,* August 1890, ADSF, HUA.

55. Cora Folsom correspondence, received, June 26, 1890, HUA.

56. Sparhawk, "Istia."

57. De Cora to Folsom, January 29, 1912, ADSF, HUA.

58. Lindsey, *Indians at Hampton Institute,* 202.

59. Box 5, Folder No. 170 (1891, Logan to Pratt), WA MSS S1175, RHPP.

60. Hultgren and Molin, *To Lead and to Serve,* 42.

61. Ibid, 22. Hultgren and Molin describe the Indian department as an "innovative program" made up of "seven non-graded levels based on competency in English."

62. Reprinted in the *Indian Helper,* September 25, 1891, transcribed by Barbara Landis, CCHS.

63. *Twenty-Two Years' Work,* HUA.

64. *The Pipe of Peace,* May 8, 1891, HHS.

65. Hultgren and Molin, *To Lead and to Serve,* 24.

66. C. J. Crandall to Folsom, Supt., Lower Brule Agency, South Dakota, March 11, 1898, Julia St. Cyr student file, HUA.

67. Isabel Eustis Correspondence, February 17, 1882, HUA.

68. Ibid.

69. Julia wrote Alice Fletcher, "my dear darling mother died last week . . . I feel so sorry but I trust in God for he knew best to take our most beloved mother away. . . . My mother was a good Christian Miss Fletcher so I feel so much better. When you have the time write to me and advise me. I feel so sick and lonesome" (Alice Fletcher Papers, Series 1: Incoming Correspondence, 1874 to 1898, AFFLP, NAA).

70. "From an Indian Graduate," *Southern Workman,* September 1886, Julia St. Cyr student file, HUA.

71. Julia wrote Fletcher from the reservation: "I expected to go back to H[ampton] as Miss Richards wanted me to, also. There is not much going on here now. It is quite dull to me. I have gotten so used to the School. I was just completely lost when I came home" (Alice Fletcher Papers, Series 1: Incoming Correspondence, July 20, 1885, AFFLP, NAA).

72. Lindsey, *Indians at Hampton Institute,* 220. In October Julia wrote to the Commissioner of Indian Affairs, according to Lindsey, detailing her complaints: "she had received lower wages than blacks," "Hampton refused to pay what it owed her," and "she had been made to scrub windows and cut wood, 'which is man's work.'"

73. In 1887 she assured Josephine Richards of the Indian department: "Yes, dear, I will be glad to help the boys & girls of my tribe by asking them to go to the good school" (Sept. 28, 1885, Julia St. Cyr student file, HUA).

74. Government Documents, *Record of Indian Students Returned,* 7.

75. St. Cyr wrote Richards: "Grace's father wants her to come home, although I reasoned with him for quite awhile. I told him how much more Grace would learn

and said every encouraging thing I could, but I could not persuade him. I know Grace will have a hard time, so I pity her" (April 20, 1887, Julia St. Cyr student file, HUA).

76. Grace and Whirling Thunder had one daughter (Heirship Findings, 1910–1911, 47–54, Roll 89, NARA-CPR RG 75, and Grace Decora Student File, HUA).

77. Government documents, *Record of Indian Students Returned*, 8. Addie (or Mary Cullen, as she was referred to on tribal records) was born in May of 1874, the daughter of White Goose and Henukaw (otherwise known as Mrs. Patrick Henry, the daughter of Mrs. William Cullen). Addie had no siblings from her father, but she had several half siblings from her mother (Heirship Findings 1908–1910, 95–96, Roll 86, NARA-CPR RG 75; Hughes, *Indian Chiefs of Southern Minnesota*, 189; "Land Allotments, Death Dates, Family Histories, Winnebago," NARA-CPR RG75; Winnebago census records 1886–1937, http://ancestry.com [accessed December 29, 2007]; and Addie Stevens Student File, HUA).

78. Addie enrolled in the Westfield State Normal School in Massachusetts. She also attended the coeducational Kimball Union Academy in Meriden, New Hampshire (Addie Stevens Student File, HUA).

79. This was Philadelphia's Lying-in Charity Hospital.

80. Lindsey, *Indians at Hampton Institute*, 173 n27.

81. Addie Stevens, Student File, HUA, and Winnebago census records 1895–1907, http://ancestry.com (accessed December 29, 2007). Census records for 1910 show the couple living without children in Lebanon, New Hampshire.

82. *Sioux City Daily*, "Winnebago Indian Woman Makes Most Enviable Record," April 1924, Addie Stevens student file, HUA, Winnebago Deaths for 1937, Indian census records, 1937–1939, http://ancestry.com (accessed December 29, 2007).

83. Government Documents, *Record of Indian Students Returned*, 8. Fannie was the daughter of My Soul Earth and Mary Black Wolf. Winnebago Agency census records show her parents and siblings as well as her own children and spouse.

84. St. Cyr to Miss Richards, April 20, 1887, Julia St. Cyr student file, HUA.

85. Winnebago census records 1886–1910, http://ancestry.com (accessed December 29, 2007). Fannie's husband was John Carmonie, aka Peter Snake.

86. Very little is known about Angel's "full-blood" friend, Carrie Alexander. She may have been related to James Alexander of the Medicine Lodge.

87. Government Documents, *Record of Indian Students Returned*, 7.

88. *Southern Workman*, Oct. 1891, ADSF, HUA.

89. *The Pipe of Peace*, November 13, 1891, HHS.

90. *Talks and Thoughts*, May 1892, ADSF, HUA.

Chapter Four

1. December 26, 1891, ADSF, HUA.

2. Lizzie graduated with Angel and spent a year-long outing in Northampton with the Bryant Family. She helped with domestic chores during the day and had lessons at night. She also earned money typing for a newspaper (Government Documents, *Record of Indian Students Returned from Hampton Institute*, 12).

3. William H. Clapp was born February 1854 in Massachusetts. The Clapp family is listed on the 1900 Massachusetts federal census, Hampshire County, Northampton. At this time he served as Clerk of Courts for Northampton. The house, where Angel lived off and on for many years, can still be seen today. See Northampton Historical Society, Massachusetts Historical Commission, Form B—Building, Form no. 31A–262, 65 Paradise Rd., W. H. Clapp House.

4. Flora ran a boarding house at 18 Henshaw Avenue for Smith College women. The college purchased the house in 1926, renamed it "La Maison Francaise" (French House) and razed it in 1972 for dormitories (http://asteria.fivecolleges.edu/findaids/smitharchives/manosca104_odd.html [accessed December 29, 2007]).

5. Anna (Floy) Quimby was only seventeen or eighteen when she gave birth to Flora in 1849. She died sometime between 1860 and 1870. Christopher Quimby, a sawmill worker, remarried. His second wife lived out her days in a Vermont insane asylum. Soon after his third marriage, the Quimby sisters moved to Northampton and resided with and kept house for widower and former minister, Steven Barker (who may have employed their father in Vermont) (http://ancestry.com [accessed December 29, 2007]: Family and Local Histories, *Western Massachusetts: A History, 1636–1925,* vol. 3, 428; 1860 and 1870 Vermont federal censuses, Caledonia County, Barnett, and Washington County, Waterbury Twp., Vermont State Hospital for the Insane; 1880 Massachusetts federal census, Hampshire County, Northampton; "Churches and Ministers, Etc.: Rev. Stephen Barker," *Historical Sketches of Andover,* 499).

6. De Cora to Folsom, February 2, 1892, ADSF, HUA.

7. Ibid., February 7, 1892.

8. See Northfield School History, www.nmhschool.org/about/history/index.php (accessed December 29, 2007).

9. De Cora to Folsom, February 7, 1892, ADSF, HUA.

10. This was a branch of the Women's National Indian Association, established "in 1879 to raise sympathetic support for the Poncas" (Tingey, "Indians and Blacks Together," PhD diss., 164 n2).

11. Isabel B. Eustis, September 16, 1892, Cora Folsom Incoming Correspondence, HUA.

12. "Circular," *School of Art,* 1892, Smith College Archives.

13. Ibid., 27.

14. Ibid., 21, 22, 27. "Angel De Cora" is listed as a School of Art student from Winnebago, Nebraska, residing at 240 Elm St.

15. Eustis, August 28, 1892, Cora Folsom Incoming Correspondence, HUA.

16. Ibid., J. E. Richards, September 8, 1892.

17. Ibid., Eustis, August 28, 1892.

18. Carley to Eustis, August 27, 1892, ADSF, HUA.

19. J. E. Richards, September 8, 1892, Cora Folsom Incoming Correspondence, HUA.

20. Ibid., Eustis, September 16, 1892.

21. De Cora to Folsom, September 20, 1892, ADSF, HUA.

22. Ibid., October 18, 1892.

23. Ibid.

24. Henry White, *The Life and Art of Dwight William Tryon*, 99–100.

25. Ibid.

26. Tryon's training in Paris gave him a drawing system that he claimed was "a thinking of the object upon the paper," rather than a "manual process." Precise antique-cast drawing was a staple of his training, in contrast to the Paris impressionists. Still, his training encouraged "the losing of edges" and the "merging of contours and forms into one another" (Henry White, *The Life and Art*, 42).

27. Tryon shared a longstanding friendship and an interest in tonalism with the American aesthete and expatriate artist, James McNeill Whistler. Whistler became the spokesperson for "art for art's sake." He subscribed to German Romanticism, so did not believe human beings had direct access to reality. Consequently, artists could only represent their feelings (Taylor, "Mr. Whistler's 'Ten O'Clock' 1885," 506).

28. Whistler preached that artworks were things in themselves and, ideally, should represent the inner life and perception of a "prophetic" artist. They were worthy of admiration and could uplift only if they were a creation of "Beauty," that is, harmoniously blended color, line, scale, and texture. To conceive of art as nonutilitarian, however, demanded an educated and "refined" intellect. It also meant artists, like Angel, saw herself as alienated from society. Thus, the aesthetic movement has been charged with "elitism." See Meyers, "American Art," and Hutchinson, "Modern Native American Art," and "Progressive Primitivism," PhD diss.

29. Baigell, *Dictionary of American Art*, 358.

30. Tryon was of the American Barbizon school that was influenced by the so-called lower-keyed painters, such as Charles Daubigny and Camille Corot (Henry White, *The Life and Art*, 35, 44).

31. Cleveland, *Intimate Landscapes*, 15–16.

32. Sarah McAnulty (Quilter), the first scholar to provide an indepth analysis of Angel's career as an artist, agreed Angel adopted Tryon's tonalism. She found her artwork "an extremely romantic, lyrical conception of what Indian life was supposed to have been prior to the white man," and representing "an Eden which never existed" ("Angel DeCora: American Indian Artist and Educator," MA thesis, 15–16, and "Angel DeCora: American Indian Artist and Educator," *Nebraska History*, 159). Elizabeth Hutchinson recently expanded McAnulty Quilter's scholarship, concluding that Angel's nocturnes "bear an ideological as well as formal resemblance to Tryon's work," as they represent an "imperialist" and "antimodernist nostalgia for pre-reservation Indian life that would have appealed to both non-Indian and Indian viewers." Angel's nocturnes redeem themselves, Hutchinson claimed, through their communal message: they are lit "by the fire that gathers a family or community together." Her observation captures the essence of Indian Commissioner Jones's compliment of Angel's painting *Fire Light* (See Government Documents, *Annual Report of the Commissioner of Indian Affairs to the Secretary of the Interior*, 1902, 49). In addition, Hutchinson finds that Angel's "use of western representational forms to humanize and correct stereotypical imagery," was "a strategy typical of educated colonized peoples." See Hutchin-

son, "Modern Native American Art," 749, and "Progressive Primitivism," PhD diss., 175 and 180.

33. Baigel, *Dictionary of American Art*, 355–56.

34. De Cora to Folsom, November 27, 1892, ADSF, HUA.

35. Ibid., Jan 3, 1892 [should be 1893].

36. Like many American Indian children at this time, Angel didn't know her correct age. Although she may have internalized the reformer's perception of her as childlike, she also feared aging was unattractive.

37. De Cora to Folsom, Nov 27, 1892, ADSF, HUA. Angel made no mention about the stereotypical way American Indians are portrayed in the celebration of Thanksgiving.

38. Ibid.

39. Ibid., Jan 3, 1892 [should be 1893].

40. Gertrude Clapp, January 13, 1893, Cora Folsom Incoming Correspondence, HUA.

41. *Southern Workman*, September 1893, ADSF, HUA.

42. See L. George Moses for a fascinating perspective on the Buffalo Bill show at the Columbia Exposition (*Wild West Shows*, 137).

43. Fletcher displayed her collection of Indian artifacts at the ethnographic exhibition (Mark, *A Stranger in Her Native Land*, 209–22). See also Lorini, "Alice Fletcher."

44. Lorini, "Alice Fletcher," 21.

45. Almeida, "The Role of Western Massachusetts," EdD diss., 112–13.

46. "World's Fair Notes from Chauncey Yellow Robe," *Indian Helper*, September 15, 1893, transcribed by Barbara Landis.

47. "Circular," 1893, *School of Art*, 30–31, 49, Smith College Archives.

48. Henry White, *The Life and Art*, 93.

49. *Southern Workman*, August 1894, ADSF, HUA. The School of Art awarded two annual prizes of $25, one to a graduate student and the other to an undergraduate or School of Art student. The article should say "School of Art" not "undergraduate" ("Circular," 1893, Smith College Archives).

50. *Southern Workman*, August 1894, ADSF, HUA.

51. Ibid.

52. Julia's outing record shows she stayed with Mrs. A. J. Wilson in Newton, Connecticut, for both her 1893 and 1894 outings (JDSF, HUA).

53. Again, Folsom published her letter (*Southern Workman*, November 1894, ADSF, HUA).

54. See Lomawaima's ground-breaking study on the development of pan-Indian identity at the Chilocco Indian School in Oklahoma (*They Called It Prairie Light*).

55. "Circular," 1894, *School of Art*, 33, Smith College Archives.

56. See Burgess, *The Lake Mohonk Conference*. She is listed as "Angel Dacora" in the "Index to Speakers and Writers" for 1895.

57. Adams, *Education for Extinction*, 11.

58. See Charles Eastman, *From the Deep Woods to Civilization*, 92–115; Graber, *Sister to the Sioux*, 155–71; Wilson, *Ohiyesa*, 40–62; and Sargent, *The Life of Elaine*

Goodale Eastman, 26–40, for accounts of the Eastmans' experience of Wounded Knee. See also Jensen, *The Indian Interviews,* for American Indians' accounts of Wounded Knee.

59. De Cora, "Native Indian Art," *Weekly Review.*

60. "Circular," 1895, *School of Art,* Smith College Archives.

61. "In Memoriam," De Cora, 1896, the Sophia Smith Collection, Smith College Archives.

62. *Southern Workman,* July 1896, ADSF, HUA.

63. Heirship Findings, 1910–1911, 290, Roll 89, NARA-CPR RG 75.

Chapter Five

1. As a youth, Pyle found inspiration in the work of Winslow Homer and Felix Octavius Darley, early illustrators of U.S. periodicals (whose pictures now appear staged and flat compared to his). Pyle learned his craft during his freelance days with the publishers of *Harper's* magazines (Pitz, *The Brandywine Tradition,* 60).

2. Ibid., 33–36. Pyle's parents, though Quakers, encouraged him to develop his dramatic sense of the pictorial.

3. Ibid., 61. Pyle sought a teaching position in Philadelphia's prestigious Academy of Fine Arts, but the school rejected him, believing illustration to be a "lesser art form." He is now deemed the "father of American illustration."

4. Ibid., 92.

5. Bertha Corson Day Bates, Lykes File 3, HFSL.

6. Pitz, *The Brandywine Tradition,* 95.

7. William L. Brown to Chas. F. Lummis, Lummis Collection, MS. 1.1.514, Autry Museum of Western Heritage.

8. Cora Folsom, "The Careers of Three Indian Women," *The Congregationalist,* March 12, 1904, ADSF, HUA.

9. "Notes about Pyle," Gertrude Brinkle and "F. Schoonover Interview," HPC and SC, HFSL.

10. "How Art Misrepresents the Indian," *The Literary Digest,* January 27, 1912.

11. Cora Folsom, "The Careers of Three Indian Women." Pyle encouraged Frank Schoonover to paint "the wild west." "I just don't feel right about the work I am doing now for I am having to project to the public too much that is really not out of my experience," Schoonover replied. "I feel that I must pick a field . . . that will say, 'This rings true; he knows because he has been there.'" In response, Pyle urged Schoonover to go to the Canadian wilderness, where Schoonover later created several well-known illustrations of Indian subjects (Schoonover, *Frank Schoonover,* 22–23).

12. Pratt brought eight-year-old Anna (or "Wild Rose") and her mother, Mary Dawson, to Hampton with his first group of recruits in November of 1878. Mary stayed for a year and a half, until she felt comfortable leaving her daughter and returned home. Annie never saw her mother again, because Mary died the following winter. Hampton staffers took Annie under their wing. She was probably the first to call Folsom "Ina" (Sioux for mother). After graduation, Anna taught at Hampton for two years, then left to further her education. She became a key figure

in the Indian reform movement in Boston, at which time Alice Longfellow, the poet's daughter, befriended her. Despite her growing celebrity, Annie returned to the Arikaras, became field matron in 1895, and remained in the position for seventeen years (Cora Folsom, "The Careers of Three Indian Women"; Hultgren and Molin, *To Lead and to Serve*, 21; Tingey, "Indians and Blacks Together," PhD diss., 208; and Almeida, "The Role of Western Massachusetts," EdD diss., 116).

13. Government Documents, *Record of Indian Students Returned*, 4.

14. *Southern Workman*, November 1897, ADSF, HUA.

15. Cora Folsom, "The Careers of Three Indian Women."

16. Angel began signing her paintings "A. de C." (in lieu of "Angel de Cora") early on. "A. de C." signed an oil on board titled *Chief Running Deer Wyoming Territory* dated 1897. The author assumes this 19 x 13.5 in. piece, sold at Freeman's in Philadelphia on April 16, 1994, is Angel's work (artnet, www.artnet.com/artist/635144/a-de-c.html [accessed December 29, 2007]).

17. The painting for the frontispiece of *The Middle Five, Lafayette's Headquarters*, and an untitled prairie scene with tepee are all that have been found to date.

18. Reprinted in the *Southern Workman*, September 11, 1897, ADSF, HUA.

19. The author recognizes Little Decora, White War Eagle, and Spoon. Two other young men are also depicted. A woman with a child may be Decorah's eldest daughter, Agathe, who had a toddler fathered by a Fort Winnebago soldier and who later married De La Ronde. See Kinzie for the details of Agathe's arranged "marriage" to the soldier (Kinzie, *Wau-bun*, 376–380).

20. National Museum Papers, Incoming Correspondence, Angel De Cora Dietz, Dec. 1, 1897, SIA.

21. Ibid. The subject of the letter was recorded however: "Mr. Howard Pyle refers to the artistic ability of Miss Angel De Cora in connection with Museum work."

22. Robert Young's "colonial desire" and Edward Said's "orientalism" are similar concepts (Young, *Colonial Desire*; Said, *Culture and Imperialism*). See also Hutchinson's discussion of "progressive primitivism" (PhD diss.).

23. *Philadelphia Inquirer*, February 13, 1898, ADSF, HUA.

24. Bertha Corson Day Bates, Lykes Files, HFSL.

25. Ibid.

26. Cora Folsom, "The Careers of Three Indian Women."

27. Goodwin, George S., "Pencil Artists," source unknown, SC, HFSL.

28. "F. Schoonover interview," SC, HFSL.

29. Pyle, James L. Wood, Elizabeth L. Bloomfield, and Clifford P. Grayson were the jurors. Angel later mentioned studying with Grayson, head of Drexel's School of Drawing, Painting, and Modeling ("Art Department Scholarships for the Year 1897–1898," Howard Pyle, Box 13, W. W. Hagerty Library, Archives and Special Collections).

30. Pitz, *The Brandywine Tradition*, 102.

31. The old Turner Mill, also N. C. Wyeth's studio in 1907, is now the Chadds Ford Township building (correspondence with Virginia O'Hare, The Brandywine River Museum, and Christine Podmaniczky, Associate Curator, N. C. Wyeth Collections).

32. Bertha Corson Day Bates, Lykes Files, HFSL. Ellen Thompson married Howard Pyle's brother. After her husband's death, she became a prolific illustrator.

33. Correspondence with Jacqueline De Groff, Sept 8, 2000, W. W. Hagerty Library, Archives and Special Collections. See also "An Indian Angel," *The Indian Helper*, November 8, 1898, transcribed by Barbara Landis.

34. Schoonover gifted the painting (now mistakenly titled *Washington's Headquarters*) to the Wilmington Society of Fine Arts in 1940 or 1941. The accession is described as "a small landscape of Lafayette's Headquarters at Chadds Ford, painted in the summer of 1898 by Angel de Cora, a full-blooded Indian girl and pupil of Howard Pyle" (Annual Meeting, 7 April, 1941, "Angel de Cora," SC, HFSL).

35. Pitz, *Brandywine Tradition*, 105.

36. Ibid., 104.

37. Ibid., 113.

38. Anna Hoopes, "Memories of Howard Pyle," 1935, Box 2A, HPC, HFSL.

39. Pitz, *Brandywine*, 107–108.

40. Hoopes, "Memories of Howard Pyle," 1935, Box 2A, HPC, HFSL. The wealthy Boston woman may refer to Gertrude Clapp.

41. Curtis, "An American Indian Artist."

42. Ibid.

43. Hoopes, "Memories of Howard Pyle," 1935, Box 2A, HPC, HFSL.

44. According to Tryon's biographer, he "never taught his pupils a particular method of painting, his own least of all," but "encouraged them to experiment widely, in fact, he insisted upon it" (Henry White, *The Life and Art of Dwight William Tryon*, 102).

45. "F. Schoonover interview, 1966," Box 2B, SC, HFSL.

46. Curtis, "An American Indian Artist."

47. Pyle's comments appear as transcribed notes in Angel's student file. The original source for the comments is missing. This may be his initial response to her portfolio (ADSF, HUA).

48. Schoonover photographed a long shot of Angel with friends in a buggy fording a stream. Another photo, titled "Friends of Angel," shows an attractive American Indian couple in Native dress. The woman may be the model for "Gray Wolf's Daughter." The last photo in the series is an American Indian man dressed in civilian clothes posing as a farmer with a plow (Scrapbook, SC, HFSL).

49. Hutchinson noted Pyle favored male students for a career in art ("Progressive Primitivism," PhD diss., 189).

50. Cora Folsom, "The Careers of Three Indian Women."

51. Angel's Indian name, "Hinook-Mahiwi-Kilinaka," was paired with "Angel de Cora" in the November *Harper's*, the form also used in *Old Indian Legends* (1901) and *Wigwam Stories* (1901). Her signature on the frontispiece of *The Middle Five* (1900) does not include her Indian name. Artwork for "The Sick Child" and "Gray Wolf's Daughter" also displays her Indian name with "A. de C." Later artwork omits it. She may have felt it inappropriate (and exploitative) to share such a personal name with the public.

52. Reprinted in *Red Man and Helper*, December 1899, ADSF, HUA.

53. Angel's early writings are currently included in many college courses that focus on Native American literature and experience.

54. ADSF, HUA.

55. Angel's obituary states: "She entered studio life in Philadelphia with a friend, and did fairly well, meeting many kind and helpful friends, such as Cecelia Beaux, Alice Barbour Stevens [*sic*], Katherine Pyle, and many others" (*Southern Workman,* March 1919, ADSF, HUA). Schoonover's photo in Katherine Pyle's studio suggests the two met well before Angel moved to 1710 Chestnut Street.

56. Tappert notes that Beaux opened a studio on 1710 Chestnut Street in 1889 when she returned from her training in Paris ("Aimeé Ernesta"). Carter states Beaux opened a studio in New York in 1899, after having several studios on Chestnut Street (*Cecelia Beaux*).

57. As a female artist, Beaux suffered discrimination and sexual harassment so would have sympathized with Angel's experience with Pyle (Carter, *Cecelia Beaux,* 65–67).

Chapter Six

1. Rydell, *All the World's A Fair,* 108. See also Wakefield for contemporaneous reports of the fair (*A History of the TransMississippi*). The Indian Congress was inspired by European fairs, which exhibited indigenous peoples from their colonial empires. According to Rydell, besides the noble goal of "uplift," the Indian Congress supported the perception of white Americans as "anything but newcomers to the imperial arena" and suggested that "the government's Indian policy was applicable to 'aborigines' abroad" (*All the World's a Fair,* 112).

2. F. A. Rinehart shot two group photographs of Winnebago people that the Omaha Library represents as part of the Indian Congress. The first, a group of nine, probably shows the actual Congress members (officially, there were nine). The author recognizes Julia in Rinehart's second photo (back row, far right), "Winnebago Group of Seven." She participated in the Indian activities, but may not have been a member of the Indian Congress. See Rinehart's photo gallery, "Trans Mississippi and International Exposition," available at www.omahapubliclibrary.org/transmiss (accessed December 29, 2007).

3. Report of the Representative of the Department of the Interior, "Trans Mississippi and International Exposition" available at www.omahapubliclibrary.org/transmiss/secretary/interior.html (accessed December 29, 2007).

4. Ibid.

5. Ibid. See also Hutchinson on Carter's Indian lace missions in "Progressive Primitivism," PhD diss., 75–96.

6. Report of the Representative of the Department of the Interior," at www.omahapubliclibrary.org/transmiss/secretary/interior.html (accessed December 29, 2007).

7. Hutchinson, "Progressive Primitivism," PhD diss., 10.

8. According to Ahern, the number of American Indians employed by the Indian service peaked between 1889 and 1893, when Indian Commissioner Morgan, "sanctioned returned students as 'instruments of progress'" ("An Experiment Aborted," 270).

9. *Talks and Thoughts,* August 1898, JDSF, HUA.

10. Younkaw Decora and Nancy Amelle, two other great aunts, died in 1894 and 1895, respectively. Mary Amelle Parrish was the only one left and still living on the reservation at this time.

11. Angel's "Individual Record" (THP, SMHC) only gives the names of her two deceased brothers. The death of the daughter Julia mentioned was not recorded, but she died before Angel. According to Winnebago census records, Emma was age one in 1880. She does not appear on records after 1882, indicating she died just before Angel left the reservation.

12. *Harper's New Monthly,* February, 1899, 446–48.

13. ADSF, HUA. The author does not know if the story was ever published.

14. *Nebraska State Journal,* "Omaha in Brief," December 20, 1898. His wife's nephew, Alexander Lamere, was arrested two weeks earlier for "introducing liquor upon the Indian reservation," suggesting a crackdown (Ibid., December 11, 1898).

15. Julia De Cora to Folsom, January 29, 1899, JDSF, HUA.

16. *Talks & Thoughts,* December 1899, ADSF, HUA; *Harper's New Monthly,* February 1899.

17. La Flesche married Rosa Bourassa, an educated Ojibwe woman. They later divorced. Mark stated, he "lived for twenty years" with Fletcher and her companion, photographer Jane Gay, "as a pampered bachelor son" (*A Stranger in Her Native Land,* 308).

18. Francis La Flesche Papers/Series 11 and 12: General Correspondence, 1890–1929 [11]; Correspondence on Specific Subjects, 1881–1930 [12]: The Middle Five, Business 1899–1907, 1927, AFFLP, NAA. The publishers stated they didn't believe the book was marketable.

19. They traveled via Yarmouth, Nova Scotia, as "tourists" ("Boston Passenger Lists, 1891–1943," http://ancestry.com [accessed December 29, 2007]).

20. The letter is addressed to "Mit Capp," September 27, 1899, from Wrentham, c/o Joseph E. Chamberlain, ADSF, HUA. Angel was in Wrentham at least by September 5 (Ida Chamberlain to Day, September 5, 1899, F. Holland Day Papers, SIA).

21. Keller, *The Story of My Life,* Part I, Chapter 22.

22. Chamberlain wrote about Keller's 1898 summer at Red Farm: "She certainly comes nearer to being completely good than any other person who I have ever known. To be 'lost' in our little woods with only a child for a guide is an intense delight to her" (*Ladies Home Journal,* "Helen Keller" (as reported by the *Daily Herald*), 20 June 1899).

23. Cora Folsom, "The Careers of Three Indian Women."

24. Ida asked Holland to pick one of Gertrude Käsebier's photographs to accompany Zitkala-Ša's article, "Impressions of an Indian Childhood." "Zitkala-Ša has been with us here nearly all summer," she wrote, "and has developed intellectually, I think, a great deal. Her written expressions of her childhood are natural, clear, and significant" (Ida Chamberlain to Day, September 18, 1899, F. Holland Day Papers, SIA).

25. See Zitkala-Ša, *Old Indian Legends,* 134.

26. *Southern Workman,* March 1919, ADSF, HUA.

27. Correspondence with Susan Rose Dominguez, Comparative Ethnic Studies, University of Milwaukee, 2006. Dominguez's biographical research, "The Gertrude Bonnin Story: From Yankton Destiny into American History, 1804–1938," was not ready for publication or the author's review.

28. Ezra Felker, born in Maine or New Hampshire, was stationed at the Grand River garrison in 1870 (1870 Dakota Territory Census, Unorganized Territory, Grand River Agency).

29. Dominguez, correspondence with author, 2006.

30. Rappaport, *The Flight of Redbird,* 44.

31. Ibid., 52.

32. Dominguez believes Gertrude chose a Lakota name because of her engagement to Lakota Thomas Marshall, correspondence, 2006.

33. Rappaport, *The Flight of Redbird,* 52.

34. Zitkala-Ša, "An Indian Teacher Among Indians," 382. See also Barbara Landis on Gertrude Simmons Bonnin at Carlisle, as reported by the school paper, *Indian Helper,* http://home.epix.net/~landis/zitkalasa.html (accessed December 29, 2007).

35. Zitkala-Ša, "An Indian Teacher Among Indians."

36. Rappaport, *The Flight of Redbird,* 81–83.

37. Spack references "A. J. Standing to Miss Gertrude Simmons, January 23, 1899, Pratt Papers," and says "her tuition and expenses at the Conservatory" were "paid by the office of the commissioner of Indian Affairs" (Spack, "Dis/engagement"). Gertrude studied with Eugene Grueberg (graduate of the Vienna Conservatory) (correspondence with Mary Alice Mohr, archivist and records manager, Spaulding Library, New England Conservatory of Music, 2004).

38. Ibid. She did not receive a diploma. Her fiancé, Marshall, died while attending Dickinson College in Carlisle.

39. *Indian Helper,* November 3, 1899, transcribed by Barbara Landis.

40. Monet's work in Giverny, France, where a handful of Boston artists studied, was the catalyst for the movement. Among the first to observe Monet paint was the most celebrated Boston painter, John Singer Sargent. Sargent painted Monet painting at Giverny (*Claude Monet Painting on the Edge of a Wood,* 1885) and exhibited with him at a Paris gallery in the spring of 1885.

41. Fairbrother, *The Bostonians,* 50–54.

42. Pitz, *Brandywine,* 105. See also Hutchinson for Pyle's opinion of "art for art's sake" ("Progressive Primitivism," PhD diss., 188–90).

43. Frank M. Cowles managed the school. An 1886 advertisement claimed it featured convenient day and evening classes in figure drawing and painting, artistic anatomy, composition, still-life painting, "Drawing and Painting the Head from Life," and "Drawing, Still Life, Oil and Water Colors, and Perspective," www.boston athenaeum.org/cowles.html (accessed December 29, 2007).

44. "The Ten" believed that these common interests along with a commitment to "small congenial installations" would enable "high aesthetic standards" to flourish, and harmony to prevail. A critic who came to one of their showings claimed, "The

whole room is a restful place. There are no bad pictures." His statement reflects the nonconfrontational nature of their work. See Fairbrother, *The Bostonians.*

45. A fire destroyed most of DeCamp's landscapes when his Boston studio burned in 1904.

46. See Fairbrother, *The Bostonians.* DeCamp began his art studies in his native Cincinnati and then attended the Royal Academy in Munich. He also studied the paintings of the old masters in Venice and Florence. Boston became his home in 1884.

47. De Cora, "Angel DeCora—An Autobiography."

48. School of Museum of Fine Arts, Boston Records, 1876–1957, 4. Register of Pupils, ca. 1879–1927, A. Register, October 1879–October 3, 1904. For the academic year 1899–1900, she attended only 29 out of 72 days the first term, and 29 out of 54 days the second (Student Card Catalogue, Library Archives, School of the Museum of Fine Arts, Boston).

49. After meeting as art students at the museum school, the young men left for Europe in 1883 to study at the Académie Julian in Paris. In 1889 they began sharing a studio and were both appointed to teach at the museum school.

50. School of Museum of Fine Arts, Boston Records, 1876–1957, 4. Register of Pupils: "De Cora, Miss Angel . . . Wrentham, Mass," student in the "Department of Drawing, Painting, and Modelling," *School of Drawing and Painting at the Museum of Fine Arts: Twenty-Fourth Annual Report,* Boston: 1900.

51. Fairbrother, *The Bostonians,* 55.

52. Ibid., 199.

53. McAnulty Quilter noticed the lessening of Pyle's influence after Boston. Instead, she found that Angel demonstrated a "tendency to generalize about settings and accoutrements," the "photographic clarity of details was gone," and her "work became more impressionistic." McAnulty Quilter sought *Lafayette's Headquarters* in 1995, but could not locate it. See her MA thesis, "Angel DeCora: American Indian Artist and Educator," 22.

54. See his *Mother and Child in the Pine Woods,* ca. 1892. A more European style impressionism appears in Angel's depiction of the personified Iktomi surrounded by forest animals. The figures are virtually inseparable from the landscape.

55. Unfortunately, the author was not allowed to copy an example of the Decorative Class work found in a museum school scrapbook.

56. These have not been given the attention they deserve in regard to their connection to her later design work, particularly the lettering of *The Indians' Book* by Natalie Curtis.

57. June 13, 1903, *Indian Helper,* and the *Sun,* March 27, 1900, Library of Congress, available at www.loc.gov/chroniclingamerica (accessed December 29, 2007). Called the only "American band in existence," 1890 Carlisle graduate Oneida Dennison Wheelock was band master. According to Barbara Landis, "Music was also an important part of the Carlisle curriculum. Every student took music classes and many received private instruction. A bandleader was hired, and the Carlisle Indian School band became a popular parade addition. The band performed at football games and

traveled to expositions and competitions. It was featured at every Presidential Inaugural Parade during the life of the school" (correspondence with author, 2005).

58. Fletcher sent Gertrude a sheet of Omaha music she had collected, hoping Gertrude would play it during her performance. She declined Fletcher's offer, explaining it was "most interesting," but she was "not equal to the work it would demand." She assured her, "In my mind I hear the Indian music which is unlike any other I know of—and so I trust the time will come when I shall feel justified in touching upon this new realm of music" (Alice Fletcher Papers, Series 1 & 2: Incoming Correspondence, 1899 to 1923 (n. d.) [1], AFFLP,SAA).

59. Rappaport, *The Flight of Redbird*, 85.

60. *Sun*, March 25, 1900, Library of Congress, available at www.loc.gov/chroniclingamerica (accessed December 29, 2007).

61. Ibid.

62. For example, see her correspondence to fiancé Carlos Montezuma (and Spack's analysis, "Dis/engagement"), as well as her correspondence to Arthur Parker about Angel's close friend, Marie L. Baldwin (SAI Papers, GLSU).

63. Wearing inappropriate Indian dress came back to haunt Gertrude Simmons Bonnin later in life. When she and Pratt lobbied against peyote use (and its advocate, ethnographer James Mooney), Mooney pointed out to those attending the 1916 Senate Peyote Hearings that Bonnin "claims to be a Sioux woman... [h]er dress is a woman's dress from some Southern tribe, as shown by the long fringes. The belt is a Navajo man's belt. The fan is a peyote fan, carried only by men, usually in the peyote ceremony" (Rappaport, *The Flight of Redbird*, 134). See also Moses for an account of Bonnin's counterattack on Mooney (*The Indian Man*, 200–10).

64. *Indian Helper*, April 13, 1900, CCHS.

65. De Cora to La Flesche, April 14, 1900, Francis La Flesche Papers, "Correspondence on Specific Subjects, 1881–1930," Series 11, Box 14, AFFLP, SAA.

66. Cook, "The Representative Indian," 80–83; Student Card Catalogue, "Remarks: June 1, 1900 awarded scholarship, withdrew 2d term," Library Archives, School of the Museum of Fine Arts, Boston.

67. The painting is currently part of an exhibit on Indian boarding schools at the Heard Museum in Phoenix, Arizona.

68. Francis La Flesche Papers, General Correspondence, 1890–1929 [11]; Correspondence on Specific Subjects, 1881–1930 [12]: The Middle Five, Business 1899–1907, 1927, AFFLP, SAA.

69. Zitkala-Ša to La Flesche, August 10, 1900, Francis La Flesche Papers, Series 11, "Correspondence on Specific Subjects, 1881–1930," Box 14, AFFLP, SAA.

70. Francis La Flesche Papers, The Middle Five, Personal 1900–1912, AFFLP, SAA.

71. Lummis and Fletcher both belonged to the American Folklore Society. According to Hultgren, "the Lummis article never materialized in the *Southern Workman*. William Lincoln Brown was a Bookkeeper and Cashier at the school from 1891–1907. He was also on the editorial staff of the *Southern Workman*, editing the section on the Indian Department until 1915" (correspondence with author, September 3, 2004).

72. Indian Commissioner Morgan said the governor of New Mexico told him that Lummis was a "Bohemian wandering place to place as a newspaper correspondent, taking photographs and collecting data for his articles on Indian life." He said the governor also disclosed that Lummis divorced his physician wife after meeting a seventeen-year-old Indian school teacher at the Pueblo of Isleta, whom he married (Thomas J. Morgan to Mr. Clement, Editor of the *Transcript*, Boston, Mass., December 9, 1892, Thomas Morgan Papers, RLM).

73. William L. Brown to Chas. F. Lummis, the *Southern Workman,* Hampton Institute, Oct. 25, 1900, Lummis Collection; MS. 1.1.514, Autry Museum of Western Heritage.

74. Office of Indian Affairs, Letters Received (October 2, 1900), Angel Decora to H. C. Tanner, LR 48326 1900, 11E3 6/8/3, Box 1836, NARA-DC RG 75.

75. Office of Indian Affairs, Letters Sent (October 9, 1900), Jones to H. B. Peairs, M., 47005/1900, LS. Misc. vol. 16, 252, NARA-DC RG 75. Jones sent instructions to Haskell Institute's superintendent, but he did not approve Haskell's settee and bookcase designs.

76. Office of Indian Affairs, Letters Sent (November 3, 1900), Jones to Decora, M. 52237/1900, LS. Misc. vol. 16, NARA-DC RG 75.

77. Office of Indian Affairs, Letters Received (November 28, 1900), Decora to Jones, LR, 58629, NARA-DC RG 75.

78. Office of Indian Affairs, Letters Sent (December 10, 1900), Jones to Decora, M. LS. Misc. vol. 16, 451–452, NARA-DC RG 75.

79. Alice C. to Miss Folsom, June 11, 1901, ADSF, HUA.

80. *Annual Report of the Commissioner of Indian Affairs to the Secretary of the Interior,* 1902, 49.

81. "Department of the Interior," from "Government Building," Rand McNally "Hand-Book to the Pan-American Exposition," available at http://panam1901. bfn.org/usgov/randmcnallygov.html (accessed December 29, 2007).

82. See Hutchinson's instructive overview of the "aesthetic reform movement," "progressive primitivism," and the popularization of "Indian corners" ("Progressive Primitivism," PhD diss.).

Chapter Seven

1. The museum scrapbooks could not be copied. See Scrapbooks, B v2m 1885–1905, Records, 1876–1957, Library Archives, School of Museum of Fine Arts, Boston.

2. De Cora to Folsom, March 8, 1904, ADSF, HUA.

3. An article in the *Southern Workman* indicates she was still living in Boston in July of 1901. She was ill in the springtime of 1902 after moving to 23rd Street, New York (Folsom correspondence, ADSF, HUA).

4. Fairbrother, *The Bostonians,* 64.

5. Ibid., 65.

6. The second of three undated letters from De Cora to Folsom from 575 W. 155th Street, New York (written in 1902 before October), ADSF, HUA.

7. Ibid., the first of three.

8. Ibid.

9. Ibid., the last of three (probably written January 1903).

10. Ibid.

11. De Cora to Folsom, October 14, 1902, 575 W. 155th St., New York, ADSF, HUA.

12. She enrolled on September 27, 1902 (Mary Sampson, 3288, CSR).

13. De Cora to Folsom, October 14, 1902, 575 W. 155th St., New York, ADSF, HUA.

14. Ibid.

15. Cora Folsom, "The Careers of Three Indian Women."

16. Tingey, "Indians and Blacks Together," PhD diss., 208.

17. Caroline W. Andrus was born in Saratoga Springs, New York, on Christmas Day of 1875. Her oldest sister, Jessie, was a teacher at Hampton during the 1880s. Carrie and her mother, Mrs. Mary Fish Andrus, came to Hampton when Jessie contracted malaria in 1855. Mrs. Andrus stayed for some time and enrolled Carrie in a nearby school. By 1900 Carrie served as a clerk for Hampton and later took over many of Folsom's duties. Jones received his undergraduate degree with anthropologist F. W. Putnam at Yale (Tingey, "Indians and Blacks Together," PhD diss., 21; Correspondence with Hultgren, 2003–2004; 1900 Virginia federal census, Elizabeth City County, Chesapeake, ED 9).

18. Pima Indians captured the four-year-old Yavapai boy, Wassaja, and his sisters. An Italian photographer paid $30 to save him and baptized him "Carlos Montezuma." Montezuma agreed with Pratt that Indians should break all ties with reservation life. This attitude infuriated his fiancé. "Perhaps the Indians are not human enough to waste your skill upon. Stay in Chicago. I consider my plan a more direct path to my high ideals. It will be a test of my character." She also informed him that "four Western men scattered from Montana to Dakota" romantically pursued her (including Raymond Bonnin) (Rappaport, *The Flight of Redbird*, 93). See also Spack, "Dis/engagement," and Sperhoff, *Carlos Montezuma*.

19. *Red Man and Helper*, July 25, 1902. Carlisle published their newsletters under a variety of names over the years. They also published two monthly magazines: *The Indian Craftsman* and *The Red Man*.

20. Ibid., December 19, 1902.

21. De Cora to Folsom, the last of three undated letters, ADSF, HUA.

22. Ibid.

23. Ibid.

24. De Cora to Folsom, February 12, 1903, ADSF, HUA.

25. Mary Sampson; Winnebago, He-na-k-ga; "Outings: July 6, 1903: To visit cousin—Angel Decorah in N. York City; returned: Sept 25, 1903," 3288, CSR.

26. "It is rather hard at times to tell these dignified matrons that they ought to do this and that," Julia admitted, "especially when I have to tell them how they must take care of their children." Her job was even more difficult because she needed an interpreter (Julia De Cora to Miss Cleveland, from Fort Berthold, November 23, 1898, JDSF, HUA).

27. Julia De Cora to Folsom, December 26, 1899, JDSF, HUA.

28. *Southern Workman*, October 1900, JDSF, HUA.

29. Julia De Cora to Folsom, Nov. 23, 1902, JDSF, HUA.

30. Ibid. Julia called the scandal that "altruistic affair." She may have taken donations from a service club she organized at Fort Berthold called the Kings Daughters.

31. Ibid. Her letter ends with a postscript listing employees of Rosebud school.

32. Julia's student file correspondence begins January 29, 1899, and ends April 12, 1960.

33. Julia De Cora to Folsom, December 30, 1902, JDSF, HUA. Folsom did not answer the letter until June 1, 1903.

34. Ibid.

35. *Southern Workman,* September 1903 and 1900, HUA, Nebraska federal census, Thurston County, Pender.

36. De Cora to Folsom, 546 W. 165th, no date, ADSF, HUA. Angel's second studio in Harlem was located at the northeast corner of Broadway at 165th.

37. Ibid., January 1904.

38. Josephine Richards, January 27, 1904, Cora Folsom, incoming correspondence, HUA.

39. De Cora to Folsom, February 18, 1904, ADSF, HUA.

40. Ibid.

41. De Cora to Folsom, February 29, 1904, 546 W. 165th Street, New York, ADSF, HUA.

42. Folsom, "The Careers of Three Indian Women." Susan was Francis La Flesche's youngest sister. Their father was Omaha Chief, Joseph La Flesche, who helped the Winnebagos gain a portion of the Omaha reservation when they escaped from Crow Creek. Susan should not to be confused with her older sister, Suzette (La Flesche Tibbles).

43. "What Hampton Graduates are Doing," 1904, ADSF, HUA.

44. De Cora to Folsom, March 8, 1904, ADSF, HUA.

45. J. E. Richards, March 12, 1904, Cora Folsom, Incoming Correspondence, HUA.

46. Undated typed note, JDSF, HUA.

47. *Sioux City Tribune,* "Indian Girl Takes Civil Service Exam," May 3, 1904. The newspaper clipping, a reprint (source unknown) is in Angel's student file, rather than Julia's, proving Julia's instincts were correct. Reports of her bad behavior reflected poorly on her sister.

48. De Cora to Folsom, May 10, 1904, ADSF, HUA.

49. Her school record says, "Went home Summer '04 visit and worked, drawing &c. stayed with mother," ADSF, HUA.

50. Julia De Cora to Folsom, January 27, 1905, JDSF, HUA.

51. Hampton staff probably edited Angel's student file. Carrie Andrus in particular was sensitive to privacy issues, burning hundreds of her fiancé's letters after his death. See Colin Davis, "Headhunting William Jones," www.okara.com/html/headhunting.html (accessed December 29, 2007).

52. Julia De Cora to Townsend, December 3, 1906, JDSF.

53. The morality play is about a man educated in a mission school who returns to his reservation intending to convert his people to Christianity. He has lost his

hunting skills and kills the cow of a white rancher to provide for his dying father. The story ends when "the soft-hearted Sioux" kills the white rancher who is pursuing him, and his father dies anyway.

54. See Spack, "Dis/engagement." Joseph Chamberlain attempted to pacify Pratt, telling him Zitkala-Ša "was animated with no other feeling toward you than one of respect and full confidence." She was only trying to right the wrongs that had been done to her people. Pratt responded, "my people and myself will submit to these aspersions without public protest or comment."

55. Zitkala-Ša, "Why I Am a Pagan," 801.

56. De Cora to Folsom, the last of three undated letters, ADSF, HUA.

57. *Final Report of the Louisiana Purchase Exposition Commission,* Part 10, available at www.fullbooks.com/Final-Report-of-the-Louisiana-Purchase.html (accessed December 29, 2007). McCowan, who became Chilocco's superintendent in 1891, also served as the assistant chief of the department of Anthropology for the fair. See Manuscripts, St. Louis Public Library, *The World's Fair Bulletin,* 9.

58. *Final Report,* www.fullbooks.com/Final-Report-of-the-Louisiana-Purchase .html (accessed December 29, 2007).

59. Ibid., 6.

60. "The Racial Exhibit at the St. Louis Fair," *Scientific American,* 1904.

61. Ibid.

62. *Final Report,* www.fullbooks.com/Final-Report-of-the-Louisiana-Purchase .html (accessed December 29, 2007).

63. "The Racial Exhibit at the St. Louis Fair."

64. Ibid.

65. The Chilocco School's St. Louis World's Fair files show Angel sold a painting titled *Medicine Lodge* for $35 while she was living at 546 W. 165th Street, New York (correspondence with Tom Benjey, 2004).

66. *The Chilocco Farmer and Stock Grower,* March 15, 1904, Oklahoma Historical Society from JEP, SAA.

67. *Washington Post,* "Striking Things Seen at the World's Fair," Aug. 21, 1904.

68. *The Indian School Journal:* St. Louis's World's Fair Daily Issue, "Exhibit News Note," June 3, 1904, JEP, SAA.

69. The spectacle validated its racist agenda by seeking to "obtain for the first time what may be called interracial athletic records" (Rydell, Findling, and Pelle, *Fair America,* 53, and Rydell, *All the World's a Fair,* 155, 166).

70. Two records state the couple met at the exhibit, the *Literary Digest,* January 23, 1911, and "Two Real Indian Artists," *Red Man,* February 1913, CCHS.

71. Enrollment Registers, Chilocco Indian School, 1884–1908: "Dietz, W. H. (1/4 Sioux)"; parents: left blank; age: 20 yrs; grade: left blank; term: unconditional," 7RA61, NARA-DC. Correspondence held by the Oklahoma Historical Society shows many letters in February and March of 1904 to and from McCowan regarding recruiting Sioux to participate in the fair. None, however, mention Dietz.

72. This should be St. Paul, *Rice Lake Chronotype,* April 1, 1904.

73. *Rice Lake Chronotype,* untitled, June 17, 1904.

74. Oklahoma Historical Society from JEP.

75. Ibid.

76. Ewers correspondence with Sarah McAnulty, JEP, NAA.

77. Enrolled for the 1904–1905 academic year: "Deitz [*sic*], William Henry … Rice Lake, Wisc., Unclassified (*Friends University Bulletin*, vol. 2, no. 4, June 1905, 55, Friends University Quaker Collection, Friends University, Wichita, Kansas). Dietz is also listed on the 1905 Kansas state census, Sedgwick County, Wichita, Fifth Ward, March 1905, KSHS.

78. Carlisle records show "Madelon DeCora." Her father, "Rickman" or "Rakeman" is unknown (3275, CSR).

79. In 1878 the social reformer, Felix Adler, established the first free kindergarten for working people's children, which became "The Workingman's School" in 1880 when elementary grades were added. By 1895 it had become the Ethical Cultural Fieldstone School ("Felix Adler," www.transcendentalist.com/felix_adler.htm [accessed December 29, 2007]).

80. Ibid. Adler established the Child Labor Foundation to help exploited children. He became an advocate for decent low-income housing to replace the growing slums inhabited by the poor of New York City. Columbia University's first chair of social and political ethics was created for him in 1902.

81. Ibid. "Every outcry against the oppression of some people by other people," stated Adler, "is the affirmation of the principle that a human being as such is not to be violated. A human being is not to be handled as a tool but is to be respected and revered."

82. "State of the Union Message, December 6, 1904," available at www.theodore-roosevelt.com/sotu4.html (accessed December 29, 2007).

83. His complaint oversimplified the problem. "We understand the United States holds that as the Winnebago Indian is now a citizen of Nebraska, the marriage question is one that should be taken up by the State. But the State does absolutely nothing," he testified, "evidence that the conditions are growing worse, and that no legal marriages are celebrated" (*Washington Post,* "Grand Jury Report on Conditions in Winnebago Reservation," December 3, 1904). See also how Schell became involved with the Winnebago in *Washington Post,* "Fleecing the Indians: Father Schell tells of Frauds Being Perpetrated," September 11, 1904.

84. "Angel DeCora Dietz," *Southern Workman,* March 1919, ADSF, HUA.

85. De Cora, "Angel DeCora—An Autobiography."

Chapter Eight

1. *Arrow,* Thursday, May 11, 1905, CCHS.

2. Curtis, "Foreword," *The Indians' Book,* 21.

3. Muncy found professional women progressives distinguished themselves from their male counterparts by inhabiting service positions for the underprivileged and disseminating esoteric or scientific knowledge (Muncy, "The Female Dominion"). According to Curtis's nephew, Al Bredenberg, Ethnomusicologist Charles Haywood said Curtis "served to introduce the study of American ethnic

music to a wide public." Bredenberg also notes that his aunt "stimulated interest in native crafts and art" (Bredenberg "Fight to Preserve Indian Culture").

4. *Arrow,* Dec 8, 1905, CCHS. He edited the periodical until 1899.

5. Curtis, "An American Indian Artist."

6. Ibid.

7. Curtis, The Indians' Book, 22.

8. During Indian Commissioner Morgan's tenure, Leupp was a correspondent for the *New York Evening Post* and had written the commissioner regarding "Elaine Goodale's case" (probably having to do with her reports on Wounded Knee) (Thomas J. Morgan Papers, RLM). See *Washington Post,* "Career of the New Indian Commisioner," December 11, 1904.

9. *Arrow,* May 4, 1905, CCHS.

10. Stephanson, *Manifest Destiny,* 82 .The theory tempered Spencer's survival of the fittest and the three stages of social evolution with Charles Darwin's random selection.

11. See also Ward for laissez faire's relationship to reform Darwinism.

12. *Arrow,* May 4, 1905, CCHS.

13. Adams, *Education for Extinction,* 307–33.

14. *Arrow,* May 4, 1905, CCHS.

15. Ibid.

16. Ibid.

17. Ibid.

18. *Saratogian,* "Miss Natalie Curtis's Talk in Saratoga," May 15, 1912, ADSF, HUA.

19. Curtis, "An American Indian Artist."

20. Government Documents, *Annual Report of the Commissioner of Indian Affairs,* 1907, 65–67.

21. Witmer, *The Indian Industrial School,* 50.

22. Rydell, *All the World's Fair,* 113–18.

23. De Cora to Mercer, January 17, 1906, Grace Sampson, 3315, CSR.

24. Ibid., "Application for Enrollment in a Non-Reservation School," "enrolled in New York City school, private instruction, for 3 months on November, 1905" (consent form signed by Angel," January 17, 1906, New York, NY).

25. *Arrow,* February 9, 1906, CCHS. Announcements also appeared in the *Indian Leader,* Feb 28, 1906, the *Southern Workman,* March 1906, and the *Indian's Friend,* newsletter for the National Indian Association (ADSF, HUA).

26. *Arrow,* March 23, 1906, CCHS.

27. Government Documents, *Annual Report of the Commissioner of Indian Affairs,* 1907, 65–67.

28. "Native Indian Art," *Arrow,* August 23, 1907, CCHS.

29. *Arrow,* April 27, May 18, and June 8, 1906, CCHS.

30. LR 1906: 48453, 11E3 7/26/5 Box 3152, NARA-DC RG 75.

31. Ibid.

32. Ibid.

33. Government Documents, *Annual Report of the Commissioner of Indian Affairs,*" 1907, 65–67. Angel mentioned the Persian Rug Factory in a letter to Carrie Andrus, 1909–1910 (ADSF, HUA).

34. "Application for Enrollment in a Non-Reservation School," "De Cora, Madelon (Hinpiwin) . . . was enrolled in Winnebago reservation school for 2 months and non-reservation school called 'Ethical Culture School,' New York City from Sept 1904–Sept 1906; consent form signed by Angel De Cora for 3 yrs, dated Aug. 27, 1906 at U.S. Indian School, Carlisle, Pa.," 3275, CSR.

35. *Arrow,* August 31, 1906, CCHS.

36. *The Nation,* "Congress of Americanists," September 29, 1906, ADSF, HUA.

37. A collection of letters from Boas to Alfred L. Kroeber on Congrès International des Américanistes letterhead shows Boas's involvement in the proceedings. Although the program had been mostly arranged, on May 8, 1906 he wrote: "I wish you would kindly send me some names of people whom you think might be interested in the Americanists Congress and who would contribute to our proceedings" (Boas, Franz 1858–1942 Correspondence, Paul Radin Papers, RLM. [these letters may have been from the Boas's correspondence archived with the American Philosophical Society]).

38. *The Nation,* "Congres of Americanists," September 29, 1906, ADSF, HUA.

39. Ibid.

40. Ibid.

41. Formerly, Charlotte van der Veer Quick, Osgood Mason is particularly known for her controversial relationship with Zora Neale Hurston.

42. Available at http://xroads.virginia.edu/~MAO1/Grand-Jean/Hurston/Chapters/patron.html (accessed December 29, 2007).

43. *The Nation,* "Congrès of Americanists," September 29, 1906, ADSF, HUA. "Professor Seler of the University of Berlin and Dr. Gordon of the University of Pennsylvania" followed Curtis and "discussed phases of the art of ancient America."

44. *Arrow,* November 9, 1906, CCHS.

45. Ibid., November 16, 1906.

46. Julia De Cora to Townsend, December 3, 1906, Klamath Agency, Oregon, JDSF, HUA.

47. The *Arrow* stated she was "renewing old friendships in New York City and suburban towns," December 28, 1906.

48. *Arrow,* January 11 and February 1, 1907. Angel participated as an advisor for the Standards. According to Witmer, students were also expected to participate in extracurricular activities (Witmer, *The Indian Industrial School,* 29). The student-run literary societies competed with each other. Boys belonged to either the Standard Literary Society or the Invincible Debating Society, while the girls chose between the Mercer and the Susan Longstreth literary societies (Longstreth was an early Quaker benefactress of the school).

49. *Arrow,* February 8, 1907, CCHS.

50. Ibid.

51. Ibid. The article stated: "About a year ago the Athletic Association foreseeing a successful season for the year 1906, and having a football team second to none in schools of its class—and above its class—conceived the idea that no better use could be made of its earnings in the field of athletics, than by erecting a building on the grounds that would be a credit to the school and at the same time afford an opportunity for the instruction of their fellow students in some line that in future years would revert to the profit of the individual."

52. *Arrow,* February 8, 1907, CCHS.

53. Ibid., Feb 1, 1907.

54. *Arrow,* February 8, 1907, stated that the prints were those "that have long years ago been drawn from publication and the plates destroyed." This indicates they were from McKenny-Hall Portrait Gallery, reproductions of original Indian portraits displayed by the Smithsonian Institution until they were destroyed by fire in 1865. See Horan, *The McKenny-Hall Portrait Gallery,* 278–92, for the Winnebago portraits.

55. Pohl, *Framing America,* 346. See also Hutchinson's "Unpacking the Indian Corner," in "Progressive Primitivism," PhD diss., 19–69.

56. Ibid. The Santa Fe style incorporates Hopi, Zuni, and Navajo design with European arts and crafts style.

57. Ibid.

58. *Arrow,* February 15, 1907, CCHS.

59. Ibid., March 1, 1907.

60. Ibid.

61. De Cora to Folsom, undated (probably early in 1907), ADSF, HUA.

62. Harvey, "Singularity of the Jamestown Exposition."

63. *Arrow,* March 8, 1907, CCHS.

64. Ibid., March 22, 1907.

65. Ibid., April 5, 1907.

66. Ibid. This supports Witmer's view of Leupp's influence at Carlisle. As she writes: "Although a step had been taken to preserve native art, twisted economic-oriented goals remained" (*The Indian Industrial School,* 78).

67. *Arrow,* April 19, 1907, CCHS.

68. Government Documents, *Annual Report of the Commissioner of Indian Affairs,* 1907.

69. Ibid.

70. *Talks and Thoughts,* May 1907, ASDF, HUA.

71. *Washington Times,* "The Indians Prosper," February 5, 1907, Library of Congress, at www.loc.gov/chroniclingamerica (accessed December 29, 2007). Also *The Indian's Friend,* reprinted in the *Arrow,* May 3, 1907, CCHS.

72. *Arrow,* June 7, 1907, CCHS.

73. Ibid., June 14, 1907.

74. De Cora to Folsom, undated (between May and July of 1907), ADSF, HUA.

75. Mary Sampson, 3288, CSR.

76. Madelon DeCora, 3275, CSR.

77. Government Documents, *Annual Report of the Commissioner of Indian Affairs*, 1907, 50–51.

78. Reprinted in the *Arrow*, June 21, 1907, CCHS (part of the *Times* article appeared verbatim in Leupp's annual report for 1907).

79. Ibid.

80. See Hutchinson on "the politics of dress" in "Modern Native American Art."

81. De Cora, "Native Indian Art," *Arrow*, CCHS.

82. Brasser, "In Search of Métis Art," 225. Floral motifs became more popular after the 1840s. Although they appear on some Winnebago items, they are more common among more northern native peoples. Brasser's study disputes 1960s scholarship equating floral designs with fur traders. He believes Catholic missionaries, who followed the fur trade routes, introduced the motifs, which were a "European folk art derivative." The route, beginning at the St. Lawrence River moving west to the Great Lakes region, shows that the "[s]mall and stylized designs were used by the French métis who came from the Great Lakes missions."

83. De Cora, "Native Indian Art." The front page shows two pictures taken inside the salon. The item was also printed in the *Native American, Reveille, Oglala Light, Indian's Friend, Indian News, Southern Workman, Chippewa Herald, Weekly Review*, and the *Indian School Journal* (ADSF, HUA).

84. See Hunter and Jacobus, *Modern Art Painting*.

85. This was Charles Lamere.

86. *Arrow*, September 27, 1907, CCHS.

87. *Washington Times*, July 28, 1907, Magazine Section, Image 48, Library of Congress, www.loc.gov.chroniclingamerica (accessed December 29, 2007).

88. *Southern Workman*, October, 1907, ADSF, HUA.

89. The efforts behind the Native art collection of the school's museum, maintained by Carrie Andrus, contributed to this change.

90. *Sun*, October 5, 1907, Page 8, Image 8, Library of Congress, www.loc.gov.chroniclingamerica (accessed December 29, 2007).

91. *Arrow*, November 1, 1907, CCHS.

92. *Indian's Friend*, November 7, 1907, ADSF, HUA. The National Indian Association was formerly the Women's National Indian Association.

93. *Atlanta Constitution*, "Of, For, By, and About Women," November 27, 1907.

94. Ewers to McAnulty, JEP, NAA.

95. Wm. H. Dietz, 1776 and 2863, CSR.

Chapter Nine

1. See Ann Brown, *Alice Barber Stephens*, and the "Alice Barber Stephens papers, 1884–1986," SIA. Alice was a skilled wood engraver. She studied art with Thomas Eakins in the first class that admitted women at the Pennsylvania Academy of the Fine Arts. In 1902 she received a commission to paint the portrait of Spain's Queen, Maria Christiana. She was a founder of the "Plastic Club," the first association in Philadelphia for women artists, including Cecelia Beaux and many of Howard Pyle's former students. She and her husband, along with Beaux and others, also

established the Fellowship of the Academy of Fine Arts in Philadelphia (The Plastic Club, http://plasticc.libertynet.org/history.html (accessed December 29, 2007), and The Rose Valley Museum, www.rosevalleymuseum.org (accessed December 29, 2007); *Olean Democrat,* "Women in the Artistic World," May 15, 1894; *Fitchburg Sentinel,* "A Talented Woman Artist," May 28, 1898; *Fort Wayne News,* "A Great Woman Artist," January 12, 1898; and *Newark Advocate,* "Honored by Queen of Spain," October 29, 1902).

2. The couple's residence, which still exists today, was compared to Frank Lloyd Wright's homes. See Rose Valley Historical Society for a fascinating glimpse of colony life, available at www.rosevalleymuseum.org (accessed December 29, 2007).

3. De Cora to Folsom, answered January 25, 1908, ADSF, HUA.

4. He took after his father, Henry Lewis Stephens, who was "an artist and photographer of the early American west" (*Daily Northwestern* [untitled] September 29, 1900, and www.rosevalleymuseum.org [accessed December 29, 2007]).

5. www.rosevalleymuseum.org (accessed December 29, 2007). He donated his Blackfeet collection to the University of Pennsylvania Museum.

6. *Arrow,* January 3, 1908, reported she went to Media, Pennsylvania, which borders Rose Valley, CCHS.

7. "Certificate and Record of Marriage," December 30, 1907, State of New Jersey. The waiting period may have been shorter in New Jersey.

8. The groom's residence is given as Atlantic City, New Jersey. Dietz might have lied to claim residency.

9. De Cora to Folsom, answered January 25, 1908, ADSF, HUA.

10. *Gettysburg Compiler,* "Carlisle Indian School in Danger," January 8, 1908.

11. Genevieve Bell conjectures that the "serious moral offense" might have had to do with the school's clerk, who "was found guilty of embezzling $1,416 from Carlisle funds on Mercer's watch" ("Telling Stories out of School," PhD diss., 84–86).

12. Ibid.

13. *Arrow,* January 24, 1908, CCHS.

14. Pratt to Olmstead, Denver, Colorado, January 24, 1908, WA MSS S-1174, Box 10, Folder 351, RHPP.

15. Ibid.

16. Boas to De Cora, Jan 17, 1908, Boas Correspondence, American Philosophical Society Archives.

17. This student was Hewett Ute (De Cora to Boas, Jan 23, 1908, American Philosophical Archives). Angel was requesting a copy of Kroeber's dissertation. Boas founded Columbia University's first PhD program in anthropology and Kroeber was his first doctoral student in 1901.

18. Boas to De Cora, Feb 5, 1908, American Philosophical Society Archives.

19. *Arrow,* February 21, 1908, CCHS.

20. Charles H. Dickson served as interim superintendent. See Bell, "Telling Stories out of School," PhD diss., 86. Friedman was hired for $2,500 per annum from Haskell Indian School, Lawrence, Kansas, where he served as assistant superintendent (*Star and Sentinel,* untitled, March 8, 1908).

21. Boas to De Cora, March 18, 1908, Boas Correspondence, American Philosophical Society Archives. Angel's old friend was probably Joseph Blackhawk, referred to earlier. At first considered one of Hampton's better students, like Julia St. Cry, he ended up "disappointing." David St. Cyr, Julia's brother, contributed to his decline, according to his school report (Joseph Blackhawk's student file, HUA). He also was an expert on Winnebago culture.

22. De Cora to Boas, March 21, 1908, ADSF, HUA, primary source unknown.

23. April 24, 1908, Boas to De Cora, Boas Correspondence, American Philosophical Society Archives. This is his last letter to Angel in this collection.

24. A lifelong friend of Edward Sapir, Radin was interested, as his colleague Kroeber said, in "how different individuals react and adjust themselves to a culture." His accomplishments include seminal studies of Winnebago culture, a study of South American Indians, the grammar of the Wappo Indians of California, Mexican kinship terms, social anthropology, the study of the Ojibwe, the "genetic relationship of North American Indian languages," a work on "primitive man as philosopher," a study of "the Italians of San Francisco," and *The Racial Myth* (1934), his attack on German fascism and antisemitism (PRP, RLM).

25. April, De Cora to Boas, ADSF, HUA, primary source unknown.

26. De Cora to Folsom, first of three letters marked "Spring of 1908," ADSF, HUA.

27. Ibid.

28. Ibid.

29. Wm. H. Dietz, 1776 and 2863, CSR.

30. De Cora to Folsom, first of three letters marked "Spring of 1908," ADSF, HUA.

31. Ibid., second letter marked "Spring of 1908."

32. Folsom addressed the note to "Joe." According to Hultgren, "Joseph Blackhawk was in the post graduate class in 1907–1908 studying agriculture," and the only other Joe at Hampton was a Pima student (Hultgren correspondence, 2004).

33. De Cora to Folsom, third letter marked "Spring of 1908," ADSF, HUA.

34. She is referring to author James Willard Schultz (1859–1947) who lived for many years with the Blackfeet Indians in Montana, "as an accepted member of their nation" (James Willard Schultz Papers, 1867–1969, Merrill G. Burlingame Special Collections). Perhaps Schultz and Charles Stephens were friends.

35. De Cora to Folsom, third letter marked "Spring of 1908," ADSF, HUA.

36. *Arrow,* May 15, 1908, CCHS.

37. *Washington Herald,* "Indian Art Discussed," May 13, 1908, Library of Congress at http://loc.gov.chroniclingamerica (accessed December 29, 2007), and *Indian's Friend,* June 1908, ADSF, HUA.

38. *Arrow,* May 15, 1908, CCHS, and Radin to Boas, May 28, 1908, Paul Radin Correspondence, Series 1, Box 1, 1901–1910, PRP, RLM.

39. Correspondence to Oscar M. Waddell, Dakota City, Nebraska, February 10, 1908, regarding whether Angel and Julia were competent as women and Indians to dispense with their allotments, source unknown, HHS.

40. Radin to Boas, May 28, 1908, Paul Radin Correspondence, Series 1, Box 1, 1901–1910, PRP, RLM.

41. Ibid.

42. Ibid. Hertzberg claimed LaMere became "a thoughtful anthropologist" after his work with Radin (*The Search for an American Indian Identity,* 113). Some today believe he sold valuable Winnebago artifacts without regard for their sacredness.

43. Boas correspondence to Radin, June 1, 1908, No. 463, American Philosophical Society Archives. A copy of this letter also appears in PRP, RLM

44. Ibid.

45. Reprinted from the *Pender Times* in *The Indian News,* September 11, 1908, HHS. On December 11, the *Carlisle Arrow* (CCHS) announced John Baptiste, a Winnebago and Carlisle graduate, would be working with Radin. (He actually attended Hampton.) "John Baptiste received an official appointment from the Smithsonian Institution accompanied by a railroad ticket and was ordered to report at once to Columbia college, New York City, where he will assist Professor Radin" (reprinted from the *Winnebago Chieftain*).

46. De Cora to Folsom, May 14, 1908, ASDF.

47. Frissell was the school chaplain until Armstrong died in 1893 (Hultgren and Molin, *To Lead and to Serve,* 41).

48. De Cora to Frissell, June 8, 1908 (the date is not in Angel's handwriting and probably indicates when Frissell answered it), ADSF, HUA.

49. *Arrow,* June 19, 1908, CCHS.

50. Ibid., June 12, 1908.

51. Addressed to "Editor the Arrow," dated Aug. 8, 1908, Washington, D.C., the *Carlisle Arrow* (first edition with the new name), September 11, 1908, CCHS.

52. *Plain Dealer,* "Indian Woman Famed as an Artist," July 2, 1908, ADSF, HUA.

53. *Southern Workman,* July 1908, ADSF, HUA.

54. Miller took the job in the beginning of May (*Arrow,* May 8, 1908), CCHS.

55. *Carlisle Arrow,* September 11, 1908, CCHS.

56. Ibid., October 23, 1908.

57. Reported in *Weekly Review,* January 30, 1909, ADSF, HUA. See also Power, *Report of the Twenty Sixth Annual Meeting of the Lake Mohonk Conference.*

58. *Carlisle Arrow,* October 30, 1908, CCHS.

59. Ibid., November 27, 1908.

60. According to Thompson, printing's "emphasis on craftsmanship" included limited, signed editions; handmade materials; heavy black "inking and impression" with red ink used for emphasis; "old-style face" text with Gothic type; relief illustrations and decorations and woodcut engravings; Gothic lettered title page with borders, including information about the book's creators and materials; and decorative borders around text and illustrations ("The Arts and Crafts Book," 115–48).

61. Ibid. Printers still emphasized the ideal of fine printing, but began to prefer a "lighter and more classical type style."

62. *Indian's Friend,* December, 1908, ADSF, HUA.

63. *Indian News,* December 1908, HHS.

64. *Carlisle Arrow,* January 29, 1909, CCHS.

65. See Moses for American Indian participants' perceptions of the Wild West shows (*Wild West Shows*).

66. From Pratt to William H. Taft, November 18, 1908, WA MSS S-1174, Box 10, Folder 352, RHPP.

67. The local town paper, the *Carlisle Volunteer*, reported: "Among the student body of the School of Industrial Art, Philadelphia, are two Indians, one a Sioux and the other of the Seneca tribe. They are Thomas Saul, or 'Wanyey' Speeding Arrow, and Rueben Charles whose Indian name, 'Gwee-yeh-is,' means Sundown. They have been awarded the Gillespie Scholarship by the Carlisle Indian school and are being trained in art. Saul is taking a course in illustrating and Charles will study interior decorating" (reprinted in the *Carlisle Arrow*, February 5, 1909, CCHS).

68. *Indian Craftsman*, February 1909, CCHS.

69. Witmer, *The Indian Industrial School*, 80.

70. The *Weekly Review* reprinted in the *Carlisle Arrow*, February 5, 1909, CCHS.

71. This was Pierre Paquette. His grandfather of the same name was the métis interpreter for the Winnebago at Portage, Wisconsin, and was murdered by a Winnebago just before Decorah died.

72. *Carlisle Arrow*, March 5, 1909, and *Indian Craftsman*, April 1909, CCHS.

73. Reprinted in the *Indian Craftsman*, April 1909, CCHS.

74. Ibid.

75. *Carlisle Arrow*, April 30, 1909, CCHS.

76. *Indian Craftsman*, February 9, 1909, CCHS.

77. From the *Carlisle Sentinel* reprinted in the *Carlisle Arrow*, May 7, 1909, CCHS. The *Judge* slanted toward Republican Party views, but was started by a cartoonist who came from the Democratic Party–biased *Puck Magazine*.

78. Her grandson is now in possession of the painting.

79. De Cora to Folsom, answered "May 3 '09," ADSF, HUA.

80. Ibid.

81. See Davis, "Headhunting William Jones," www.okara.com/html/headhunting .html (accessed December 29, 2007). The murder of Jones tragically illustrates the era's craze for indigenous arts and crafts—whether for the market place *or* the museum.

82. "Mr. Leupp's Resignation and President Taft's Reply," *Carlisle Arrow*, June 25, 1909, CCHS.

83. Adams, *Education for Extinction*, 308.

84. "Carlisle Roster of Employees," *Carlisle Arrow*, September 17, 1909, CCHS.

85. *Indian Craftsman*, September 1909, CCHS.

86. *Every Evening*, July 26, 1909, reprinted in the *Carlisle Arrow*, September 10, 1909, CCHS.

87. *Evening Wisconsin*, August 17, 1909, reprinted in the *Carlisle Arrow*, October 1, 1909, CCHS.

88. *Carlisle Arrow*, November 5, 1909, CCHS.

89. Ibid., October 1 and December 17, 1909.

90. Ibid., January 21, 1910.

91. Letter from the CCHS.

92. Ibid.

93. De Cora to Andrus, answered "Jan — 26–10," ADSF, HUA. Note on bottom: "Persian Rug Factory/894–900 Broadway/New York."

94. *Evening Sentinel,* "Changed Name of Indian Magazine," January 31, 1910, CCHS.

95. *Carlisle Arrow,* February 4, 1910, CCHS.

96. Ibid., February 11, 1910.

97. Ibid., January 28 and February 25, 1910.

98. Ibid., February 18, 1910.

99. Ibid., March 18 and 25, 1910.

100. *Red Man,* March 1910, 6, CCHS.

101. *Carlisle Arrow,* April 1, 1910, CCHS.

102. Ibid., April 22, 1910.

103. Ibid.

104. On May 17, 1910 Angel and Dietz lived in a residence at the Carlisle Indian School, while Angel's half sister, Grace Sampson, was a student (Dietz, head of household, aged 25. Angel, wife, 30, 1910 Pennsylvania federal census, Cumberland Co., Carlisle, ED 32, household 11). The Nebraska Winnebago Annuity Pay Roll for 1910 shows Angel's age to be 42.

105. *Carlisle Arrow,* June 17 and September 9, 1910, CCHS.

Chapter Ten

1. *Carlisle Arrow,* October 7 and November 4, 1910, CCHS; correspondence with Landis, 2005; and Cove Hill Boathouse, www.kathymaxwell.com/pages/ch_boathouse.shtml (accessed December 29, 2007).

2. *Carlisle Arrow,* "Carlisle Roster of Employees," September 16, 1910, CCHS.

3. *Wichita Daily Eagle,* "The Big Ball Game," November 24, 1904, KSHS.

4. *University Life,* December 1904, 17, Friends' University Archives.

5. *Wichita Daily Beacon,* "Their Athletic Boards Clash," November 25, 1904, 3, KSHS.

6. Ibid. Fairmont protested before the game that they were not given their right to approve the players list from Friends, as ordered by the Topeka conference rules. The December 1904 issue of Fairmount's *Sunflower* called Dietz their rival's "imported halfback" (who was also penalized for "slugging"). It featured a lengthy article titled, "Honesty in Football," reprinted from the *Outing.* It criticized the use of professional players and seems to be a thinly veiled attack on Friends' use of Dietz (*Sunflower,* 4–7, 12–13, Wichita State University Library, Special Collections).

7. *Wichita Daily Beacon,* "Deitz [*sic*] Was Not a Chilocco Man," November 26, 1905, and "May Be Made a Test Case," November 28, 1905, KSHS.

8. *University Life,* January 1905, 12. He was listed as an unclassified major for the 1904–1905 academic year (*Friends University Bulletin,* June 1905, 55).

9. Steckbeck, *Fabulous Redmen,* 8, and the *Carlisle Arrow,* September 30, 1910, CCHS.

10. He is listed simply as "Lone Star" on the official team roster for the 1910 and 1911 seasons (Steckbeck, *Fabulous Redmen,* 81, 85, and 137).

11. See Oriard, *Reading Football,* for a history of football as "spectacle."

12. *Carlisle Arrow,* October 7, 1910, CCHS.

13. Ibid., October 7, 1910.

14. Ibid., October 14, 1910.

15. John C. Ewers, late senior ethnologist for the Smithsonian, wondered how Lone Star could have been "both student and faculty member at the same time at Carlisle." He concluded: "Football at the Indian schools (and probably at others too) in Lone Star's days was surely not subject to the rigid eligibility rules that characterize interscholastic and intercollegiate athletics today" (correspondence to Sarah McAnulty, November 22, 1974, JEP, NAA).

16. *Evening Sentinel,* untitled, December 8, 1910, CCHS. Steckbeck said that between 1907 and 1913, "eligibility rules" for Carlisle's football team were in effect (*Fabulous Redmen,* 68).

17. *Carlisle Arrow,* November 4, 1910. CCHS.

18. "Orientalism in Dress: Edwardian Fashion," at www.fashion-era.com/ orientalism_in_dress.htm (accessed December 29, 2007).

19. *Carlisle Arrow,* November 11, 1910, CCHS.

20. Steckbeck, *Fabulous Redmen,* 84.

21. *Evening Sentinel,* untitled, December 8, 1910, CCHS.

22. *Carlisle Arrow,* December 23, 1910, CCHS.

23. Her Christmas postcard reads: "Dear Carrie—This is just to wish you a Merry Xmas & a Happy New Year—somewhat in person—Angel De Cora Dietz," ADSF, HUA.

24. *Carlisle Arrow,* January 13, 1911, CCHS.

25. *Arrow,* November 8, 1907, and May 29, 1908, CCHS.

26. She married Louis Big Bear by 1932 and George Whitesnake (a Wisconsin Winnebago) by January 1, 1937 (Winnebago Census, June 30, 1917, April 1, 1932, January 1, 1937, http://ancestry.com [accessed December 29, 2007]).

27. *Carlisle Arrow,* February 24, 1911, CCHS.

28. De Cora to Folsom, March 1, 1911, ADSF, HUA.

29. See 1910 Pennsylvania federal census, already mentioned.

30. She may have been referring to Louisa Sampson's granddaughter Angeline Little Beaver, born about 1903.

31. *Marion Daily Star,* untitled, March 21, 1911.

32. *The Red Man,* March 1911, CCHS.

33. See McCormick on the progressives' failure to achieve the degree of social justice expressed by their rhetoric ("Evaluating the Progressives").

34. Hertzberg, *The Search for an American Indian Identity,* 307–308.

35. Ibid.

36. The possibility has crossed the author's mind that Dietz might not have been strictly heterosexual, if at all.

37. *Carlisle Arrow,* April 7, 1911, CCHS.

38. "A new tennis court has been made in the rear of Mr. Deitz's [*sic*] home. It is the only 'skin' court we have," *Carlisle Arrow,* May 12 and May 26, 1911, CCHS.

39. De Cora to Folsom, April 27, 1911, ADSF, HUA.

40. Ibid.

41. "The Donnelly Collection of Presidential Orders," www.conservativeusa.org/eo/1904/feb27.htm (accessed December 29, 2007). In 1914 Baldwin was promoted as clerk to a salary of $1,200 to $1,400 (*Washington Post,* July 26, 1914).

42. 1870 Minnesota federal census, Hennepin Co., Maple Grove, 1880 and 1900 Minnesota federal census, Hennepin Co., Minneapolis. Marie died on May 21, 1952, from a cerebral hemorrhage. She is buried at Forest Lawn Cemetery in Los Angeles (State of California Certificate of Death, Marie Lillian Bottineau Baldwin).

43. Bottineau's French-Canadian paternal uncle worked on the Long Prairie reservation with the Winnebago in 1850 (1850 Minnesota Territorial Census).

44. See Neill, *History of Hennepin County*; Holcombe and Bingham, *Biography of Polk County Minnesota*; Stevens, *Personal Reflections of Minnesota*; Williams, *A History of St. Paul*; and W. H. Folsom, *Fifty Years in the Northwest* on the Bottineau family. Marie's father represented Ojibwe Chief Little Shell during the twelve-year-long Turtle Mountain treaty (1892–1904). In 1863 Marie's paternal grandfather, Pierre Bottineau, signed the treaty of the Red Lake Chippewas. He and his son, John B., located a large number of métis from the Twin Cities area of Minnesota along Red Lake River and Clearwater River. In 1900 Marie lived with her widowed father and his grandson in Minneapolis. She was married by 1886, but her husband's identity is unknown. See also Houghton, 126–28 and 173.

45. *Carlisle Arrow,* June 9, 1911, CCHS.

46. Ibid., September 15, 1911, CCHS.

47. *Christian Intelligencer,* December 6, 1911, from Elaine Goodale Eastman's Scrapbook, No. 7, Elaine Goodale Eastman Papers, Smith College Archives.

48. *Kindergarten Review,* December 1911, from Elaine Goodale Eastman's Scrapbook, No. 7, Elaine Goodale Eastman Papers, Smith College Archives.

49. *New Bedford Standard,* September 16, 1911, from Elaine Goodale Eastman's Scrapbook, No. 7, Elaine Goodale Eastman Papers, Smith College Archives.

50. Steckbeck, *Fabulous Redmen,* 85.

51. *Carlisle Arrow,* November 10, 1911, CCHS.

52. Steckbeck, *Fabulous Redmen,* 85.

53. Program from the Carlisle Opera House, April 15–16, 1912. The night's entertainment also included: "The Dark Skin Dandies: The Carlisle Elks Minstrels," (Pamphlet, P4–9, CCHS).

54. "Preserving the Indian's Art" retains more of the original *Sun* interview than does the *Literary Digest* article (*Philadelphia Press,* January 7, 1912, Lila Connolly Papers, CCHS; "How Art Misrepresents the Indian," *Literary Digest,* January, 27,1912). Also reprinted in the *Carlisle Arrow,* April 5, 1912.

55. Pittsburgh's *Press,* January 24, 1912, ran a summary of the *Sun*'s interview. It was illustrated with Hensel's cropped photograph of Angel, with a small Indian man in a headdress in the foreground painting on an easel. The caption reads "Creates New Indian Art" (ADSF, HUA).

56. Andrew J. Darling shared a scan of the photograph he inherited from his grandmother, Mollie Gorton Darling, with the author. Smith College Archives also has a copy.

57. "How Art Misrepresents the Indian."

58. Vizenor's concept, "manifest manners" (akin to Said's "orientalism"), suits Dietz well as he flaunted pseudo esoteric knowledge of the perfectly coifed and authentically attired American Indian (or "indian" as a postcolonial Vizenor writes it). Moreover, Dietz exposed his deep psychological, modern-era alienation in his clear identification with his over-the-top aestheticized construct. As Deloria states: "The quest for an authentic Other is a characteristically modern phenomenon, one that has often been played out in the contradictions surrounding America's long and ambivalent engagement with Indianness" (*Playing Indian*, 101). See also Berkhofer, Jr., *The White Man's Indian.*

59. Waggoner, "Reclaiming James One Star."

Chapter Eleven

1. Iverson, *Carlos Montezuma,* 65. Iverson found McKenzie realized that "an association of educated Indians could do much to alleviate the Native American condition" while studying at the University of Pennsylvania.

2. Hertzberg, *The Search for an American Indian Identity,* 36.

3. Reprinted in the *Carlisle Arrow,* October 27, 1911, CCHS.

4. Hertzberg, *The Search for an American Indian Identity,* 31.

5. Ibid., 71.

6. Ibid.

7. Ibid., 59.

8. "The First National Conference of Indians: By F. A. McKenzie," *Red Man,* November 1911, 109–17, CCHS.

9. Hertzberg, *The Search for an American Indian Identity,* 72.

10. Ibid., 60.

11. Iverson, *Carlos Montezuma,* 73.

12. Wilson, *Ohiyesa,* 157.

13. *Red Man,* November 1911, 109–17, CCHS.

14. *Ohio State Journal,* untitled, October 14, 1911, ADSF, HUA. Apparently referring to her art department's relationship with Philadelphia's School of Industrial Arts, Angel "pointed out that many Indians are given technical training in art schools in return for the help they give other students in the way of original suggestions in designing."

15. "Native Indian Art, By Mrs. Angel De Cora Deitz," Series 2: Publications, SAI Papers, GLSU.

16. Ibid.

17. Ibid.

18. Charles Eastman, "Indian Handicrafts," and "'My People': the Indians' Contribution to the Art of America." (The source of the letter is erroneously labeled "SAI journal, 1914" in ADSF).

19. See Hutchinson, "Indigeneity and Sovereignty" for a view of Goodale Eastman and Angel in regard to Native American art.

20. Hertzberg, *The Search for an American Indian Identity*, 66–67.

21. Ibid., 46, 67. Roe Cloud "was one of the most balanced and temperate men in the organization . . . firm but not dogmatic," according to Hertzberg. He paid his own way as he became educated and was not inspired by the industrial training in Indian schools. In 1915 he established the only American Indian run high school in America, the Roe Indian Institute in Wichita, Kansas (Adams, *Education for Extinction*, 152).

22. Hertzberg, *The Search for an American Indian Identity*, 76–77.

23. *Washington Post*, untitled, November 5, 1911.

24. Reprinted in the *Carlisle Arrow*, October 27, 1911, CCHS.

25. Mrs. Angel Decora-Deitz, October 23, 1911, Parker Correspondence, SAI Papers, GLSU.

26. Ibid.

27. Ibid.

28. Parker Correspondence, November 23, 1911, SAI Papers, GLSU.

29. De Cora to Folsom, Dec. 22, 1911, ADSF, HUA.

30. *Carlisle Arrow*, January 26, 1912, CCHS.

31. See Gere, "An Art of Survivance," 672, for a list of accomplished Carlisle art students.

32. According to Hultgren, "Kidnapping and abduction do not appear on records or in the *Southern Workman*" (correspondence with author, February 23, 2004).

33. De Cora to Folsom, January 29, 1912, ADSF, HUA.

34. Hultgren and Molin, *To Lead and to Serve*, 51. See also Tingey, "Indians and Blacks Together," PhD diss., 320–28.

35. Tingey, "Indians and Blacks Together," PhD diss., 320–28.

36. Lindsey, *Indians at Hampton Institute*, 253. See also Tingey, "Indians and Blacks Together," PhD diss., 324.

37. For unknown reasons, Sloan claimed he graduated from Carlisle. "Sloan was a staunch admirer of General Pratt, whom he credited as the inspiration of 'my life, my present career, my ambition in life'" (Hertzberg, *The Search for an American Indian Identity*, 46).

38. Hultgren and Molin, *To Lead and to Serve*, 52.

39. Ibid.

40. Part II, Series I, Correspondence, reel 8, October 10, 1912, SAI Papers, GLSU.

41. *Carlisle Arrow*, "Mrs. LaFlesche, Mrs. Deitz, Anna Hauser, Sadie Ingalls, Jeanette Pappin, and Leila Waterman, left last Tuesday for Columbus, Ohio, to attend the Indian Congress," October 4, 1912, CCHS. Charles Eastman was also absent.

42. School of Industrial Art of the Pennsylvania Museum: Circular of the Art Department (School of Applied Art) 1912–1913, from JEP, SAA.

43. *Quarterly Journal of the Society of American Indians* 1 (January–April 1913): 71–73.

44. Iverson, *Carlos Montezuma*, 107.

45. Part II, Series I, Correspondence, reel 8, October 10, 1912, SAI Papers, GLSU.

46. *Indian News,* December 1914, 113, HHS.

47. Hertzberg, *The Search for an American Indian Identity*, 99. Lindsey erroneously attributes this resolution and discussion to the 1913 conference (*Indians at Hampton Institute*).

48. Hertzberg, *The Search for an American Indian Identity*, 81.

49. Baldwin to Parker, November 18, 1913, Parker Correspondence, SAI Papers, GLSU.

50. Ahern stated Angel "felt driven from the Indian Service" ("An Experiment Aborted," 301, fn 58). However, she was not driven from the service as much as the job she signed up for was not supported after Leupp's retirement.

51. Ibid., 283.

52. Ibid., 288.

53. Baldwin to Parker, November 18, 1913, Parker Correspondence, SAI Papers, GLSU.

54. *Washington Post,* "100 Degrees for 47," May 24, 1914. and "Portias Among Graduates," May 23, 1915.

55. Lindsey states that "neither [Hampton] institute nor SAI records reveal exactly how far the society was involved in the moves against Hampton," *Indians at Hampton Institute,* 256.

56. Ibid., 257.

57. Julia De Cora to Andrus, March 28, 1956, JDSF, HUA.

58. Hultgren and Molin, *To Lead and to Serve,* 53–54.

59. Ibid., 55.

60. *Carlisle Arrow,* March 22, 1912, CCHS.

61. *Red Man,* April 1912, 331–32, CCHS.

62. *Carlisle Arrow,* February 2 and March 8, 1912, CCHS.

63. Sallie, whose Indian name was *Witie* ("Face Woman"), first married Edward Yankton and then, second, John Eagle Horse, both of Pine Ridge (Pine Ridge census records, Oglala Lakota College).

64. Letter from Carlisle, Pa., March 29, 1912, reprinted in *Spokesman Review,* June 26, 1919.

65. *Saratogian,* "From Miss Natalie Curtis's talk in Saratoga," May 15, 1912, ADSF, HUA.

66. *Carlisle Arrow,* July 4, 1912, CCHS.

67. *Carlisle Arrow,* September 6, 1912, CCHS. According to the reporter, this project along with "Thorpe's victory at Stockholm" shows "Carlisle is receiving unusual recognition from abroad this year." See also *Carlisle Sentinel,* "More Carlisle Indians Honored," September 6, 1912, CCHS.

68. Parker Correspondence, September 6, 1912, SAI Papers, GLSU.

69. *Carlisle Sentinel*, "Indians are Practicing Football Good and Hard," September 17, 1912, CCHS.

70. See Government Documents, "Carlisle Indian School," *Hearings Before the Joint Commission of the Congress of the United States, Sixty-third Congress Second Session, to Investigate Indian Affairs*, vols. 1–3.

71. Steckbeck, *Fabulous Redmen*, 92.

72. With credit given to both Warner and Friedman, the Wannamaker store in Philadelphia exhibited Thorpe's medals. "As befitting their character, we are showing them, with a Guard of Honor, on the Main Floor, New Building, North Entrance, in front of the Burlington Arcade" (*Sentinel*, September 17, 1912, CCHS).

73. *Carlisle Arrow*, January 24 and January 31, 1913, CCHS.

74. As far as the author could determine, the first use of "red-skins" as a sport term in print referred to Carlisle football players. A Chicago reporter quoted the term for a November 12, 1898, piece on Carlisle: "Every time the reports of Indian games are printed hundreds of Chicagoans are heard to express a desire to get them out west. 'Jimminy, I wish we could get those Indians to play out here,' 'Oh, how I would like to see those redskins play,' and other expression of that sort are heard every time the news of an Indian battle is printed" (*Daily Review*).

75. *Inquirer*, "Indian Art as Valuable Asset," February 2, 1913, ADSF, HUA.

76. *Red Man*, February 1913, CCHS.

77. *Carlisle Arrow*, February 21, 1913, CCHS.

78. Ibid., March 7, 1913.

79. Ibid., April 25, 1913.

80. Ibid., September 5, 1913.

81. *Carlisle Arrow*, September 26, October 3, and October 10, 1913, CCHS.

82. *Indian News*, September 1912, CCHS.

83. *Adams County News*, "School Gets Diploma," September 6, 1913.

84. Hertzberg, *The Search for an American Indian Identity*, 112.

85. Ibid., 113.

86. See *Washington Post*, "Chief Gives 'War Bundle,'" November 3, 1914.

87. Hertzberg, *The Search for an American Indian Identity*, 113.

88. Ibid., 114.

89. "Indian School Recollections," An Interview with Henry Flickinger by Helen F. Norton, GI FLI OH7, CCHS.

90. Government Documents, "Carlisle Indian School," *Hearings Before the Joint Commission of the Congress of the United States, Sixty-third Congress Second Session, to Investigate Indian Affairs*, vols. 1–3.

91. *Carlisle Arrow*, October 31, 1913, CCHS.

92. *Carlisle Sentinel*, October 27, 1913, CCHS, and Steckbeck, *Fabulous Redmen*, 99. See also Jenkins's wonderful, well-researched history of Carlisle football (*The Real All Americans*). Unfortunately, the book came out too late to incorporate in this work.

93. Steckbeck, *Fabulous Redmen*, 100.

94. Ibid., 102.

95. *Carlisle Arrow,* November 14, 1913, CCHS.

96. *Atlanta Constitution,* "Cubist Art Founded by American Indian," December 5, 1913.

97. Curtis, "The Perpetuating of Indian Art," 629–30.

98. A neighbor remembered Dietz walked his dogs a few times a week. One day one of the wolfhounds attacked his father's foxhound and almost killed it ("An Interview with Henry Flickinger," CCHS).

99. *Carlisle Arrow,* January 23, 1914, CCHS.

Chapter Twelve

1. Herbert Welsh and Henry Spackman Pancoast founded the Indian Rights Association, a powerful non-Native-run organization for protecting the rights of American Indians, in Philadelphia in 1882.

2. Government Documents, *Hearings Before the Joint Commission of the United States to Investigate Indian Affairs,* Part 2, 1017–18, 1342, and 1372. Bell states 276 students signed the petition ("Telling Stories out of School, PhD diss., 92).

3. *Star and Sentinel,* "Carlisle Superintendent Ordered to Return to Post," January 31, 1914, CCHS.

4. Government Documents, *Hearings,* Part I, 5.

5. Ibid., Parts 1–3. This evolved into eighteen reports, published in three large volumes. The reports consist of investigations conducted on reservations, in Indian schools, the BIA's medical service, the Board of Indian Commissioners, and so on.

6. Some speculated that the investigation "was all about finding a scapegoat for the Jim Thorpe Olympic medal debacle" (Bell, "Telling Stories out of School, PhD diss., 95–96). This was not the focus of the commissioners or Linnen. The investigation did disclose that Warner knew about Thorpe playing professional baseball and sent him to the Olympics anyway.

7. *Washington Post,* "'Jim' Thorpe Professional, Pleads Guilty to Charge," January 28, 1913.

8. *Adams County News,* "Indian School Trouble Again," January 31, 1914.

9. Ibid.

10. *Adams County News,* "Will Not Move Indian School, February 7, 1914.

11. Government Documents, *Hearings,* 1368.

12. *Gettysburg Times,* "Probers Visit Indian School," February 7, 1914.

13. *Gettysburg Times,* "Irregularities at Indian School," February 10, 1914.

14. Ibid.

15. Ibid.

16. Government Documents, *Hearings,* 1340.

17. Ibid., 999.

18. *Adams County News,* "Friedman Says No Charges Yet," February 21, 1914.

19. Government Documents, *Hearings,* "Testimony of Mrs. Angel Dietz," 1106–11.

20. Bell states Winnebago Ethel Greenhair was sent home for being in a "delicate condition" ("Telling Stories out of School, PhD diss., 273–74). According to Bell,

after Greenhair's mother died of tuberculosis, she came to Carlisle and "spent a good deal of time on Outings" including from 1911–1914. In April of 1915, Greenhair was discharged. Her baby boy died, and his father, Sterling Snake, hung himself on April 22. Ethel, the granddaughter of Good Old Man, died the next year. Heirship Findings 1909–1914, Roll 86, 324–28, Register of Births and Deaths, 120, Roll 84, NARA-CPR RG 75, and *Winnebago Chieftain,* "Local Happenings," April 1, 1910.

21. Government Documents, *Hearings,* 1110.

22. Ibid., 1388.

23. Ibid., 1167.

24. Ibid., 1169.

25. Pratt's campaigning may have contributed to the demise of the Indian art department, though Pratt received permission from Lipps to have Angel hand color some "before and after" Carlisle student photographs (Lipps to Pratt, August 11, 1914, RHPP).

26. Government Documents, *Hearings,* 1277.

27. Ibid., 1094.

28. Ibid., 1337.

29. Ibid.

30. Ibid., 1365.

31. Ibid.

32. Ibid., 1377.

33. Ibid., 1342.

34. Ibid., 1374.

35. Ibid., 1387.

36. *Adams County News,* "Hear Complaints," February 13, 1914. Pratt's complaint about the "curio trust fund" was not investigated.

37. A newspaper clipping (source unknown) reported that the spanking incident was the main reason for his suspension (correspondence, Reel 8, Part II, Series 1, SAI Papers, GLSU).

38. Government Documents, *Hearings,* 1379 and 1390.

39. *Gettysburg Times,* "Suspend School Superintendent," February 13, 1914.

40. *Evening Sentinel,* "Friedman Suspended," February 13, 1914. He also said the "bill founding the school provided that it should come under military supervision and the inquiry has convinced many members of the commission that this should be done speedily."

41. De Cora to Andrus, March 24, 1914, ADSF, HUA.

42. Nori confessed he had destroyed and changed fraudulent government vouchers "by intimidation and admonishment of Friedman." Nori said he placed the money in an envelope and delivered it to Friedman and several hundred dollars disappeared in this fashion. Linnen believed Friedman tried to make Nori "the 'goat' by having him arrested for embezzlement and by having his premises searched under a search warrant" (Government Documents, *Hearings,* 1386–87).

43. *Adams County News,* "Employees Did Not Testify," March 28, 1914.

44. *Spokesman Review,* "Dietz Letters Go to U.S. Jury," June 26, 1919.

45. James One Star, 5682, CSR.

46. Ibid.

47. RG 34 Regular Army enlisted personnel, One Star, James, August 9, 1892; PRD 4651, 1531545: Indorsement to Richard W. Pratt, June 9, 1909 and 1445230: Indorsement to M. K. Sniffen, October 30, 1908, Roll A; summary of One Star's discharge is recorded in RG 34 Document File, 4435–37, Box 39, September 19, 1894.

48. General Correspondence, Copies of Misc. Letters Sent, vol. 77, Feb. 28–April 6, 1914, Series 6, Box 74, NARA-CPR RG 75.

49. *Carlisle Arrow,* April 10, 1914, CCHS.

50. *Carlisle Arrow,* April 17, 1914, CCHS.

51. *Adams County News,* "More Trouble at Carlisle School," May 2, 1914.

52. *Washington Post,* "President of Carlisle A.A.," May 10, 1914.

53. *Adams County News,* "School Trouble," May 16, 1914.

54. *Star and Sentinel,* "Indian School Head May Not Be Prosecuted," July 11, 1914.

55. *Adams County News,* "Friedman Wants Investigation," July 11, 1914.

56. Ibid.

57. *Cumberland Advocate,* "Dietz-Johnson Wedding, December 19, 1907"; *Rice Lake Chronotype,* "On the Street," October 8, 1909, and "Lest You Forget," October 15, 1907, and 1910 Wisconsin census.

58. *Barron County Shield,* untitled, March 13, 1908, and Barron County Court Records, March 7 and 9, 1908, Stout University Archives, Wisconsin.

59. *Carlisle Arrow,* October 30, 1914, CCHS.

60. *Carlisle Arrow,* September 11 and 18, 1914, CCHS.

61. *Wisconsin State Journal,* "The Indian Girl Must Have Public Education," October 9, 1914, ADSF, HUA, and the *Madison Democrat,* "Women's Club Holds Session in Honor of Feminine Delegates to Indian Conference," October 11, 1914.

62. Ibid.

63. *Carlisle Arrow,* October 30, 1914, CCHS.

64. *Carlisle Arrow,* November 20, 1914, CCHS.

65. Smith, Page, *America Enters the World,* 431–82.

66. Hofstadter, Miller, and Aaron, *The United States,* 597.

67. Smith, Page, *America Enters the World,* 339.

68. Ibid., 499.

69. Ibid., 813, and Government Documents, Woodrow Wilson's speech to Congress, April 2, 1917.

70. *Washington Post,* "Emblem is Thunder Bird," November 1, 1914.

71. Ibid.

72. *Carlisle Arrow,* December 18, 1914, CCHS.

73. Ibid.

74. Hertzberg, *The Search for an American Indian Identity,* 128.

75. Ibid.

76. Parker to Mrs. Angel Decora-Deitz, Dec. 16, 1914, Parker Correspondence, SAI Papers, GLSU.

77. *Carlisle Arrow,* December 18, 1914, HHS.

78. *Adams County News,* "Will Push Charges," December 19, 1914.

79. *Spokesman Review,* "Dietz Letters Go to U.S. Jury," June 26, 1919.

80. *Rice Lake Chronotype,* untitled, December 24, 1914. On January 3, 1915, the Oakland, California *Tribune,* in an untitled article, also announced Dietz "will probably be chosen to coach the 1915 Carlisle Indian School team."

81. McGillis, "Athletic Banquet and Reception," *Carlisle Arrow,* January 8, 1915, CCHS.

82. Smith, Page, *America Enters the World,* 437.

83. *Mountain Democrat,* "Is Wrong Emblem," January 2, 1915.

84. *Indian News,* January, 114, HHS, from the *Christian Science Monitor.* The Smithsonian ethnologist was F. W. Hodge.

85. Ibid.

86. Ibid., 115.

87. Hiram Chase stated early on in SAI meetings, "there is one failing in these institutions. The Indian should be taught the history of his race" (Hertzberg, *The Search for an American Indian Identity,* 68).

88. *Carlisle Arrow,* April 23, 1915, CCHS.

89. *Adams County News,* "Say They Burned Public Records," January 16, 1915. The prosecution only found $5.72 missing for number three.

90. De Cora to Folsom, January 18, 1915, ADSF, HUA.

91. *Chicago Daily News,* "Efforts Are Made to Restore Indian Art," January 20, 1915.

92. *Carlisle Arrow,* February 26, 1915, CCHS.

93. *Carlisle Arrow,* February 5, 1915, CCHS.

94. *Carlisle Arrow,* March 5, 1915, CCHS.

95. *Carlisle Arrow,* February 26, 1915, CCHS. Steckbeck stated the farewell celebration signified "the end of the trail" for the Red Men (*Fabulous Redmen,* 116).

96. Pine Ridge Agency, Trust Responsibilities Records, Series 124, Registers of Unpaid Annuities, 1892–1918, pages 24, 29, and 116, NARA-CPR RG 75.

97. See Waggoner, "Reclaiming James One Star."

98. The affidavits are included in "In the Matter of the Estate of W. W. Dietz," State of Wisconsin, County Court of Barron County (courtesy of James L. Hansen, WSHS).

99. Lipps began as a teacher in the Indian service in 1898. He went on to become a superintendent at a school in Utah, and later its supervisor.

100. "The Last Word," available at www.geocities.com/Athens/Acropolis/2216/clsctexts/Hubbard_Lusitania.htm (accessed December 29, 2007).

101. *Star and Sentinel,* "Lipps Made Head of Carlisle," May 15, 1915, and *Adams County News,* "Hear Testimony," May 15, 1915. The prosecution called Margaret Buffalo and Susie Wallace who claimed that money they had given to the men for safekeeping had never been returned to them.

102. *Star and Sentinel,* "Friedman Goes Free," June 19, 1915.

103. *Adams County News,* "Clean Slate for Moses Friedman," October 23, 1915.

104. *Carlisle Arrow,* July 30, 1915, CCHS.

105. Sargent, *Life of Elaine Goodale Eastman*, 100–102.

106. "Oahe: A Camp for Girls," Third Season, July and August, 1917, Elaine Goodale Eastman, HUA.

107. Ibid.

108. Sargent, *Life of Elaine Goodale Eastman*, 98.

109. *Carlisle Arrow*, September 17, 1915, CCHS.

110. De Cora to Andrus (answered? May 1, 1916), ASDF, HUA.

111. Roger K. Todd to Sarah McAnulty, July 25, 1974, JEP, SAA.

112. *Carlisle Arrow*, November 19, 1915, CCHS.

113. *Southern Workman*, December, 1915, ADSF, HUA. This item also covers Dietz's new job.

Chapter Thirteen

1. *Seattle Post Intelligencer*, "Three Views of Unique Pullman coach," December 9, 1915, Suzzallo Library, University of Washington, Seatttle.

2. *Pow Wow*, 6:2 (November, 1915) 8–10, JEP, SAA.

3. *Grand Rapids*, "Brother of John Dietz Dies," December 29, 1915.

4. W. W. Dietz was not feeling well for a few weeks after tripping over a pipe in the dark on a train depot platform (*Rice Lake Chronotype*, "Obituary," May 22, 1913, July 15, 1913 (untitled), and "W. W. Deitz" [*sic*], December 23, 1915).

5. *San Francisco Chronicle*, "William Lone Star Dietz May Coach California Football Eleven," December 25, 1915, from Wm. H. Dietz, 1776, CSR.

6. Newspaper clipping (unknown source), "Washington State University Beats Brown in South by 14 to O," Pasadena, January 1, [1916]; written in by hand: "Dietz is Getting a Rep[?] out here[?] on the coast," from Wm. H. Dietz 1776 and 3863, CSR.

7. De Cora to Folsom, January 27, 1916, ADSF, HUA.

8. *Edwardsville Intelligencer*, "A German Indian is Dietz," March 22, 1916.

9. *Pow Wow* 6:2 (November, 1915): 8–10, JEP, SAA.

10. *American Indian Magazine* 4: 183–85.

11. *Carlisle Arrow*, January 7, 1916, CCHS.

12. The film was released December 27, 1918. Only the 1923 remake (with a cameo by young John Wayne) is remembered ("Internet Movie Database," *Brown of Harvard*, www.imdb.com/title/tt0008932 [accessed December 29, 2007]).

13. *Middletown Daily Times*, "Theatrical," May 4, 1916.

14. Santa Barbara preceded Hollywood as the center of movie making.

15. *Lincoln Daily Star*, untitled, January 7, 1917.

16. Baldwin to Parker, August 26, 1916, Parker Correspondence, SAI Papers, GLSU.

17. *American Indian Magazine* 4 (October–December, 1916): 213–68.

18. *Indian News*, February 1916, reprinted from the *Indian School Journal*, HHS.

19. De Cora to Folsom, ADSF, HUA; note in another's handwriting reads, "1915?" Louisa Clapp married in 1917, Marriage Certificate, State of Massachusetts, Louisa Clapp and George Blaisdell, vol. 638, 349, Mass-Doc Retrieval.

20. Ibid., ADSF, HUA.

21. Ibid.

22. If there were subsequent letters, they were not saved in her student file.

23. "Oahe: A Camp for Girls, Third Season, July and August, 1917," Elaine Goodale Eastman File, HUA. Angel's picture appears in the 1917 brochure, but it was taken the year before. Elaine's, sister, Dora Read Goodale, Mabel Ostrom of the Albany School of Fine Arts, and Dora Winona Eastman are listed as arts and crafts instructors for 1917.

24. *Indian News,* October 1917, HHS.

25. *American Indian Magazine* 6: 175.

26. Hertzberg, *The Search for an American Indian Identity,* 171.

27. The author is just imagining the arrangement of her house ("Inventory and Appraisement of the personal property of Angel DeCora Dietz," Folio D-472, and Reel 04/718/Box 13, Filed May 20, 1919, $631.90 Record 14, 458, CCHS).

28. Only one oil painting is listed in her estate items.

29. De Cora to Andrus, Dec 20, 1917, ADSF, HUA.

30. De Cora to Andrus, "Ans. Jan. 2 — 1918." This is the last letter retained in her file.

31. Chaffey, "Silent Memories of Silver Movies at Minnehaha Park." This resort was Minnehaha Springs.

32. Ibid.

33. *Spokesman Review,* January 27, 1819.

34. Borzage acted in many silent films. He received an academy award for directing *Seventh Heaven* in 1927. See "Internet Movie Database," *Seventh Heaven,* www.imdb.com/title/tt0019279 (accessed December 29, 2007).

35. *Spokesman Review,* January 27, 1819.

36. *Indian News,* March 1918, 194, HHS.

37. Charles Eastman, "The American Eagle," 88–92.

38. Crosby, *America's Forgotten Pandemic,* 228.

39. See Liartis, "Spanish Flu in Cumberland County."

40. Witmer, *The Indian Industrial School,* 89.

41. BO562–78A; State Museum Director's State Geologist and State Palentologists Correspondence Files; Box 30, 1918, A–G, New York Archives.

42. Ibid.

43. Ibid.

44. Goodale Eastman, "In Memoriam: Angel De Cora Dietz."

45. Ohiyesa Eastman, Maryland Military Men, 1917–1918, at http://ancestry.com (accessed December 29, 2007).

46. Sargent, *Life of Elaine Goodale Eastman,* 103–20. Charles and Irene were particularly close. After her death, he fathered the illegitimate child with a Camp Oahe counselor. He and Elaine separated in 1921. Elaine told her sister his infidelity was not the issue. She instead claimed Charles would not give her "an honest recognition of the truth," nor "assent" to "do what was in our power for his illegitimate child."

47. BO562–78A; State Museum Director's State Geologist and State Palentologists Correspondence, New York Archives.

48. Vital Records, No. 57440, Findings of Fact and Conclusion of Law and Decree, In the Superior Court of the State of Washington, In and for the County of Spokane, Spokane County Clerk.

49. Chaffey, "Silent Memories of Silver Movies."

50. *Fool's Gold* was released on May 26, 1919. There were eight supporting roles. "Lone Star Dietz" was second to the last. "Internet Movie Database," www.imdb .com/title/tt0010134 (accessed December 29, 2007).

51. "Winnebago Death Book," transcribed by Linda M. Waggoner, HHS.

52. Goodale Eastman, "In Memoriam: Angel De Cora Dietz."

53. *Coshocton Tribune,* untitled, February 2, 1919.

54. *Oakland Tribune,* "Possibility of Mistake in Warrant is Seen by Vallejo Friends of Dietz," February 2, 1919.

55. Certificate of Death, Angel DeCora Dietz, City of Northampton, August 23, 1994, The Commonwealth of Massachusetts.

56. *Daily Hampshire Gazette,* "Obituary," February 8, 1919, ADSF, HUA.

57. "Thurlow Lieurance, Mrs. Thurlow Lieurance, George B. Tack," 1922[?], Redpath Chautauqua Collection, Special Collections, University of Iowa Libraries.

58. LaMere wrote Minnesota historian, Thomas Hughes, "I will send you . . . a copy by Angel Decora of a painting of De-Kawray—I got it from Angel Decora's things after her death and gave it to her sister, Mrs. Julia Lukecart, and I am borrowing it from her, so please send it back to me again." It's unknown what happened to the painting. It may have been destroyed in a flood that Julia later mentioned (LaMere to Hughes, May 16, 1921, THP, SMHC).

59. *Evening Sentinel,* "Late Mrs. Deitz [*sic*] a Noted Indian Artist," February 22, 1919, microfilm, CCHS.

60. *American Indian Magazine* 7 (summer 1919): 62.

61. Curtis, "An American Indian Artist."

Epilogue

1. *Southern Workman,* October 1920, ADSF, HUA.

2. Julia De Cora to Andrus, February 16, 1921, JDSF, HUA.

3. See Case No. 3162, United States of America, Eastern District of Washington, Northern Division, United States District Court. September Term, 1918. First Count, Record Group No. 21, Records of the United States District Courts, Eastern District of Washington at Spokane, Criminal Case Files, 1890–1955, Box 53, Case 3162: "U. S. vs. William H. Dietz," and Box 55, Case # 3248, NARA—PAR. Unfortunately, the court files from this period are not as complete as they would be today, so it was necessary to supplement them with newspaper reports.

4. *Rice Lake Chronotype,* "Sensational Dietz Trial," June 30, 1919. See also *Spokesman Review,* June 23–27, 1919; *Seattle Post Intelligencer,* June 22, 24, 25, and 27, 1919; *Seattle Times,* 24–26, 1919.

5. *June Spokesman Review,* "Dietz Trial Starts Today," June 23, 1919.

6. W. W. Dietz, Probate Record, Barron County, Wisconsin (courtesy James L. Hansen, WSHS).

7. Registration of Births, Barron County Wisconsin Registers of Deeds. His birth was not recorded until 1889, though this was not brought up at trial. According to James L. Hansen of the WSHS, a late registration date was not unusual in remote areas such as Rice Lake for that time period.

8. *Rice Lake Chronotype,* "Sensational Dietz Trial," June 30, 1919.

9. See John F. Deitz Papers, Archives, WSHS.

10. "The Pennsylvania Museum and School of Industrial Art: Circular, 1920–1921," from Drexel Archives in JEP, SAA.

11. An author (cited in this book), whose daughter wishes him to remain anonymous, became acquainted with Dietz in later years and purchased his painting of Angel made to look like her self-portrait.

12. Charles Eastman, "'My People,'" 183. An autographed picture of Dietz illustrates the page with a caption: "A pioneer for his race."

13. "Angel DeCora Dietz," *Southern Workman,* March 1919, ADSF, HUA.

14. Student files, "De Cora, 1896," 1919, Sophia Smith Collection, Smith College Archives.

15. Kellogg, "Angel Decorah Dietz," 103–104, ADSF, HUA.

16. Ibid.

17. Curtis, "An American Indian Artist."

18. Ibid.

19. Goodale Eastman, "In Memoriam: Angel De Cora Dietz."

20. Ibid.

21. Ibid.

22. The contents page of the SAI journal identifies the painting as *Two Lovers,* but it is the same painting as *Fire Light.*

Bibliography

General Archives

American Philosophical Society Archives, Philadelphia, Pennsylvania. Franz Boas Correspondence.

Beinecke Rare Book and Manuscript Library, Yale University, New Haven, Connecticut. Richard Henry Pratt Papers, WA MSS S-1174.

Blue Earth County Courthouse, Mankato, Minnesota. Births, deaths, and marriage books.

Blue Earth Historical Society, Mankato, Minnesota. Obituary books, Winnebago File.

Coffrin Library, Green Bay Area Research Center, Wisconsin. Grignon, Lawe, and Porlier Papers, 1886 Winnebago Annuity Roll Book.

Cumberland County Historical Society, Carlisle, Pennsylvania.
 Carlisle School Publications
 Arrow
 Carlisle Arrow
 Indian Craftsman
 Indian Helper
 Red Man and Helper
 Red Man by Red Men
 Carlisle Sentinel
 Evening Sentinel
 "Indian School Recollections," An Interview with Henry Flickinger by Helen F. Norton.
 Inventory and Appraisement of the Estate of Angel De Cora Dietz deceased.
 Inventory and Appraisement of the personal property of Angel DeCora Dietz.
 Lila Connolly Papers, The Carlisle Barracks Collection
 Photo Archives

Free Public Library of Philadelphia, Pennsylvania
 Philadelphia Record

Friends University Archives, Wichita, Kansas
 University Life
 Friends University Bulletin

Hampton University Archives, Hampton, Virginia.
 Angel De Cora Student File

Carrie Andrus Correspondence

Catalogues of the Hampton Normal and Agricultural Institute, Hampton, Virginia

Cora Folsom Correspondence

Elaine Goodale Eastman Papers

Josephine E. Richards Correspondence

Julia De Cora Student File

Southern Workman

Talks and Thoughts

Twenty-Two Years' Work of the Hampton Normal and Agricultural Institute at Hampton, Va., Record of Negro and Indian Graduates and Ex-Students, Hampton: Normal School Press, 1893.

Winnebago Students Files

Helen Farr Sloan Library and Archives, Delaware Art Museum, Wilmington

Howard Pyle Manuscript Collection

Lykes Files

Schoonover Manuscript Collection

Schoonover Scrapbooks

Ho-Chunk Historical Society Archives, Winnebago, Nebraska

Alice Fletcher Allotments (copies)

Anna Romero and Paulette F. Molin Angel De Cora Papers

David Lee Smith Collection

The Pipe of Peace and *Indian News*, Genoa Indian School, Nebraska (on microfilm)

Winnebago Death Book

Institute for the Study of the American West, Autry National Center, Southwest Museum, Los Angeles, California. Charles Lummis Papers.

Kansas State Historical Society, Topeka, Kansas

1905 Kansas state census, Sedgwick County, Wichita, Fifth Ward

Wichita Daily Beacon

Wichita Daily Eagle

Karrman Library, Southwest Wisconsin Room, University of Wisconsin, Platteville, Wisconsin. Iowa Marriages.

Merrill G. Burlingame Special Collections, Montana State University, Bozeman

James Willard Schultz Papers, 1867–1877

Minnesota Historical Society, St. Paul

Foster's Indian Record and Historical Data, Washington, D.C.: 1876–1877

Monkato Independent

Winnebago file, Alan R. Woolworth

Nebraska State Historical Society

Emerson Enterprise

Winnebago Chieftain

Winnebago Indian News

New York State Archives, Albany, New York. State Museum Director's State Geologist and State Paleontologists Correspondence.

Northampton Historical Society, Northampton, Massachusetts. Massachusetts Historical Commission.

Oglala Lakota College Archives, Kyle, South Dakota. Pine Ridge Reservation census records (microfilm).

Oklahoma Historical Society. Chilocco Indian School records.

Raynor Library, Special Collection and Archives, Marquette University, Milwaukee, Wisconsin

Paul Radin Papers

Thomas Morgan Papers

School of the Museum of Fine Arts, Library Archives, Boston, Massachusetts

Miscellaneous Scrapbook (circa 1899–?)

School of Drawing and Painting at the Museum of Fine Arts: Twenty-Fourth Annual Report, Boston: 1900

School of Museum of Fine Arts, Boston, Records

Sioux City Public Library, Sioux City, Iowa

Sioux City Tribune

Smith College Archives, Northampton, Massachusetts

"Circulars," *Smith College, Volume III, 1893–1900*

Sophia Smith Collection

Smithsonian Institution Archives

National Museum Papers, Incoming Correspondence

Archives of American Art

F. Holland Day Papers

Alice Barber Stephens papers, 1884–1986

Smithsonian National Anthropological Archives, Suitland, Maryland

John C. Ewers Papers

Alice Fletcher Papers and Francis La Flesche Papers, MS 4558

South Dakota Historical Society, Pierre, South Dakota

Historical Newspapers (microfilm)

Pine Ridge Reservation Records

Southern Minnesota Historical Center, Memorial Library, Minnesota State University, Mankato

Thomas Hughes (1854–1934) and Family Papers, 1855–1946 (SMHC Manuscript Collection 101)

Stanford University, Green Library, Palo Alto, California

The Papers of the Society of American Indians, ed., John W. Larner, MFILM N.S. 7685, 10 microfilm reels.

Suzzallo Library, University of Washington, Seattle

Post Intelligencer (Seattle)

Spokesman Review (Spokane)

Seattle Times

St. Louis Public Library, St. Louis, Missouri. *World's Fair Bulletin.*

Thurston County Courthouse, Pender, Nebraska. Marriage Books.
University of Iowa Libraries, Special Collections, Redpath Chattaqua Collection,
 http://sdrcdata.lib.uIowa.edu/libsdrc (accessed December 29, 2007)
University of Wisconsin-Stout, Library Learning Center, Menominee, Wisconsin
 Barron County Births
 Barron County Judgment Books
 Barron County Marriage Records
 Barron County Shield
 Cumberland Advocate
 Final Records of Pupils of High School, Rice Lake
 Rice Lake Chronotype
Wichita State University Library, Special Collections, Wichita Kansas. *Sunflower.*
Wisconsin State Historical Society, Madison Wisconsin
 1836 Wisconsin Territorial census, Iowa County
 1885 State of Wisconsin census, Barron County, Village of Rice Lake
 Barron County Birth Records
 Barron County Marriage Record
 Barron County Probate Records
 John F. Dietz Papers
 Madison Democrat
 Rice Lake Chronotype
 Wisconsin Federal Census Records
W. W. Hagerty Library, Archives and Special Collections, Drexel University,
 Philadelphia, Pennsylvania
 Catalogue of the Second Exhibition of the School of Illustration under the Direction
 of Howard Pyle, May 30thJune 4th, 1898
 Drexel Institute Yearbook
 Howard Pyle, Box 13
 School of Industrial Art of the Pennsylvania Museum: Circular of the Art
 Department (School of Applied Art) 1912–1913

 National Archives and Records Administration Records
 (NARA)

NARA—Central Plains Region, Kansas City, Missouri, Original Documents
Record Group 75 (RG 75): Records of the Bureau of Indian Affairs
 Pine Ridge Agency, South Dakota
 Trust Responsibilities Records (Series 124)
 Copies of Miscellaneous Letters Sent, August 25, 1876–June 30, 1914 (Series 6)
 Winnebago Indian Agency, Winnebago, Nebraska
 Land allotments, death dates, family histories (no date, no accession number,
 Box 2)
 Probates 1910–1927 (no accession number, Box 4)
 Receipt Roll 1857, 1863 (no accession number, Box 5)
NARA—Central Plains Region, Kansas City, Missouri, Documents on Microform

RG 75: Winnebago Indian Agency, Winnebago, Nebraska
 Annuity Rolls, 1870–1910, non-inclusive (Rolls 101–104)
 Heirship Records, 1899–1913 (Rolls 84–97)
 Register of Births and Deaths, 1900–1926 (Roll 84)
NARA—Pacific Alaska Region, Seattle, Washington
 RG 21: Records of the United States District Courts
 Eastern District of Washington of Spokane
 Criminal Case Files, 1890–1955
NARA—Washington D.C., Original Documents
 RG 34: Office of Adjutant General
 PRD 4651, 1531545, 1445230 (Indorsements)
 Document Files
 RG 49: Records of the General Land Office
 Relating to Claims: Records Concerning Indian Land Reserves
 Reserve File A, ca 1825–1907, Boxes 10–12
 RG 75, Correspondence of the Office of Indian Affairs
 Letters Received, 1900
 RG 75.20.3: Records of the Carlisle Indian Industrial School, Carlisle, PA
 Student Records, 1879–1918, Record Number 1327
NARA—Washington D.C., Documents on Microform
 RG 34: Office of Adjutant General
 Regular Army enlisted personnel, serving 1789–October 31, 1912
 RG 75, Correspondence of the Office of Indian Affairs
 Letters received, 1824–1881 (M234)
 Prairie du Chien Agency, 1824–1842. (Rolls 696–702)
 Turkey River Agency, 1842–1846 (Rolls 862–864)
 Winnebago Agency, 1826–1875. (Rolls 931–947)
 Letters Sent, 1900
 Records of the Northern Superintendency, 1851–1876 (M1166)
 Winnebago Agency, 1865–66, 1873 (Roll 35)
 Territorial Papers of the United States, Wisconsin, 1836–1848 (M236)

Vital Records

The Commonwealth of Massachusetts, Certificate of Death, Angel DeCora Dietz, February 6, 1919, Copy from City of Northampton, August 23, 1994 (Ho-Chunk Historical Society from Deirdre Almeida).

The Commonwealth of Massachusetts, Certificate of Marriage, Louisa Clapp and George Blaisdell, 1916, Professional Massachusetts Public Record Researchers.

State of California, Certificate of Death, No. 52–035200, Marie Lillian Bottineau Baldwin.

State of New Jersey, Certificate and Record of Marriage, No. 678, Bureau of Vital Statistics, Wm. Dietz and Angel DeCora.

State of Washington, Spokane County, Findings of Fact and Conclusion of Law, and Decree, In the Superior Court of the State of Washington. William H. Dietz, Plaintiff, vs. Angel Decora Dietz, Defendant, No. 57440, Thomas R. Fallquist, Spokane County Clerk.

State of Wisconsin, Pepin County. Registration of Marriages, L. R. Ginder and Wm. W. Deitz, October 26, 1879.

Government Documents

American State Papers, Indian Affairs. 2 vols. Washington, D.C.: Gales and Seaton, 1832–1834.

Annual Report of the Commissioner of Indian Affairs to the Secretary of the Interior. Washington, D.C.: Government Printing Office, 1902.

Annual Report of the Commissioner of Indian Affairs. House Documents, Volume 15, Washington, D.C: Government Printing Office, 1907. *Hearings Before the Joint Commission of the Congress of the United States, Sixty-third Congress Second Session, to Investigate Indian Affairs.* Vols. 1–3. Washington, D.C.: Government Printing Office, 1914.

Fletcher, Alice C. "Indian Education and Civilization." *Bureau of Education Special Report, 1888.* Washington: Government Printing Office, 1888.

Kappler, Charles J., ed. *Indian Affairs, Laws, and Treaties.* 2 vols. Washington, D.C.: Government Printing Office, 1904.

Record of Indian Students Returned from Hampton Institute. 1892, 52D Congress, 1st Session, Senate. Ex. Doc. No. 31.

Woodrow Wilson's speech to Congress, April 2, 1917, Congressional Record, 65th Congress, Special Session, vol. 55, Pt. 1, 102–104. Washington, D.C.: U.S. Government Printing Office, 1917.

Collections (Primary Sources)

The American Indian Magazine: The Quarterly Journal of the Society of American Indians 1–7 (1919).

Minnesota Genealogical Journals. 38 vols., 1984–2006. Roseville, Minn.: Park Genealogical Books.

Wisconsin Historical Society Collections. 31 vols. Madison: Wisconsin Historical Society, 1855–1931.

Books and Articles

Abbott, Charles D. *Howard Pyle: A Chronicle.* New York: Harpers Brothers, 1925.

Achebe, Chinua. *Things Fall Apart.* New York: Faucett Crest, 1991.

Adams, David Wallace. *Education for Extinction: American Indians and the Boarding School Experience 1875–1928.* Lawrence: University of Kansas Press, 1995.

Ahern, Wilbert H. "An Experiment Aborted: Returned Indian Students in the Indian School Service, 1881–1908." *Ethnohistory* 44, no. 2 (1997): 263–304.

Anderson, Gary Clayton. *Kinsmen of Another Kind: Dakota-White Relations in the Upper Mississippi Valley, 1650–1862.* Lincoln: University of Nebraska Press, 1964.

Anderson, Gary Clayton, and Alan R. Woolworth, eds. *Through Dakota Eyes: Narrative Accounts of the Minnesota Indian War of 1862.* St. Paul: Minnesota Historical Society Press, 1988.

Appleton, Leroy H. *American Indian Design and Decoration.* 1950 Reprint. New York: Dover Publications, 1971.

Aslin, Elizabeth. *The Aesthetic Movement: Prelude to Art Nouveau.* New York: Excalibur Books, 1969.

Atwater, Caleb. *Remarks Made on a tour to Prairie du Chien; thence to Washington City in 1879.* Columbus, Ohio: Isaac N. Whiting, 1831.

Baigel, Mathew. *Dictionary of American Art.* New York: Harper & Row, 1979.

Barrow, Isabel C. *Proceedings of the Thirteenth Annual Meeting of the Lake Mohonk Conference of Friends of the Indian, 1895.* New York: The Lake Mohonk Conference, 1896.

Bataille, Gretchen M., and Kathleen Mullen Sands. *American Indian Women: Telling Their Lives.* Lincoln: University of Nebraska Press, 1984.

Beck, Ruth Everett. *The Little Buffalo Robe.* New York: Henry Holt and Company, 1914.

Beider, Robert E. "Scientific Attitudes Toward Indian Mixed-Bloods in Early Nineteenth-Century America." *Journal of Ethnic Studies* 8 (summer 1980): 17–30.

———. "The Representation of Indian Bodies in Nineteenth-Century American Anthropology." *American Indian Quarterly* (spring 1996): 165–79.

———. *Native American Communities in Wisconsin 1600–1960: A Study of Tradition and Change.* Madison: University of Wisconsin Press, 1995.

Berkhofer, Robert F., Jr. *The White Man's Indian: Images of the American Indian from Columbus to the Present.* New York: Vintage Books, 1979.

Bhabha, Homi K. *The Location of Culture.* London: Routledge, 1994.

Blair, Emma H., ed. *The Indian Tribes of the Upper Mississippi Valley and Region of the Great Lakes, as Described by Nicolas Perrot, French Commandant in the Northwest; Bacqueville de la Potherie, French Royal Commissioner to Canada; Morrell Marston, American Army Officer; and Thomas Forsyth, United States Agent at Fort Armstrong.* Cleveland: Arthur H. Clark, 1911.

Bokovoy, Matthew F. *The San Diego World's Fairs and Southwestern Memory, 1880–1940.* Albuquerque: University of New Mexico Press, 2005.

Bonnin, Gertrude Simmons. See Zitkala-Ša.

Brasser, Ted J. "In Search of Mètis Art." In *The New Peoples: Being and Becoming Métis in North America,* edited by Jacqueline Peterson and Jennifer S. H. Brown, 221–29. Lincoln: University of Nebraska Press, 1985.

Bredenberg, Al. "Fight to Preserve Indian Culture," www.nataliecurtis.org (accessed December 29, 2007).

Brokaw, Howard Pyle. *The Howard Pyle Studio Group: A History*. Wilmington: Studio Group, 1983.

Brown, Ann Barton. *Alice Barber Stephens: A Pioneer Woman Illustrator*. Chadds Ford, Penn.: Brandywine River Museum, 1984.

Brown, Jennifer S. H. *Strangers in Blood: Fur Trade Company Families in Indian Country*. Vancouver: University of British Columbia Press, 1980.

Brumble, H. David, III. *American Indian Autobiography*. Berkeley: University of California Press, 1988.

Bucklin, Clarissa, ed. "Angel De Cora." In *Nebraska Art and Artists*, 18. Lincoln: University of Nebraska, 1932.

Burgess, Larry E. *The Lake Mohonk Conference of the Indians; Guide to the Annual Reports,* New York: Clearwater Publishing, 1975.

Burns, Sarah. "The Price of Beauty: Art, Commerce, and the Late Nineteenth-Century American Studio Interior." In *American Iconology: New Approaches to Nineteenth-Century Art and Literature,* edited by David C. Miller, 209–38. New Haven: Yale University Press, 1993.

Calloway, Colin G., ed. *New Directions in American Indian History*. Norman: University of Oklahoma Press, 1992.

Campbell, Maria. *Halfbreed*. Lincoln: University of Nebraska, 1973.

Carley, Kenneth. *The Dakota War of 1862: Minnesota's Other Civil War*. 2nd ed. St. Paul: Minnesota Historical Press, 1976.

Carter, Alice A. *Cecilia Beaux: A Modern Painter in the Gilded Age*. New York: Rizzoli, 2005.

Catlin, George. *Letters and Notes on the North American Indians: Two Volumes in One*. North Dighton: JG Press, 1995.

Caudill, Edward. "Social Darwinism: Adapting Evolution to Society." In *Major Problems in the Gilded Age and the Progressive Era,* edited by Leon Fink, 253–62. 2nd ed. Boston: Houghton Mifflin, 2001.

Chaffey, Christina. "Silent Memories of Silver Movies at Minnehaha Park." www.spokanecda.com/articlesmin.html (accessed March 9, 2004).

Child, Brenda J. *Boarding School Seasons: American Indian Families, 1900–1940*. Lincoln: University of Nebraska, 2000.

Clark, Robert Judson, ed. *The Arts and Crafts Movement in America: 1876–1916*. Princeton: Princeton University Press, 1972.

Clements, William M. *Oratory in Native North America*. Tucson: University of Arizona Press, 2002.

Cleveland, David A. *Intimate Landscapes: Charles Warren Eaton and the Tonalist Movement in American Art 1880–1920*. De Menil Gallery at Groton School, 2004.

Clifton, James A., ed. *Being and Becoming Indian: Biographical Studies of North American Frontiers*. Chicago: The Dorsey Press, 1989.

Cook, Jessie W. "The Representative Indian." *The Outlook*, May 1900.

Costain, Thomas B. *The White and the Gold: The French Regime in Canada*, Garden City, N.Y.: Doubleday, 1954.

Crary, Margaret. *Susette La Flesche: Voice of the Omaha Indians.* New York: Hawthorne Books, 1973.

Crosby, Alfred W. *America's Forgotten Pandemic: The Influenza of 1918.* Cambridge: University Press, 1989.

Cumming, Elizabeth, and Wendy Kaplan. *The Arts and Crafts Movement.* London: Thames and Hudson, 1991.

Curtis, Natalie. "An American Indian Artist." *The Outlook,* January 14, 1920.

———. "From Miss Natalie Curtiss [*sic*] talk in Saratoga." *Saratogian,* May 15, 1912, ADSF.

———, Compiler. *The Indians' Book.* New York: Harper and Brothers Publishers, 1907.

———. "The Perpetuating of Indian Art." *The Outlook,* November 22, 1913, 621–31.

Danker, Kathleen A. "The Winnebago Trickster." In *New Voices in Native American Literary Criticism,* edited by Arnold Krupat, 505–28. Washington, D.C.: Smithsonian Institution Press, 1993.

De La Ronde, John T. "Personal Narrative." In *Wisconsin Historical Collections 7,* edited by Lyman Copeland Draper, 345–65. Madison: State Historical Society of Wisconsin, 1876.

De Cora, Angel. "Angel DeCora—An Autobiography." *The Red Man by Red Men,* March 1911, 279–80, 285.

———. "Gray Wolf's Daughter." *Harper's New Monthly Magazine,* November 1899, 860–62.

———. "Native Indian Art." *The Arrow,* August 23, 1907, CCHS.

———. "Native Indian Art." *Report of the Executive Council on the Proceedings of the First Annual Conference of the Society of American Indians,* October 12–17, Columbus, Ohio, 82–87. Edited by Arthur C. Parker. Washington, D.C.: Society of American Indians, 1912.

———. "Native Indian Art." *Weekly Review,* January 30, 1909, ADSF, HUA.

———. "The Sick Child." *Harper's New Monthly,* February 1899, 446–48.

Decorah, Spoon. "Narrative of Spoon Decorah." In *Wisconsin Historical Collections 13,* edited and annotated by Rueben Gold Thwaites, 448–62. Madison: State Historical Society of Wisconsin, 1895.

Deloria, Philip. J. *Playing Indian.* New Haven: Yale University Press, 1998.

Deloria, Vine, Jr. *Custer Died for Your Sins: An Indian Manifesto.* Norman: University of Oklahoma, 1988.

Diedrich, Mark, ed. *Ho-Chunk Chiefs: Winnebago Leadership in the Era of Crisis.* Rochester: Coyote Books, 2001.

———. *Winnebago Oratory: Great Moments in the Recorded Speech of the Hochungra, 1742–1887.* Rochester: Coyote Books, 1991.

Dippie, Brian W. *The Vanishing American: White Attitudes and U.S. Indian Policy.* Lawrence: University Press of Kansas, 1982.

Earenfight, Phillip, Advisor/Director. *Visualizing a Mission: Artifacts and Imagery of the Carlisle Indian School, 1879–1918.* Carlisle, Penn.: The Trout Gallery, Dickinson College, 2004.

Eastman, Charles A. (Ohiyesa). *From the Deep Woods to Civilization: Chapters in the Autobiography of an Indian*. Boston: Little, Brown, 1916.

———. "The American Eagle an Indian Symbol." *The American Indian Magazine: A Journal of Race Progress* 7 (summer 1919): 88–92.

———. "Indian Handicrafts." *Craftsman* 8 (August 1905): 659–62.

———. "'My People': The Indians' Contribution to the Art of America." *Craftsman* 27 (November 1914): 179–86.

Edgar, Joseph. "Chamberlain." In *The Twentieth Century Biographical Dictionary of Notable Americans: Volume II*. Boston: The Biographical Society, 1904.

Edmunds, R. David. ed. *American Indian Leaders*. Lincoln, University of Nebraska Press, 1980.

———. "'Unacquainted with the laws of the civilized world': American attitudes toward the métis communities in the Old Northwest." In *The New Peoples: Being and Becoming Métis in North America*, edited by Jacqueline Peterson and Jennifer S. H. Brown, 185–93. Lincoln: University of Nebraska Press, 1985.

Ewers, John C. "Five Strings to His Bow: The Remarkable Career of William (Lone Star) Dietz." *Montana the Magazine of Western History* 27, no. 1 (1987): 2–12.

———. *George Catlin: Painter of Indians of the West*. Reprint from the Annual Report of the Smithsonian for 1955, no date.

Ewers, John C., Helen M. Mangelsdorf, and William S. Wierbowski. *Images of a Vanished Life: Plains Indian Drawings from the Collection of the Pennsylvania Academy of the Fine Arts*. Philadelphia: Pennsylvania Academy of the Fine Arts, 1956.

Fairbrother, Trevor J. *The Bostonians: Painters of an Elegant Age, 1870–1930*. Boston: Museum of Fine Arts, 1986.

Fear-Segal, Jacqueline. "Nineteenth-Century Indian Education: Universalism versus Evolutionism." *Journal of American Studies* 33, no. 2 (1999): 323–41.

Featherstonhaugh, G. W. *A Canoe Voyage of the Minnay Sotor; with an Account of the Lead and Copper Deposits in Wisconsin; of the Gold Region in the Cherokee Country; and Sketches of Popular Manners*. St. Paul: Minnesota Historical Society, 1970.

Fiske, John. "John Fiske Reconciles Evolutionism and Christian Doctrine (1882), 1902." In *Major Problems in the Gilded Age and the Progressive Era*, edited by Leon Fink, 226–28. 2nd ed. Boston: Houghton Mifflin, 2001.

Fixico, Donald L., ed. *An Anthology of Western Great Lakes Indian History*. Revised abridged ed. Milwaukee: The Board of Regents, University of Wisconsin, 1989.

———, ed. *Rethinking American Indian History*. Albuquerque: University of New Mexico Press, 1997.

Folsom, Cora W. "The Careers of Three Indian Women." *Congregationalist and Christian World*, March 12, 1904, ADSF, HUA.

Folsom, William Henry. *Fifty Years in the Northwest*. St. Paul: Pioneer Press, 1888.

Fournier, Suzanne, and Ernie Crey. *Stolen from our Embrace: The Abduction of First Nations Children and the Restoration of Aboriginal Communities*. Vancouver: Douglas and McIntyre, 1997.

Gallop, Alan. *Buffalo Bill's British Wild West*. Phoenix Mill, England: Sutton Publishing, 2001.

Gere, Anne Ruggles. "An Art of Survivance: Angel DeCora at Carlisle." *American Indian Quarterly* 28 (summer and fall 2004): 649–84.

Gilman, Carolyn. *Where Two Worlds Meet: The Great Lakes Fur Trade*. St. Paul: Minnesota Historical Society, 1982.

Gilman, Rhoda R. "The Fur Trade in the Upper Mississippi Valley, 1630–1850." *Wisconsin Magazine of History* 58 (autumn 1974–75): 3–18.

Gilmore, Jann Haynes. *Almost Forgotten: Delaware Women Artists and Art Patrons 1900–1950*. Dover: The Biggs Museum of American Art, 2002.

Goodale Eastman, Elaine. "In Memoriam: Angel De Cora Dietz," *American Indian*, Spring 1919, 51–52.

———. "Miss Cora M. Folsom," *The Berkshire County Eagle*, June 4, 1943, Historical Newspaper Collection, at http://ancestry.com (accessed December 29, 2007).

———. *Pratt: The Red Man's Moses*. Norman: University of Oklahoma Press, 1935.

———. *Yellow Star: A Story of East and West*. Boston: Little, Brown, 1911.

Graber, Kay, ed. *Sister to the Sioux: The Memoirs of Elaine Goodale Eastman. 1885–1891*. Lincoln: University of Nebraska Press, 1978.

Green, Rayna. *Native American Women: A Contextual Bibliography*. Bloomington: Indiana University Press, 1983.

Grignon, Antoine. "Recollections" and "Antoine Grignon." In *History of Trempealeau County Wisconsin*, compiled by Franklyn Curtis-Wedge and edited by Eben Douglas Pierce, 129–36, 212–18. Chicago: H. C. Cooper, 1917.

Grignon, Augustine. "Recollections of Grignon." In *Wisconsin Historical Collections 20*, edited by Lyman C. Draper, 197–295. Madison: State Historical Society of Wisconsin, 1857.

Hansen, James L. "'Half-Breed' Rolls and Fur Trade Families in the Great Lakes Region—An Introduction and Bibliography." In *The Fur Trade Revisited: Selected Papers of the Sixth North American Fur Trade Conference*, edited by Jennifer S. H. Brown, W. J. Eccles, and Donald P. Heldman, 161–69. Mackinac Island: Michigan State University Parks, 1994.

———. "Records of St. John Nepomucene Catholic Church, Little Chute, Wisconsin, 1836–1851." Unpublished.

Harvey, George. "Singularity of the Jamestown Exposition." *North American Review* 184 (March 15, 1907).

Hertzberg, Hazel W. *The Search for an American Indian Identity: Modern Pan-Indian Movements*. Syracuse: University Press, 1971.

Hexom, Charles Philip. *Indian History of Winneshiek County*. Decorah, Iowa: A. K. Bailey, 1913.

Hill, Edward E. "Winnebago Agency, 1826–76." In *Historical Sketches for Jurisdictional and Subject Headings Used for the Letters Received by the Office of Indian Affairs, 1824–80*. The National Archives and Records Service, Washington, D.C.: 1967.

Hill, Tom, and Richard W. Hill, Sr., eds. *Creation's Journey: Native American Identity and Belief.* Washington, D.C.: Smithsonian Institution Press in association with National Museum of the American Indian, 1994.

Hofstadter, Richard, William Miller, and Daniel Aaron. *The United States: The History of a Republic.* New Jersey: Prentice-Hall, 1961.

Holcombe, Maj. R. I., and William H. Bingham, eds. *Compendium of History and Biography of Polk County Minnesota.* Minneapolis: W. H. Bingham, 1916.

Hollinger, David A. *Postethnic America: Beyond Multiculturalism.* New York: Basic Books, 1995.

Horan, James D. *The McKenny-Hall Portrait Gallery of American Indians.* New York: Bramhall House, 1986.

Horsman, Reginald. *Race and Manifest Destiny: The Origins of American Racial Anglo-Saxonism.* Cambridge: Harvard University Press, 1981.

Houghton, Louise Seymour. *Our Debt to the Red Man: The French-Indians in the Development of the United States.* 1918. Reprint. Whitefish, Montana: Kessinger Publishing, n.d.

"How Art Misrepresents the Indian." *The Literary Digest,* January 27, 1912, 160–61.

Hoxie, Frederick E., ed. *Talking Back to Civilization: Indian Voices from the Progressive Era.* Boston: Bedford/St. Martins, 2001.

Hughes, Thomas. *History of Blue Earth County.* Chicago: Middle West Publishing, 1901.

———. *Indian Chiefs of Southern Minnesota: Containing Sketches of the Prominent Chieftains of the Dakota and Winnebago Tribes from 1825 to 1865.* Minneapolis: Ross & Haines, 1969.

Hultgren, Mary Lou. "'To Be Examples to . . . Their People': Standing Rock Sioux Students at Hampton Institute, 1878–1923" (Part Two). *North Dakota History: Journal of the Northern Plains* 68, no. 3 (2001): 20–42.

Hultgren, Mary Lou, and Paulette Fairbanks Molin. *To Lead and To Serve: American Indian Education at Hamtpon Institute 1878–1923.* Charlottesville: Virginia Foundation for the Humanities, 1989.

Hunter, Sam, and John Jacobus. *Modern Art: Painting/Sculpture/Architecture.* 2nd Ed. Engelwood Cliffs, New Jersey: The Vendome Press, 1985.

Hutchinson, Elizabeth. "Indigeneity and Sovereignty: The Work of Two Early Twentieth-Century Native American Art Critics." *Third Text* 52 (summer 2000): 21–29.

———. "Modern Native American Art: Angel DeCora's Transcultural Aesthetics." *The Art Bulletin* 83 (December 2001): 740–57.

Iverson, Peter. *Carlos Montezuma and the Changing World of the American Indians.* Albuquerque: New Mexico Press, 1982.

Jackson, Helen Hunt. *A Century of Dishonor: A Sketch of the United States Government's Dealings with Some of the Indian Tribes.* 1885. Reprint. Norman: University of Oklahoma Press, 1995.

Jenkins, Sally. *The Real All Americans: The Team that Changed a Game, a People, a Nation.* New York: Doubleday, 2007.

Jensen, Richard E. *The Indian Interviews of Eli S. Ricker, 1903–1919*. Lincoln: University of Nebraska Press, 2005.

Jones, John Alan. *Winnebago Ethnology*. New York: Garland Publishing, 1974.

Judd, Mary Catherine, compiler. *Wigwam Stories: Told by North American Indians*. Boston: Ginn, 1901.

Kaplan, Amy, and Donald E. Pease, eds. *Cultures of United States Imperialism*. Durham: Duke University Press, 1993.

Katanski, Amelia V. *Learning to Write "Indian": the Boarding-School Experience and American Indian Literature*. Norman: University of Oklahoma Press, 2005.

Keller, Helen. *The Story of My Life*, www.bygosh.com/hk/index.htm (accessed December 19, 2007).

Kellogg, Louise Phelps. "Angel Decorah Dietz." *The Wisconsin Archeologist* 18 (August 1919): 103–104.

———. "Glory of the Morning and the Decorah Family." *Madison Democrat*, February 21, 1912. Wisconsin Local History and Biography Articles, Wisconsin Historical Society at www.wisconsinhistory.org (accessed December 29, 2007).

———. *The French Régime in Wisconsin and the Northwest*. New York: Cooper Square Publishers, 1968.

———. "The Removal of the Winnebago." *Transactions of the Wisconsin Academy of Sciences, Arts and Letters* 21 (1924): 23–29.

Kinzie, Juliette M. *Wau-bun: The "Early Day" in the North West*. 1856. Reprint. Menasha, Wisc.: George Banta Publishing, 1930.

Knox, Robert. "An Inquiry into the Laws of Human Hybridité." In *The Races of Men*. 2nd Ed., 481–507. London: Saville and Edwards, 1862.

Krupat, Arnold. *Ethno-Criticism: Ethnography, History, Literature*. Berkeley: University of California Press, 1992.

———. *For Those Who Come After: A Study of Native American Autobiography*. Berkeley: University of California Press, 1985.

La Flesche, Francis. *The Middle Five: Indian Boys at School*. Boston: Small, Maynard, 1900.

LaMere, Oliver, and Harold B. Shinn. *Winnebago Stories*. New York: Rand McNally, 1928.

Lang, John D., and Samuel Taylor Jun. *Report of a Visit to Some of the Tribes of Indians, Located West of the Mississippi River*. New York: M. Day, 1843. Reprint. Oaksdale, Washington: Ye Galleon Press, 1974.

Lass, William E. "The Removal from Minnesota of the Sioux and Winnebago Indians." In *Minnesota History*. St. Paul: Minnesota Historical Society, 1925.

Leupp, Francis E. *In Red Man's Land: A Study of the American Indian*. New York: Fleming H. Revell, 1914.

Liartis, Christopher T. "Spanish Flu in Cumberland County, 1918." *Cumberland County History* 11. Carlisle: Cumberland County Historical Society, Summer 1994.

Lindsey, Donal F. *Indians at Hampton Institute 1877–1923*. Urbana: University of Chicago Press, 1995.

Little Hill. "The Uprooted Winnebago." *Native American Testimony*. Rev. ed. Peter Nabakov, ed. New York: Penguin Books, 1999.

Livingston, Karen, and Linda Parry, eds. *International Arts and Crafts*. London: V&A Publications, 2005.

Lomawaima, K. Tsianina. *They Called it Prairie Light: The Story of Chilocco Indian School*. Lincoln: University of Nebraska Press, 1994.

Lorini, Allesandra. "Alice Fletcher and the Search for Women's Public Recognition in Professionalizing American Anthropology." *Cromohs* 8 (2003): 1–25, at www.cromohs.unifi.it/8_2003/lorini.html (accessed December 29, 2007).

Ludlow, Helen. "Indian Education at Hampton and Carlisle." *Harper's Monthly*, April 1881, 659–75.

Lund, Duane R. *Our Historic Upper Mississippi*. Cambridge, Minn.: Adventure Publications, 1991.

Lurie, Nancy Oestreich. "A Check List of Treaty Signers by Clan Affiliation." *Journal of the Wisconsin Indians Research Institute* 2 (June 1966): 50–73.

———. "Cultural Change Among the Wisconsin Winnebago." *Wisconsin Archeologist* 25, no. 4 (1944): 119–25.

———. "Winnebago." In *Handbook of North American Indians 15*, edited by Bruce G. Trigger, 690–707. Washington, D.C.: Smithsonian Institution Press, 1978.

———. *Wisconsin Indians*. Madison: The State Historical Society of Wisconsin, 1987.

———. ed. *Mountain Wolf Woman: The Autobiography of a Winnebago Indian*. Ann Arbor: University of Michigan Press, 1961.

MacLane, Mary. *The Story of Mary MacLane by Herself*. Chicago: Herbert Stone, 1902.

Madill, Dennis F. K. "Riel, Red River, and Beyond: New Developments in Métis History." In *New Directions in American Indian History*, edited by Colin G. Calloway, 49–78. Norman: University of Oklahoma Press, 1987.

Malon, Bill. *The 1904 Olympic Games: Results of All Competitors in All Events, with Commentary*. Jefferson, N.C.: McFarland and Co., 1999.

Malval, Fritz J., ed. *A Guide to the Archives of Hampton Institute*. Westport, Conn.: Greenwood Press, 1985.

Mark, Joan. *A Stranger in Her Native Land: Alice Fletcher and the American Indians*. Lincoln: University of Nebraska, 1988.

Marks, Paula Mitchell. *In a Barren Land: American Indian Dispossession and Survival*. New York: Quill, 1998.

Martin, Calvin, ed. *The American Indian and Problem of History*. New York: Oxford University Press, 1987.

Mazzuchelli, Samuel Charles. *Memoirs, historical and edifying, of a missionary apostolic of the order of Saint Dominic among various Indian tribes and among the Catholics and Protestants in the United States of America*. Available at http://memory.loc.gov/cgi-bin (accessed December 29, 2007).

McAnulty, Sarah (Quilter). "Angel DeCora: American Indian Artist and Educator." *Nebraska History* 57 (summer 1976): 143–99.

————. "Angel DeCora Dietz: The Art Career of a Winnebago Woman." In *Perspectives: Women in Nebraska History*, edited by Susan Pierce, 97–112. Lincoln: Nebraska Department of Education, June 1984.

McCormick, Richard L. "Evaluating the Progressives." In *Major Problems in the Gilded Age and the Progressive Era*, edited by Leon Fink, 367–79. 2nd ed. Boston: Houghton Mifflin, 2001.

McKenny, Thomas L. *Sketches of a Tour to the Lakes*. 1827. Reprint. Minneapolis: Ross and Haines, 1959.

Merrell, Henry. "Pioneer Life in Wisconsin." In *Wisconsin Historical Collections 9*, edited by Lyman C. Draper, 366–404. Madison: State Historical Society of Wisconsin, 1882.

Meyers, Kenneth John. *American Art*. Washington, D.C.: Freer Gallery of Art and Arthur M. Sackler Gallery, 2000.

Michaelsen, Scott. *The Limits of Multiculturalism: Interrogating the Origins of American Anthropology*. Minneapolis: University of Minnesota Press, 1999.

Michelson, Truman. "Some Notes on Winnebago Social and Political Organizations." *American Anthropologist* 37 (July–September 1935): 446–49.

Mihesauah, Devon A., ed. *Natives and Academics: Researching and Writing about American Indians*. Lincoln: University of Nebraska Press, 1998.

Molin, Paulette Fairbanks. "'To Be Examples to . . . Their People': Standing Rock Sioux Students at Hampton Institute, 1878–1923" (Part One). *North Dakota History: Journal of the Northern Plains* 68, no. 2 (2001): 2–23.

————. "'Tracing the Hand, the Head, and the Heart': Indian Education at Hampton Institute." *Minnesota History: The Quarterly of the Minnesota Historical Society* 51, no. 3 (fall 1858): 82–98.

Monroe, Dan L., ed., *Gifts of the Spirit: Works by Nineteenth-Century and Contemporary Native American Artists*. Salem, Mass.: Peabody Essex Museum, 1996.

Moses, L. G. *The Indian Man*. Lincoln: University of Nebraska Press, 1984.

————. *Wild West Shows, and the Images of American Indians, 1883–1933*. Albuquerque: University of New Mexico, 1996.

Muncy, Robyn. "The Female Dominion of Professional Service." In *Major Problems in the Gilded Age and the Progressive Era*, edited by Leon Fink, 244–53. 2nd ed. Boston: Houghton Mifflin, 2001.

Murphy, Lucy Eldersveld. "Autonomy and the Economic Roles of Indian Women of the Fox-Wisconsin Riverway Region, 1763–1832." In *Negotiators of Change: Historical Perspectives on Native American Women*, edited by Nancy Shoemaker, 72–89. New York: Routledge, 1995.

————. "Public Mothers: Native American and Métis Women as Creole Mediators in the Nineteenth-Century Midwest." *Journal of Women's History* 14 (winter): 142–66.

————. *A Gathering of Rivers: Indians, Métis, and Mining in the Western Great Lakes, 1737–1832*. Lincoln: University of Nebraska Press, 2000.

Myers, Kenneth John. "American Art." Brochure. Washington, D.C.: Smithsonian Freer Gallery of Art, 2003.

Nabokov, Peter. *Native American Testimony: A Chronicle of Indian-White Relations from Prophecy to the Present, 1492–2000.* Rev. ed. New York: Penguin, 1991.

Naylor, Gillian. *The Arts and Crafts Movement: A Study of its Sources, Ideals and Influence on Design Theory.* Cambridge: MIT Press, 1971.

Neill, Rev. E. D. *History of Hennepin County and the City of Minneapolis.* Minneapolis: North Star Publishing, 1881.

———. *The History of Minnesota.* Philadelphia: J. B. Lipincotte, 1858.

Nies, Judith. *Native American History: A Chronology of a Culture's Vast Achievements and Their Links to World Events.* New York: Ballantine Books, 1996.

Nott, J. C. "The Mulatto a Hybrid—Probable Extermination of Two Races if the Whites and Blacks are Allowed to Intermarry." *American Journal of the Medical Sciences* 6 (July 1843): 252–56.

O'Meara, Walter. *Daughters of the Country: The Women of the Fur Traders and Mountain Men.* New York: Harcourt, Brace & World, 1968.

Oriard, Michael. *Reading Football: How the Popular Press Created an American Spectacle.* Chapel Hill: University of North Carolina Press, 1993.

Paquette, Moses. "The Wisconsin Winnebagoes." In *Wisconsin Historical Collections* 12, edited by Rueben Gold Thwaites, 399–433. Madison: State Historical Society of Wisconsin, 1892.

Parezo, Nancy. "Indigenous Art: Creating Value and Sharing Beauty." In *A Companion to American Indian History*, edited by Philip J. Deloria and Neal Salisbury, 209–33. Malden, Mass.: Blackwell Publishing, 2004.

Peterson, Jacqueline. "Many Roads to Red River: Métis Genesis in the Great Lakes Region, 1680–1815." In *The New Peoples: Being and Becoming Métis in North America*, edited by Jacqueline Peterson and Jennifer S. H. Brown, 35–71. Lincoln: University of Nebraska Press, 1985.

Peterson, Jacqueline, and Jennifer S. H. Brown, eds. *The New Peoples: Being and Becoming Métis in North America.* Lincoln: University of Nebraska Press, 1985.

Pettit, Lani. "The Ancestry of Charles Raymond III Kada-Mah-Ga." *The Waukaw* 2 (winter 1986).

Phillips, Ruth B. *Trading Identities: The Souvenir in Native North American Art from the Northeast, 1700–1900.* Seattle: University of Washington Press, 1998.

Pitz, Henry C. *The Brandywine Tradition.* Boston: Houghton, Mifflin, 1969.

Pohl, Frances K. *Framing America: A Social History of American Art.* New York: Thames and Hudson, 2002.

Power, Lillian D., ed. *Report of the Twenty-Sixth Annual Meeting of the Lake Mohonk Conference of Friends of the Indian.* New York: Lake Mohonk Conference, 1908.

Pratt, Richard Henry. *Battlefield and Classroom: Four Decades with the American Indians, 1867–1904.* Reprint. Edited by Robert M. Utley with a foreword by David Wallace Adams. Norman: University of Oklahoma Press, 2003.

Prucha, Francis Paul. *American Indian Policy in Crisis: Christian Reformers and the Indian, 1865–1900.* Norman: University of Oklahoma Press, 1976.

————. *American Indian Treaties: The History of a Political Anomaly.* Berkeley: University of California Press, 1994.

————, ed. *Documents of United States Indian Policy.* 2nd ed. Lincoln: University of Nebraska Press, 1990.

Quaife, Milo Milton, ed. *Life of Blackhawk.* 1916. Reprint. New York: Dover Publications, 1994.

"The Racial Exhibit at the St. Louis Fair." *Scientific American* (December 10, 1904): 412, 414.

Radin, Paul. *Crashing Thunder: The Autobiography of an American Indian.* New York: Appleton and Company, 1926.

————. *The Autobiography of a Winnebago Indian.* 1920. Reprint. New York: Dover Publications, 1963.

————. "The Influence of Whites on Winnebago Culture." In *Proceedings of the State Historical Society of Wisconsin 1913,* vol. 16, 137–45. Madison, Wisc., 1914.

————. "The Social Organization of the Winnebago Indians, an Interpretation." *Canada Department of Mines: Geological Survey: Museum Bulletin No. 10.* Ottawa: Government Printing Bureau, 1915.

————. *The Trickster: A Study in American Indian Mythology.* New York: Schocken Books, 1978.

————. *The Winnebago Tribe.* Lincoln: University of Nebraska Press, 1990.

Rappaport, Doreen. *The Flight of Red Bird: The Life of Zitkala-Ša.* New York: Dial Books, 1997.

Remini, Robert V. *Andrew Jackson and His Indian Wars.* New York: Pengin.

Rentmeester, Les, and Jeanne Rentmeester. *The Wisconsin Creoles.* Copyright 1987.

————. *The Wisconsin Fur-Trade People.* Copyright 1989.

Richter, David H. *Narrative Theory.* White Plains, N.Y.: Longman Publishers, 1996.

Rosenblum, Robert, Maryanne Stevens, and Ann Dumas. *1900: Art at the Crossroads.* New York: Harry N. Abrams, 2000.

Ruoff, A. LaVonne Brown. *American Indian Literatures: An Introduction, Bibliographic Review, and Selected Bibliography.* New York: The Modern Language Association, 1990.

Rydell, Robert. *All the World's a Fair: Visions of Empire at American Expositions, 1876–1916.* Chicago: University of Chicago Press, 1984.

Rydell, Robert, John E. Findling, and Kimberly D. Pelle. *Fair America.* Washington, D.C.: Smithsonian Books, 2000.

Said, Edward W. *Culture and Imperialism.* New York: Vintage Books, 1994.

Sargent, Theodore D. *The Life of Elaine Goodale Eastman.* Lincoln: University of Nebraska, 2005.

Scanlan, Peter L. *Prairie du Chien: French, British, American.* Wisconsin: The Prairie du Chien Historical Society, 1998.

Schoolcraft, Henry Rowe. *Narrative Journal of Travels through the Northwestern Regions of the United States Extending through the Great Lakes to the Sources of the Mississippi River in the Year 1820,* edited by Mentor L. Williams. East Lansing: Michigan State University Press, 1953.

Schoonover, Courtland. *Frank Schoonover: Illustrator of the North American Frontier.* New York: Watson-Guptill Publications, 1976.

Schraeder, Julie Hiller. *The Heritage of Blue Earth County.* Dallas: Curtis Media, 1990.

Schultz, Duane. *Over the Earth I Come: The Great Sioux Uprising of 1862.* New York: St. Martin's Press, 1992.

Schultz, Emily A. *Dialogue at the Margins: Whorf, Bakhtin, and Linguistic Relativity.* Madison: University of Wisconsin Press, 1990.

Shoemaker, Nancy, ed. *Negotiators of Change: Historical Perspectives on Native American Women.* New York and London: Routledge, 1995.

Sleeper-Smith, Susan. *Indian Women and French Men: Rethinking Cultural Encounter in the Western Great Lakes.* Amherst: University of Massachusetts, 2001.

Smith, David Lee, compiler. *Treaties and Agreements with the Winnebago Tribe, 1816–1928.* Unpublished, 1998.

———. *Folklore of the Winnebago Tribe.* Norman: University of Oklahoma Press, 1997.

———. *Ho-Chunk Tribal History: The History of the Ho-Chunk People from the Mound Building Era to the Present Day.* Copyright 1996 David Lee Smith.

———. "People of the Parent Speech." Winnebago, Nebraska: Ho-Chunk Historical Society, 1996.

Smith, Donald B. *Chief Buffalo Child Long Lance: The Glorious Imposter.* Red Deer, Alberta: Red Deer Press, 1999.

Smith, Huron H. "Among the Winnebago." In *Yearbook of the Public Museum of the City of Milwaukee 1928*, edited by S. A. Barret, 76–82. Milwaukee, Wisc.: Board of Trustees, 1929.

Smith, Page. *America Enters the World: A People's History of the Progressive Era and World I.* New York: Penguin Books, 1985.

Spack, Ruth. "Dis/engagement: Zitkala-Ša's Letters to Carlos Montezuma, 1901–1902." *MELUS* 26 (spring 2001): 172–204.

Sparhawk, Frances. "Istia, A Story." *The New England Magazine* 17, no. 2 (October 1894): 243–52.

Sperhoff, Leon. *Carlos Montezuma, M.D.: A Yavapai American Hero.* Portland, Oregon: Arnica Publishing, 2003.

Steckbeck, John S. *Fabulous Redmen: The Carlisle Indians and Their Famous Football Teams.* Harrisburg, Penn.: J. Horace McFarland Company, 1951.

Stephanson, Anders. *Manifest Destiny: American Expansion and the Empire of Right.* New York: Hill and Wang, 1995.

Stevens, John H. *Personal Recollections of Minnesota and Its People and Early History of Minneapolis.* Minneapolis: Marshall Robinson, 1890.

Sumner, William Graham. "William Graham Sumner Elaborates the Principles of Social Darwinsim, 1885." In *Major Problems in the Gilded Age and the Progressive Era*, edited by Leon Fink, 229–31. 2nd ed. Boston: Houghton Mifflin, 2001.

Szasz, Margaret Connell. *Between Indian and White Worlds: The Cultural Broker.* Norman: University of Oklahoma Press, 1994.

———. *Education and the American Indian: The Road to Determination Since 1928.* 3rd ed. Albuquerque, University of New Mexico Press, 1999.

Takaki, Ronald. *Iron Cages: Race and Culture in 19th-Century America.* Revised ed. New York: Oxford University Press, 2000.

Talbot, Edith Armstrong. *Samuel Chapman Armstrong: A Biographical Study.* New York: Doubleday, Page and Co., 1904.

Tanner, Helen Hornbeck, Adele Hast, Jacqueline Peterson, and Robert J. Surtees, eds. *Atlas of Great Lakes Indian History.* Norman: University of Oklahoma Press, 1987.

Tappert, Tara Leigh, "Aimeé Ernesta and Eliza Cecelia: Two Sisters, Two Choices," *The Pennsylvania Magazine of History and Biography* 124 (July 2000): 249–91.

Taylor, Joshua C., ed. "Mr. Whistler's 'Ten O'Clock' 1885." *Nineteenth-Century Theories of Art.* Berkeley: University of California Press, 1987.

Thompson, Susan Otis. "The Arts and Crafts Book." In *The Arts and Crafts Movement in America 1876–1916,* edited by Robert Judson Clash, 115–48. Princeton: University Press, 1972.

Thwaites, Rueben Gold. *Wisconsin: The Americanization of a French Settlement.* Boston: Houghton Mifflin, 1908.

Trennert, Robert A. "Educating Indian Girls at Non Reservation Boarding Schools, 1878–1920." In *The American Indian: Past and Present,* 3rd ed., edited by Roger L. Nichols, 218–31. New York: McGraw Hill, 1986.

Trenton, Patricia, ed. *Independent Spirits: Women Painters of the American West, 1890–1945.* Berkeley: Autry Museum of Western Heritage in association with University of California Press, 1995.

Truettner, William H., ed. *The West as America: Reinterpreting Images of the Frontier.* Washington D.C.: Smithsonian Institution Press, 1991.

Turner, Andrew Jackson. *The Family Tree of Columbia County.* Portage: Press of the Wisconsin State Register, 1904.

Turner, Frederick Jackson. *The Character and Influence of the Indian Trade in Wisconsin: A Study of the Trading Post as an Institution,* edited by David Harry Miller and William W. Savage, Jr. Norman: University of Oklahoma Press, 1977.

Tusmith, Bonnie. *All My Relatives: Community in Contemporary Ethnic American Literatures.* Ann Arbor: University of Michigan Press, 1994.

Utley, Robert M. *The Indian Frontier of the American West 1846–1890.* Albuquerque: University of New Mexico Press, 1984.

Van Kirk, Sylvia. *"Many Tender Ties": Women in Fur Trade Society, 1670–1870.* Norman: University of Oklahoma Press, 1983.

Vizenor, Gerald. *Manifest Manners: Narratives on Postindian Survivance.* Lincoln: University of Nebraska Press, 1999.

———. *Word Arrows: Indians and Whites in the New Fur Trade.* Minneapolis: University of Minnesota Press, 1978.

Waggoner, Linda, ed. *"Neither White Men Nor Indians": Affidavits from the Winnebago Mixed-Blood Claim Commissions, Prairie du Chien, Wisconsin 1838–1839.* Roseville: Park Genealogical Books, 2002.

———. "Reclaiming James One Star or the Legacy of Coach Lone Star Dietz and the Redskins." *Indian Country Today.* New York: Oneida, 2004.

———. "When Great Grandma Became a Naturalized Indian in St. Paul: The Winnebago Métis Families of 1870 and Their Citizen Mothers." Unpublished essay, American Society for Ethnohistory Conference, November 2006.

Waldman, Carl. *Who Was Who in Native American History.* New York: Facts on File, 1990.

Wakefield, John. *A History of the TransMississippi and International Exposition, May 1903. www.omaha.lib.ne.us/transmiss/secretary/table.*html (accessed December 29, 2007).

Ward, Lester Frank. "Lester Frank Ward Attacks Laissez Faire in the Name of Reform Darwinsim, 1884." In *Major Problems in the Gilded Age and the Progressive Era,* edited by Leon Fink, 231–34. 2nd ed. Boston: Houghton Mifflin, 2001.

White, Henry C. *The Life and Art of Dwight William Tryon.* Boston and New York: Houghton Mifflin, 1930.

White, Richard. *The Middle Ground: Indians, Empires, and Republics in the Great Lakes Region, 1650–1815.* 5th ed. Cambridge: University Press, 1995.

Whiteford, Andrew Hunter. *North American Indian Arts.* Rev. Edited by Herbert S. Zim. New York: Golden Books, 1990.

Williams, J. Fletcher. *A History of the City of Saint Paul, and of the County of Ramsey, Minnesota.* Saint Paul: Minnesota Historical Society, 1876.

Wilson, Raymond. *Ohiyesa: Charles Eastman, Santee Sioux.* Urbana: University of Illinois, 1999.

Witmer, Linda. *The Indian Industrial School: Carlisle, Pennsylvania 1879–1918.* Carlisle, Penn.: Cumberland County Historical Society, 2002.

Wozniak, John S. *Contact, Negotiation and Conflict: An Ethnohistory of the Eastern Dakota, 1819–1839.* Washington D.C.: University Press of America, 1978.

Young, Robert. *Colonial Desire: Hybridity, Race and Theories of Culture.* London: Routledge, 1995.

Zitkala-Ša (Gertrude Simmons Bonnin). "An Indian Teacher Among Indians." *Atlantic Monthly,* vol. 85, March 1900.

———. "Impressions of Indian Childhood." *Atlantic Monthly,* vol. 85, January 1900.

———. *Old Indian Legends.* Boston: Ginn and Company, 1901.

———. "Soft-hearted Sioux." Electronic Text Center, University of Virginia Library, http://etext.virginia.edu/toc/modeng/public/ZitSoft.html (accessed December 29, 2007).

———. "The School Days of an Indian Girl." *Atlantic Monthly,* vol. 85, February 1900.

———. "Why I am Pagan." *Atlantic Monthly,* vol. 90, December 1902.

Dissertations and Theses

Almeida, Diedre Ann. "The Role of Western Massachusetts in the Development of American Education Reform Through the Hampton Institute's Summer Outing Program (1878–1912)." EdD diss., University of Massachusetts, 1992.

Bell, Genevieve. "Telling Stories out of School: Remembering the Carlisle Indian Industrial School, 1879–1918." PhD diss., Stanford University, 1998.

Hutchinson, Elizabeth West. "Progressive Primitivism: Race, Gender and Turn-of-the-Century American Art." PhD diss., Stanford University, 1998.

Lubman, Hyman. "A History of the Nebraska Winnebago Indians with Special Emphasis on Education." MA thesis, University of Omaha, Nebraska, 1962.

McAnulty, Sarah (Quilter). "Angel DeCora: American Indian Artist and Educator." MA thesis, University of New Mexico, 1976.

Peterson, Jacqueline. "The People in Between: Indian-White Marriage and the Genesis of a Métis Society and Culture in the Great Lakes Region, 1680–1830." PhD diss., University of Illinois at Chicago Circle, 1981.

Schindall, Katie. "Within Bounds but Pushing Boundaries: The Teachers at the Carlisle Indian Industrial School, 1879–1904. BA with honors, Wellseley College, 2004.

Tiger, Yvonne Nicole. "Angel de Cora—Assimilation and Indian Identity in the Life of an Indian Woman." BA with honors, Smith College, 2003.

Tingey, Joseph Willard. "Indians and Blacks Together: An Experiment in Biracial Education at Hampton Institute (1878–1923)." PhD diss., Columbia University, 1978.

Historical Newspapers (with Sources)

Barron County Shield (Wisconsin), University of Wisconsin, Stout
Carlisle Sentinel (Pennsylvania), CCHS
Cumberland Advocate (Wisconsin), University of Wisconsin, Stout
Daily Hampshire Gazette, ADSF, HUA
Emerson Enterprise (Nebraska), NSHS
Evening Sentinel (Carlisle, Pennsylvania), CCHS
Indian's Friend, ADSF, HUA
Indian News, ADSF, HUA
Madison Democrat, (Wisconsin) WSHS
Mankato Independent, (Minnesota) MHS
The Nation, ADSF, HUA
Ohio State Journal (Columbus, Ohio), ADSF, HUA
Philadelphia Inquirer, ADSF, HUA
Philadelphia Record, Free Public Library of Philadelphia, Pennsylvania
The Philadelphia Press, Lila Connolly Papers, CCHS
Plain Dealer (Cleveland, Ohio), ADSF, HUA
Post Intelligencer (Seattle, Washington), Suzzallo Library, University of Washington, Seattle
Press (Pittsburg, Pennsylvania), ADSF, HUA

Rice Lake Chronotype (Wisconsin), WSHS, and University of Wisconsin, Stout
San Francisco Chronicle, Wm. Dietz, CSR
Seattle Times, Suzzallo Library, University of Washington, Seattle
Sioux City Daily, Addie Stevens Student File, HUA
Sioux City Tribune (Iowa), Public Library
Spokesman Review (Spokane, Washington), Suzzallo Library, University of Washington, Seattle
Sun (New York, New York), CANC
Washington Herald, CANC
Washington Post, CANC
Washington Times, CANC
Weekly Review (Flandreau, South Dakota), ADSF, HUA
Winnebago Chieftain (Winnebago, Nebraska), NSHS
Winnebago Indian News (Winnebago, Nebraska), NSHS
Wisconsin State Journal (Madison), ADSF, HUA

Additional Internet Resources

http://ancestry.com
 Historical Newspaper Collection
 Adams County News (Gettysburg, Pennsylvania)
 Atlanta Constitution (Atlanta, Georgia)
 Coshocton Tribune (Coshocton, Ohio)
 Daily Herald (Delphos, Ohio)
 Daily Northwestern (Oshkosh, Wisconsin)
 Edwardsville Intelligencer (Edwardsville, Illinois)
 Fitchburg Sentinel (Fitchburg, Massachusetts)
 Fort Wayne News (Fort Wayne, Indiana)
 Gettysburg Compiler (Gettysburg, Pennsylvania)
 Gettysburg Times (Gettysburg, Pennsylvania)
 Marion Daily Star (Marion, Ohio)
 Mountain Democrat (Placerville, California)
 Nebraska State Journal (Lincoln, Nebraska)
 Newark Advocate (Newark, Ohio)
 Olean Democrat (Olean, New York)
 Star and Sentinel (Gettysburg, Pennsylvania)
 Washington Post (Washington, D.C.)
 Births, Deaths, and Marriages
 Illinois Marriages, 1790–1869
 Census Records
 U.S. Federal Census, 1790–1930
 U.S. Indian Census, 1885–1940
 Iowa State Census Collection, 1836–1925
 Minnesota Territorial and State Census, 1849–1905
 Nebraska State Census, 1885

Family and Local Histories
 Historical Sketches of Andover
 Western Massachusetts: A History: 1636–1925
 Knowles, Elizabeth. "John Folsom and His Descendants, 1615–1882."
Military Records
 American Civil War Soldiers Record and General Officers Record
Immigration and Naturalization Records
 Boston Passenger Lists, 1891–1943

Index

Abbott, Lyman, 67
Achebe, Chinua, 28
Adams, David W., 272n39
Adler, Felix, 126, 293nn79–81
Aesthetic movement/art for art's sake,
 61–62, 78, 79, 127, 251, 279n27; and
 Angel, xxv, 121, 122, 279n28
African Americans: attitudes of Indians
 toward, 160, 170, 197, 198–201; at
 Hampton Institute, 32, 33, 35–36, 51,
 131, 160, 170, 196–97, 198–201,
 272n37, 273n63; slavery, 273n58
Ahern, Wilbert H., 272n36, 284n8,
 307n50
Alexander, Carrie, 25, 36, 55, 277n86
Almeida, Diedre Ann, 273n1
Amelle, Catherine. *See* Lamere,
 Catherine Amelle
Amelle, Elizabeth (Henukaw), 3–5, 11,
 12–13, 19, 257–58, 264n5
Amelle, Joseph, 4
Amelle, Louis (son of Oliver), 4
Amelle, Louis (son of Prosper), 113, 121
Amelle, Mary, 4, 19
Amelle, Nancy, 4, 19, 285n10
Amelle, Oliver, 3–4, 11, 13, 18, 19, 257–
 58, 264nn6–7, 266n43
Amelle, Oliver, Jr., 4, 264n11
Amelle, Prosper, 4, 19
Amelle, Theresa, 4
American Anthropological Society, 161
American Barbizon school, 279n30
American Folklore Society, 288n71
American Fur Company, 4
American illustration as an art form. *See*
 Pyle, Howard
American Indian Magazine, 243, 246,
 258–59, 316n22
American Indians: assimilation of, xxvi–
 xxvii, 27–28, 32–35, 38, 86, 131, 147,
 169, 180–81, 271n15, 272n39, 273n3,
 274n10; music of, 108, 111, 128, 137–

38; sign language of, 186, 192, 235,
 273n66; status of women among, 26,
 39–40, 41–42, 74–75. *See also* Dakotas
 (Eastern Sioux); Design elements,
 American Indian; Navajos; Omahas;
 Pueblos; Sacs and Foxes;
 Sioux/Lakotas; Winnebagos
American Printer, 171
American Type Founders, 205
Anderson, Gary Clayton, 269n85
Andrus, Carrie, 42, 150, 200, 201,
 297n89; early life, 290n17;
 relationship with Angel De Cora, 29,
 110, 167, 170–71, 173, 179, 190, 203–
 204, 219, 233, 236–37, 244–45,
 256–57, 291n51, 295n33; relationship
 with Julia De Cora, 252–53;
 relationship with William Jones, 110,
 170–71, 290n17; and Society of
 American Indians, 190
Ankle, Mathew, 108
Anti-Semitism, 203, 213
Armel. *See* Amelle
Armstrong, Samuel Chapman: during
 Civil War, 31–32, 272n31; at
 Hampton, 30, 33–35, 36, 38, 40–41,
 49, 53, 55–56, 63, 200, 272n37, 273n1
Arthurs, Stanley, 75
Arts and crafts movement, 133, 139; and
 Angel, xxv, 94, 98, 102, 104, 105, 147,
 174, 193; and printing, 164, 166, 167,
 300n60; and Pyle, 69–70
Atkins, J. D. C., 36
Atlanta Constitution, 151, 208
Atlantic Monthly, 89, 98; "An Indian-
 Teacher Among Indians" published by,
 90; "Why I am Pagan" published by,
 122
Authenticity, 166–67, 305n58; and Angel,
 xxiii–xxiv, xxvii, 44, 70, 97–98, 99, 132,
 132–33, 141, 143, 156–57, 181, 191,
 195, 227, 229, 232; "How Art